The Critics on Matt Lamb's Art

"The brightly colored canvases come from the brush of a lively character named Lamb, a former funeral director who believes in reincarnation and the existence of a spirit world."
—Ruth Gledhill, *The Times of London*, June 9, 2000

"Here is an artist who celebrates life with big, free shapes and unabashed color."
—Sister Wendy Beckett, *The Catholic Herald* (London), June 3, 1998

"The paintings seize the viewer on an emotional level with freewheeling, joyous movement and exuberant, earthy colors . . . sending up a kind of hymn to universal forces and the ascendancy of natural order."
—Margaret Hawkins, *Chicago Sun-Times*, September 8, 2000

"These powerful protests against social and political injustice meld Christian beliefs with Zen Buddhist and Jewish echoes and Romantic contemplations of the American Indian."
—Angela Tamvaki, curator, National Gallery, Athens, Greece, *Agony and Hope: Matt Lamb's Optimistic Vision of the Universe*, November 1994

"Lamb's paintings perfectly express the core of pure emotion unique to his sensibility."
—Pierre Cardin, *Visions*, October 2, 1990

". . . a remarkable body of work characterized by bright, clashing colors and dark, dreamlike imagery. These mysterious dramas are enhanced by the rich and often rugged surface textures he creates. Seemingly transforming from plant to animal to human to spirit, these figures take part in fragmented narratives drawn from Lamb's imagination."
—Carol Damian, *Art News*, January 2000

"Lamb's work evokes a surreal, fairy-tale sense of the fantastic . . . integrating semblances of Chagall's poeticism with Lamb's personal symbology of primordial memory in an exquisitely sensuous vocabulary of pure, luscious pigment."
—Olga Zdanovics, *New Art Examiner*, September 1994

"His rainbow-hued oil paintings . . . of folks, flora, and fauna recall the slap-dash, faux-naïve style of European postwar artists like Karel Appel and Asger Jorn."
—Elisa Turner, *Miami Herald*, November 14, 1999

"For more than a quarter-century I have dealt in art. I know thousands of artists. But I have encountered only one true visionary: Matt Lamb."
—Virginia Miller, *A Life-Affirming Art Born of Death*, November 2001

MATT LAMB

the art of success

RICHARD SPEER

WILEY

John Wiley & Sons, Inc.

Published by John Wiley & Sons, Inc., Hoboken, New Jersey
Published simultaneously in Canada

For general information about our other products and services, please contact our Customer Care Department within the United States at 800-762-2974, outside the United States at 317-572-3993 or fax 317-572-4002.

Wiley also publishes its books in a variety of electronic formats. Some content that appears in print may not be available in electronic books. For more information about Wiley products, visit our web site at www.wiley.com.

Library of Congress Cataloging-in-Publication Data

Speer, Richard.
 Matt Lamb : the art of success / Richard Speer.
 p. cm.
 Includes bibliographical references and index.
 ISBN-13 978-0-471-71154-4
 ISBN-10 0-471-71154-3 (cloth)
 1. Lamb, Matt, 1932- 2. Painters—United States—Biography. I. Title.
ND237.L255S65 2005
759.13—dc22
2004029112

Printed in the United States of America

10 9 8 7 6 5 4 3 2 1

For Patricia and Janie,
my cheerleaders

CONTENTS

PART FOUR
The New Life

PART FIVE
The Career Blossoms

Contents

Contents

"What I want is to be able to live like a poor man with plenty of money."

—*Pablo Picasso*

PART ONE

THE PRINCE OF PARADOX

"We need our art fictions. We need Paul Gauguin dumping his career in stock brokering to paint in Tahiti. We also need that which ties the Gauguin myth to a contemporary saga in which a Chicago entrepreneur named Lamb sells his corporation to spend time among the flowers, gnomes, and archangels that materialize under his paintbrush."

—*Michael D. Hall ("Just A'Looking for a Home,"*
Raw Vision, *Summer 2000)*

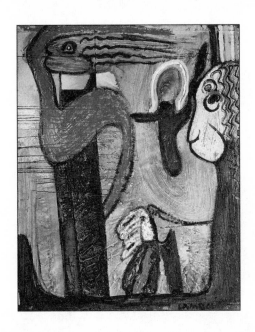

CHAPTER ONE

A PORTRAIT OF THE STARVING
ARTIST AS TYCOON

There are demons in the gallery. Swooping up from the underworld, sulfur clouds in their wakes, they bolt up in front of us, only to be met and repelled by archangels descending with flaming swords. Other creatures pile into the mêlée: things that look half-man, half-insect, wielding umbrellas like shields against the angels' onslaught; and a Cossack on horseback, galloping alongside a Cherokee brave in full headdress; and a troupe of harlequins tossing confetti into the air as if to conjure a glittery fog of war; and a woman with a pink beehive hairdo, emerging from a plume of smoke, her mouth agape in some unknown horror or rapture. It's not clear whose side these motley combatants are on, the demons' or the angels', but clearly they're locked in some sort of winner-takes-all cosmic conflict—and while in

reality these creatures are confined to canvases on the gallery walls, something about the angry insistency of their forms, colors, and textures allows them, seemingly, to puncture the picture plane and blaze forth into three-dimensional space.

This is not the kind of battle normally waged in an art gallery. But then, there is nothing normal about the painter Matt Lamb, who brought these Manichean warriors into being, nor is there anything remotely normal about the art itself. Make no mistake, this is some majorly weird stuff. Fellini freak show meets fine art. A menagerie of the damned and the redeemed. Garishly hued, splattered as if in a mad rage with oil paint, cement, turpentine, and a toxic, secretive mix of other ingredients, the paintings portray their armies of good and evil atop an undulating, puckered background. Indeed, the canvas itself is scarred and charred, as if the artist had thrown it wholesale into the mouth of a volcano, fished it out, then immediately freeze-dried its lava-layered surface only a split-second before the whole shebang would have burst into flames. This artist, this Lamb fellow, must be either profoundly inspired or profoundly disturbed. His technique is as sophisticated as his imagery is primitive, his demons as fearsome as his harlequins are droll. It's as if he's walking a tightrope over the great eternal questions, holding for balance a steel bar weighted with profundity on one end, whimsy on the other.

Lamb is standing tonight in the center of the battles he's painted, here amidst the Syrah and brie and hardwood floors of the Judy A. Saslow Gallery in Chicago's River North district. I'm standing next to him, watching him mingle with the city's most prominent art collectors, because it's my job to follow him around for a year, to find out what makes him tick and uncover the combination of skill, inspiration, and luck that transformed him from a dyslexic gang member on the rough-and-tumble streets of 1940s Southside Chicago, into the CEO of one of the Midwest's largest family-owned businesses, and then, improbably, into one of the world's most revered—and reviled—painters. To figure Lamb out will be an epic challenge, because his has been an epic life.

But the woman who's talking to him now, the one with the obnoxious voice and the attitude to match, doesn't know anything about

Lamb, except that he made the paintings all around us. She's not impressed.

"I've never heard of you," she brays, approximating the sonic effect of Melanie Griffith and Fran Drescher declaiming the word "Fahrvergnügen" in unison.

He smooths his white hair casually back. "Well, I've been painting for 20 years."

Gucci-garbed, Bulgari-ringed, she peers down her spectacles, looking and sounding every inch and decibel the imperious collector she is, her hauteur fitting her even more snugly than her couture. "If you've been painting 20 years," she demands, "then why haven't I heard of you?"

He smiles. "I don't know."

As even the most militant feminist would be forced to concede, the gal's a shrew in need of taming, and Matt Lamb is about to oblige her. But for the moment, she has the upper hand, because she has him cornered. Literally. The three of us form points of a triangle, the woman and myself at its legs and Lamb at the pointy tip, wedged in the gallery's corner. Which is exactly where she wants him.

"Where else have you shown your work?" she wants to know.

"Oh, here and there."

"For example?"

"I've shown with Carl Hammer and Ingrid Fassbender," he says, invoking the names of two respected Chicago gallerists. "Here in town, that is."

"So you show out of town, too?"

"Oh, yes."

"Where at?"

There's a glint in his eye now. "Well, where do you want to start? New York, Miami, Buenos Aires, Lucerne . . ."

She arches her left eyebrow.

". . . and Germany and China, and I did a big installation over at Westminster Cathedral and a show for Pierre Cardin at his gallery in Paris, and . . ."

"But you live in Chicago?" she interrupts, her voice ricocheting off the walls.

"Part of the time."

"And the rest of the time?"

"I have studios in Paris, Ireland, Germany, the Florida Keys, Wisconsin . . ."

"My, my! And these are big studios or small or . . ."

"One of them is 30,000 square feet, another one is 20,000 . . ."

"Thirty-thousand feet?" she gasps.

"The others are much smaller, only 9,000 or 10,000." He's beginning to enjoy this.

"You must sell a lot of paintings."

"It's all thanks to Judy," he tells her, shooting me a quick wink as he gestures toward Judy Saslow across the room. "See?" And he points at the little red dots beside several paintings, the stickers that indicate a work has sold.

Lamb knows, as do many, that he was a high-profile business tycoon decades before he ever laid hands on a paintbrush. He hadn't purchased his expansive studios with money made from selling paintings. But this woman doesn't know that, and Lamb likes the fact that she doesn't.

"So," she intones in the manner of summation, "you jet around to all these studios in Paris and Germany and Key West . . ."

There's a sudden draft as someone opens the door behind us.

". . . and you have 30,000 square feet here and 20,000 there . . ." The pitch of her voice is rising.

A man in a black suit pokes his head into the gallery and nods in Lamb's direction. Behind him, through the open door, a stretch limousine idles.

The woman looks up and sees the waiting car. "You have all this money, and you ride around in a limo, and . . . so . . ." Flustered, she shakes her head, takes a breath, and says something I'll never forget. "What kind of a starving artist's life is *that*, anyway?"

A hint of a smile traces his mouth.

There is a beat, and another.

The man in the black suit approaches and ends the silence with a deferential whisper. "The car's ready when you are, Mr. Lamb."

And with that, Lamb bids the woman adieu, waves good-bye to

Judy Saslow, and bids me follow him out into his black bubble of luxury on wheels. As the driver pulls onto West Superior, Lamb chuckles over the fun he had with the collector. "Did you see her face when I told her about the studios?" he asks, then breaks into a lusty laugh.

His amusement and her pretensions aside, I can't help but think, as we slink through the blur of city lights, that something important was buried within the woman's hypothetical question: What kind of starving artist's life *is* this, indeed?

We love our starving artists, after all: young and piss-poor, selling plasma to buy paint, tossing poetry into the woodstove to keep the garret warm while Puccini swells in the sound track. We like our artists right out of central casting, and we give bonus points if they're cute, fashionably scruffy, and/or addicted to heroin. Extra bonus points if they're under 30 or dead (provided they died penniless), and a shiny gold star if they hail from broken homes, lead colorful sex lives, have multiple facial piercings, or spell their names all in lowercase. It's our ideal, this melding of Left-Bank *vie bohême*, with its tableaux of cafés and rat-ridden apartments, with the American street-artist prototype, downtown and downrent. If only the art world could borrow from science and fuse the exhumed DNA of Vincent van Gogh and Jean-Michel Basquiat, then implant the cloned zygote in the postmenopausal but still avant-garde uterus of Yoko Ono! No doubt the unholy spawn would become the toast of SoHo.

Nowhere does our fantasy of the starving artist hold more sway than within the fiefdom of Outsider art, in which Matt Lamb's work has been stirring up controversy for decades now. Outsider art (a term coined in 1972 by British critic Roger Cardinal) is the domain of the untrained, naïve, and self-taught. The French painter and collector Jean Dubuffet began the Outsider boom in the middle of the twentieth century when he took a shine to the crude but highly expressive art of a Swiss schizophrenic and asylum inmate named Adolf Wölfli. Dubuffet called Wölfli's art—and other, similar work he later discovered—*Art Brut*. Which pretty much means what it sounds like: brutal art. Art that punches you in the gut when other, more refined, art merely tickles your ribs. A whole movement grew out of Dubuffet's obsession with *Art Brut*, and gradually the public came to appreciate these

unschooled painters, who made up for in sheer visceral impact what they lacked in academic training.

Today's Outsiders flourish on the fringes. While many of them are as well adjusted as the next person, those considered the most glamorous (and therefore most collectible) are in some fashion disadvantaged: drug addicts selling their art on the streets, paranoids, sociopaths, shut-ins, and deaf-mutes who paint as a sole means of expression. Even more so than dime-a-dozen starving artists, the art establishment values Outsiders who are damaged goods: marginalized economically, geographically, socially, or psychologically. The worse the life, the better the life story. The better the life story, the better the sales.

All of which is why Matt Lamb, who is neither destitute nor deranged, has made and is still making such a stink. He confounds the gatekeepers who sort artists into piles to make them more profitable to dealers. How are the categorizers to categorize Lamb? Into which pile are the sorters to sort him?

Consider the conundrum. Like all Outsiders by definition, Lamb is self-taught. He never once took an art lesson during his 73 years, but taught himself to paint through trial and error. Like most Outsiders, he works obsessively and prolifically, completing between 500 and 1,000 paintings a year. Like many Outsiders, he's guided by an inner vision: He claims to see the spirits of dead people and creatures from other dimensions in the chaotic ooze of his paintings and considers it his life's mission to give these ghosts corporeal form by outlining their contours in shocking color. Finally, like the work of many Outsiders, Lamb's painting is fueled in part by emotional wounds: He had an authoritarian father who didn't know how to express love, and he suffered—and suffers—from a learning disability that made his school years a living hell and left him with a playground nickname that echoes to this day in his mind's ear: "Dummy."

But that's where his similarities end, because unlike the typical Outsider, Lamb is loaded. Not Bill Gates loaded, not Donald Trump loaded, but assuredly richer than most. He is, as they say, "comfortable." Despite his academically challenged childhood, he used his

street smarts and tireless work ethic to achieve great wealth and prominence, parlaying his father's cash-poor funeral parlor into one of the largest and most profitable family businesses in the Midwest, Blake-Lamb Funeral Homes.

During what he calls his "first life," before he became a painter in his early 50s, he lived the type of life that bohemian Outsiders condemn (and sometimes secretly covet), traveling by Rolls-Royce and private jet and hobnobbing with the world's political elite: Chicago Mayor Richard M. Daley, presidential cabinet member Ed Derwinski, Vice President Walter Mondale, congressmen, senators, and a cadre of other players who push the buttons and pull the strings that make things happen. Using the funeral business as his cornerstone in the 1960s and 1970s, he branched out into real estate, oil, and stocks, eventually running 36 different businesses throughout the nation and consulting for other companies around the world. Far from a shut-in, the guy was all over the place.

Making a living from death was a job with all the drama and pathos of the HBO drama, *Six Feet Under*, and Lamb played the role of power-brokering patriarch to the hilt, dealing deals, chairing boards, organizing fundraisers, and living in opulent fashion. Paparazzi snapped his picture at charity balls and glitterati gatherings, plastering him all over the society pages: There he was with Sherill Milnes on opening night at Chicago Lyric Opera, and there on the next page with Hollywood tan-man George Hamilton and crooner Tony Bennett, and on the overleaf getting tapped on the shoulder with a golden sword by order of Pope John Paul II. The man was loaded, lauded, *knighted*, for crying out loud, which is about as far from a schizophrenic sanitarium dweller as you can get—all of which has made him a pariah among New York art dealers hell-bent on limiting the Outsider club to an easily controlled handful of spare-changers and head cases.

Then there's the matter of Lamb's outspokenness. While more typical Outsiders have a vested interest in keeping their mouths shut, even if their dealers rape them financially, Lamb is beholden to no such restriction. With a sharp Irish tongue and Southside Chicago

temper, he indulges his penchant for withering tirades against the art establishment, entertaining the press, the cognoscenti, the neighbors, and anyone else who'll listen, with bon mots like:

"An artist and a gallery owner are like two whores dancing."

"Museums are about exclusion; galleries are about business; neither is about art."

"Some gallery owners are great people, but a lot of them are shitheads, and most of them don't have a clue what my art is about."

And "The art establishment is like OPEC. They determine who's in and who's out, and then they control the artist by determining the output, the distribution, and the price. But they can't control me—I don't have to prostrate myself before the almighty dealer. I'm too old and too rich to give a shit."

He's a loose cannon, this man relaxing in the limo tonight as the Sears Tower looms through the moonroof. He's also a cipher with whom the art arbiters, press, and public have had a field day, projecting onto him their most Machiavellian stereotypes of the greedy, robber-baron fat cat: J.R. Ewing with a paintbrush. How they love to attack Lamb, damning wealth and fetishizing poverty as an artistic credential even as they sit in Le Corbusier cube chairs in sprawling Sotto galleries, whispering that he simply *must* have bought his way into the art world. How they—the board members of Sanford L. Smith & Associates, the powerhouse New York art-fair organizer—love to blacklist him, as they did in 2003, when they kicked him out of the Outsider Art Fair explicitly because of his wealth, in a move that prompted the *Wall Street Journal* to ask, "When Is an Outsider Really an Insider?"

And yet there are so many things that they, the naysayers and detractors, don't know about Lamb in their rush to judge him, things like the medical crisis that led him to become a painter in the first place. Diagnosed at the age of 48 with a grim trio of diseases, he'd been given only two to three years to live.

"If I were you," his doctor had intoned, "I would put my affairs in order."

The millionaire undertaker, now facing the prospect of becoming his own customer, had taken stock of his frenetically paced life, so full

of meetings, profit-and-loss statements, and the trappings of material wealth. On death's doorstep, he'd experienced only one regret: Deep within himself, he had always harbored a secret dream to paint, a dream he'd ignored in his quest to expand Blake-Lamb and his other businesses into major financial players. But now, suddenly, the boundless future, the "someday" when he'd finally get around to painting the spirit-laden visions in his head, had been whittled down to an hourglass swiftly draining two to three more years' worth of sand.

"If I can just kick this thing," he'd told his wife, Rose, after a long night of soul-searching, "then I'm going to sell all the businesses, resign from all the boards, and become a painter."

"Why would you do that?" she'd asked, surprised.

"Because I think I have something to offer the world as an artist. I think I have something to say."

Something amazing had happened next. During a follow-up visit at another hospital, after a week of exhaustive tests, a team of specialists had sat him down and told him the news: "For whatever reason, Mr. Lamb, your tests turned up negative on each of the three conditions we were testing you for."

He'd sat there, stupefied.

"Other than some stress," the lead specialist had told him, "you're a perfectly healthy man."

While some had attributed his medical turnaround to a misdiagnosis, he had preferred to think of it as a miracle, a kick in the pants needed to jump-start his life as a painter. He'd made good on his promise to Rose, sold the businesses, and begun the arduous task of teaching himself to paint. Starting from a point of utter ignorance, he'd eventually arrived at a technique of eye-popping sophistication, discovering along the way a series of innovations no painter had ever before achieved, and which none has thus far replicated. He'd painted in seclusion at first, then finally allowed artist friends to see his work. Thereafter, word of his talent had quickly spread. His Chicago gallery debut had nearly sold out but was trashed ruthlessly by the city's most influential art critic, the redoubtable Harry Bouras, who'd pronounced the show "horrible . . . the work of an undertaker who thinks he's an artist."

Far from deterring him, the critical flogging had emboldened Lamb to up the ante and produce increasingly more outlandish portraits of the spirit world only he could see. Within three years, legendary fashion designer Pierre Cardin, struck by Lamb's "core of pure emotion," had invited the painter to exhibit at the Espace Cardin in Paris. Four years after that, the Vatican Museums in Rome had acquired Lamb's work and hung it in its permanent collection. In 2000, Her Royal Highness, Princess Michael of Kent, had officially opened a soaring installation of Lamb's work inside Westminster Cathedral. The next year, in the aftermath of the September 11 attacks on the World Trade Center and the Pentagon, Lamb had led a series of art workshops for children orphaned by the tragedies. Sponsored by the Tragedy Assistance Program for Survivors (TAPS) and mandated by the U.S. Congress, Lamb's "Good Grief Camp" had helped the children begin to overcome their paralyzing grief. Painting umbrellas as symbols of protection and inclusion, Lamb and the kids had paraded through Washington, D.C., like a latter-day Pied Piper and his flock. Later that year he'd founded the nonprofit "Lamb Umbrellas for Peace" project, working pro bono to instill the values of understanding and tolerance in children around the world.

These are things the pigeonholers don't know about Lamb—nor do they likely know that he's worked for years to improve the infrastructure and quality of life in remote Peruvian villages, traveling into the jungles in the midst of revolutions, obey-or-be-shot curfews, and the firebombing of his colleagues' homes by the Shining Path terrorist organization. It's doubtful J.R. Ewing would have done such things, with or without a paintbrush in hand. Nor would J.R. have spent the better part of the 1980s as Lamb did, organizing symposia between Jewish, Muslim, and Christian leaders with the aim of finding common ground between them. No, the stereotypers are more interested in the controversy that dogs Lamb in the United States than for his humanitarian causes and his art itself, which is embraced without caveat in Europe. Fixated on his ouster from the Outsider Art Fair in January 2003, the pigeonholers neglect to note that in September of that same year, he was hailed as an heir to Pablo Picasso and fêted with a one-man show at the Centre Picasso in Horta, Spain, one of the world's

premier centers for Picasso studies. In a move that highlighted the cultural divide between Europe and the United States, Elias Gastón, director of the Centre Picasso, had placed one of Lamb's paintings, which had been deemed unfit to hang in SoHo, on Picasso's antique easel.

The man whom critic Harry Bouras had called "an undertaker who thinks he's an artist" has gone on to win rapturous reviews from critics at *ARTnews, Raw Vision, The New Art Examiner, The Times of London*, the *Miami Herald*, the *Chicago Sun-Times, La Vanguardia* (Barcelona), and other publications from Mexico City to Karachi. His body of work has since been compared not only to Picasso's, but also to Miró's, van Gogh's, Gauguin's, Klee's, and Chagall's. A university course on his art is planned at Texas A&M University, and talks are underway in the European Union for one of his paintings to adorn an E.U. postage stamp. His artworks hang on the walls of museums, mosques, medical centers, and government landmarks; number in the collections of Oxford University and the Sorbonne; and beautify the private homes of celebrities, members of Parliament, cardinals, and counts.

These successes notwithstanding, the road to respectability has not been a smooth one for Lamb as either businessman or artist. Along the way, he has endured not only the snickers, slings, and arrows of critics and curators, but also the ups and downs of high-risk business deals that could have plunged him into bankruptcy; a complicated financial and emotional relationship with his stern, often disapproving father; a betrayal by one of his earliest artistic champions; the intrigues of an unctuous British bureaucrat; the sudden, mysterious cancelation of his massive planned installation at the Mall of America; and a recent creative crisis so extreme, it pitted him against his most cherished artistic truths and promised either to turn his paintings into pablum or elevate them into the echelons of genius.

These are things you learn when you chase Lamb's shadow around the world, searching for the keys to his fabled business bravado and aesthetic inspiration. Over the years, whenever I'd read about Lamb in the art press, I'd thought of him as straddling the intersection of Joyce, Kafka, and Fitzgerald: a golden-years update on *A Portrait of the Artist*

as a Young Man, a *Twilight Zone* twist on *A Hunger Artist*, and a worthy heir to *The Last Tycoon*. Imagine my surprise to learn, late in 2002, that one of my high school friends, Dominic Rohde, had wound up as Lamb's agent in Europe, South America, and Asia, and Dominic's concurrent surprise to learn that I had wound up as an art critic on the West Coast. Upon this discovery, I'd begged Dominic to put me in touch with Lamb, whom I felt would make for a fascinating magazine profile. But the reclusive painter, holed up in his cliffside manor in Ireland, was beyond the reach of even his closest associates.

"Matt has his cell phone set up so that he can call out," Dominic informed me, "but no one can call in."

Finally, when Lamb returned to his native Chicago, I was able to get him on the phone and interview him. Initially reserved, he eventually opened up in a big way. In fact, he talked my ear off. Still, in many ways he remained an enigma. During subsequent interviews coordinated by Dominic, as I flipped on my speaker phone and scribbled notes, I had an odd feeling of disconnect, as if I were in some kind of *Charlie's Angels* scenario: Lamb as Charlie, Dominic as Bosley, and I as—dear God, did that make me Farrah Fawcett?

I scheduled another phone interview, then another and another, until I realized that in my notes were the makings not of an article on Lamb, but of a book. Would he, I asked, be interested in my writing his biography? By way of answer, he demanded I fax him reams of my writing and a sample chapter. I complied. Eventually, he came around.

Over the next year I spent hundreds of hours talking with him in person and by phone. He also sent me on a few goose chases: "Go to Taos, New Mexico," he told me. "All the spirits in my paintings are there. Go to my studios around the world—there's a different part of me in every one of them. And before you finish the book, read everything ever written about me, then tell me who's full of shit, the critics or me."

And so I went out in search of Lamb's inspirations, like the reporter in *Citizen Kane* who searches for the elusive Rosebud. I'd been a news reporter myself before I'd become an art critic, and as I entered the world of Lamb I endeavored, perhaps foolishly, to take my reportorial objectivity with me. My goal was to infiltrate the cult of personality that surrounds him without drinking the grape Kool-Aid. This

strategy proved easier formulated than executed. Like the reporter in Orson Welles' film, I never found a definitive answer to the subject of my search. Just when it seemed within my grasp, it dissolved into riddles and paradoxes, for Lamb is a walking, breathing contradiction. The naïve sophisticate. The artist adored in Europe but considered controversial in his own country. The insider who became an Outsider, only to be made an outsider among Outsiders because he was too much the insider. The jet-setter who entertains royalty but seems happiest sitting on the floor, finger painting with grade-school kids. A deeply religious man who can outcuss the saltiest sailor, who quotes Scripture one minute and Pink Floyd lyrics the next. The recovering alcoholic whose paintings are reproduced on wine bottles. A preacher of peace and love who wasn't a hippy in the 1960s, but a ruthless businessman who made mincemeat of his enemies and whose paintings today look like LSD trips come to life, except that he never dabbled in psychedelia. Lamb is such an assortment of paradoxes that many of his best friends may not recognize him as the man portrayed in this book. People who knew him and still think of him as the deferential funeral director in the charcoal morning coat and nary a hair out of place, would never guess that the outspoken, take-no-prisoners iconoclast he has become is the same person they thought they knew.

So which slice of Lamb is the meatiest: the conservative businessman he used to be or the raving radical he is now, who takes aim at the art world's sacred cows like a top-ranked bowler eyeing a set of pins? There are other questions, too, that must be tackled to make sense of what arts writer Donald Kuspit calls "the madness of Matt Lamb." Why does the artist insist that his peace-and-love paintings come from a cauldron of seething rage? Who or what are the spirits he claims he sees in the canvas, and why are they agitating Lamb and, through him, the rest of us? What kind of family and religious background produced this flamboyant specimen, who one moment seems the embodiment of preternatural wisdom and the next moment of flat-out kookiness? Finally, is Lamb an Outsider or not, and does it really matter to anyone besides a handful of art-geek power-trippers who live and die inside the 26 square blocks bordered by Greenwich Village, Little Italy, and TriBeCa?

The limo slows down as my hotel looms on the right. Studying the enigma that is Lamb's face, I know my work is cut out for me if I'm to sniff out the secrets of his past as entrepreneur and his present as provocateur. There is an adventure ahead in which a West Coast Gen-X writer of dubious religiosity and negative bank-account balance shadows a Midwestern septuagenarian Roman Catholic millionaire, searching for the essence of his paradigm-pulverizing, Rodolfo-meets-Rockefeller success story. There will be clues and clashes, dead ends and epiphanies along the way, and at the end of the road, perhaps even the answer to the question everyone wants to know about Matt Lamb: Is he one of the world's great artists or one of the world's great scam artists—or both?

The car eases to a halt.

"Good night," I say to Lamb.

"Good night," he replies. "Tomorrow morning at eight I'll swing by to pick you up, and then we'll go down into the belly of the beast."

"Belly of the beast?"

"Yes," he says. "My studio."

PART TWO

THE BACKSTORY

"The Southside of Chicago was all about the Church, the priests, the gangs, and the Mafia. In retrospect, it was a great place to grow up."

—*Matt Lamb*

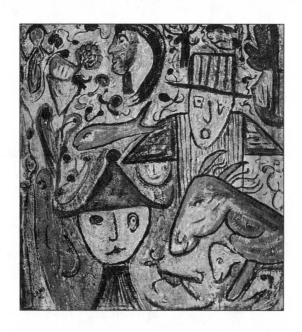

CHAPTER TWO

BUTCHERING SHEEP AND SIPPING TEA

Matt Lamb's dramatic, diametric causes célèbres in the early years of the new millennium—his expulsion from the Outsider Art Fair and his triumphant one-man show at the Centre Picasso—were only a small chapter in the saga of a colorful, cantankerous clan of Irish immigrants who arrived in America in the nineteenth century and are still raising Cain in the twenty-first.

Matthew Lamb—Matt Lamb's great-grandfather—was born in County Kerry, Ireland, in 1837 and sailed to New York in 1860. He spent the 1860s working odd jobs around the country, trying vainly to find steady employment during the decade of the Civil War. In 1865, he tried Saint Louis; in 1867, Buffalo; and in 1869, he moved to Chicago, where he remained. To support himself, he butchered sheep. Thousands of them. Their deaths were his life. In 1875, Lamb was

appointed the first meat inspector for the City of Chicago's Board of Health. For the next 22 years he worked at the Union Stock Yards, retiring as Chief Inspector in 1894, two years before his death. His wife, Bridget Ryan, hailed from Limerick, Ireland, and bore him 13 children, one of whom was Matthew Joseph Lamb—Matt Lamb's grandfather—born in 1869.

This Matthew Lamb followed for a while in his father's footsteps, going to work at the Union Stock Yards in 1888. But butchering sheep wasn't this Lamb's cup of tea; he was a creature of more cultivated sensibilities. Leaving behind the stinking gore of the Stock Yards, he opened a saloon on South Halsted Street and for a brief time poured stiff Irish whiskeys, playing the role of proprietor with finesse. Before long, though, it became apparent that slinging drinks wasn't his cup of tea, either. No, his cup of tea turned out to be—a cup of tea. Beginning in 1895 and for the following 20 years he owned and operated Lamb Tea Company on Wallace Street. A yellowed advertisement in the Lamb family archives trumpets the company as "Importers and Dealers in High-Grade Teas and Coffees" and "Proprietors of Lamb's Pure Cream Tartar Baking Powder." The shop became a neighborhood favorite, awaft with the fragrances of coffee beans and tea leaves, cinnamon, ginger, and nutmeg. Glass shelves lined the walls, displaying jewel-toned china sets, cloisonné lamps, and decorative Asian masks, all for sale.

Short in stature, dapper in dress, and a born raconteur, Mr. Lamb entertained customers with stories that never failed to elicit belly laughs. He was a spirited man and a man fond of spirits, well after he'd sold the saloon, and while he no longer doled them out, he had no problem throwing them back. No amount of drinking during the evening kept him from his bedtime ritual, his "special": half a jigger of Irish whiskey and half a jigger of crème de menthe. Eventually the coffee and tea business slowed, and in the summer of 1915 Lamb took over a livery business recently inherited by his second wife, Margaret. In newfangled "motor carriages" he drove grieving families to funerals, and the business thrived. Exotic teas may fall in and out of fashion, but dying never goes out of style. Like his father before him, he made his living from death. He and his wife had four children, one of whom

was Matthew Joseph Lamb II—Matt Lamb's father—born in 1899 in the Bridgeport neighborhood of Chicago, just a few blocks north of the Union Stock Yards where his grandfather had worked.

Bridgeport at the turn of the century was a community of tightly knit neighborhoods with strong ethnic and religious pride. It was not uncommon to see four churches within a five-block radius, one for Irish Catholics, another for Italian Catholics, yet another for Orthodox Greeks, the last for Poles. "During my dad's and grandfather's times," Matt Lamb remembers today, "the churches and religious schools were the center of everything: your education, your social life, your business contacts. Everyone knew everyone's problems, and everybody wanted to help out. But you generally didn't go outside your political and religious communities. The Irish weren't looked upon well outside their niche. My dad remembered, as a kid, a tavern that had a sign posted: 'Dogs and Irish Not Allowed.' There was a sewage canal called Bubbly Creek where they used to take the Irish to beat the shit out of 'em and throw 'em in the sewer. But as long as you knew your place and didn't have too much interchange with the other communities, you'd be fine."

Matt Lamb's father, who typically signed his name "M.J." to distinguish himself from his own father, began working in the tea business around the age of 11, when his mother died. When M.J. was 16, his father underwent a serious operation that left him incapacitated for a significant period, and young M.J. was given power of attorney to run the shop. The lad also washed cars when his father took over the livery business.

One night he was sent to wash cars at a distillery operated by Al Capone. There he was, the young M.J., all soap and water and rags, as Capone and one of his money men walked by, chatting.

"Good for you, young man," Capone said to M.J., "earning a living by the sweat of your brow! May you never make a dishonest dollar." The gangster turned to his associate, then turned back to the boy and added, "One exception. If you can steal a million, do it, 'cause you can always buy your way out!"

The men chuckled and walked on. M.J. shrugged and resumed washing the car with extra care.

M.J. attended high school at St. Ignatius and De LaSalle, went to technical school at Greer's Automotive Engineering, then majored in business administration at Northwestern University. In 1918 he was called upon to fight in the Great War and departed Chicago for basic training. Fortunately, the Armistice of November 11, 1918, came before he was deployed, and he returned home to continue helping his father run the livery business, gradually assuming more important leadership duties. It was his initiative in 1928 to purchase one of Chicago's most successful businesses, Blake Brothers Funeral Homes, from the Livestock National Bank, which was serving as ward to the heirs of cofounder Thomas Blake.

Blake Brothers had set up shop in 1880 at Canalport and Jefferson Streets. When plans were announced for the Columbian Exhibition of 1893, Thomas and his brother, Michael, decided to move their operations to the Southside and purchase a facility at 712 West 31st. They converted the structure into a garage for carriages and erected a new, three-level building. In the basement were horse stables, on the first floor the funeral home itself, and on the top floor the owners' living quarters.

When M.J. took over the business, he renamed it Blake-Lamb Funeral Homes, opting to keep the Blake name and reputation in the minds of customers. This tactic was more than just a marketing strategy to M.J., however. He'd taken to heart the Blakes' commitment to service and vowed to uphold it. As was customary, he wore to every service a dark Chesterfield overcoat, striped pants, a heavily starched white shirt and cravat, black Florsheim shoes, and either a gray homburg or black derby. As an early ad stated:

> No effort is too great, nor involvement too demanding, to be foregone by M.J. Lamb because of expense or inconvenience. His primary concern is the sorrows of others, his greatest service their protection and consolation.

On June 24, 1925, Lamb married Margaret Lawler, who was known as Peg. It was the age of the flapper, and Peg was a lively lass with bobbed hair and a penchant for Sunday drives in the rumble seats of friends' roadsters. During Prohibition she loved to kick up her heels

at her favorite dance hall, the Trianon Ballroom, wearing beaded tunic dresses and hiding in her purse a flask of hooch or bathtub gin. The girl loved to Charleston. No doubt, she was a breath of fresh air for M.J., who'd been working since the age of 11 and who, unlike his more flamboyant father, had a manner described by one colleague as "quietly efficient" and by another, less charitably, as "dour."

The year after M.J. bought the business from the Blake heirs, the stock market crashed and the Great Depression commenced. Luckily for the Lambs, people kept dying. "In our field," he was fond of saying, "we offer a service that no one wants to buy."

In the Depression, however, many people couldn't afford to buy burials for their loved ones at pre-Depression prices. M.J. offered discounts to needy families and sometimes comped entire funerals. He made up the difference by cultivating a rigorous frugality in other areas of his business and personal life. "In business," he told his employees, "if you can't make a dollar, save a dollar." He was fond of such sayings and drafted a set of core beliefs, which he dubbed "The 26 Points" and published in the suburban papers. Among the entries:

> Never refuse service to a customer because they lack the ability to pay.
> Never say no to any request asked.
> Render extra services as requested, whether they fall in the regular line of duty or not.
> Treat every man as if he were your father or brother, every lady as if she were your mother or sister.
> Endeavor to make every service a masterpiece.

He also published a small newsletter, a "magazet" called *Lamb's Tales*, and sent it to his mailing list. On the masthead was another of his personal mantras: "That which constitutes the supreme worth of life is not wealth, nor position, nor ease, nor fame, nor even one's own happiness, but helpfulness." Correspondingly, he attacked his work with self-sacrificial dedication. Other than the daily newspaper, he read only trade journals, scouring them in search of new ways to grow his business. Nineteen-hour workdays were not uncommon. He may have

been Catholic, but his work ethic was decidedly Protestant. Often he would show up late to parties, having been detained at work, only to fall asleep on the hosts' sofa, exhausted. At night, he and Peg were often awakened by the telephone, which was patched through to the Blake-Lamb overnight switchboard. Whenever the Reaper came calling past midnight in Southside Chicago, chances were good the bereaved would call M.J., and he'd shake off the cobwebs and snap into action, consoling and counseling, sending a car to pick up the body, and making preliminary arrangements. It was a hell of a way to spend a night after a 19-hour day, but that's the price you pay when you make your living from other people's deaths.

For her part, Peg Lamb not only endured this often trying lifestyle, she dove into it with an energy and commitment approaching her husband's. At the time, most wakes were held in the grieving family's home. During the depths of the Depression, family members were often embarrassed by their shabby furnishings during wakes. Peg intuited this and often sent as a courtesy her own furniture—sofas, leather chairs, carpets—to the bereaveds' homes, so they would appear better off than they actually were.

Eventually the American economy recovered, and as the years went on, the funeral business changed significantly. The custom of home wakes waned in favor of funeral chapel wakes, and to be on the leading edge of the trend, M.J. in 1939 bought a building at 1413 West 79th Street and renovated it into a dedicated wake chapel. This kicked off a series of property acquisitions that continued through the decades that followed, expanding Blake-Lamb from a small, mom-and-pop operation into one of the largest family-owned companies in Chicagoland, with dozens of funeral homes, chapels, and livery businesses throughout downtown and the suburbs.

In the midst of this maelstrom of activity, M.J. and Peg managed to find the time to have three children. The first, born in 1927, was Margaret Regina ("Peggy"). The last, born in 1940, was Richard Joseph ("Dick"). In the middle of these two, born April 7, 1932, was Matthew James Lamb, and at the time, no one could have dreamed that the flaxen-haired infant would one day become the art world's white-maned enfant terrible.

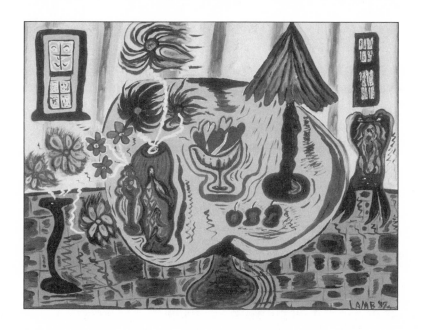

CHAPTER THREE

SOUTHSIDE STORY

Matt Lamb's circumcision cost $3.00. The bill from the Little Company of Mary Hospital in Chicago is in his late mother's archives, along with an invoice for her stay at the hospital: $9.17 per day for the room, $5.00 for lab work, and $7.00 for the anesthesiologist. Those were the days.

Lamb arrived in the world 13 days earlier than expected, apparently eager to get things rolling. When Peg's water broke, her husband and father-in-law were on the city's West Side at a rally for presidential candidate Franklin Delano Roosevelt, then running against incumbent Herbert Hoover. M.J. had phoned home from the rally, only to learn that Peg's contractions had begun minutes earlier. The men sped home to the Southside, running red lights along the way in time-honored fashion.

Lamb was born decades before the South Side attained its stigma as "the baddest part of town," a stigma that has only recently begun to fade as failed housing projects along the Dan Ryan Expressway have been razed and neighborhoods such as Kenwood and Englewood have slowly clawed their way out of the morass of crime and poverty. In the 1930s the area was a patchwork of neighborhoods with bungalows and porches, church spires and corner stores. With its small-town feel, the South Side was to old Chicago what Brooklyn was to old New York: a place that fostered a sense of community that lasted a lifetime and produced some of the world's future movers and shakers. The Lambs lived in Bridgeport, a neighborhood that spawned five Chicago mayors. Not far from the streetcar track, which rattled the family's house at all hours of day and night, were the stomping grounds of the Daleys: Chicago Mayor Richard J. Daley, the loved-and-feared Democratic boss who ran the city with an iron fist from the mid-1950s through the mid-70s; Daley's wife and clan matriarch Eleanor "Sis" Daley, who continued to live in Bridgeport until her death in 2003 at the age of 95; and the Daleys' son and current Chicago Mayor Richard M. Daley, who has held his office since 1989. Another prominent South Sider and lifelong Lamb friend, Edward Derwinski, went on to become a U.S. Congressman and the nation's first Secretary of Veterans Affairs. The Daleys, Derwinski, and others, including Lamb himself, numbered among the South Side nobodies who grew up to be somebodies.

Baptized Matthew James on April 24, 1932, at Saint David's Church on 32nd and Union, Lamb was an agreeable little cherub with blue eyes and wavy hair. From the start, his folks toted him from funeral home to funeral home, occasionally breaking away from the city's frenetic pace to visit Pistakee Lake, a resort area near Wauconda, Illinois. Photographs of Lamb as a toddler show him at the lake decked out in a shoulder-strapped one-piece swimsuit and green swimming cap.

When he was four, Lamb went with his parents on a 6,900-mile road trip across the West. Before the trip, he cried to his father, "I don't wanna go! I wanna stay home and ride on my wagon!" Persuaded to give it a chance, he played with big sister Peggy in the back of the family car, looking forward to malted-milk stops and overnights at

Alamo Camps and Texaco cabins, where the kids swam for hours. As the little tyke climbed out of a pool in Arizona, M.J. asked him, "Now tell me, son, would you rather be home riding your wagon?"

"Aw, dad," he replied, "I was just foolin'!"

When they dined in restaurants along the way, M.J. and Peg told their kids to "mind your manners and behave as if you were at the captain's table." And they did.

The trip, ordered by M.J.'s doctor, who was concerned the man was working himself into a stress-induced breakdown, took the Lambs to the Grand Canyon, Yosemite, Sequoia, and Yellowstone National Parks, Pike's Peak, San Francisco, Los Angeles (where a starstruck Peg arranged a drive-by of Rudy Vallee's and Claudette Colbert's homes), and Mount Hood, Oregon, where they toured the recently opened W.P.A. hotel, Timberline Lodge (years later used as a location shoot for Stanley Kubrick's *The Shining*). Peg, who by this time had shed much of her flapper frivolity and absorbed a measure of her husband's meticulousness, recorded every aspect of the journey in her journal. Over the course of 24 days, she wrote, they had traversed "15 states and bought 416 gallons of gasoline, which totalled $106.12."

Back in Chicago, Lamb began taking piano lessons but was more interested in playing boogie-woogie than scales. He didn't much care for elementary school, either, but he did like to draw. One Valentine's Day he gave his parents a card adorned with an oversized heart surrounded by seven smaller hearts. He also drew them a handful of orange and pink balloons floating around a black-outlined monolith containing stars, planets, and a swirling nebula—motifs that would reemerge 40 years later when he took up painting.

To prepare for his son's first communion on May 12, 1940, M.J. took the boy down to Lytton's clothing store and bought him a $25 Palm Beach suit in pearly white. When the ceremony at Saint David's Church was over, M.J. carted Lamb and a group of his friends over to Lynch's Candies and bought them chocolates. It was a hot day; the chocolates melted; the white suit was now white and brown. Matt Lamb had mixed his first colors.

His assigned chore at home was to carry garbage cans from the third-floor apartment to the curb outside the funeral home, a job he

hated with a passion. One day he came up with the idea to pay his friends a few pennies to do it for him, and they agreed. Lamb had completed his first business transaction.

He loved to climb trees with the boy next door, Ronny Herman. "You're my little monkeys," sister Peggy called the two. He also liked to climb up and down fire escapes and ride his bicycle to his Grandpa and Grandma Lawler's place on Rhodes Avenue.

"What's your name?" one of the new kids on Rhodes asked him one day.

He racked his brain to come up with something tough sounding. "Hank," he answered. Lamb had reinvented himself for the first time.

When Lamb was eight, his little brother, Dick, was born. Because Dick was sick with rheumatic fever throughout much of his childhood, Lamb became quite protective of him. Often the two would play with Lincoln Logs in their small bedroom, which was in reality a corner of the living room with a Murphy bed and a couch for the boys to sleep on. They loved to wear outlandish hats (another motif that would later resurface in Lamb's art), often favoring tattered knit caps, which Peggy, finding them ragamuffin, would hide in protest. On one such occasion, unable to find his navy cap, Lamb dug an old derby out of his father's closet, decorated every inch of it with colored buttons, and took to wearing the thing everywhere. One afternoon a man stopped him on the street and offered to buy the hat for $1.00. Lamb sold it to him for $1.50, then promptly went home, took another derby out of his dad's closet, and decorated it even more flamboyantly. For the first time, Lamb had combined art and commerce.

He got a Great Dane (bigger has always been better for Lamb), the first of many Danes he owned over the next several decades, and spent the evenings wrestling on the floor with the dog and listening to the radio, which fueled his young imagination. Orson Welles as *The Shadow* was a particular favorite. An altar boy, he was confirmed at Saint Sabina Church on May 29, 1944, at the age of 12, and took "Joseph" as his confirmation name, after his father and grandfather. Grandpa Lamb and M.J.'s brother, Ray, a policeman, were strong influences on the youth as he entered his teens. Unlike the more reserved M.J., these two had a

story for every occasion, always delivered with the proper dramatic hyperbole. They imparted to the lad the Irish gift of gab, so aptly described by novelist Maeve Binchy as telling "long, boring, showy, overopinionated, pointless, rambling stories about your life and times."[1]

Lamb also hung out with a funeral home employee from Lithuania named Paul, who taught his young friend inventive ways to make mischief. One way: Wax the casket ramp and watch everybody fall on their rear ends as they try to descend it. Another employee named Snooks taught Lamb a lesson in moxie. After Snooks got into a rile with M.J., he left the funeral home wide open one night, lights glaring, with a parting sentiment spray-painted on Blake-Lamb's front window: "Fuck you, Mister Lamb—I quit." M.J., having been tipped off to the incident, rushed to the funeral home, his sons in tow, to see the scene himself.

"Well, dad," the 13-year-old Lamb told his father, "at least he called you 'Mister.' "

Soon thereafter, young Lamb and the neighborhood boys formed a gang called the Dirty Dozen. They bought maroon jackets, had them embroidered "D.D.," and wore them over overalls. These kids played rough. One Sunday after church, Lamb went out with the gang, still dressed in his suit and "feeling like King Tut." The kids beat him up and threw him in the mud.

"We kicked the shit out of each other," he remembers. "We'd play dungeon, where you'd get the new guy, throw him down in the sub-basement, and pee on him."

The boys excelled at playing pranks. The sponsor of their baseball team owned a company called Auburn Glass. One day the Dirty Dozen selectively blacked out letters in the company's sign, "AUBURN GLASS COMPANY," until it read, "A BURN ASS COMPANY." For all their mischief, Lamb believes to this day that his gang-mates, not his parents, were the people who truly raised him.

Consumed with business, M.J. didn't spend much time with his kids one on one. "The authority figure," as Lamb sometimes refers to his father, did not find affection easy. Lamb cannot remember ever hearing the words, "I love you," issue from his father's lips.

Peg Lamb handled the social component of the funeral business.

"My mother was a great manipulator of the scene," Lamb remembers. "With her it was never straight on; she worked in a circular manner. But if you watched closely—and I did—you'd see that she always ended up with what she wanted." Peg was crafty in a literal sense as well, arranging flowers, sewing sweaters and ice-skating outfits for daughter Peggy, and stuffing holiday baskets for the nuns with cookies, fruitcake, and, tucked discreetly underneath, a bottle of wine and a fifth of Irish whiskey. Generous gifts for the good sisters notwithstanding, finances in the household remained tight. Dinnertime portions were rationed: two lamb chops, not three; one baked apple, not two. Lamb always wanted a new bicycle with a radio on it, but such a purchase was out of the question.

In the family tradition, Lamb began playing a role in the family business from an early age. At 15, he joined the Teamster's Union, to which his father and grandfather also belonged, and started driving hearses. Little did he realize at the time, he would be a Teamster for the next 55 years. He also vacuumed the chapels after wakes. Late one night while vacuuming, when he was the only person left in the building, a trio of dark-suited Italian men arrived to "make arrangements for our father," whose badly mangled body, according to the eldest of the men, needed to be picked up and brought to the funeral home. "He killed himself," the man said.

"I'm sorry to hear that," Lamb replied.

"Don't be shocked when you see his body. He's banged up pretty bad."

"Oh . . ." Lamb was beginning to put two and two together.

"He cut his own throat, then he shot himself. Then, when that didn't work, he jumped out a third-story window."

Lamb got a sinking feeling in his stomach. "You should really come back tomorrow and speak with my dad," he told the men. "He runs the place. I'm just closing up tonight."

"No, we're gonna make some decisions right now," the man countered in a tone that did not invite argument.

So Lamb opened the casket viewing room, showed the men the floral selection booklet, and began explaining the options, starting with the most affordable packages.

"Don't show me this cheap crap," the man said. "Just the best."

When the arrangements had been settled upon, the total came to $2,500, a remarkable sum at a time when the average funeral ran about $200. The man paid in cash from a briefcase, then got up and walked toward the door.

"Don't you want a receipt?" Lamb called after them.

The man turned around and exchanged an amused glance with the others, then said to Lamb, "Do you really think I'm gonna pay you twice?"

The men did not attend their "father's" funeral.

Late nights when he'd get off duty, Lamb would prowl the streets with the Dirty Dozen, boozing, brawling, and gambling. Beating each other up on the Southside instilled a certain street smarts in the boys, helpful to Lamb because he had no book smarts to speak of.

"I was a dummy," he says. "I had a learning disorder that would probably be called dyslexia if it were diagnosed today. My very first memory in life is not being able to do my schoolwork."

The disorder made it difficult for him to read. (Even today, when reading aloud from complicated text, he struggles.) So poorly did he score on his high school entrance exams at the Jesuit-run St. Ignatius, his father's alma mater, that he was rejected for entry and had to take a second set of exams at his Uncle Dick's old school, the Augustinean-run St. Rita. There, for the second time, he flunked the exams and was denied entry. Exasperated, M.J. called a family friend, Monsignor Shewbridge, and arranged a counseling session. As soon as father and son arrived at Shewbridge's door, the Monsignor grabbed Lamb by the shoulders and in his booming Irish accent bellowed, "So this is the dumb kid who flunks every test he takes!"

Sheepishly, Lamb suggested, "Monsignor, I just want to go to public school. I'm going to go to Calumet."

Shewbridge cast a wry glance at M.J. "We won't be havin' that, now! If you go to Calumet, you're liable to lose your immortal soul!" He picked up his telephone and called St. Leo High, asking to speak with Brother McCarthy. "Brother, this is Monsignor Shewbridge. I have Mr. Lamb here at the rectory . . . He's the undertaker, don't you know? A good man. So this Mr. Lamb has a son of high school age

who's going to be enrolling at St. Leo. Can you manage that? . . . No, no, there'll be no tests! The boy can't pass any tests! The boy's going to be enrolling at St. Leo, I say! Can you manage that?"

Brother McCarthy could manage that, and Lamb attended St. Leo, graduating by the skin of his teeth in 1950. Thirty-eight years later, when St. Leo named him Man of the Year, he opened his acceptance remarks by saying, "I'm probably the worst student to ever come out of this school. Asking me to give a speech here is like asking a goat to guard the cabbage patch."

But though his reading acumen was limited, the young Lamb did read one thing at St. Leo that left a lasting impression. He was in the school library, thumbing through an assigned book, when a loose sheet of folded paper slipped out and fell to the floor. He picked it up:

> As you think, you travel; as you love, you attract.
>
> You are today where your thoughts have brought you.
>
> You will be tomorrow where your thoughts take you.
>
> You cannot escape the results of your thoughts, but you can endure and learn, accept and be glad.
>
> You will realize the vision, not the idle wish, of your heart, be it base or beautiful or both.
>
> You will gravitate toward that which you secretly most love.
>
> Into your hands will be placed the exact result of your thoughts.
>
> You will receive that which you earn, no more, no less.
>
> Whatever your present environment may be, you will fall, remain, or rise with your thoughts, your vision, your ideal.
>
> You will become as small as your controlling desire, as great as your dominant aspiration.

The aphorisms were taken from two books, *Above Life's Turmoil* and *As a Man Thinketh*, by English inspirational author James Allen (1864–1912), the Anthony Robbins of his day. Allen's words resonated with Lamb more than any of his school curriculum. He folded the sheet of paper and stuffed it in his pocket. Today it is pinned to a corkboard in the watercolor studio of his Chicago home.

As Lamb neared the end of his teens, he and his family went on a

family trip to Banff in the Canadian Rockies. Photographs of him show a 17-year-old boy poised on the cusp of manhood, lanky and shirtless, his hair, once golden brown, now dark. Posing on the shores of Lake Louise, he has a certain dreaminess to his countenance. There's a reason for this. There's someone on his mind, someone back home: a spunky, brown-eyed girl named Rosemarie Graham.

And as it turned out, she had him on her mind, too.

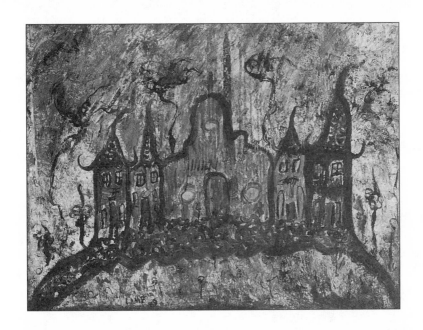

CHAPTER FOUR

THE LOVE AFFAIR THAT
BEGAN IN THE WOMB

Rose Lamb's face has adorned the society pages for decades now, and in every photo at every age, whether in snapshots or formal portraits, she exudes a tawny, just-off-the-cruise-ship glow. She also has one of the most radiant smiles in Chicago, a smile that can light up a banquet hall or ballroom like enamel sunshine. But she's not flashing that smile today as she and Lamb sit for an interview with me in the paneled library of their Gold Coast town house. Perhaps she's a tad leery, protective of her high-profile husband's public image, just as Nancy Reagan famously guarded her husband from those who might work against him.

"One thing you should know about Rose," Lamb volunteers. "She's tough."

Rose nods her head. "Tough as nails," she says, a steely edge to her tone. "Fifty years of living with Matt will toughen anybody up!"

"Fifty years," Lamb echoes, his voice trailing off.

"We met in the womb, you know." She looks at him and smiles. "Our mothers were best friends."

"Her mother was a tightwad," Lamb interjects.

"My mother and Matt's mom were pregnant with us at the same time . . ."

"Rose's father was a saint, but her mother was a tightwad. She hated a nickel because it wasn't a dime."

Rose presses on. "And they were always together throughout their pregnancies. Matt and I must have brushed up against one another when we were both in the womb."

The story unfolds. Lamb's and Rose's mothers, Peg Lawler and Rose Newkirk, met in first grade at Nativity School at 37th and Lowe in Bridgeport. They played tag and hopscotch together. Went to the matinée to see moving pictures starring Mabel Normand and Mary Pickford. Took their pennies to a candy store called Cheap Charlie's and bought peanut butter kisses and fudge. In high school, they dressed—daringly for the time—in Balkan blouses, skirts, and high-top black shoes with white laces instead of the customary black. Newkirk would come over to Lawler's house, where Lawler's mom would serve cakes and cocoa as the girls cranked up the Victrola, pulled up the dining room carpet to sprinkle wax on the hardwoods, and danced for hours. Sometimes Newkirk played the piano, shaking her shoulders while she pounded out ragtime and jazz tunes, making Lawler squeal with laughter. After the two graduated from high school on June 20, 1919, Newkirk went to work right away, while Lawler attended Moser Business College. They married their respective husbands within a year of one another and got pregnant within a month of one another.

When the babies—little Rose and little Matt—arrived, the families grew even closer. The kids played together as children, but it wasn't until high school, at the tender age of 14, that they began dating.

"I wore his signet ring," Rose recalls fondly. "When we went on the streetcar, he would get off first to help me out."

They often double-dated with other teen couples. Black-and-white photographs show them in a restaurant, her head resting on his shoulder, a blissed-out look on her face, a serious one on his. Another picture shows them standing together in a field, him reaching his arms around her from behind. Yet another shows Rose standing by herself at the beach, her hair pixie short, the strap of her swimsuit pulled ever so slightly down. But even back then, with stars in her eyes and butterflies in her stomach each time she neared her playmate-turned-boyfriend, Rose was no gushy ingénue. There was steel underneath all the downy teenage insouciance.

As graduation neared, Lamb invited her to the Cotillion at the South Shore Country Club. After they turned their tassels in 1950, Rose attended Mundelein College for Women, and Lamb enrolled in mortuary school. One day on a date, he gave her his frat pin. For the next few years, the two were inseparable.

The Korean Conflict was underway during this period, and some 1,529,539 Americans would eventually answer the U.S. Draft Board's call to service. Lamb registered for the Armed Forces' voluntary civilian draft in 1953, as the conflict was nearing its end. One afternoon, the phone rang in the apartment above the funeral home, and it was a Draft Board officer calling to summon Lamb to his physical. The physical would be conducted two weeks later at an ad-hoc screening site at the central train station, after which he was to immediately depart for basic training at Fort Leonard Wood, Missouri.

Peg threw her son a farewell party, and Rose bade her sweetheart a tearful adieu. With a single suitcase under his arm, Lamb left to meet his destiny. Or so it seemed.

Later that same day, M.J. Lamb got a call from his son: "They didn't take me, dad! My back is bad. So I can come home!"

"That's great news, son!"

"But I'm subject to recall in six months. They want me to have another physical then and see if I've gotten any better."

"Matt, I want you to get a cab right now and come on home."

"I'll just take the streetcar, dad. A cab'll be too expensive."

"No, no, you get a cab, and get it quick, before they change their minds!"

Six months later, Lamb was once again summoned to report, and once again, he failed the physical. His second rejection, and the fact that the Korean Conflict had formally ended with the Armistice of July 27, 1953, practically guaranteed he would not be called before the Board again. With this in mind, he asked Rose for her hand in marriage, and she accepted.

On October 2, 1954, at Saint Dorothy's Church, with Lamb's sister, Peggy, and his brother, Dick, in the wedding party, the couple that had met in the womb became husband and wife. As the local papers announced, "The bride wore a white imported taffeta-and-lace gown trimmed in iridescents, her veil held in place with a Juliet cap. She carried white orchids and stephanotis on a prayer book."

They honeymooned in Honolulu, returned, and moved into a small home. Within a year Rose gave birth to the first of their four children, Matthew James Lamb, named after his father. Rosemarie would follow, then Colleen, and finally Sheila. And while raising four children would have proved a challenging enough task for any woman, Rose was not content merely to play the role of homemaker. From day one, she did public relations work for the funeral home, juggling P.R., Blake-Lamb politics, and parenting—and never dropping a ball.

"Rose is my rock," Lamb says today, sitting next to her on the sofa. He squeezes her hand. "Without her, I'd be long in my grave."

Stoically, she nods. " 'Supportive' is my middle name."

"She's also the only woman I've ever been with, biblically."

She neither blushes nor scolds him for supplying this personal tidbit. "Matt has always been obsessive about certain things," she says matter-of-factly. "One of them is business. Another one is art. Another one is me."

They exchange glances, and then, suddenly, Rose breaks out into a smile, *the* smile, the one in all the photographs, a smile so wide and unguarded it seems it could warm the world. They're true partners, these two, watching one another's backs, switching off between good cop and bad cop as the need arises. It's a good thing, too, for few marriages could have withstood the whiplash that awaited Matt and Rose Lamb in 1954, when the honeymoon was over and they returned from Waikiki to the politics and power plays of the family business.

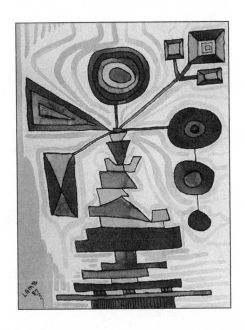

CHAPTER FIVE

FAMILY BUSINESS AND
OTHER OXYMORONS

HBO's dramatic series, *Six Feet Under*, makes running a funeral home seem glamorous. Watching it affords at least a glimpse at what it must have been like for the Lambs as, for decades, they mixed money, family, and death. *Six Feet Under*, which debuted in 2001, offers "a darkly comic look at the Fishers, a dysfunctional family who own and operate an independent funeral home in Los Angeles."[1] But the sheen of television belies the less-than-glamorous daily realities of a business in which your customers are families in the throes of grief and your charge is to escort a dead body through a series of rituals and put it, finally, into the ground. The Lambs saw their jobs as neither glamorous nor un-glamorous, but simply as something they did—and had always done—to put bread on the table.

"We lived and died by the family business," Lamb says now, "and the funny thing about that is there's no such thing as a family business. Either it's family or it's business. One is nurturing and supportive, the other is all about the bottom line."

That Matt and Dick Lamb would work for and eventually own their father's funeral business was a foregone conclusion.

"It was tradition," Lamb says. "There was never a single discussion about us *not* becoming funeral directors."

He had learned the business from the bottom up, having driven hearses since the day he got his driver's license. Much of his on-the-job training came through trial and error. Driving the hearse, he got lost on more than one occasion on the way to cemeteries, with no one to ask for directions except the body in the back. Once, he was on his way to a suburban Illinois cemetery and wound up 12 miles outside Milwaukee, only to be chewed out by his father upon his return. Fearing his father's wrath, he began driving to the cemeteries ahead of time to familiarize himself with the routes, but this, too, irked M.J., who scolded him for "wasting gasoline."

For formal training in the art of directing funerals, he attended the Worsham College of Mortuary Science.

"Mortuary school was one big party," he says with a chuckle. "You couldn't take things too seriously, because who knows, you might be the next one lying on the slab."

The students were forever playing pranks on their teachers. One day they hung a condom on the chalkboard before class. When their embalming instructor, Dr. Feinberg, entered the room, the class erupted in hysterics. To their surprise, Feinberg rolled with the punches.

"Am I to assume," he intoned, deadpan, "that by this gesture you're suggesting I'm a prick?"

The class fell silent.

For the next 10 minutes, he delivered a monologue in driest wit relating himself to the condom from a variety of critical perspectives.

Lamb remembers, "We couldn't believe it. It was this brilliant dissertation on the relationship between a human being and a rubber. We

were in awe. When it was over, we realized he'd been pulling our legs the whole time."

The pranks helped pull Lamb through a class he hated: Embalming 101.

"It was necessary, but I couldn't wait for it to be over. I only did it to get my license, and after that, I never did it again. There are some very talented people out there who are master embalmers, but I wasn't one of them. Dealing with a dead human in that context is not something I enjoy doing. But it gave me the ability to tell if the embalmers at Blake-Lamb were doing their jobs the right way over the years."

Formaldehyde aside, and despite the nonstop partying, Lamb applied himself in mortuary college in a way he hadn't in primary school. Rather than learning strictly by reading, he used his visual memory to commit the chemical symbols and anatomy charts so integral to his lessons. Rose helped him, too, by drilling him on formulas and regulations. To everyone's surprise, including his own, he passed the State Board exams with exceptional marks.

Now officially a funeral director, he began to assume more important duties at Blake-Lamb. At the same time, he began taking business management courses at Loyola University in Chicago and Saint Joseph's College in Rensselaer, Indiana. Being a full-time undertaker, however, made it difficult to handle a full-time course load, so after a year, he ceased regular studies but hired his favorite teacher from Loyola to tutor him on-site at Blake-Lamb.

"I learned more from doing that than I would have in 10 years of college courses."

It was a strategy he would return to again and again, first in the business world, later in the art world: seeking the counsel of mentors who would work with him one on one.

In 1954, M.J. and Peg booked passage on the *Queen Elizabeth* and took a 10-week holiday in Europe. M.J. left his son in charge of two of the chapels but worried throughout the trip about business back home. He jotted off frequent letters to his son, full of minutiae and errands. One letter read:

Saturday, May 1, 1954

The Hague, Netherlands

Dear Matt, Peggy, and all,

We arrived here at noon today after spending a most enjoyable visit in London. The tulips are in full bloom here. They are beautiful. That reminds me of our tulips at Mount Oliver. Matt, when you are out there, will you see how they are doing? If the weather permits, would you have flowers planted for Decoration Day? The plants I used last year I got at Amling's Florist. They come already planted in a box, which you can just drop in front of the store. If you call them, they will deliver them to 79th Street.

If anyone has time, have the trees on the side of the building trimmed.

I see by a recent letter that Bob O'Mara's wife had a baby. You might call him and file a claim with the Mass. Mutual for him. After the claim is paid, you had better cancel out his Health and Accident with the association company.

When the checks for the parking lot come in, record the amount and check the description and deposit in West Highland.

Also, if you get a notice about an income tax payment, send the amount due to the Collector of Internal Revenue.

Well, that's enough.
[no signature]

In 1958, M.J. was eager for his son to become a partner in the building component of Blake-Lamb, an affiliate company called the 103rd Street Building Corporation. This company would soon build what was to become the flagship funeral home of Blake-Lamb, a sprawling, modern facility at 4727 West 103rd Street in Oak Lawn. Impatient not only for the long-term continuity such a move would ensure, but also the cash it would immediately put in his pocket, M.J. encouraged (or "insisted," as Lamb tells it) that his son buy in for

$10,000. To come up with the money, Lamb cashed in a $25,000 insurance policy early and sold his and Rose's house. The liquidations left the couple so strapped, they reluctantly moved back into an apartment above the existing funeral home, for which accommodations M.J. charged them $132 per month. The apartment's living room stayed bare for an entire year, because the couple couldn't afford any furniture. For transportation, the Lambs drove the junkiest car on the funeral home lot, a clunker once used for livery but no longer fit for customers. A few years later, the couple moved into an apartment above a different funeral parlor—right down the hall from M.J. and Peg's apartment. It wasn't easy for the young Lambs to live in such close quarters with the elder Lambs. When a man and wife who have tasted independent living are forced by circumstances to move back in with the parents and in-laws, it's hard not to experience the move as a step back.

"There were too many ghosts there," Lamb says now, "ghosts from my childhood."

And what of the other ghosts, the spooky vibes you'd expect to emanate upwards from the basement mortuary, where bodies awaiting embalming lie in coolers, to the main-floor funeral chapel, with its dozens of caskets? Not every newly married couple could deal with living above a house of death, where, after closing time, those without a pulse often outnumbered those with one. But the Lambs heard no bumps in the night and waded by day through the nonstop parade of deeply grieving families, unshaken, with deferential whispers of support for those in the throes of loss. To deal with such sadness through the workday, then walk upstairs afterwards, put on a happy face, have dinner, and qvetch about the Bulls and the Bears, would make for a jarring transition for most couples. But not for the Lambs.

"The bodies downstairs never bothered me," Lamb says. "I didn't think of them as corpses, I thought of them as people's loved ones. In a way, there was an advantage to growing up in a funeral home, because my brother and sister and I learned that death is inevitable. We're born, we die. What happens in the middle is the important part: the relationships we build with one another."

The young Lambs scraped and saved their way through those early

years, steadily increasing their incomes. To look over their savings account books from West Highland Savings and Loan from the late 1940s through the late 1960s, is to see in black numbers two people scrimping their way to financial viability. During the late 40s the deposits are $2.52, $2.75, $2.57 . . . By the early 50s they break the $3 threshold. In the mid-50s, there's $5.26, $5.13, and on one occasion a whopping $10. By 1961 they're up to $47, $120, $160 . . . and in 1966, weekly deposits of $250, $494.61, and $670.78 were not uncommon.

M.J. and his sons put up a unified public front, posing together in ads and making sure the business's various departments ran, to all outward appearances, "like the inner workings of a Swiss watch." But as with any business, things were not always so smooth under the surface. There were disagreements over strategy. Lamb was more tolerant of risk than his parents, who'd been profoundly affected by the Depression and, like many among their generation, had never gotten over the paranoia it engendered.

"My father was a great funeral director but not the greatest businessman. He couldn't pull the trigger. He'd walk around the block five times before he'd walk in the door, metaphorically speaking. Whereas I always pull the trigger, sometimes too fast. My father was 'Ready, aim, wait,' and I'm 'Ready, fire, aim.' I'm more like my Grandpa Lamb than my dad in that respect. Maybe traits skip a generation. Grandpa Lamb didn't take any bullshit. If he didn't like you, he'd be the first to tell you to go to hell."

M.J. and Peg's financial and personal restraint could veer into the extreme.

Says Lamb: "They always worried about what other people would think: Don't step out of line, because the Depression could come back any minute, and everything will fall to hell!"

When Lamb showed an interest in organizing political campaigns, his parents cautioned him (unsuccessfully) against it. To their minds, the funeral home and everyone associated with it should be apolitical; the less public positions the Lambs took, the less chance of alienating customers. M.J. didn't like his son wearing too many rings, flashy tie clips, or lapel pins, either, since customers might find such accessories ostentatious.

Though Lamb instinctively disliked his father and mother's reactionary attitudes, he realized that such sensibilities were not particular to his parents, but rampant in the funeral business in general. One acquaintance of Lamb's was a competing funeral director. The man went to five different barbers, seeing them on a rotating basis, one haircut a week. He did this not because he actually needed four haircuts per month, but so he could keep up with the circle of customers at each barber shop: their news, gossip, weddings, births, and most importantly, deaths. He left his cards at each shop, lest bad fortune befall the other customers' family members or friends.

One day, Lamb remarked to the man, "No wonder you're always so clean cut—you have five barbers!"

"Truth is," the man confessed, "I only like one of the haircuts."

Lamb resolved not to go through life hating four of his haircuts.

There were other frictions between M.J. and his son as the latter's more risk-tolerant behavior led him to successes that threatened to eclipse his father's. When Lamb, at 33, became the youngest president in the history of an elite trade association, the Preferred Funeral Directors International, his father did not even offer his congratulations. On another occasion in the early 1960s, after Lamb had worked three straight years without a vacation, he approached M.J. and told him that he, Rose, and the kids had all saved up to take a five-week family trip to Spain.

"Do what you need to do, but I can only pay you for two weeks' vacation," M.J. said.

"Why's that?"

"Company policy. You should know that."

Lamb's blood pressure rose. "What I know," he shot back, "is that I've been busting my tail here without a single vacation in three years."

"The policy is the policy, Matt. End of discussion."

Lamb wasn't about to let the discussion end. "Let me put it to you like this, dad: You either pay me for the five weeks, or you can take this company and shove it up your ass." He stormed out.

In a family business, childhood scenes have a way of repeating themselves even after the children are grownups.

After the scene, Lamb and his father didn't speak for several days, but Lamb did speak by phone with his friend and mentor, the Texas

funeral-home impresario Pat Foley, who'd recently opened a chapel in Houston. "What do you think I should do, Pat?"

Foley didn't hold back. "Fuck the old bastard! Come on down here and work for me! What are you making up there?"

Lamb told him.

"I'll double it, and I'll give you the company when I'm gone—you know I don't have children."

The offer took Lamb aback. "I don't know what to say, Pat. That's an incredible offer."

"I'm completely serious. You think about it and get back to me."

Lamb thought about it over the next several weeks as his planned Spain trip drew near. Only two days before he, Rose, and the children were to leave for Madrid, M.J. walked up to his son and handed him a check for the full five weeks' vacation. The rift patched up, Lamb stayed with Blake-Lamb.

In 1965, wanting to diversify, Lamb and his brother formed Matt-Rich Investments, a real estate firm through which they scouted out, bought, and sold land and properties. One of their first acquisitions was an office building at 3737 West 79th Street, which they converted into a funeral home, catering to a customer base that was gradually migrating from east Chicago to west. Next, they bought an auto dealership at 5800 West 63rd Street and remodeled it into a funeral home, then branched into the far-west Chicago suburb of Lombard, Illinois, where they bought another home. Returning to the Gold Coast, they acquired a building at 1035 North Dearborn, which would become one of their most valuable pieces of property. The strategy to buy out other family-run funeral homes proved integral to Matt-Rich's increasingly valuable portfolio. John Caroll & Son, a funeral business that buried prominent Roman Catholics, and C.H. Jordan, which served an affluent Protestant constituency, were both pulled underneath the Blake-Lamb umbrella, although the businesses continued to be known to the public by their original names in order to capitalize on their long history of service and preexisting clienteles. The Lamb brothers purchased Becvar Funeral Homes, Bukema Funeral Homes, the Dora Kill Ward Funeral Home, Hickey Funeral Homes, and Patka Funeral Homes, which catered to the Polish community, in addition to

Drumm Funeral Home in South Holland, Illinois. They also made deals whereby they linked the Blake-Lamb name to Adenamis, an important Greek funeral home on the North Side, and Sheehy Funeral Home at 127th and Harlem. The brothers also helped found a South Side funeral home called Cedar Park, sending Blake-Lamb managers and employees to train Cedar Park's fledgling staff.

Many of these acquisitions led to the creation of new companies, which managed individual properties. Sometimes, Lamb and Dick co-owned these companies; other times, Lamb was sole owner; still other times, Lamb and Rose were co-owners. There was the Lamb Cremation Society, the Gold Coast Development Company, which owned and managed the property on North Dearborn, and a company that Lamb whimsically named Stinkfish, Inc., which owned and managed a condominium building in Florida, and yet another company whose sole purpose was to sell insurance policies to cover the funeral costs upon the insured's death. Lamb and Rose formed a company that bought and remodeled distressed buildings and homes, then sold them at a healthy profit. Lamb also formed a company that invested in oil and gas exploration.

At the height of his business expansion, Lamb owned or co-owned 36 different companies, with holdings around the country but concentrated in the Chicago area. None of these businesses made a mint overnight—the growth was gradual over a period beginning with Matt-Rich's inception in 1965 and continuing over the next 15 years—but the incremental expansion reduced the brothers' dependence on Blake-Lamb Funeral Homes and thereby on their father.

In the mid-1960s, then, as Lamb hit his mid-30s, he began to hit his stride as his own man. A strong presence one-on-one but afflicted with stage fright in front of groups, he knew he had to conquer this fear in order to be comfortable with his leadership roles in corporate and political life.

"I knew I had a problem with public speaking when I got up one night in front of the Preferred Funeral Directors and was stuttering and shaking like a leaf. I had the people in the banquet room turn the lights down so people couldn't see how badly I was shaking."

He began attending Toastmasters and Dale Carnegie seminars to

grow more confident, and within a year, he had gone far toward over-coming his phobia. In the years that followed, he grew to enjoy the spotlight and became known as a superb, often uproarious storyteller behind the podium. His Grandpa Lamb, himself a born raconteur, would have been proud.

As Lamb was gaining confidence as a speaker and entrepreneur, he continued to put the thrust of his energies behind Blake-Lamb Funeral Homes. As the 1960s came to their turbulent conclusion, he took over more of Blake-Lamb's daily operations from his father, and while he had not inherited M.J.'s conservative personal demeanor, he did inherit his dad's perfectionism. As was the case with his parents before him, his and Rose's phone was tied into the Blake-Lamb switchboard's 16 lines from 11 o'clock at night till 8 o'clock the next morning. If a phone call came in the middle of the night for any of the family's 14 funeral homes, Lamb took it personally and dispatched the appropri-ate personnel to pick up the deceased. Also like his father, he was determined that every funeral service go off without a hitch. To that end, he instituted severe new policies at the homes he oversaw. If a limousine driver was late picking a family up for a service, Lamb not only fired the driver, he also comped the entire funeral, made the driv-er's manager personally apologize to the family, and went to the funeral himself to sit beside the family.

"If the family was mad about the late pickup and wanted to bitch me out," he recalls, "I stood there and took their shit with a smile."

Other times, at unpredictable intervals, Lamb would bump the scheduled chauffeur from a pickup, don a driver's cap and gloves, and without divulging that he was a top member of Blake-Lamb's manage-ment, drive the family to the cemetery, asking them along the way how they had found the company's service. Having observed as a boy how some employees would fly into hyperproductive mode when his dad made his rounds, only to loaf the second M.J. left the premises, he made a point to arrive at chapels unannounced, often through the freight doors. Each time he showed up in this fashion, he headed straight for a different part of the facility: the livery garages, break rooms, embalming rooms, and so on. If the ashtrays in the smoking

lounge hadn't been emptied and cleaned, the director on duty would catch hell. Ditto if the coffee in the casket display room wasn't fresh.

One evening he arrived just after closing and "the bathroom was so filthy, it would have made a goat gag." He marched into the director's office and told him.

"I'm sorry to hear that," the director apologized. "I'll get the cleaning crew on it first thing in the morning."

"We need to get it clean now," Lamb countered, then turned to leave.

"There's no one here to do it at this hour, Mr. Lamb, but first thing . . ."

Lamb interrupted, a sudden edge to his voice. "*You're* here, aren't you?"

"Certainly, sir, and you know, I, uh, do many things here, but I don't clean toilets."

"What did you say?" Lamb demanded.

"I said," the director repeated, "that I don't clean toilets."

As if on a hair trigger, Lamb exploded. "You're damn right you don't clean toilets, because you don't work here anymore—you're fired. Get the fuck out."

The director cleaned out his office that night as Matt Lamb cleaned the toilet.

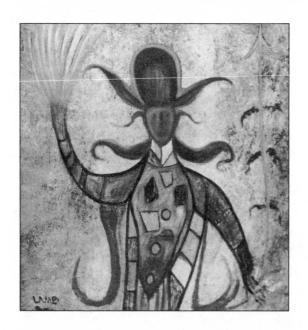

CHAPTER SIX

THE SALES OF A DEATH MAN

During the late 1960s and early 1970s, Matt Lamb went from being his father's point man to being his own man. As M.J. grew older and became more of a figurehead, Lamb and his brother, Dick, did more of the wheeling and dealing, expanding Blake-Lamb from a well-reputed but debt-ridden small business into a multi-million-dollar company. Although he had taken college-level business classes and hired his favorite professor to tutor him hands-on, Lamb credits his savvy as an entrepreneur not to academic study—he was far from a Wharton MBA—but to the mentors who took him under their wings. Whereas M.J. was fond of quoting his "26 Points" and dispensing aphoristic chestnuts like "Do more than you're paid for, and eventually you'll get paid for more than you do," Lamb's own mentors were men of action

as well as principle. And unlike M.J., these men were gregarious fellows who knew how to raise hell, not just raise capital.

Among these mentors were well-known Chicago and Oak Lawn businessmen such as Herb Huskie, who owned auto parts companies and developed real estate, Vince Barcelona, president of Colonial Savings and Loan in Oak Lawn, and Pat Foley, who had offered Lamb the job in Houston and whom Lamb remembers as "a crazy Texan who played the good ole boy but was always the shrewdest fox in the room." Huskie, Barcelona, and Foley respected the enthusiasm and insight with which Lamb picked their brains. They also recognized his enormous ambition and potential and perhaps saw in him a younger version of their own rabble-rousing selves.

"Pat Foley loved to swear," Lamb remembers. "If you think I swear, you should have heard Pat. I was a nun compared to him."

It was Foley who lobbied for Lamb to become president of Preferred Funeral Directors International, a group over which he held considerable sway but for which he displayed little reverence. During an association roundtable in 1970, after one of the members finished presenting a self-serving proposal on "how to revolutionize the entire industry," Foley rose from his chair, picked up the cover sheet to the man's report, and asked the group, "You wanna know what I think of this?"

Everyone sat expectantly.

Turning his back to them, Foley flipped up his coattails, stuck out his butt as if to moon them, and wiped the cover sheet on his ass. "That's what I think of it," he said, then walked out of the room, leaving half of the room in stunned silence, the other half in hysterics. Clearly, this was well before the age of political correctness.

There were other mentors. John Hildenbrand sold luggage, hospital properties, and caskets.

"John could pack you up with his luggage, send you to the hospital, and bury you if you died. He was one-stop shopping."

Hildenbrand often sent private planes to pick Lamb up in Chicago and dispatch him on industry-related-sorties around the country.

"The only place John wouldn't send me to was Vegas," says Lamb. "He said I'd need a note from my wife before I could go there."

The businessman also taught Lamb perhaps the most valuable lesson of his career as an entrepreneur—and perhaps also as an artist: "Surround yourself," he told Lamb, "with people who know a lot more than you do, and learn from them. Never let your ego get in the way of your common sense. Surround yourself with giants, and you'll be safe. But surround yourself with dwarves, and you'll feel big—as your entire world goes to shit."

Another mentor, Bill Bard, owned a shopping center and a bowling alley across the street from Blake-Lamb's flagship funeral chapel. Bard was also an avid car collector and owned an auto auction house. To Bard's thinking, the beat-up livery car Lamb was driving was an automotive abomination, and he told him so. "You're an up-and-comer!" he said. "You shouldn't be tooling around town in that old junkheap!"

"Believe me," Lamb conceded, "I hate it, but I can't afford anything else."

"What's your dream car?"

"Well, I suppose a Lincoln Continental!"

Within a week, Bard had pulled a Continental off the auction block and, to Lamb's astonishment, rented it to him at ridiculously low monthly payments. A few years later, Bard told Lamb he had grown tired of one of his own cars, a canary-yellow Cadillac El Dorado.

"How come?" Lamb asked.

"It's garish! I'm riding around in a big canary! I hate it!"

"I think it's pretty keen."

"Well then, here!" Bard threw the keys at Lamb. "You take it!"

And so for the next few years, it was Lamb who drove the big canary.

Another of Lamb's mentors, Ray Greune, helped him out of one of the worst financial binds of his life. M.J. had agreed to sell his sons the Blake-Lamb livery business. The company, a separate entity from the funeral home, had always kept $50,000 in a reserve account to cover contingencies. When money was needed to cover payroll, the account was tapped into, then re-infused with cash in a matter of days. The night before transferring ownership of the business, M.J. withdrew the entire $50,000 and deposited it into his personal account. When payroll came around the following month, Lamb and Dick opened the

reserve account's checkbook and discovered that the balance was zero. This was a potentially devastating development that left the brothers with the option of either defaulting on their payroll or groveling for a bank loan that was unlikely to be granted, given Blake-Lamb's high debt-to-cash-flow ratio at the time.

The morning he and Dick had made this discovery, Lamb was beside himself but continued, coolheaded, with the day's itinerary. He went to his scheduled lunch appointment with Ray Greune and, over a Rat-Pack meal of steak, baked potatoes, and martinis, divulged to Greune the nature of the pinch he was in. Attentively, Greune listened, interjecting some choice vulgarisms directed at M.J. as Lamb told him about his father's $50,000 withdrawal. When the two finished lunch and were about to part ways in the parking lot, Greune stopped Lamb and said, "Follow me over to my office."

"What for?"

"Just do it."

Fifteen minutes later Greune offered Lamb a seat while he retrieved something from his desk. It was a checkbook. He scribbled something on it, tore out a check, and handed it to Lamb. "You let me know if you need more," he said.

Lamb looked down at the check now in his hands, payable to the order of Matt Lamb in the amount of $50,000. "Ray," he said, "thank you, but you don't have to do this."

Greune beamed. "Just shut up and take it, you asshole!"

"You want me to sign some paperwork to make this loan official?"

"Nope."

"You want to talk about how and when I'm going to pay you back?"

"Nope."

Lamb took the check, saved the livery business, and paid back the loan within a year. He and Greune are still friends, and Greune still calls him "you asshole."

Having survived this near-implosion, Lamb and Dick forged forward into the 1970s with ever-increasing momentum. Matt-Rich Investments was expanding dramatically, and each of the brothers was cultivating individual projects.

"My workday," Lamb recalls, "was from 6:30 in the morning to midnight."

The brothers had very different personalities but made excellent partners.

"We had seen so many families going crazy over nothing," Lamb says, "furniture, a brooch, a few dollars. So Dick and I made an unwritten rule: If we can't resolve a problem, to hell with the whole thing— we'll call it quits. It never happened."

They complemented one another's strengths. Dick, a voracious reader who'd excelled in school, had the more analytical nature, the temperament required to study the relationship between industry trends and specific problems within the Chicagoland market. Lamb, who'd had no enthusiasm for school but made up for it in street smarts, supplied dead-on gut instincts and the relentless forward motion needed to close a deal.

"It's like that saying I found inside the book back in school: 'You will gravitate toward that which you secretly most love.' That's what Dick and I did in business. He was very strong in prioritizing, budgeting, and accounting, a great organizer who brought new ideas to the table and embedded them in the organization. But he hated going out to dinner meetings and standing around at all the industry parties we had to go to. Meanwhile, that's the kind of thing I loved: keeping everybody happy, rescuing the employees from whatever hurricane they were stranded in the middle of. We never really formalized our roles, it just happened. When it came time to sit down with third parties and make deals, he would crunch the numbers while I kissed the people's asses and told them how great they were. I'd brew the tea and all that crap. Some of these guys drank like fish, so I'd take Dick aside and say, 'You do the figuring, and I'll do the drinking.' So Dick's function would be to keep his wits about him, and my function was to get the bastards drunk."

Lamb often paints his brother as the detail man and himself the big-picture man. But when it came to the aesthetic elements of the funeral business, he had an eye for detail that rivaled or surpassed both his brother's and his father's. In fact, M.J.'s dictum to "endeavor to make every funeral a masterpiece" never left Lamb's mind.

"You build no goodwill in the funeral business unless everything's perfect," Lamb believes. "You can't say to a family, 'Well, I really fucked up your Grampa's funeral, but wait till your Gramma dies— we'll get that one right, promise!' "

And so he stalked the wake rooms, sniffing with a bloodhound's nose for the scent of imperfection. If a candle on one side of a casket had burned down a quarter-inch shorter than its counterpart on the opposite side, he replaced both with fresh candles rather than letting an asymmetrical composition stand. If a carnation was poking out of a bouquet at an odd angle, he fiddled with it until the arrangement returned to visual harmony. If there was something short of ideal in the presentation of the deceased in the casket—the suit rumpled, the hands folded too high on the chest, the face over-rouged—he had the matter attended to before the family arrived. If he discovered at 11 P.M. the night before a 9 A.M. funeral that the deceased's name was incorrectly spelled on a prayer card, he called the printer at home and demanded that the cards be reprinted overnight.

Each morning at 7 o'clock when he arrived at the office, he summoned his managers and department heads. "Don't tell me what's going right," he told them. "Tell me what's going to hell. Dump all the horseshit on my desk, and I'll spend the rest of the day trying to grow flowers through it."

During this period, Rose's importance to the company was growing as well. With her gift for listening to families and her intuitive knack for finding just the right words for any occasion, she had helped Blake-Lamb with public relations matters for years, eventually winding up as the company's public relations and advertising supervisor. Beginning in the early 1960s and stretching into the late 1970s, she also led an initiative to forge even stronger bonds between Blake-Lamb and its clients. She invited the families attending wakes to come upstairs afterwards to her and her husband's apartment for a full, complimentary dinner. At first she cooked the meals herself. Then, realizing the enormity of the commitment, she began having them catered. These were two-hour-long affairs attended by dozens of family members, complete with appetizers, salads, wines, and desserts, in addition to a main course. Rose carried this off five days a week for nearly 20

years. The practice proved both logistically and emotionally demanding. Over dinner, the Lambs and their four children consoled their guests and listened to the stories they told of their loved ones' lives, illnesses, and deaths. Although the dinners were part of a P.R. strategy (the families left with feelings of great warmth and loyalty toward the Lambs), they also stemmed from Rose's desire to put a human touch on the company's services.

The cast of characters who passed through the Lambs' dining room ranged the highs and lows of Chicago society. "We buried everybody, and we fed everybody's families. It didn't matter whether you were a cardinal, a Mafia don, or a whore." A quick survey of newspaper microfiches proves this no idle claim. Blake-Lamb buried Cardinals John Cody and Joseph Bernardin, but they also buried "Gypsy King" Steve Evans, patriarch of the tribe's Midwest clan, as well as many a Mafioso unlucky enough to be on the receiving end of blades and bullets.[1] The majority of the company's clients were Catholic, but Blake-Lamb also had strong ties to the city's Greek Orthodox community.

In Matt-Rich Investments and his own companies, Lamb was intent on avoiding what he saw as his father's most serious misstep in running Blake-Lamb: "overexpansion and undercapitalization—in other words, when your eyes are bigger than your stomach. Dick and I expanded Matt-Rich very judiciously. We never brought on a new baby until the other ones were happily fed."

As M.J.'s influence over Blake-Lamb began to wane, Lamb and Dick endeavored to apply their philosophy for their own businesses to Blake-Lamb itself, transforming the company as it had existed under their father—great customer satisfaction but low cash flow—into a more muscular, less financially encumbered performer. This was no simple undertaking and consumed the brothers throughout the 1970s.

"Some people have tried to paint me as a spoiled rich kid who inherited everything. In truth, what I inherited was a business with a great tradition but also tremendous debt, and Dick and I were able to turn it around."

As if running 36 businesses were not enough, Lamb became active on dozens of boards of directors and charities, working "with some great people over the years—and also a lot of swine and sleazebags."

He was a member of the State of Illinois Comptroller's Office Advisory Board and was district chair of the Boy Scouts of America. "We did petition drives to clean up Lake Michigan, but mostly it was about fund-raising—it's not as if we sat around in the conference room making campfires and singing "Kumbaya." He raised money for Christ Hospital in Oak Lawn by flying in actor George Hamilton for a fund-raiser; raised $93,000 for the Leo High School Alumni Association by arranging a benefit concert by Tony Bennett at Drury Lane Theater; and raised $175,000 for the Little Company of Mary Hospital, on whose board he sat for a dozen years. He was president of the Oak Lawn Chamber of Commerce.[2] And he was an Illinois delegate to President Carter's Commission on Small Business; chair of the St. Xavier University education committee; a patron of the Fra Angelico Art Foundation of Oakbrook Terrace, Illinois; a member of the Morgan Park Academy; a member and Professional of the Year in the Young Irish Fellowship Club of Chicago; and a member of the Knights of Columbus. For supporting liberal-arts education for Catholic women he received the Catherine McAuley Leadership Award and was honored with the Mary Potter Humanitarian Award for his involvement in Chicago charities.[3] He also became active in the Hundred Club of Cook County, an organization that raised money for the surviving families of policemen killed in the line of duty.

"I was also," he says, "a member of the City of Chicago Building Inspectors' Ball of Fire Club. I never inspected a single building, but I sure built a lot of them, mostly funeral chapels, so it was a good group for me to show my face in. One other group I was involved in as a P.R. outreach kind of thing was the Benevolent Protective Order of Elks. Everyone knew me as Matt Lamb the undertaker, and they'd all send business my way when people died. So I wore the moose hat. I wore every damn hat there *was* in those years. I would have been a member of the NAACP if I could have. That whole period of my life was one big chicken-and-green-bean dinner."

Rose was also hyperactive in the community, a member of the Ladies' Auxiliary of the Knights of Columbus, the Women's Board of Misericordia Heart of Mercy, the Board of the American Diabetes

Association, and the Brother Rice Mother's Club, an educational program at an Oak Lawn Catholic school. She was also active in nearly a dozen local and regional charities and organized fund-raisers for the Little Company of Mary Hospital for the better part of a quarter-century.

Throughout these years, Lamb kept up his involvement in the Local 727 chapter of the Teamsters Union. The 15-year-old boy who had once joined the Teamsters as a hearse driver now found himself an adult businessman on the opposite side of the labor/management divide. But Lamb's dealings with the union "were always civil and in the spirit of problem solving," he says. "They were always sensitive not to set up picket lines in the way of people's funeral routes, which I respected a great deal. I always found them every bit as honorable an advocate for labor as they were an adversary for management, and I wound up being a proud Teamster for 55 years. I retired when I turned 70, but now all my kids are Teamsters."

Finessing the sometimes competing agendas of labor and management drew upon Lamb's natural political acumen. Despite his father's objections, Lamb continued his forays into politics as the 1970s continued, taking an active role in legislative issues related to the funeral business. Sometimes he supported industry regulation, other times he vehemently opposed it. One initiative, ostensibly aimed at protecting the public against fraud, would have stipulated that only licensed funeral directors be allowed to interact with customers when money was involved. If the law had passed, Lamb explains, only employees who had graduated from mortuary school would have been able to consult with customers, even about minor issues like choosing bouquets, printing memorial cards, or deciding what kind of music to play over the speakers during a wake. Blake-Lamb and most other funeral homes at the time hired licensed funeral directors to oversee general operations, but employed people who were not licensed funeral directors to help customers with more direct concerns. Why should employees be required to take classes in embalming, for example, if their only job is helping customers choose between snapdragons, mums, and irises for the floral spray? If the bill had passed into law,

Lamb would have had to fire dozens of his best employees or demand that they begin the long, expensive path to licensure.

"These were people I had personally trained and had full confidence in," he says, his voice indignant even now. "This is a discipline that has to do with empathy, with being sensitive to people in the worst stages of grief. This is not like going to school to become a dentist."

Thanks in part to Lamb's efforts, the measure failed, but state politicians were quick to follow up with similar initiatives. Lamb rallied allies to help him lobby against these ill-conceived efforts in Illinois' capital, Springfield, and in Washington, D.C. One such ally was the heir to one of America's great fortunes, Potter Palmer. Palmer's namesake great-grandfather had been one of Chicago's prime movers, a retail magnate and hotelier who in 1870 built the historic Palmer House, to this day one of the Windy City's most opulent hotels. Lamb was acquainted with the contemporary Potter Palmer through Palmer's profitable cemetery business in Rose Hill, on whose grounds Lamb wanted to build a funeral home. A combined funeral home/cemetery operation would have provided a kind of one-stop shopping for the bereaved. Illinois law was not in favor of such an arrangement, however, construing it as an unfair competitive advantage over more traditional operations. Lamb and Palmer engaged lobbyist George Cullen to represent their interests in Springfield, and while the trio won many political battles, they eventually tired of the war, and plans for the combined funeral home/cemetery were dropped. Still, the experience forged a personal bond between Lamb and Palmer that endures to this day.

"Matt's his own man," Palmer says. "If he's your friend, he's the warmest, friendliest, funniest guy you'll ever meet. But there were people in the funeral business who weren't his friends, and Matt had no problem separating himself from them, even though it made him a pariah in some quarters."

Politically, professionally, and personally, the Lamb family has also had ties to Chicago's Daley dynasty for nearly half a century. From the late 1950s through the early 1970s, Matt Lamb remembers fondly, Mayor Richard J. Daley could often be found dropping by Blake-Lamb funeral chapels throughout the city. "After his workday was

through, he'd go home and have dinner with 'Sis,' and then he'd make the circuit of wakes, fund-raisers, and parties. If the mother of a secretary at City Hall had died, he'd come to the wake. If a policeman had died in the line of duty, he'd come. It wasn't uncommon for him to drop by one of our chapels and go to four wakes in one night, and he'd talk to the families at each one."

When Daley's son, Richard M. Daley, ran for State's Attorney of Cook County (an office to which he was elected in 1980), the Lambs threw him a fund-raising gala at their funeral home at 103rd and Cicero. Nine years later, when Daley ran for mayor, Matt and Rose Lamb hosted another lavish fund-raiser for him, this time at their spectacular residence on the Gold Coast. They have continued to support him since.

"Richard M. Daley will go down in Chicago history as one of the great builders," Lamb enthuses. "There's something almost Paris-like to many parts of the city now, with all the cafés, the horses and buggies, the newly rebuilt arenas. There's a cleanliness about the city that is a direct result of the mayor's leadership."

Lamb's political involvement over the years wasn't limited to helping elect and reelect the Daleys. He backed Marty Russo in his successful bids for Illinois' Third-District seat in the U.S. House of Representatives; helped his mentor, Herb Huskie, run for a spot in the Illinois Constitutional Convention; went door to door when his friend, Buzz Yourell, ran for Democratic Committeeman for the Worth Township; supported Tom Powell's and Fred Dumke's runs for Mayor of Oak Lawn; supported Tom Hynes for Mayor of Chicago and George Dunne for the presidency of the Cook County Board; backed a number of successful and failed contenders for U.S. Congressional seats; and met on several occasions with Vice President Walter Mondale to discuss public policy issues related to the funeral industry.

Raising money for campaigns came naturally to a man who was raising hundreds of thousands of dollars for charities, and organizing political campaigns came equally naturally to a man who was running 36 businesses. His combination of warm-and-fuzzy people skills and ruthless business sense proved invaluable as he campaigned, mostly for Democrats but also for the occasional Republican.

"Whenever a campaign would have a problem so messy it looked like a bowl of spaghetti, they'd call me in," he says. "I'd do my homework, and then I'd wave my magic wand."

He also displayed a flair for theatric gestures. When campaigning against one mayoral incumbent, he hired a printer to make up stickers, which he affixed to hot-air hand blowers in public restrooms. "Press This Button for a Message from Your Mayor," the stickers read.

Inevitably, all the politicking began to give him ambitions of his own: "I dreamed of running for County Dogcatcher and working my way up to President of the United States." But he worried that if he entered the arena, his obsessive nature would lead him on potentially quixotic quests for power that could drain his fortune and destroy his family. He sought the advice of a friend "highly connected in national politics," whose name he will not divulge.

"Don't do it," the friend warned. "A man like you is too intransigent to be a politician. They'll try to tempt you with money, women, booze, drugs. But it won't work, because you won't bend. Your enemies will destroy you for that."

Lamb shelved his plans to run for County Dogcatcher and President of the United States.

But while he opted out of the rough-and-tumble world of politics, he never shied away from ruthlessness in business when the circumstances called for it. Lamb could and did make mincemeat out of his enemies in the business world—and he had plenty of enemies. Owners of competing funeral homes hated Blake-Lamb's policy of comping the funerals of firemen and policemen killed in the line of duty, a policy that endeared Blake-Lamb to the public and compelled competitors to follow suit at great expense. Competitors also resented Blake-Lamb's aggressive advertising and marketing campaigns, which stressed the company's multigenerational history. This soft-sell technique hit other homes' profit margins hard. Lamb's lobbying efforts in the state capital also impacted other funeral homes negatively at times. This combination of factors put Lamb on the receiving end of vicious attacks by some of Chicago's leading businessmen. He became adept at parrying thrusts and, when necessary, mounting preemptive attacks—sometimes with a velvet glove, other times with a sledgehammer. His modus operandi

was what he calls "the Irish tradition: Forgive but remember—and I do—I'm proud of my friends, but I'm also proud of my enemies."

Of all the enemies Lamb has collected over the course of his long life, there was one that attacked him in a manner so powerful—and with monetary and legal resources that dwarfed his own—that the ensuing battle threatened to undo him completely. He is not legally allowed to discuss this battle because of the terms of the settlement— a prohibition that kills him, as he is not a man who makes a habit of holding his tongue. Suffice it to say that in the end, Lamb emerged from the battle with his reputation and fortune intact but his sense of idealism forever scarred.

Through all the wheeling, dealing, and battles royal, Lamb has kept the upper hand by wielding what he calls "fuck-you money," which means that you never enter a deal you need so badly that you can't walk away from it. You always have enough cash on reserve that if the other party won't budge on a deal-breaker, "you can tell him, 'Fuck you,' and walk out the door." Lamb built an empire on fuck-you money.

Although he could—and still can—be ruthless with enemies, he is exceedingly loyal to and generous with his friends, and this is another secret to his business success. His personal archives brim with thank-you notes spanning the decades: thank you for lending me your limousine; for arranging our private tour of the Vatican; for making it possible for my daughter to attend the debutante ball; for donating to our charity auction . . .

Lamb looks back on these years, during which he began to flex his muscles as a deal-maker and power broker, as a critical formative period. Certainly, he enjoyed making money and enjoyed the things it could buy. He sent his children to the best schools, bought two Rolls-Royces, and splurged on fine clothes and jewelry for Rose and himself. Still, in retrospect, he wonders whether perhaps he enjoyed the trappings a little too much sometimes: "I was striving to 'be somebody.' I was concerned with dressing well, with the whole outward package. I had a jeweler friend design me this big, gold stickpin with thirty little diamonds and a big one in the middle. I looked like a gypsy, but at the time I thought I was the cat's meow."

Among the Lambs' greatest extravagances were their homes. As the 1970s yielded to the 1980s, the couple finally moved out of the funeral home once and for all. The freedom felt good, and they reveled in it, purchasing an 18-room penthouse atop an exclusive North State Parkway building. The building had been erected in 1912 by Benjamin H. Marshall, the architect behind Chicago's opulent Drake, Blackstone, and Edgewater Beach Hotels, and had been occupied by prominent Chicagoans like John Shedd, A.B. Dick, and Eugene Pike before the Lambs moved in.[4] Hung with eight crystal chandeliers, the residence boasted a paneled library with an Italian Baroque ceiling, early-nineteenth-century carved oak doors imported from a French chateau, and a Romweber display cabinet in the living room, housing Baccarat goblets from the collection of Napoleon Bonaparte.

With its 11,000 square feet and sweeping views of the city, Lincoln Park, and Lake Michigan, the Lambs' penthouse was the venue for their splashy parties, breathlessly chronicled in the society pages of the *Tribune* and the *Sun-Times*, as well as *Today's Chicago Woman* and the suburban papers. For more than 10 years, the couple's opening-night after-party for the stars, patrons, and artistic leaders of the Chicago Lyric Opera was one of the most sought-after invitations on the city's social circuit. The Opera's general director, Ardis Krainik, a friend of the Lambs who lived in the same building, would always personally escort the night's biggest stars into the glittering penthouse, which was filled with strolling musicians, catered cuisine, and champagne.[5] This was the scene on opening night for productions including Mozart's *Cosi fan tutte*, Johann Strauss Jr.'s *The Merry Widow*, Ambroise Thomas' *Hamlet* with baritone Sherill Milnes in the title role, and Leonard Bernstein's *Candide* with Elizabeth Futral as the evening's Cunegonde. "Thank you both for 'the Best of All Possible Parties,' " read Futral's thank-you note to the Lambs. The couple played genial hosts with a loose-and-lively personal style that contrasted with the surroundings' formality.

"Everything's here to be used and enjoyed," Rose told a magazine reporter covering one of the soirées. "If something breaks, it's not the end of the world."[6]

Several years later the couple moved into the historic Bullock Folsom House on Chicago's Gold Coast. Built in 1877, the mansion played host to a roster of illustrious guests, including U.S. Presidents Grover Cleveland and Franklin Roosevelt and poets Robert Frost and Carl Sandburg. The home was a true showplace, with pierced fretwork tracery over gliding pocket doors, 12-foot pier mirror moldings, William Morris wallpaper in red silk, a cherrywood library, and luxurious draperies puddling onto hardwood floors.

For two people who had lived for a year with no furniture in the living room, this was truly living large. Says Lamb, "We'd gone from pig-shit Irish to lace-curtain Irish!"

But sometimes the nonstop entertaining could be taxing. As a hideaway, Lamb rented a studio apartment to which he and Rose could disappear when they needed a break from the prominent partiers parading through their home, the never-ending silver trays bringing flutes full of champagne and tumblers full of scotch and soda. The people who knew about the couple's studio apartment could be counted on one hand. Lamb paid the landlord in cash and installed no phone lines. Downstairs on their mailbox, their names were listed as "Mr. and Mrs. Rodriguez." It was wonderful to escape periodically from the hectic pace of work, charities, boards, politics, and parties, but for Matt Lamb, as for many people at the end of the 1970s, there was no escaping the reality of the excesses that had come to characterize his life. Rose had always watched his back, and in recent years she'd begun to see a monkey on it. Now he saw it, too: he was an alcoholic.

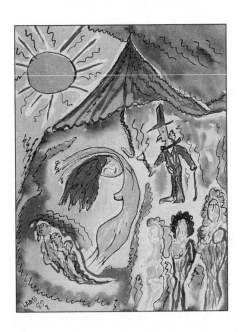

CHAPTER SEVEN

DRUNKEN DAYS AND PAPAL KNIGHTS

The extent to which drinking and smoking were ingrained in the business culture of the 1950s and 1960s is hard to fathom today. We look back upon the three-martini lunch as a Hollywood cliché and the proverbial "smoke-filled room" as a figure of speech. It's easy to let nostalgia blur an entire era into a mental movie set. But take a look at the black-and-white photographs of opening parties for new Blake-Lamb chapels in the late 1950s and early 1960s, and you will see that the cocktails and cigarettes in everyone's hands, including the priests', are not just props to be wielded as Dean Martin croons "Volare" and Zemeckis cranes up as Marty McFly runs down Main Street. Alcohol and nicotine were the lubricants and conduits that made deals happen.

"That was the culture of the time," Lamb remembers. "If you didn't drink, you were suspect."

Adds Rose: "During that period of our lives, most people didn't know Matt was drunk. He never let on."

Lamb's recollection is different. "After drinking all day, I got way too candid by the end of the night. I would always say to Rose the next morning, 'Give me a list of the people I pissed off last night, so I can do damage control.' I suppose I could say I drank because it was a release from dealing with people's grief all day, but that would be a cop-out. The fact was, I drank because I liked to drink, and I liked the way it released my inhibitions in social situations. I'm obsessive about anything I do: business, art, drinking, smoking. I smoked everything they put in front of me, except marijuana: cigarettes, pipes, cigars, cigarillos, starting when I was 12. By the time I was 30, I was smoking five packs a day. I drank every drink there was to drink. Red wine. White wine. Green crème de menthe. Yellow crème de banana. I threw up in Technicolor. Maybe that's where my sense of color came from later, when I started painting."

One of Lamb's great drinking buddies was Blake-Lamb general manager Dick Yarnell. "One night in March back in the late 60s, Dick and I were out, and I offered to buy him a drink. 'No thanks,' he said, 'I've given up drinking for Lent.' So I said to him, 'But a martini isn't really drinking,' and he says, 'Oh, well in that case, order me one!'" One turned into five apiece before they began drinking beer and wound up so hammered, "we would have pounded a land mine to see if it was live."

Another night the two got so loaded they parked their cars horizontally across the street, blocking traffic.

"Luckily," Lamb says, "we had very understanding wives."

One day on the golf course, between holes and swigs from their flasks, Yarnell turned to Lamb with a boozy-woozy revelation: "I just realized something. When I'm golfing, I'm thinking of screwing, and when I'm screwing, I'm thinking of golfing."

Lamb has never let him live the comment down, despite the fact that Yarnell has since stopped drinking.

As the 1970s came to a close, Lamb realized his own drinking was

out of control. He was dependent on alcohol, needed it multiple times a day to function. Hours-long chunks of his evenings disappeared from his memory, washed down a river of cocktails. He joined Alcoholics Anonymous, and his sponsor was a Chicago policeman named Joe. One evening after a meeting, Joe took Lamb aside, pulled his pistol from his holster, and removed a bullet from its chamber. Placing the bullet in Lamb's hand, he said, "Take this and keep it in your pocket. Whenever you're tempted to take a drink, get the bullet out, look at it, and think to yourself: Taking this drink is the same thing as firing this bullet into my head."

Lamb kept the bullet in his pocket for years. He also turned, as many alcoholics do, to the power of prayer, asking a higher power to save him from himself: "I asked that the pleasure be taken out of drink and smoke. I said, 'Please make alcohol and cigarettes taste like shit.'" The immediate result was a whole lotta nothin'. But gradually his intake began to diminish, until one year about 20 years ago while vacationing in Ireland, he ordered his favorite beer, Murphy's, and to his astonishment, it didn't taste the way he remembered. He drank half the mug and left the other half on the table. This was a revelation, which he believed had been ordained by divine powers, with a little help from A.A. and the ever-supportive Rose. After that day, he drank only a few more times before his urge dropped off entirely. Today, he cannot recall when he took his last drink.

As Lamb faced his personal demons in 1980, the funeral home was facing intense competition—and turning every challenger into an also-ran. Blake-Lamb had become the unquestioned 800-pound gorilla of the Chicagoland funeral business. A leading trade organization named the company's flagship operation "the most progressive funeral home in the nation."[1] When the *Chicago Sun-Times* published a multipart exposé on funeral-home scams entitled "The Death Merchants," several of Blake-Lamb's competitors were skewered for dishonestly inflating costs, but Blake-Lamb emerged smelling like a rose. The articles gave the company extra kudos for suggesting low-cost alternatives every time the undercover reporter requested a more expensive arrangement.[2]

By almost any criteria, Blake-Lamb was reaching the peak of its

saturation and success. Several years earlier, Lamb and Dick had held a series of talks with M.J. about establishing a transition plan in the event of his death. The tax laws were set up such that, if M.J. remained the controlling owner of Blake-Lamb until he died, his heirs would be saddled with massive penalties, endangering the continuity of the business. Lamb and Dick, therefore, suggested a scenario whereby they would buy the company from their father outright but keep him on the payroll as senior consultant. Initially reluctant to give up control, M.J., whose health had begun to decline, eventually recognized the plan's necessity and sold his boys the company. He continued to direct funerals and make appearances as the company's patriarch.

"He loved standing at the door, shaking hands, and being 'Mr. Lamb,'" his oldest son remembers.

The pride M.J. took in this ongoing role may have been one of the things that kept him alive after his wife, Peg, died in the mid-1970s from a sudden stroke at the age of 75.

As the new joint owners of Blake-Lamb, Lamb and Dick thrived on the communal spirit of running the family business, no longer subservient to their father, but co-patriarchs of a new generation of company employees. Each of Lambs' growing children began working for the funeral home in various capacities, a phenomenon the local press found irresistible. One Father's Day, the *Chicago Tribune Magazine* ran a cover story entitled "Family Ties," featuring full-color photographs of the Lamb clan posing together and interviews probing into the nature of working with your parents, children, and siblings.[3]

Though he was loath to admit it, and while he still enjoyed the high-level wheeling and dealing, Lamb was becoming less interested in the business's day-to-day operations as he entered his forties.

"At a certain point, I realized it just wasn't as fun anymore. I started doodling a lot in meetings when I got bored."

Newspaper clippings of him posing with other funeral directors at the time show a man surrounded by other men who look twice his age, even though they're contemporaries. There's a certain twinkle in his eye, beaming out of the yellowing newsprint. Unlike the other undertakers flanking him, he looks as if he's not content to bide his time selling caskets and cremations until it was time for his own. This may be

because, despite his somber exterior, Lamb's imagination was running wild.

"I started making up little fantasy games to keep my sanity. I'd rewrite the lyrics to nursery-rhyme songs like 'The Farmer in the Dell.'"

In Lamb's absurd version of the tune, it was not the farmer taking a wife, but the farmer taking the cow, and the dog was taking the nurse, and the nurse taking the cheese, and so on in ever more perverse permutations. When he ducked into the privacy of his office or the break room, he'd sing these songs aloud and dance jigs, flapping his arms like a chicken. When he got home at the end of the workday, he'd often pester Rose with silly word games.

"I'd substitute the word 'animal' for other words: 'Did you have a good animal today, my dear? Let me tell you about my day at Blake-Lamb Animal Home.'"

He'd continue these word games so obnoxiously that Rose, exasperated, would yell out to silence him, "Matt, if you say 'animal' one more time, I'm going to cut your tongue out!"

He also found humor in odd scatological speculations, occupying his mind during wakes by constructing elaborate, mock-academic dissertations on the nature of bowel movements and flatulence: "What exactly would constitute the world's most perfect fart? How would you judge its properties? What would be the criteria?"

When he encountered a difficult or pretentious customer, he would create short plays in his head.

"I'd puff up inside, all hoity-toity like the customer, and say: 'Why, hello there, Mr. McDick!' And the other character would say, 'Hello back to you!' 'Let me ask you, dear sir, are you with the Boston McDicks or the Shitta McDicks?' And the other one would get offended and say, 'Why, the Boston McDicks, you fool!' And so on."

Sometimes these imaginary characters would wear flamboyant hats or morph into horses or dogs. Several years later, when he began to paint, he would mine these fantasies for inspiration.

One of his friends at the time was an amateur abstract painter, Kenneth Chapman, who taught some of the Lambs' children at Brother Rice High School. Lamb bought some of Chapman's works

and hung them in his funeral homes. He had enjoyed strolling through museums on trips to Europe with Rose and the kids—gravitating especially to van Gogh and Chagall—and enjoyed having oil paintings as part of his work environment at Blake-Lamb. While he wasn't conscious of it at the time, he says now that seeing Chapman's work may have planted a seed in his mind: "What if *I* could paint?" For the time being, the impulse lay dormant.

Another friend during this period was Cardinal Joseph Bernardin, beloved Archbishop of Chicago and a progressive thinker whose mix of metaphysical curiosity and sometimes mischievous humor matched Lamb's own. When a church-related award ceremony brought both Lamb and Bernardin to Detroit one night, the two were equally distressed when the speeches grew longer and longer, threatening to make both men miss their plane back to Chicago.

"Finally," Lamb recalls, "Joe went up front to say a few words and honor people, including myself, with awards. When it was my turn, I was escorted up to him with great pomp, and he bent down and whispered in my ear for some time. Everyone in the audience thought he was speaking to me about something very spiritually profound. What he actually said was, 'This is running way too long—we're going to miss our flight! Listen, in five minutes, no matter what, meet me in the back, and we'll sneak out of here!' "

A few months later, Bernardin found himself bestowing yet another award on Lamb, this time at the Drake Hotel in downtown Chicago. "I've gotta tell you," Bernardin began his remarks to the audience, "I looked in the mirror this morning and said to myself, 'I'm honoring Matt Lamb tonight at the Drake, I should really get a haircut.' Then I came to my senses. Why would I get a haircut for Matt Lamb? He always looks like he got blown in by the wind!"

Bernardin's residence was across the street from the Lambs' home on North State Parkway, and the cardinal would often drop in on the Lambs for a drink after an evening stroll. Lamb and Bernardin would spend hours discussing a wide variety of topics, spiritual and otherwise. One issue of mutual concern was the need for humanitarian aid in South America. Several years previously, the Lambs and their friends, Leo and Holly Hennessy, had teamed up with Chicago priest (and

later bishop) John McNabb, to provide emergency relief to villagers in the backwaters of the Piura River in Peru. On a fact-finding trip for the Church, McNabb had been moved by the plight of a remote village called Chulucanas and had subsequently founded a mission there. Rome was worried that insurgency in the area might lead to a revolution similar to Cuba's, bringing instability and Communist atheism to the country and eventually the continent. But McNabb was more concerned with the immediate humanitarian needs of the villagers than with any grand, metaphysic quest to save souls from the scourge of godlessness.

"John McNabb knew you had to cover the basics, and I agreed," Lamb says. "Food, bread, a roof over your head—this was what you needed to help people with before you worried about going around evangelizing people."

Lamb had supported McNabb's mission energetically for more than a decade. Back in his drinking days, he'd thrown a party for a dozen Chicago businessmen at his home, and by the party's end, the men had committed to raising $60,000 to support the priest's efforts.

"We woke up the next morning with hangovers and vaguely remembered we'd made this pledge when we were all drunk out of our minds. But we knew we had to keep our word."

The men had formed an ad-hoc committee called the Chulucanas Fellows, which indeed raised the $60,000 for the cause and, more importantly, put the money to good use. In the late 1970s, some members of the group, including the Lambs, visited Peru personally to offer McNabb hands-on help. Lamb and the others built a gas station for the villagers, established a printing press, a bakery, a dairy, and a radio station, and taught the village's citizens how to use them. They also set up a farmers' co-op so the villagers could buy their own feed and seed, cleared an airfield to enable supply planes to land, brought in water purification technology, improved sanitation "so the kids wouldn't have to go to the bathroom in the streets," and helped get the local teenagers off the fermented maize liquor, chicha, "which was turning bright, energetic kids into zombies."

The Shining Path (Sendero Luminoso) terrorist group didn't care for McNabb's efforts, nor the Fellows' help, because the priest was

undermining the Path's own control of the area. McNabb narrowly escaped harm one night in the mid-1970s when the Sendero Luminoso firebombed his house. The Lambs' six-week visit came during a political revolution, and upon their arrival in Chulucanas, they were ordered to abide by a mandatory curfew or be shot. Despite this sub-Welcome-Wagon greeting, the couple stayed on and were eventually thanked for their help by the villagers, who in 1979 bestowed on them the honorary Ecclesiastical Order of Chasqui.

The Church also took notice of the work Lamb was doing in Peru. During the 1980s he was knighted not once, but twice, by order of Pope John Paul II in recognition for his humanitarian work at the Chulucanas mission and elsewhere. The first investiture, in 1985, was into the Equestrian Order of the Holy Sepulchre of Jerusalem, a chivalric order stretching back to the Crusades, charged with advancing the Catholic faith and preserving the Holy Land's great shrines. Lamb was advanced to the rank of Lieutenant of the Order's North Central Lieutenancy in 1990. His second knighthood was in the Association of the Master Knights of the Sovereign Military Order of Malta, a group whose members, beginning in 1020 A.D., hurtled through the centuries battling Turks and ramming fortresses before settling into the more genteel activities with which they occupy themselves today. New York Archbishop John O'Conner did the honors at Lamb's second knighting, tapping him on each shoulder and bidding him "Arise, Sir Matthew."[4] Clad in a black camel-hair habit adorned with the eight-point Maltese Cross, a black velvet beret atop his head, Lamb had come a long way from the back alleys of Chicago, where, so many years ago, the Dirty Dozen had thrown him in the mud and sullied his white suit.

His dual knighthoods entitle Lamb to be addressed as "Your Excellency" and Rose as "Lady Rose." Neither uses the titles, except in formal correspondence with the Vatican, but his status as Papal Knight does afford Lamb a marvelous set of bejeweled medals and sashes to wear with formal attire. Still, in the early 1980s, as Lamb faced a new decade with his alcoholism behind him, neither the glittering medals nor elaborate costumes could save him from a new crisis, one that threatened to dress him in a very different outfit—his own funeral suit—long before his time.

PART THREE

THE CRISIS

Who, if I cried out, would hear me among the angels' hierarchies?
And even if one of them pressed me suddenly against his heart,
I would be consumed into that overwhelming existence.
For beauty is nothing but the beginning of terror . . .
> —*Rainer Maria Rilke ("The First Elegy,"* Duino Elegies,
> *translated by Stephen Mitchell)*

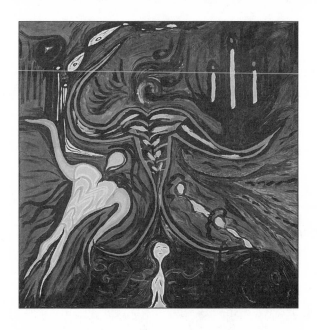

CHAPTER EIGHT

THE FUNERAL DIRECTOR PICKS
HIS OWN CASKET

Knighthoods, mansions, a loving marriage, and four children all working for the family business—this was Matt Lamb's world in 1980. Life was sweet. And then, suddenly, it soured.

Lamb's father suffered a stroke and a series of complications, which led to his death from kidney failure two years later.

Rose was diagnosed with diabetes in 1980, after her symptoms—which she had experienced for years but had not recognized as diabetes—reached a crisis stage. Had she not been treated, she would have plunged into a coma and quite possibly died.

Then, one morning only a few months after Rose's diagnosis, Lamb, normally a fount of energy, awoke to find himself so inexplicably fatigued, he could not rise from bed. He had been diagnosed with

mononucleosis several years before but had always rebounded from the bouts of weakness it occasionally produced. His fatigue on this particular morning, he was convinced, was probably no more than just another, particularly bad "mono day." He had meetings scheduled from 7:30 A.M. to 5 P.M., with a board meeting from 5:30 to 6:30 P.M. and dinner plans afterwards. But Lamb could not get out of bed. He phoned his secretary and had her cancel everything. The next day arrived, and he could still barely move a muscle. Through sheer force of will he made himself go to work, although in the coming days and weeks he began conducting more and more business by telephone. This was not the Matt Lamb his colleagues knew. More alarmingly, this was not the Matt Lamb that Matt Lamb knew.

He might have suspected chronic fatigue syndrome if that diagnosis had been more common at the time. He might have suspected that, at 48, middle age had finally caught up with him, giving him a not-so-gentle warning that his physical capabilities were gradually diminishing—except that there was nothing gradual about this: It was 100 mph to zero overnight. He might have taken it as a wake-up call to stop overindulging in alcohol, except that by 1980 he had already begun to curtail his drinking. Lamb was stumped. So he decided to do something radical, something he generally tried to avoid at all costs: He went to the doctor.

"I'm the kind of guy who goes to his annual physical religiously— every five years," he quips.

His physician did the usual routine—stethoscope, rubber hammer on the knee, turn your head and cough—then ordered a series of diagnostic blood tests. Early the next week, the results came in.

Bad news comes in threes. Lamb's first bad news was that he was suffering from a relapse of acute infectious mononucleosis, a more serious and advanced form of what schoolkids call "kissing disease" because of the virus' contagiousness. Mono is an abnormal increase of mononuclear leukocytes—white or clear cells—in the blood, caused by the Epstein-Barr virus. If left untreated, it can in some cases lead to hemolytic anemia (a blood disorder), myocarditis (an inflammation of the heart), Bell's palsy (which can paralyze facial nerves), Guillain-Barré syndrome (a nervous disorder that can lead to paralysis), and the

potentially life-threatening rupture of the spleen. The second piece of bad news was that he was also suffering from chronic active hepatitis, an inflammation of the liver that can kill liver cells and lead to fibrosis, cirrhosis, cancer, coma, or death. The third piece of bad news was that, according to the results of a final round of tests, he had developed sarcoidosis of the liver, a chronic condition of unknown cause that attacks the organs by forming nodules—small, abnormal lumps—impairing their function, sometimes to the point of failure.

The doctors prescribed medication and ordered Lamb to rest, but his symptoms did not improve; over the following months, they worsened. Valiantly he tried to keep himself afloat enough to run the businesses, even though he was operating at a fraction of his normal powers. He divulged the details of his diagnosis to no one, save immediate family. This continued for a year, and another, and part of another.

A particularly bad bout with the trio of conditions came with especially awful timing in November 1983. Lamb was involved in a deal that had the potential to launch Blake-Lamb in a whole new direction. He and Dick were researching the possibility of acquiring and running cemeteries, a business that, while related to funeral homes, has an entirely different profile economically and legislatively. More than ever, Lamb needed his every mental and physical resource as the brothers debated whether to travel down this new road, which could potentially lead to undreamed-of profits or, if the move proved a misstep, to financial hemorrhage. Knowing that accepting or rejecting the deal would have a lasting impact on Blake-Lamb's future, he forced himself to attend the meetings. As deliberations neared their end, it was not Lamb, but his attorney, who wound up having to cancel the deal's most important meeting.

"I have to leave town on the next plane," the lawyer apologized. "You know my brother has been ill . . ."

"Yes," Lamb said, "you mentioned that to me a year or two ago."

"He's taken a turn for the worse. I just got a call from my sister-in-law, and apparently the doctors are saying I should get out there ASAP if I want to say good-bye."

"Well, you get on out there, then. He has cancer, doesn't he?"

"No, he has a combination of two different diseases."

"Oh?"

"Chronic active hepatitis and something called sarcoidosis of the liver."

Lamb blanched.

A week later the attorney returned after burying his brother.

Lamb saw his doctor again and updated him on his worsening symptoms. He mentioned his attorney's brother and asked how long his own trio of conditions would take to run their course.

"Hard to say with any degree of certainty. Everyone's system handles things in a different way . . ."

"Do me a favor. Cut the crap," Lamb said curtly. "How long do you think I have?"

A pause. "I know your life is very complicated financially. I know you have a wife and four children in their twenties who work for you. If I were you, I would look into contingency plans as soon as possible."

"You mean put my affairs in order."

"Yes."

"As soon as possible."

"Yes."

Lamb took it in.

"And since you asked me to cut the crap, I should warn you that if the diseases don't kill you, the cure might."

"Meaning what?"

"The medications you're on can have brutal side effects on the body and organs."

"I see."

"You're free to get a second opinion, of course. In fact, in a case this serious, I'd recommend it."

Lamb knew Blake-Lamb's and Matt-Rich's books. The funeral home was pulling in more revenue than ever, but cyclical downturns in several of the other businesses had Lamb highly leveraged or locked into multiyear contracts. During the downturn, he had operated on the premise that markets eventually recover, and that investors with the belly to ride out the storm would eventually be rewarded. But now,

"eventually" had been whittled down to a span of months, perhaps a year or two if he were lucky. If market conditions and industry trends improved before he died, Rose and the children would be well provided for, but if he died before the uptick, they might inherit not the products of a lifetime of hard work, but several million dollars' worth of debt. If he were to die within the next year, there was a chance the Lambs' businesses could be plunged into bankruptcy, their homes repossessed, their possessions auctioned off to pay creditors and the government. Lamb was not a man to leave his family's future to chance.

He would need to figure out a plan, look over his will, meet with the accountants. He would need, he realized with bitter irony, to begin planning his own funeral arrangements: the casket, the flowers, the cemetery plot, the dozens of details through which he had patiently and professionally walked thousands of families for the last three decades of his life. The undertaker had become his own customer.

Leaving the doctor's office demoralized and deeply troubled that autumn day in 1983, he returned home, holed himself up in the living room, and played his LP of *La Bohème* on the stereo for hours on end, sobbing as he listened to it. It was the one and only time he broke down over his condition.

"At the time," he says, "I told myself I was crying because it was *La Bohème*, and the music was beautiful. In retrospect, I know it was because I'd been told I was dying."

He and Rose decided they needed to leave town for a few days to clear their heads and think things over, and so they flew to Albuquerque, New Mexico, and drove north through Santa Fe and Española to Taos, a favorite getaway. The first snows of the season were falling over the Sangre de Cristo mountains as they arrived, and sombreroed skeletons from the *Dia de los Muertos* celebration still hung in the town's historic Plaza. Ensconced in their hotel room before a kiva fireplace, they talked about the future, and while the setting may have been romantic, Lamb could not have been more dispassionate as he walked Rose through scenario after scenario, strategizing the various ways in which the companies' succession plans could be structured to insulate her and the children from debt. His death, he promised her,

would not leave them destitute; he would create tax shelters, irrevocable trusts, airtight protections against probate court, whatever needed to be done to guarantee their security.

With her characteristic realism, Rose listened and added input without an iota of sentimentality. When the logistics had been hashed out in every conceivable permutation, she told her husband she had something else to add: He should take his doctor's advice and seek a second opinion, not from another general practitioner, but from the best specialists money could buy. He must not give up, but fight the diseases with the same stamina and ruthlessness with which he'd built his businesses. He owed it to himself, to her, and to the family. He could beat it. He could live.

They looked at each other for a long time, the only sound the juniper logs crackling in the fire.

"If I beat it," he said at last—and then he said something she had never expected to hear—"I'm going to paint."

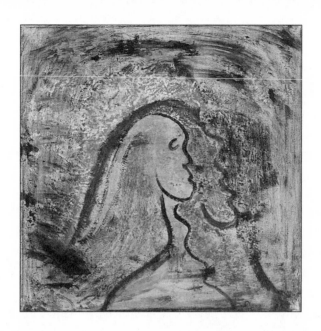

CHAPTER NINE

MISDIAGNOSIS OR MIRACLE?

"Paint?"

"Paint."

"In your spare time?"

"No, all the time. I'm going to get us out of debt as fast as I can, sell my half of Blake-Lamb, sell the other companies, and become a painter—if I live."

"I never knew you wanted to be a painter."

"It's been in the very back of my mind. I think I have something to say as an artist."

"You do?"

"Yes."

"Like what?"

"Things about spirituality and society and politics. The world, this one and the next one."

"Well, you know I'll support you whatever you do, Matt, but this is news to me."

"The games I make up in my head at work to keep my sanity, the characters, you know, the big buffoons all puffed up and full of themselves . . ."

"Right . . ."

"The creatures I dream up, the little animals."

"You want to paint them?"

"Yes. They're like Polaroids to me—I can see them! They're like spirits that want to come out into the real world."

"Matt, why have you never shared this with me before?"

He had no answer. And then he did: "Because I never thought I was going to die before."

Upon the couple's return to Chicago, Lamb took Rose's advice and sought a second opinion. He got a referral to the Mayo Clinic in Rochester, Minnesota, where specialists interviewed him at length about his medical history and subjected him to a punishing battery of blood work, biopsies, and X-rays. Nurses gave him noxious dyes to drink, then fastened him inside cold, metal machines and told him to lie very still. This routine went on for five days. For the doctor-phobic Lamb, it was pure hell, as was the waiting, holed up in a Rochester hotel room, trying to keep up by telephone with business back in Chicago.

At the end of the week, specialists reviewed the test results independently, then met as a panel and compared notes. They delivered their thoughts in written and oral form to the medical manager, who in turn called Lamb into his office to discuss the test results. Rose stood at his side as the doctor told him his fate.

Bad news comes in threes. So does good news. First, the results showed no evidence of any active mononucleosis. Second, the results showed no evidence of chronic active hepatitis. Third and finally, the results showed no evidence of sarcoidosis of the liver or of any other organ.

Lamb listened in disbelief.

Item by item, the doctor proceeded to show him the results, walking him through the purpose of each test, the data collected, and the implications thereof.

"I don't understand," Lamb said. "They all came up negative?"

"That's correct."

"That can't be."

"You saw the results, Mr. Lamb."

"So you're saying I'm healthy?"

"Well, from what you've told us about your lifestyle, I think you're more likely to die from stress and high blood pressure than anything else."

"But the diagnosis before . . ."

"We can only tell you what we found, Mr. Lamb."

"And you found . . ."

"We found nothing. Now, we know you've suffered from mono for many years now, and we're going to prescribe you a new medication to take, should you have a recurrence of your symptoms, but in terms of the three conditions we were looking for—the severe, chronic conditions we tested for—you appear to be free and clear."

His head awhirl, Lamb walked out through the waiting room into the hallway. He and Rose took the elevator down to the lobby and strode into the sunshine. He took her in his arms. "I just got my life back," he said.

After he returned to Chicago from the Mayo Clinic, he never again experienced symptoms that approached the severity of those that had plagued him over the preceding three years. Does this mean his symptoms had been psychosomatic? Or that the initial diagnosis had been wrong? The question of why one set of tests turned up an acute viral infection and a duo of potentially deadly conditions, while another set of tests gave him a clean bill of health, still puzzles Matt Lamb.

"What if both doctors were right?" he speculates. "What if I had the diseases, and then I didn't have them? Who knows, maybe I *still* have them, I just don't have the symptoms anymore—I haven't been tested since, so how would I know? The bottom line is, if you get your life back, is that really a gift horse you want to look in the mouth? If your second opinion is that you're healthy, are you going to rush out and get a third?"

In his heart of hearts, Lamb believes the disparity between the first set of tests and the second was not the result of a misdiagnosis, but of a miracle. He looks upon the experience as an answer to his prayers, as destiny's way of shaking him out of one paradigm and opening the gateway to another. As a child, he'd been struck by a quote that fell out of a library book: "You will gravitate toward that which you secretly most love." Now, at the age of 51, three years after the diagnosis that changed the course of his life, he was getting the chance to do something he'd secretly yearned to do for years. He intended to make good on the promise he'd made Rose that snowy night in New Mexico: to leave behind the world of margins and mergers and venture into the terra incognita of canvas and oils.

But the dream of becoming an artist, so romantic by the glow of juniper logs in a kiva fireplace, was a very different proposition from the reality of selling his interests in 36 businesses back in the concrete jungle of Chicagoland. Lamb had cut his teeth in the funeral business, a field that, at least to outward appearances, had little or no overlap with the art world. Did he, well into middle age, really want to abandon the company his ancestors had built, the field he knew like the back of his hand, and the additional businesses that provided the income he and Rose were banking on for retirement—all for the pipe dream of entering the world of art, about which he knew absolutely nothing?

These questions would not leave his mind in the days following his return to Chicago from Rochester in December 1983. Recalling the difficult decision he had to make—to follow his dream or stay with the tried-and-true—he later told an arts writer that giving up his prominence as an established funeral director was like "going from top to bottom. If adulation was what I sought, I would have stayed where I was in the business world."[1]

He also had to consider Rose. She had offered her support, but was she prepared for the transition from being prominent members of the business community to being outsiders in the art world? In the monograph, *Matt Lamb: His Art and Philosophy*, Dr. Mary Towley Swanson calls Rose "an understanding confidante and cheerleader, totally supporting the painter in his decision to change careers at a time in life

when most couples begin to plan for retirement."[2] This chipper but simplistic characterization fails to capture the nuance of Rose's feelings at the time.

Says Lamb, "It was a shock for Rose. For her, it was like going from a queen to a scullery maid. I kidded her that we were not going to be Mr. and Mrs. Big anymore, we were going to be Mr. and Mrs. Little."

Rose had played a major and well-defined role in growing Blake-Lamb and the other businesses. Her skills in public relations perfectly matched her official and unofficial duties in the funeral business. What would her role be in her husband's new paradigm? To sit around and watch TV while her husband painted all day?

"I didn't know where I would fit into this new thing he wanted to start," she confesses. "I was afraid I'd become obsolete."

Family friend Simone Nathan adds: "Matt had fallen in love with another woman, a very demanding and time-consuming other woman: art. There aren't many women who would have put up with that, but Rose did."

Leaving behind a field in which he possessed world-class expertise, and entering a field in which he possessed no expertise was a scary but thrilling prospect for Lamb. "I felt like a 17-year-old," he later told *The University of St. Thomas Bulletin.*

But how many 51-year-olds get to feel like a 17-year-old? And how many men work their way up to the level of a "somebody," then become a nobody, only to slowly climb their way up a different ladder until finally they reach the ranks of the somebodies again? This was Lamb's opportunity and his risk, and the way he faced it said much about his personality, but also about his generation. His parents had been so traumatized by the Depression that, once it was over, they largely clung to any semblance of security they could find. Lamb is only one generation downstream from this mentality, yet he is also only one generation upstream from the Baby Boomers. He was able to observe the contrast between his parents' generation and the Boomers, who, empowered by the counterculture and sexual revolution, abandoned and reinvented preexisting paradigms at will. Unlike their gold-

pocket-watch-carrying, company-man fathers in gray flannel suits, the Boomers went on to switch careers midlife like they had swapped partners at key parties, sometimes with similarly disastrous results.

So Matt Lamb is in the middle of this odd generational sandwich, too young to have been devastated by the Depression but too old to be liberated by the hippies, too rich to be bohemian but too free-spirited to fit in with the stuffed shirts at the country club—and faced with what he thinks is a death sentence, he gets this completely irrational idea that he's going to ditch the life of the CEO and live the life of Picasso. He's shaking hands at wakes every day, dreaming of what he wants to do to a blank canvas. His business associates can sense this and think he's lost it. His friends worry that he's making a big mistake. His wife, though outwardly supportive, harbors reservations. His children don't know what to think.

So you're Matt Lamb circa December 1983, and the deck seems stacked against your ever realizing your dream, your dominant aspiration, which you gravitate toward because it's what you secretly most love. You're 51. The clock is ticking. There is a wife to consider, and four children, and millions of dollars. What do you do?

You take a deep breath. You fire. And then you aim.

PART FOUR

THE NEW LIFE

"An artist has to be all of this: poet, explorer, philosopher."

—Paul Klee

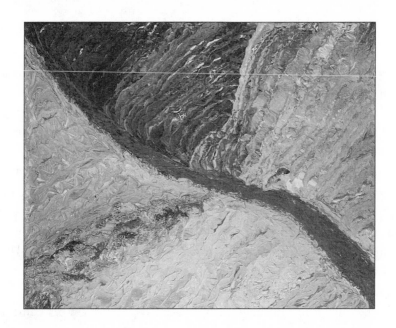

CHAPTER TEN

THE UNDERTAKER'S NEW UNDERTAKING

In April 1984, Matt Lamb walked into an art supply store for the first time in his life. It was a small shop near his house, and when he walked in, a young employee asked him if he needed help.

"I don't know anything about painting, but I want to paint," he said. "Give me some stuff to play around with."

"Are you interested in working in oils or acrylics or watercolors or . . ."

"I have no idea. Give me whatever you think I need."

"Sure. Now, we do offer some painting classes here on Tuesdays and . . ."

"I'm not interested in classes, thanks. Just give me the stuff."

In 30 minutes, Lamb was leaving with oversized bags filled with acrylic paints, brushes, and small, pre-stretched canvases. When he got

home, he cleared out an extra room, covered the floor with a tarp, and without further ado put brush to canvas.

"I just fooled around with it, trial and error. I was concocting a world based on my own strengths and limitations, and loving every minute of it."

He was reinventing the wheel, but what an odd and wondrous wheel it was. At first, it was more odd than wondrous. He mixed paints haphazardly, trying for vibrant reds and instead getting sludgy browns and black. He mixed water-based and oil-based paints together and wound up with a runny soup that never mixed and never dried. He attempted to mix collage, gouache, oil paints, and acrylics, in ways that simply did not work. Indefatigable, undiscouragable, he plowed on. A gallery owner told him his blocky, all-caps signature on his paintings looked "juvenile." Lamb continued to sign them the same way. A neighbor came calling one day as he was painting, and Lamb asked him his honest opinion.

"To be totally honest, they're pretty shitty. But you're a beginner, what do you expect?"

A fellow painter tried to offer tips for rendering figures in a more realistic fashion. Lamb did not follow the advice. A realist technique never interested him; he was not aiming to recreate the natural world, but to create new worlds.

"I don't have the patience or talent to paint realistically," he says. "If you want a great, controlled, representational technique, collect Andrew Wyeth, not me. I can't achieve that kind of control, because my emotions are out of control."

While he at first did not know how to achieve the effects he desired, he did have definite ideas about what he wanted to say. Having grown up in an environment saturated with death, he wanted to convey through art the lessons the dead had taught him about the living. "As a funeral director, I saw people through the eyes of the people they left behind. And I noticed there were always the same regrets: Why didn't we take that trip we always dreamed of? Why didn't we drink that wine we saved for 20 years to drink on a special occasion? Why didn't I show him more love? Why didn't I tell her I loved her? A loved one's death made people bump up against the same questions

over and over again: Who are we, anyway? Why are we here? What's it all about?"

Lamb's observations recall the painter Paul Gauguin's 1897–98 masterpiece, *Where Do We Come From? What Are We? Where Are We Going?*, questions that artists and thinkers have faced since the advent of self-referential consciousness. Lamb wanted to answer these questions in his own art, and to do it, he felt that his paintings should be a conduit for discussion, a conversation starter. Indeed, the idea of the conversation—the nonviolent exchange of ideas between two or more people who may or may not share similar cultural reference points—was to become a recurring visual and thematic motif in his work. He began painting simple figures facing each other, as if in a dialogue only they could hear.

"It's hard to kill somebody you're having a conversation with," Lamb says. "Once we begin talking to each other, we begin building bridges. We open ourselves up to new ideas that are different from our own. We move beyond prejudices and begin to see possibilities."

This fascination with conversation comes from a man who, as a child and young man, yearned for inclusive discussions but found precious few of them in the household in which he was raised: "Our house wasn't about discussing things and coming to a consensus; it was about the authority figures making their decision, and that was that." Just as his new life as an artist was to be a rebellion against the constricting decorum of the funeral business, so his new life would be a rebellion against the constricting autocracy imposed by his father. It was as if, having been forced to bottle up his feelings for 51 years, he was now exploding, an evangelist for expression over repression, heterogeneity over homogeny, open systems over closed minds.

That *his* ideas and *his* art could encompass such ideas, filled a need within him for what psychologist Nathaniel Branden terms "psychological visibility," a need to see our thoughts and personalities reflected back at us in the reactions of others. Lamb never fully experienced this kind of visibility in the business world. As he so brutally puts it, "When it comes down to the wire, who gives a damn what a funeral director thinks about *anything*, besides maybe how to make a buck?"

Teeming with opinions and observations on every conceivable

issue, passionately interested in the great metaphysical and ethical questions of life and death, yet confined to a profession that demanded conservatism, he had always felt like a lightning bug trapped in a glass jar. But now, as an artist, he felt credentialed to muse on the profundities that captivated him. This, after all, was what artists were supposed to do: start a conversation about life, love, and the universe, a conversation with the potential to continue after the artist's death.

"Every artist wants immortality through their art, and I'm no exception," he says unabashedly. "I want people to be talking about and arguing about these images and themes after I'm gone. Will that happen? Probably not. The pyramids are crumbling. The Statue of Liberty got so corroded it had to be restored. No art really lasts forever. But I can still try."

No one ever said Lamb wasn't ambitious.

Shortly after he began painting, he and Rose were riding an elevator in the Chicago Hilton Hotel, up to a black-tie hospital fund-raiser on one of the top floors. As the couple chit-chatted, Rose's eyes suddenly bugged out, fixed on the left side of her husband's head.

Alarmed, he asked what was wrong.

"The entire left side of your hair is blue."

He looked at his reflection in the polished brass door. "Damned if it isn't! That's ultramarine blue. I was using it today in one of my paintings."

"You want to duck into the bathroom to see if you can get it out?"

The man who had, for more than 30 years, been the model of freshly scrubbed perfection, thought about it for a second before pronouncing his verdict: "To hell with it." That night, the fledgling artist debuted his first painting: his own hair.

In the months that followed, he began growing that hair longer. Started wearing brighter colors. Sometimes tied an Hermès scarf about his neck. His friend Jack Basso recalls entering a party and seeing Lamb in a black suit and a long, purple velvet scarf. "Who the hell are you?" Basso demanded, "Count Dracula?"

The changes in his outward appearance mirrored larger shifts within as Lamb continued reinventing himself.

"In the funeral business, 9:30 means 9:30," he says, "not 9:29 or 9:31. It's a business where you have to follow the union rules and the state and federal health and safety laws to the T. I was sick of all those laws and rules. I loved the messiness of painting. I loved that there were no lines to color inside of."

But the transition from punctual taskmaster to wild-and-wooly art fiend didn't happen overnight. The task of divesting himself of his companies and board obligations was easier imagined than implemented. Thirty-six companies, including one of the largest family-owned businesses in the Midwest, do not turn magically at midnight into a set of paintbrushes and fairy dust. Lamb's transformation from full-time businessman to full-time artist spanned the three years between 1984 and 1987 and were one of the most exhilarating but unnerving periods of his life.

As soon as he'd made the decision to become a painter, he'd called his accountants. "Help me get out of it," he'd told them.

"Out of what?"

"Everything. Get me out of everything. I'm going to be a painter."

As businesspeople, the Lambs had always relied heavily on their accountants, foremost among whom is Chuck Mack of the suburban Chicago firm, Mack-Conway, Inc. Mack had represented Lamb's competitor during a tough negotiation with Blake-Lamb, and Lamb had found him so formidable an opponent that after the deal was done, he hired him as his own money man. To this day, Mack and his colleague, Leticia Cadwallader, administer all details of the Lambs' financial life: invoices and checks, bills and wills, taxes and investments, which they coordinate with Lamb's investment consultants at J.P. Morgan, Erin Hoban and Fabrice Braunrot.

With input from the accountants and his investment advisors, Lamb began selling off his auxiliary businesses one by one and resigning from the boards of directors on which he sat. He informed his brother, Dick, that he intended to sell his half of Blake-Lamb. As it turned out, Dick, for reasons of his own, had also been exploring the possibility of selling his half. Quietly, the two began entertaining offers.

Publicly, business went on at its usual, frenetic pace. Lamb directed several high-profile funerals and kept up his punishing progression of business meetings, prayer breakfasts, retirement dinners, award banquets, ballets, concerts, and fund-raisers. On his three-year appointment calendar from 1984 through 1986, his formative years as an artist, he never once penciled in time to paint. That time was stolen from the sandman. In order to function as both "a full-time businessman and a full-time artist," he told a writer at the time, he had no choice but to paint in the wee hours of the morning.[1] He cut his sleeping in half, from eight hours to four. "It's a matter of choosing priorities," he said.

In his business circles, Lamb generally kept his double life to himself. Those associates who did know he was a painter would occasionally ask him questions like, "Are you still doing your hobby?"

In reality, the "full-time businessman and full-time artist" was growing weary of the concurrent careers: "A lot of people can do two things at once. I can't. Actually, I can, but I hated it. I wanted to completely stop as a businessman and just concentrate on my art."

The incoming offers for Blake-Lamb had yet to prove tempting enough for Lamb and Dick to sell the company, so the brothers called upon an informal advisory committee to help them field more options. Among the members of this group were some of the Midwest's highest-profile businesspeople, including Edwin R. Schwinn Jr., president of the Chicago-based Schwinn Bicycle Company, and Mark Levy, head of a multimillion-dollar international catering firm.

"The reason we'd formed the outside consulting board was that we needed advice from people who weren't just going to build up our egos and kiss our asses," Lamb says. "Everyone else we were dealing with had an agenda. The banks we were talking with wanted to loan us money, the real estate people we were talking with wanted to sell us property, and they'd talk us up and try to make us feel good. We didn't need that. We needed people who had nothing to gain from us, who'd tell us we were full of shit. Ed Schwinn and Mark Levy were rich and entrepreneurial and had no fiduciary or legal ties to us whatsoever, so they could be completely dispassionate."

Meeting with the brothers on Wednesday mornings from nine to

noon, the advisory members offered expertise on the tax implications of selling the company, implications even more pressing in light of Ronald Reagan's controversial Tax Reform Act of 1987. The timing of any sale in relation to the Reform Act's instatement on January 1, 1987, was of critical importance, as the changing laws would significantly impact the Lambs, as well as millions of other American small businessmen. The tax deadline came and went, and still no sale.

An offer came on the table from Service Corporation International (S.C.I.), a publicly traded funeral-home giant that in the mid-1980s was performing upwards of 120,000 funerals per year across the United States. S.C.I.'s multimillion-dollar offer was aggressive by any standard. Under its terms, Lamb and Dick would receive a tax-free exchange of S.C.I. stock for Blake-Lamb's 12 funeral homes and would remain on salary for at least five years as CEO and President, respectively. To capitalize on the decades of goodwill and name recognition built up by Blake-Lamb, the funeral homes would retain the Blake-Lamb name. The ad hoc advisory group gave the offer an enthusiastic green light, but the brothers didn't need a committee to tell them this was a great opportunity. It was a no-brainer.

Still, selling the company they had bought from their father, and he from his—the company they'd worked for during their teenage years and built up with the help of their families—was a prospect with emotional as well as financial overtones. Lamb considered the offer with greater deliberation than typical of his ready-shoot-aim style.

In the end, he stuck with his vow to sell the businesses and trade the life of an undertaker for a new undertaking in art. On Wednesday, November 25, 1987, one day before Americans traditionally give thanks for their bounty and blessings, Matthew James and Richard Joseph Lamb signed the deal with S.C.I.

They dealt with S.C.I. founder and CEO Bob Waltrip, whom Lamb calls "a man of the highest integrity, whose word is his bond and whose handshake is better than all the legalese a hundred lawyers could come up with—it's rare in life that business deals go the way you want them to on both sides of the negotiating table, but that's the way my dealings with Bob went from the beginning."

The brothers honored their five-year contracts with S.C.I., and

Lamb continued to consult for the corporation for many years longer, donning his morning coat and white gloves to direct the high-profile funerals of his friend, Cardinal Joseph Bernardin, in November 1996, and veteran baseball broadcaster and Chicago icon Harry Caray in February 1998.

After the sale to S.C.I., Dick decided to start his own business, Richard Lamb Funeral Service, which is now a friendly competitor to Blake-Lamb.

Closely on the heels of the sale, authors Barbara B. Buchholz and Margaret Crane were scouring the country looking for juicy stories about money, power, and intrigue within family businesses for their book, *Corporate Bloodlines: The Future of the Family Firm*. When the authors found the Lambs and decided to include them in the book, they hit the jackpot, catching the clan at the pivotal moment when their long-time family business went corporate. The book was written in a scandal-sheet tone that oozes the success-and-excess Zeitgeist of the late 1980s and tries to fit the Lambs into the mold of *Dallas*, *Dynasty*, and *Lifestyles of the Rich and Famous*. The authors described the Lamb home by invoking the "white-gloved, uniformed doorman" who "guards the entrance to the building, which reeks of old money."[2] They claimed that Lamb and Dick "never let compassion interfere with the company's bottom line," an assertion that doesn't square up with the fact that, even during Blake-Lamb's cash-poorest years, the company offered free grief counseling to widows and widowers and comped the funerals of firemen and policemen killed in the line of duty. The authors also painted this generally convivial family as the adversarial, power-playing caricatures Americans loved to hate on their prime-time soap operas, intimating discord between Lamb's and Dick's wives and children and playing Lamb's son and daughter, Rose-marie, off one another as if they were competing for the family jewels.

Lamb himself, who had freely cooperated with Buchholz and Crane, was nonplussed when he read his description in the published book:

> Matt is the Bohemian of the family. Artistic. Soulful. Flamboyant, with gaudy gold and diamond rings on both hands. A craggy-faced

Irishman with a great appetite for the best surroundings . . . He
craves the limelight and drops names of individuals and
organizations with whom he's involved with the frequency of a tree
shedding leaves in autumn.

The catty style of *Corporate Bloodlines* was but a taste of criticisms
to come. After he sold Blake-Lamb and began to establish himself as
an artist, "I incurred plenty of antagonism and criticism. It was a
threatening environment."[3]

As he hurtled headfirst into this unwelcoming world in the mid-
1980s, his romantic vision of art as a conversation starter for intercul-
tural understanding could not have been further from the direction the
larger art world was taking at the time. Pop art's enshrinement of the
mundane and minimalism's reductio ad absurdum were giving way to
postmodernism's deconstruction of meaning. The modernist conceit
of the artist as a conjurer of exotic worlds was yielding to a view of the
artist as a vessel for ironic disconnect. Lamb's quest to express pure
emotion and universal truths through painting seemed a relic of the
Abstract Expressionists of the 1950s. Lamb seemed to intuit that his
sensibility was a kind of counterprogramming to contemporary aes-
thetic fashion. Through the years he has publicly railed against such
works as Andy Warhol's urine-on-canvas *Oxidation* series; Andres Ser-
rano's *Piss Christ* (crucifix photo submerged in urine); Dread Scott
Tyler's *What Is the Proper Way to Display a U.S. Flag?* (step on the flag
in order to sign a guestbook); Damien Hirst's sliced, diced, and taxi-
dermized tiger sharks and cows; Chris Ofili's *The Holy Virgin Mary*
(with the infamous elephant-dung breasts); and Paul McCarthy and
Jason Rhoades' *Shit Plug* (triple-ripple butt plugs as fine art). Lamb's
objection to these works was not the typical reactionary aversion to
conceptual art, for his own brutally unconventional technique was
quite radical, but rather, an objection to nihilism. He was interested
not in deconstruction, for it is easy to tear down paradigms, but in the
artist's generative power to improve existing paradigms or build new
ones entirely.

Lamb set out to create these new worlds in an astoundingly prolific
burst of creativity, painting hundreds, even thousands, of works a year.

Northwestern University art historian James Yood believes this burst was "a making-up for lost time."[4] Painting with the same obsessiveness and gusto that had made him such an energetic deal-maker, fund-raiser, and political organizer, he now believed that because he'd gotten a late start, he had to create a lifetime's worth of art in whatever years he had remaining.

Perhaps there was more to his prolificacy. For decades as a businessman, his mission had been to maximize his businesses' name recognition, public profile, customer loyalty, and profitability. As an artist, he continued to maximize: the number of works he produced per year, the number of galleries representing him around the world, and the number of his paintings those galleries sold. To his thinking, perhaps, the more paintings produced and notoriety gained and conversations started, the more immortality attained.

Whatever the final cause of his deluge of work, beginning in 1984, Lamb the novice, asking an art-store clerk for "some stuff to play around with," had his work cut out for him. And while he refused to go to art school, he did receive important guidance from a trio of characters whose interactions with him sound like the setup for a politically incorrect joke: a Jew, a nun, and an architect who helped this "old Irish bastard" (a friend's pet name for Lamb) flesh out his high-minded but abstract ideas into fully realized high art that aimed to change the world—and had an outside chance of doing it.

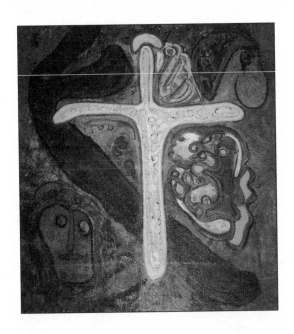

CHAPTER ELEVEN

THE JEW, THE NUN, THE ARCHITECT, AND THE OLD IRISH BASTARD

When Lamb had finished about two dozen paintings in the early summer of 1984, he stood back and looked them over. He knew that the experience of creating them had moved him profoundly. He knew that he liked the way the finished paintings looked, their richly slathered depictions of eccentric-looking people and animals. He knew that Rose liked the works. But he didn't know whether they were any good, didn't know whether he had real talent or was just a "weekend painter." He kept painting.

A year later he phoned a friend, Chicago art dealer and public-access talk show host Arthur Rubin, whom he'd met several years before on an art-history tour to Saint Petersburg, Russia. Lamb asked Rubin to come over, look at the paintings, and give him his honest

opinion. Leery of placing himself in a position in which he might hurt a friend's feelings, Rubin resisted. Lamb insisted. Rubin warned Lamb he would look at the paintings only if he were free to give his completely objective opinion, even if it were unkind. Ravenous for feedback, Lamb agreed.

Perhaps to his surprise, Rubin found himself impressed with the works' uninhibited use of color, luxuriant application of paint, and unconventional sense of composition. He told Lamb he had talent and should not be discouraged by his bumbling attempts to mix incompatible media. These, Rubin assured him, were simply the growing pains of the autodidact and would pass if he persevered. Lamb launched into a battery of technical questions about the chemistry of various paints and varnishes and the value of using palette knives versus brushes. As an indirect answer, Rubin made a recommendation that would have an inestimable effect upon Lamb as an artist and a phenomenon. He suggested he meet with Simone Nathan, an artist-cum-public relations consultant whom Rubin believed would be better equipped to handle his barrage of hyperdetailed questions.

Like Maria von Trapp, Simone Nathan was a former nun who, having concluded after much soul-searching that veils and wimples, abbeys and celibacy, were not her cup of tea, had kicked the habit. As a young woman, she had joined the School Sisters of Notre Dame, teaching art to inner-city kids at Saint Michael's High School in the Old Town Triangle area of North Chicago. After leaving the Sisters, Nathan had concentrated on developing herself as an artist, winning juried shows and becoming an art historian of some repute. Testing the waters as an artist and finding them lukewarm, she had entered a field in which creativity and business strategy meld: public relations. Jumping from nunnery to strategy in a way that recalls Gilbert and Sullivan's model major-general ("When I know more of tactics than a novice in a nunnery . . ."), Nathan dove into her new field by doing P.R. for the insurance and health care industries before landing a gig as Director of Creative Services for the *Chicago Sun-Times*. At the *Sun-Times* she oversaw a $6-million-per-year division within the paper and built upon her network of contacts throughout the city's creative community.

Later, she left the *Sun-Times* to open, with her husband as partner, her own firm, Nathan & Nathan. It was as head of this firm, which specialized in arts-and-culture promotion, that Nathan picked up the phone one day and heard Matt Lamb's voice on the line, asking her to look at his paintings. She agreed and met him in his studio.

"My first impression," she remembers, "was that this man had an instinctive feel for color and composition, and that he had absolutely, positively no fear."

She took an interest in his work, meeting with him once a week at his studio or in museums or galleries, answering his questions and acting as a sounding board for his insatiable curiosity.

"I learn through my ears," Lamb says, "not by reading books, so hearing Simone's perspective on things was very valuable."

Yet Nathan had to walk a fine line. She knew Lamb did not want to be coached or dissuaded from trying things that might end in failure.

"It wasn't really teaching, what I did with him," she says. "It wasn't even suggesting things. It was just . . . sharing. I was there when he needed me, but the main thing I did to help him was to stay out of his way. One day I met with him, and he had discovered printer's ink and drizzled it over the paint, something he still does. In a million years, I would never have thought to suggest such a thing, but there he was, showing me this marvelous effect he'd achieved."

Lamb was excited by the process of building up thick surfaces on a canvas over a long period of time. Sometimes, either by mistake or intention, he would scrape off some of the paint and delight at the layer beneath peeking out as if excavated from an archaeological dig. Nathan told him the effect was similar to the Italian idea of *pentimento*, an underlying image that shows through when paint is scraped away or becomes transparent with age. Typically, *pentimenti* are mistakes that the artists have painted over too thinly or with paints unsuited to long-term color holding, but Lamb seized upon the idea as a kind of deliberate mistake he could make in order to suggest the presence of layers beneath layers beneath layers. A painting, like a human life, he believed, should have a rich history beneath the surface. He termed the style "generational."

"This idea of generational painting intrigued Matt very much," Nathan says, "the idea of ghost images, shadows of other lives. The mystery of that was delicious to him."

Nathan's weekly "sharing sessions" with Lamb led to a more formal relationship. In 1986 he employed her P.R. firm to get the word out about his foray into the art world, raising—or rather, *creating*—his profile as a painter and establishing him as a blip on the radar. It was Nathan who used a phrase Lamb latched fiercely onto and made a cornerstone of his career plan: "building the myth." To Nathan, building Lamb's myth meant using the techniques of marketing, public relations, and publicity to make Lamb the artist and Lamb the personality known to a wider audience. This concerted push, above and beyond the making of the art itself, could not have fit more naturally into his business-honed belief that product and publicity, quality and quantity, go hand in hand. It was clear from the beginning that Lamb was the anti-Emily Dickinson.

"I've always believed," he says, "that there may have been a thousand Pablo Picassos, but nobody knew the other 999 because nobody built the myth in the way he did. To just expect the world to come to your doorstep and hail your art as the Next Big Thing is unreasonable. I don't want my art to be the tree branch that falls in the forest that no one hears. When I'm dead, I don't want people to wrap garbage in my unstretched canvases. I don't want my grandkids going down into the basement and saying, 'Look, here's all of Grampa's old shit. Let's take it to the landfill and put a pool table down here.' My job is to make the best art I possibly can, get it out into the world while I'm here, and shine on after I'm gone. When I die, I would hate for God to say to me, 'Lamb, I gave you the vision, the opportunity, and the monetary means to spread the message, but you were too scared. You just wanted to take the easy road, have people kiss your ass, go down to the country club and eat the turkey club sandwich and play golf until you croaked. You should have taken the ball and run with it."

Committed to "giving Matt as much formal support as possible," Nathan began cataloging his paintings, noting which were produced in which year and measuring the paintings meticulously, noting the

thickness on paintings which protruded more than an inch from the canvas. She also counseled Lamb to brand his work with an iconic signature, handing him a sketchbook and asking him to draw a dozen lambs (of the wooly, white variety) in different styles.

"Zoom zoom zoom, I dashed them off and handed them to her," he says. "She looked at them, pointed, and said, 'That's the one!' "

The stylized lamb appears emblazoned on Lamb merchandise worldwide and on the back of the German-press coffee-table book, *Lamb: Peace, Tolerance, Understanding, Hope, and Love.*

To expose Lamb to further critique, in 1985 Nathan contacted neo-Surrealist painter and renowned Chicago architect Jack Levin and asked him to view Lamb's work. During his 35 years in the practice of Gordon & Levin, Levin had specialized in high-rise residential architecture but also designed business projects such as the East Bank Club, a sprawling fitness center on the Chicago River near Grand Avenue. A meticulous painter, Levin also possessed an unforgiving eye for detail. When Nathan contacted him, Levin said he was "very leery of this businessman who said he was becoming an artist" and refused to critique the works. Nathan persisted. Two years later, Levin finally relented and agreed to view the paintings on the condition he never had to meet Lamb and could look at the works "in a neutral space." In a rented warehouse hung with 700 Lamb paintings, Levin, with notepad and pencil in hand, inspected the works, classifying each according to a four-point evaluation criterion that was every bit as ruthless as it was simplistic:

1. This piece could hang in a museum one day.
2. This piece could sell in a gallery.
3. This piece might impress your wife and kids.
4. This piece might impress the garbage collector who throws it into the dump truck.

It took two months for Levin to grade each of the 700 paintings on this scale. In the end, he graded more than 50 percent of the paintings as gallery-worthy. Still, he found the work confounding.

"There's so much going on here, it drives me crazy!" he scrawled

in his notebook. "I think he has a terrific color sense—he's not afraid to do anything. He's pure emotion!"

Eventually, Levin and Lamb met.

"He walked me over to one of my paintings," Lamb recalls, "and said, 'This one looks like you painted a little bit, then went out to lunch. And when you came back, you never finished it. You ran out of steam, didn't finish the edges.' "

The comment stung but stuck with Lamb. From then on, each time he finished a painting, he asked himself, "Was I out to lunch on this one?"

Levin could always be relied on to balance positive with negative critique. He still can. "Some of the images Matt's used through the years," he says, "could stand to be more refined. He's always done these sort of cartoonish figures, very linear and reminiscent of draw-ing, some of which come across very nicely and some of which, frankly, look corny as hell. From very early on, he had a good sense of design, but he's not selective enough—he cranks 'em out. He doesn't sit down and evaluate. He doesn't keep track of how many paintings he does in a given year. He just doesn't care. He also has a big ego. I wish he would sort of calm down and stop being obsessed with being recog-nized and selling a lot of work. This organization he has all over Europe now, all these people pushing his work, and the ads I see for his shows in the magazines—that's sort of taken over, in my opinion, and I have no idea why he's running himself so ragged. I don't think *he* has any idea why. He'd need a shrink to figure it out."

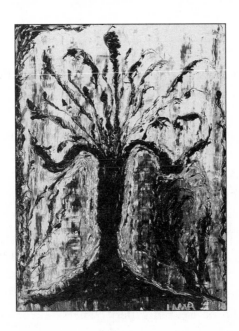

CHAPTER TWELVE

LAMB DEBUTS TO RANTS AND RAVES

In 1987, three years after embarking on his "second life," Lamb had sold several dozen of his paintings privately but was not represented by any gallery anywhere and had never shown his work publicly. One spring day, a private agent brought a collector to the artist's studio, and the collector expressed interest in a piece thematically inspired by the Second World War. Lamb was particularly fond of this painting and didn't want to part with it.

"How much will it take," the collector asked, "for me to go home with this piece?"

At the time, his most expensive paintings were selling for $700. Lamb excused himself momentarily, went into the next room, and phoned Simone Nathan, who advised him, "If you don't want to sell it, just quote him some outrageous price that he would never agree to."

Lamb strode back into the room and told the collector he could not accept anything less than $2,500.

"All right," the man said, and whipped out his checkbook.

Stunned, Lamb watched as the man left the studio with the work.

"That," he says, "was a big lesson to me about the business of art."

When Nathan heard about the transaction, she knew the time had come to take Lamb to the next level. "I think it's time for you to be represented by a gallery," she told him.

At first he resisted. "I'm too old and too rich to prostrate myself before the almighty gallery owner," he said. "I kissed ass the whole first half of my life, and that was enough."

For most emerging artists, getting gallery representation is a sign of validation and promise. For gallery owners—deluged by slides, photographs, bios, and solicitous phone calls from artists every day—there is both the bother and cachet of being in a position of power, of separating the chaff from the grain. But for Lamb, the gallery system was a source of deep suspicion. He had no feet for the peculiar dance of niceties and tough-nosed negotiations, the choppy tango ("two whores dancing," he called it) of fawning and feigning, neediness and condescension. This was not a man dependent on art sales to put bread on the table, but a successful entrepreneur who'd negotiated million-dollar deals with industry titans whose resources put even the highest-rolling gallerists in a decidedly less impressive light.

"I know what art is, and I know what business is," he railed, "and the two have nothing to do with one another."

On some level, though, Lamb wanted to know whether his work could pass muster with a gallery and exist viably within the art world's established commercial channels. After a bit more gentle arm-twisting by Nathan, he relented.

She carted some of his works to Renata Beuhler, owner of the small but chic Renata Galleria in Chicago. Taken with the sheer drama of color and form, Buehler promised to keep him in mind but did not add him to her stable of artists. Three months later, in the fall of 1987, when difficulties with another artist left a hole in the gallery's schedule, Buehler called Nathan and asked if Lamb could fill the void. The answer was an immediate "Yes."

Due to Lamb's high profile in Chicago business and social circles, advance press coverage of his debut was considerably greater than most emerging artists receive. *Finesse* magazine announced the debut in Ann Gerber's column, "On the Town," while the *Sun-Times* ran a full-color photo of the painter posing in front of his work on the paper's "Celebs" page, with a caption announcing the upcoming show. On the day of the opening, Irv Kupcinet, the *Sun-Times'* veteran columnist (who died in November 2003 after 60 years with the paper), wrote in "Kup's Column": "Funeral director Matt Lamb, a man of many interests, blossoms today as an artist. His one-man exhibit opens at the Galleria Renata on North Wells for a long stay . . ." Kup considered the debut a big deal; his blurb about Lamb ran above Sally Field (although below Diahann Carroll).

The most astute coverage came from reporter Sally Ruth Bourrie in *New City: The Chicago Biweekly:*

> [Lamb is] an easy target for gibes like, "It's no big deal for a big muckety-muck to do this. He's got money. He can do anything he wants." But it takes guts for anyone who's been painting for only two years to show his work publicly. Because of his position, Lamb will get much more attention than the usual starving beginner. People have already heard about this show in Kup's Column, for instance. In some ways, that's a bigger risk than for the complete unknown who wouldn't get this kind of exposure. If Lamb fails, he fails big time.

Clearly, Chicago was watching. The pressure was on.

The week of the opening, Rose, who had worried she might become "obsolete" in her husband's new life, presented him a notebook full of congratulatory cards from each of his children. In her own note, she called him a "man with a refined sense of integrity and commitment, an open and receptive attitude to new ideas and people, and a wild and wacky sense of humor." She concluded: "Now we will all follow your new dream and rejoice with you in excitement and happiness."

On November 6, 1987, Matt Lamb's paintings received their first

public showing. The gallery sold 19 out of the 25 total, a more than respectable tally for any artist, newbie or established. Later, Lamb, a man who had routinely signed on the dotted line for million-dollar deals, proudly marked on the bottom of the Polaroids he'd taken of his paintings: "Sold for $400," "Sold for $250," "Sold for $350 . . ."

Across its "Party Page," *Skyline* newspaper splashed photos of the debut, the beaming artist posing with local notables including Cook County Circuit Judge Carole Bellows and County Assessor Tom Hynes. Even the critical response was largely favorable, "largely" being the operative word. There was an exception. His name was Harry Bouras.

Harry Bouras was an artist, sculptor, professor at Columbia College, and for 25 years the art-critic host of *Critic's Choice with Harry Bouras* on FM 98.7, WFMT, "Chicago's Fine Arts Radio Station." Bouras, who died in 1990, was the kind of critic whom artists now remember as "the late and great . . ." if he lauded their work and as "the notorious . . ." if he panned it. Lamb's debut fell under the latter category. Years earlier, *Chicago Scene* magazine had taken Bouras to task for his "critical excesses, his personal hang-ups, his browbeating of younger talents, his stern sermonizing, his heavy-handed scholarship, his humorless bloodletting practices, his egotistical vitality."[1] But the criticism leveled at the critic did nothing to curb the glee with which he routinely eviscerated his victims or the especial cruelty he often directed at emerging artists such as Lamb. Andrew Patner, WFMT's current critic-at-large and contributing critic for the *Chicago Sun-Times*, remembers Bouras' Sunday-night radio art reviews, which were syndicated throughout the Midwest, as "half-hour performances, almost entirely improvised—that's the only way I can describe his incredible essay-perorations."[2]

The Sunday after Lamb's Friday-night opening, Bouras launched into a 13-minute-long rant on *Critic's Choice* that was, by all accounts, withering. (There is no extant copy of the broadcast in WFMT's archives, according to Bouras' producer, Lois Baum. Lamb himself kept a recording of the show for years but lost it in a move during the mid-1990s.) Lamb was listening that Sunday night, hoping the critic would have encouraging—or at the very least constructive—things to

say about his art. No one, after all, no matter how thick his skin, wants to be lambasted while thousands of ears listen. Oh well. According to contemporary accounts of the review, Bouras pronounced the Galleria Renata show "horrible" and used the phenomenon of a business tycoon essaying an art career to vent on the incompatibility of the business and artistic mind-sets.

"At the end of it," Lamb remembers, "he addressed me directly: 'Mr. Lamb, if you're listening, go to Italy and look at some real art. You might learn something. Better yet, stick to your day job.' "

The following morning, a nippy November Monday, the artist rose from bed, donned his smock, descended the staircase to his studio, and put the cassette of the review into his boom box on the "loop" setting. Instead of the heavy metal music he normally listened to while painting, he listened to Bouras' diatribe as he flung paint and inks onto canvas after canvas. He did this for the remainder of the week.

"I love it," he says, "when somebody tells me I can't do something."

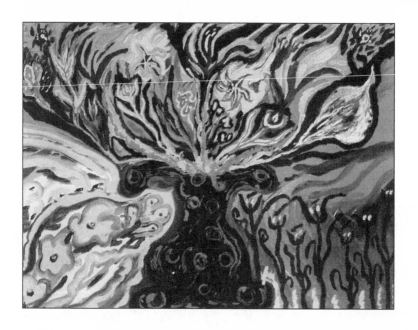

CHAPTER THIRTEEN

THE WAKE AS COLLAGE

Some of the first paintings Lamb made were floral still lifes, except that to call them "still" is a misnomer. He painted them wildly, splashing down blobs of paint for blooms, connecting them to their stems with impetuous gestures that mimicked the vegetative chaos of nature itself. That he gravitated to flowers was not coincidental. As an undertaker, he had come to view the funeral wake as a kind of collage: an artwork comprised of disparate, often overlapping elements in harmony—the casket in the center of the room, flanked by candles and bouquets, the ambiance complemented by music, the event documented by prayer cards. During his nearly four decades in the family business, he personally handled thousands of bouquets, and in the process he thought a lot about flowers. How were they most appropriately arranged? What symbolisms lay in the colors of various roses?

And why did flowers in general evoke such powerful reactions that they're used to commemorate both the happiest and saddest occasions of our lives?

Unlike the funeral bouquets for which he'd always demanded absolute symmetry, the floral still lifes he painted and still paints were and are far from fastidious. While he generally places a vase in the center of his composition, the flowers themselves jut willy-nilly akimbo. These are bouquets not of the earth, but of the imagination, defying the laws of physics with their cantilevered, top-heavy arrangement, their centers often black holes in the vortex of wild, swirling nebulae of color. These are the flowers Stephen Hawking would draw if he could and were so inclined: eccentric blooms coaxed into being by a cosmologist-cum-gardener from some tripped-out galaxy far, far away. They are miracles of surface, each bloom an overgenerous dollop of paint puckered by his alchemical recipe of repellant ingredients, colors weeping into one another, awash with exotic inks that pool in valleys of topographic impasto. They are Handel meets Beethoven in a vase: Baroque in their extravagance, Romantic in their unbridled emotionalism and vaguely fatalist undertones.

They were amazing from the start, pouring out of Lamb in his first years as an artist with a maturity of technique and vision that took him years to develop as fully in other areas of his output. The fertility and abundance of flowers themselves met their match in the fecundity and variation of Lamb's portrayal of them. Not since Georgia O'Keeffe has an American artist painted flowers with such drama and brazen originality.

His years of ruminating over the symbolism of bouquets have led Lamb to view flowers as more than flowers. To him, they are a metaphor for the stages of human life, each element of the bouquet a signifier of man's place in the universe. He sees the vase as "the cauldron of the eternal," a volcano-like source from which life in all its forms explodes: "I believe when God created color, he created a cauldron in which all the colors separated into flowers, and all the flowers spilled down from the heavens and filled the earth." Like Picasso, who in the 1930s painted female figures sprouting blossoms and vegetation,

Lamb anthropomorphizes flowers: "Flowers are humans, humans are flowers, and we're all on the same journey of life, death, and rebirth. We go to seed, grow, wilt, die, and go into the earth, which other flowers are born from."

Without consciously thinking about it, Lamb began using the fertility imagery present in his early floral works in his other paintings as well. His obsession with life, death, and rebirth crept into his figurative tableaux, the so-called "spirit paintings," in the form of often blatant fertilization imagery. His balloons looked like sperm, his women like full-figured fertility goddesses circa the *Venus of Willendorf*, 30,000 B.C., perhaps in a nod to Catholicism's transubstantiation of ancient fertility goddesses into the Holy Blessed Mother. From his hand flowed embryonic forms that floated in fluidic space or gestated in swollen bellies. A 1986 piece called *Woman in Control* consisted of a black gash in the center of the canvas, flanked vertically by red forms. Another 1986 oil, *Emerging Forms*, featured a vase that rather unsubtly resembled a scrotum and penis, flowers shooting out the top and a white, sperm-like figure on the vase's left. 1987's *Rising Forms* juxtaposes fallopian-tube imagery with totemic masks.

Yet when asked about writer Michael D. Hall's observation that his "flowers are overtly sexual," Lamb responds, "Bullshit. That's somebody's interpretation. It doesn't have anything to do with what's going on in my head."[1]

Like O'Keeffe, he distances himself from overtly genital interpretations of his florals. Unlike Picasso, he does not come across as a ragingly hypersexual presence, nor does he place an overweening value on sex, either in art or life.

"I don't think of sex as an accomplishment," he says. "It's something you do, like eating, breathing, going to the bathroom. Nobody says, 'Oh, he *screwed!* Where did he go to school?!' "

Lamb is more interested in love than sex, more moved by the abstracted life cycle than by its hot-and-heavy mechanics. His diction reflects this remove but leaves no doubt of his underlying intrigue with reproduction: He speaks of drying paintings as "gestating," refers to the psychic space of his *Once Upon a Time* cityscapes as "the womb,"

and at one point regularly pressed wet canvases together so they would imprint their mutual colors and contours and "become children of one another."

The reproductive bent in his output has not escaped the attention of critics and art historians. Michal Ann Carley, art professor at Cardinal Stritch University in Milwaukee, asserts that for Lamb, "fecund forms hearken fertility and richness of the heart, as well as warn of the dangers of desire."[2] Carol Damian, Art Department Chair at Florida International University, observes that the painter's figures are "dominated by mysterious natural forces, its members possessing arcane and procreative powers. They can journey through the cycle of life and watch people sprout like flowers from seeds, grow, wilt, and die to become seeds again."[3]

Gallerists have also gravitated toward Lamb's flowers. In 1991, a Michigan gallery curated a one-person show solely from Lamb's floral still lifes, and in April 2004, the Mark Woolley Gallery in Portland, Oregon, hosted a similarly focused show entitled *People Are Flowers*.

One of the first bouquets Lamb ever painted, he entitled *Power.* Why would a painter call a floral still life *Power?* Because he's obsessed with it.

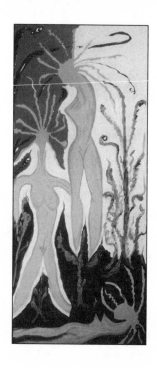

CHAPTER FOURTEEN

POWER PLAYS

"In one way or another," Lamb says, "all my paintings are about power, which is interesting, because I don't believe that power really exists."

In the mid- to late 1980s, Lamb titled more than half a dozen of his paintings *Power*, including a thoroughly innocuous-looking floral study. He also painted strange-looking people and animal-human hybrids wearing hats as a visual metonym for power: great, floppy bonnets, bowlers, berets, crowns, sombreros, and toreador's hats. Often, the hats dwarfed the creatures who were wearing them. There was a good-natured mockery in this, a satire of the self-important types Lamb had encountered "in bars where some guy acts like a big shot and think he farts through silk, but never buys anybody a drink."

Although he freely admits he's obsessed with the machinations of power, Lamb holds that "power is transitory—look at the Roman emperors, or look at Saddam Hussein today. On top of the world one moment, in the gutter the next. You know who's the most powerful person in the world? The pool boy. These rich old bastards are down by the pool in Florida. Back home, everybody kisses their ass, but in Miami Beach they're just another white-haired geezer by the pool. So the pool boy brings one of them a towel, and the other one gets jealous that *he* didn't get the towel first: 'I'm Mr. So-and-So, and my bank account has $50 million in it, whereas this other idiot's only got $40 million in his. So damnit, I deserve the first towel!' Who's the most powerful person at the hotel? The pool boy."

It's easy to underestimate the degree to which power figures into Lamb's philosophy until you talk with him for five minutes. Ask him a question about one of his paintings, and he's apt to respond with a proverb, homily, sermon, or full-blown encyclical about power. Ask him about his years in the funeral business, and he'll wind up talking to you about power. Ask him about the stock market, the art world, or the world of politics, and he responds with an indictment of power's corrupting influence. Lamb thinks on a macro level. Ask him about specifics, and he responds in universals. Like a politician on the Sunday morning public affairs shows or a movie star sitting for 20 interviews a day to promote a film, Lamb has a set of talking points that inevitably tie back to his central themes, power high among them. This is both fascinating and frustrating. If you ask him what color a 1992 still life was, you don't want a talking point strung out into airy filigree, you want "Red," or "Green," or even, "I don't know." But Lamb has returned to the pool boy, or to another favorite anecdote: "A big dog is teaching a little dog a lesson about power. The big dog comes to a bowl of meat, scarfs it all down, and tells the little dog, 'That's Lesson #1.' Then a poodle comes along, and the big dog screws her. 'That's Lesson #2,' he tells the little dog. Then they come to a Rolls-Royce parked on the curb. The big dog hikes his leg, pees on the tire, and says, 'That's Lesson #3.' The little dog says he doesn't understand. 'Here's the way of the world,' the big dog explains. 'If you can't eat it and you can't fuck it, piss on it.' "

Ultimately, the madly hatted kings, queens, and buffoons who populate Lamb's paintings are a self-parody. His life has made him aware of both the trappings and the traps of power.

"I was a pompous ass the first half of my life," he says. "Now, I'd rather be Mr. Little than Mr. Big."

But Mr. Big did not become Mr. Little cold turkey, he walked the road in baby steps. After he became a painter, he sold his Rolls-Royces but bought a BMW to take their place. He forsook the life of a high-profile businessman for the life of a high-profile artist. Gave up the rush of running 36 businesses for the rush of giving birth to 500 to 1,000 paintings a year. Gave up the manifest destiny of spreading his funeral home empire throughout the Midwest for the manifest destiny of spreading his message of world peace and dialogue throughout the world. In effect, he traded one power trip for another. Or did he?

When posed the question, Lamb relates another anecdote: "There's an old Irish saying. Enlightening the powerful is like trying to teach a pig to sing. It will frustrate you and agitate the pig."

Which doesn't really answer the question, and who knows what it even means, but it's funny, and it disarms the questioner. Lamb has that power over people.

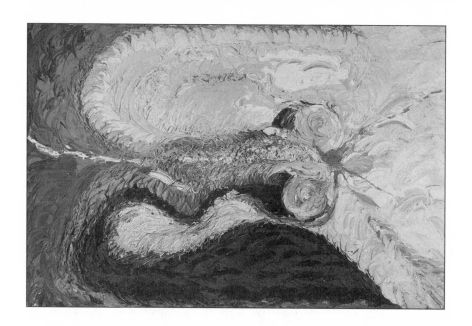

CHAPTER FIFTEEN

THE TYCOON TACKLES GANDHI

In the summer of 1985, when he was still taking his baby steps as an artist, Lamb visited India, and as happens more than occasionally when Westerners visit the subcontinent (see the Beatles, Ram Dass, or Philip Glass for a surface-skimming primer), he returned home profoundly affected by what he'd seen and experienced there—and ready to incorporate those experiences into his art.

Lamb had always enjoyed traveling. "Always take time to travel," his mother had told him, adding darkly, "It is later than you think."

In the early 1960s, he had officiated at four wakes one night, "and every one of the deceased was under the age of 40. I brought Rose downstairs to see it, and I told her, 'We're going to Europe.' And so we went to Spain for five weeks. When we got back, we went to the bank

and opened what we called a 'goof-off account.' We could only with-draw from it to travel. If the washer and dryer broke, we couldn't use the money. If we wanted to go to Mardi Gras, we could."

And they did. The Lambs' photo album shows them strolling down Bourbon Street, and on the next page, posing at the Coliseum in Rome. On another page, Lamb's sitting in a rattan chair in Hawaii in 1965, wearing a white dinner jacket, yellow lei around his neck, umbrella drink in his hand. In another picture, Rose reclines, tan and chic, on the Mexican Riviera, a long cigarette in her hand, while her husband beside her strikes a beefcake pose, no shirt, red-and-white swimming trunks.

Over the years, the family went up the Amazon with a group of English ecologists. Trekked to Kathmandu and the base camp of Mount Everest. Visited the great museums of Europe, where Lamb fell in love with the work of Vincent van Gogh, "because of his power and swirling brushstrokes," and Marc Chagall, "for his romanticism and whimsy," and Pablo Picasso, "for his sheer force and fearlessness." From time to time, a European funeral home conglomerate for whom Lamb consulted would fly the couple over the Atlantic, first-class, put them up in London, then dispatch them on the corporate jet to meet-ings in Paris, Madrid, and Rome. In the midst of these trips, executives wined and dined them on Chateaubriand and 100-year-old Bordeaux, treating the pair "like we were King Farouk and his queen."

Rose parlayed the couple's insatiable wanderlust into a gig as travel writer for *South Town* newspapers. For six years, her syndicated column appeared in 35 suburban papers throughout Chicagoland.

Other journalists reported on the Lambs' travels, too. "Lambs Take Glittering Roman Holiday," trumpeted *The Reporter*: "Blake-Lamb CEO Matt Lamb and his wife, Rose, were escorted through the Vatican Gardens and Castelandolfo, the Pope's summer residence. Later, they dined at Circolo della Caocia, a private club in the Alban Hills . . ."[1]

Did these glamorous adventures have an effect on Lamb's future art? Art critics and historians certainly think so.

Michal Ann Carley, Assistant Professor of Art at Cardinal Stritch University, believes the painter's output is so eclectic because "Lamb

had the opportunity to view and consume a vast range of art forms, including prehistoric and iconic Irish stone effigies."[2]

"His art is based on a personal philosophy that draws from his extensive journeys," writes Angela Tamvaki, curator of the National Gallery of Athens, Greece. As such, Lamb's oeuvre is a melting pot of "Christian beliefs together with Zen Buddhist and Jewish echoes."

Lorraine Swanson writes in *Sky* magazine: "He weaves much of the spirituality and imagery of Peruvian and Native American life into his work."[3]

And *The Windy City Times* speculates that Lamb's work reflects an Eastern sense of "Zen renewal."[4]

Lamb himself is skeptical of overdramatizing his travels' impact: "People fantasize about going to exotic places and coming back forever changed. We went to a luau on Waikiki. Forty-five dollars a piece, 300 people, and one pig. It wasn't the fantasy people have of a luau." But in the next breath, Lamb is waxing profound about his visit to the Dachau concentration camp in October 1984: "It made an impression on me that's never faded. I felt the evil coming out of the ground. How could a Nazi gas a hundred Jews to death on Friday, kiss their kids on the forehead and tuck them into bed on Saturday, go to Mass and take Holy Communion on Sunday, then go back to work Monday morning throwing more Jews in the oven?"

Even though he is Christian, not Hindu, lives a lavish life, not an ascetic one, and has never spun his own tunic with a box charkha, Lamb was nevertheless profoundly inspired by his 1985 visit to India. Gandhi, along with Martin Luther King Jr., Nelson Mandela, and, further back in time, Jesus Christ, are the pacifists and passive resisters he admires most. His tour through India retraced the life of Gandhi and reaffirmed his beliefs about power and the consequences of not bowing down to it.

"People like Gandhi and Dr. King, who have the courage to stand up to those in power, wound up changing the world but paid the ultimate price. Our society likes to kill peacemakers, then turn them into heroes."

A year after returning from India, Lamb still couldn't get Gandhi out of his mind. He stood in front of a blank 4'×5' canvas and was

suddenly possessed of the idea to paint Gandhi's life as an abstracted linear journey. Twenty-three straight hours of painting later, he looked at the completed canvas and wept. Before him stood one of his watershed works, *Gandhi*, which represented the first time he had made a complex metaphoric statement in a large-format work. Drying his tears, he collapsed on the bed in his studio and slept for 12 hours.

If you were to look at *Gandhi* without knowing it was about Gandhi, you might appreciate its luxuriant impasto and richly colored patterns emanating from a central axis, but you'd be hard-pressed to know if it represented Mahatma Gandhi or Ronald McDonald. The painting portrays Gandhi's life as a chronological timeline from left to right, birth to death. Above and below the line are currents of paint that represent the geopolitical forces Gandhi faced and ultimately overcame in his quest for a free India. His assassination on January 30, 1948, is represented by a splattered explosion of red paint near the right-hand edge of the painting. Emerging from the explosion, a white line symbolizing his legacy continues, and the currents above and below turn lighter, as if neutralized by his legacy of peace.

Gandhi, which was purchased by a prominent Chicago doctor who went on to own the largest private Lamb collection in the world, was the first in a series of similar paintings by the artist. After *Gandhi*, he painted a piece entitled *Composite Conceptual Man*, a metaphysical meditation on Gandhi's great-great-great-grandmother, who, as Lamb muses, may have been more important to world history than Gandhi himself, since, if she had never lived or had married differently, Gandhi would never have been born. *Dachau*, which was unveiled on April 27, 1988, at the Spertus Museum of Judaica in Chicago, traced the oppression of the Jews by the Third Reich, the liberation of the concentration camps by Allied forces, and "the indestructible spirit, pride, faith, and history of the Jewish people." *The Ascent of Man*, acquired in 1989 by the Veterans Administration Medical Center in Washington, D.C., shows the progression of *Homo sapiens* from prehistory through the development of written language, to the advent of mankind's seminal achievement, which, according to Lamb, was the realization that human beings are comprised of coequal elements: spirit and matter. *The Civil War*, which was welcomed into the permanent collection of

the U.S. State Department in the early 1990s, addresses the injustice of slavery, the bloodshed of the War between the States, and the long road to racial equality that followed. Finally, *An Gorta Mor* deals with the Great Famine that plagued Ireland from 1846 to 1850 and the Irish people's resilience in ultimately surmounting it.

Each of these pieces shows a historico-ideological progression from oppression to crisis to liberation to denouement, via a timeline traversing the canvas horizontally, vertically, or diagonally. It's significant that the good always triumphs over the evil in these works. Lamb believes that "the forces of good win 51 percent of the time." It is important to him to portray human beings as "victors, not victims," which is why he says he "would never do a *Guernica*." Early in his career as an artist, he had painted a series based on the Great Depression but found the works so dark, he had one of his daughters lock them away in a closet in her house. This is the romantic optimism and distaste for defeatism seeping out of Lamb's psyche into his work.

"Whenever I see a really negative, really pretentious piece of art like *Piss Christ*," he says, "it makes me think of a little ant floating on his back underneath a giant bridge, and the ant gets this microscopic little erection and screams up at the attendant, 'Open the bridge, open the bridge!' "

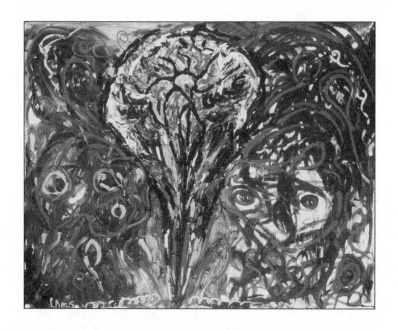

CHAPTER SIXTEEN

CHAOS, RAGE, AND THE WHITE
HEAT OF PASSION

It's 1987. Matt Lamb is doing a painting called *Spreading Joy*, and he's reaching for something he doesn't know how to achieve. The abstract shapes have a freedom of form, but they don't know what to do with that freedom. They have imagination and invention to burn but don't have any matches to start the fire. They just meander around the canvas in search of a composition. Lamb knows he can do better than this, but he has no formal training in composition to help him. He needs help but refuses to take an art lesson. He needs something, badly, to coax the piece into fruition, because a blank canvas isn't doing the trick. He's reaching for "the dip," even though he doesn't know yet what the dip is.

During a nearly desperate bout of trial and error that lasts more than a year, he tries in myriad ways to do things to his canvases, in advance of painting them, that will make it clearer what he needs to do when he does start painting. He begins distressing the canvases, quite inventively, and he notices that doing so leaves marks on them that guide him to the next step—marks that he paints over, and then over again, building up the first of many layers. It jump-starts the process for him, cures his "painter's block." Wintering in the Florida Keys, he throws an unstretched canvas into the Atlantic and lets it slowly make its way back to shore. Then he buries it under the sand and leaves it overnight. The next morning he digs it up and hangs it on a clothesline to dry. Next day, he notices that the sand and salt have left patterns, so he tears the canvas off the clothesline, spirits it off to his studio, grabs paints and brushes, and traces along the patterns. Then he paints new patterns atop the old patterns. Then he paints something that the patterns merely suggest. He's onto something.

That night he throws another unstretched canvas into the washing machine along with a handful of rocks, stonewashing it like a pair of jeans. Rose stands patiently by while her laundry is preempted by this mad experiment. He tosses canvases onto his driveway and proceeds to run over them with his BMW, skidding his tires, leaving the canvases blackened and threadbare in spots. He tramples other canvases with his dirty shoes. Sands their surfaces with a belt sander. Steams them with a fabric steamer. Pokes holes in them with an ice pick.

"You terrorize the canvas!" Simone Nathan exclaims after observing him in action.

He lays down a coat of gesso (a milky coating used to prep canvases for paint) and a coat of monochromatic color on a stretched canvas, then blows it with a hairdryer on the hottest setting. He likes the effect, so he kicks it up a notch by buying a blowtorch and singeing canvases before, during, and after he applies the paint. He saturates two canvases in paint, sticks them together face to face, and lets them dry. A few months later, they're melded to one another like conjoined twins. Unceremoniously, he rips them apart, cracking the paint, leaving pockmarks and protrusions on each surface that correspond

inversely to the other's. In his fertility-obsessed mind, the canvases now share a common DNA; they are brothers and sisters.

As a result of these violent interactions of processes and materials, there is no longer a blank canvas staring him in the face; there's a canvas with a past. A history and character. Scarred, singed, blistered. Sadder but wiser, like a weathered face that suggests stories and trials no unlined countenance could ever muster.

Lamb starts working this way all the time and for the most part is pleased with the results.

Then, in the early 1990s, he meets Dr. Walter Persegati, a head curator at the Vatican Museums of Modern Religious Art and a leader in the restoration of the Sistine Chapel. The two begin discussing Michelangelo Buonarroti's technique as a fresco painter, and Lamb is intrigued by the idea of sinking color into a wet base. He barrages the Italian with questions: What exactly happens as the base hardens? How does the fresco method affect the intensity and longevity of pigment? Patiently, Persegati submits to the interrogation.

Afterwards Lamb can't stop thinking about the conversation. Something's percolating in his head, something about color and concrete, and mixing cheap concrete with expensive gesso and seeing what happens. He digs out the old Rolodex from his funeral home days and calls a couple contractors who built chapels for him, asking them to explain everything he ever wanted to know about concrete but was afraid to ask.

Like concrete itself, all this information needs some time to set, so Lamb stands back for a few days and takes it in.

And then he commences the inaugural dip, an event which was to have lasting impact on his development as an artist and allow him to achieve effects with far more nuance and efficiency than his haphazard, throw-it-in-the-ocean, blow-it-with-a-hairdryer experiments had. The dip was big news, a revolution in his technique that, perhaps more than any other component of his work, would set him apart from any other painter of his time.

The dip begins with a phone call to Jack Basso, his brother Dick's longtime neighbor and godfather of Dick's daughter, Meghan. Before

Basso eased into semi-retirement, he was a top executive with Borden Chemical and Sun Chemical, two corporations that manufacture inks and other materials for the publishing and advertising industries. Lamb tells Basso he needs a batch of paints custom mixed, and Basso heads into a laboratory near his home to combine iron oxides, organic and inorganic pigments, and cement into a selection of paints and subtly shaded concrete. Lamb tells Basso the viscosity and drying time he's going for, along with his favorite colors: deep purple, ultramarine and alkalide blue, rhodamine red, ochre, and silver. Basso works his magic, then phones Lamb back. A truck picks up the paints, 100 gallons of them, and drops them off at Lamb's studio.

Next, Lamb's assistant goes to an art supply store and buys off-the-rack Windsor Newton paints, along with linseed oil, turpentine, gesso, printer's inks, and cartons of rubber gloves, all in extravagant quantities. (Says Simone Nathan: "Matt's not a conservationist. He buys paint by the truckload, which doesn't always endear him to the people standing behind him in line.")

At 8:30 on the morning of the dip, he arrives at his studio. Four assistants have already laid out the supplies and prepared the concrete in the cement mixer Lamb has bought. Together, Lamb and the assistants pour the materials into deeply lipped 8'×8' wooden platforms, which the artist calls "motherboards." They keep pouring until the liquids "are as deep as a miniature swimming pool." Working intuitively like a gourmet chef, Lamb tweaks his recipe, adding more of this, sprinkling in a bit of that, according to the mixture's appearance and consistency.

"I have to get it exactly right," he tells the assistants, "or else it'll all turn to brown crud."

Lamb is looking at the chunky soup of the mixture and thinking of it as a kind of primordial sea. In his mind, the chaos of the dip corresponds to the chaos at the beginning of the universe and the chaos of daily life.

Dressed in an aviator's suit, he dons rubber gloves (he'll go through 25 pairs over the next three hours). His assistants—among them Bob Banci, the caretaker of his Wisconsin farm—hand him a blank canvas, which he plops down, face first, into whichever quadrant

of the motherboard he fancies; different sectors have different colors and differing thicknesses, so his choice will impact the final composition. Lamb, like painter Gerhardt Richter, likes to "control the spontaneous," and this is how he does it.[1] He pats the back of the canvas, bangs it with his fist, moves it around in fluid or choppy motions, then hands it off to an assistant, who takes it, in turn, to a large table to await the next step. In the meantime, other assistants are raking the materials in the motherboard to keep them fluid, and Lamb is already dipping and patting down another canvas, handed to him by yet another assistant. He'll do this to as many as 120 canvases before he's ready to head over to the tables for step two.

Step two is all about the brooms. He takes whisk brooms and larger, janitor-sized brooms and dunks them into massive buckets of paint. With one broom in each hand, he commences a sort of digital ballet, with each hand working independently, making broad gestural strokes across the canvas, some legato, some staccato. Sometimes he moves the brooms from one canvas to another without stopping, so that a stroke that begins on one canvas will conclude on another. Whenever the mood strikes him, he throws down the brooms and uses his hands and fingers to trace shapes in the gloppy mess. It's all very quick, the whole broom-and-finger routine, thirty seconds, a minute at the most. No deliberation, no second-guessing, no talking to the assistants other than the occasional "Bring me another one."

"The liquids in the motherboard dry up so quickly," Lamb says, "there's no time to piss."

When he's done with a canvas, he and the assistants, using spacers, stack it in piles several feet high beside massive industrial fans that are never turned off (it takes at least a year for a Lamb painting to dry). He specifies whether each painting is to dry upright or horizontally and determines "which way is up"; the direction the paint drips and dries will affect the final composition. He climbs up on a 15-foot ladder and surveys the paintings, directing his assistants to earmark certain "families" to be shipped after drying to his studios around the world—this batch to Ireland, this pile to the Keys, this family to Germany—where step three will continue the long process to completion.

As the works dry, awaiting shipment, the repellant materials slowly

separate, pool, pucker, and crystallize. Dante, the dog owned by assistant Bob Banci, saunters over to the drying canvases, stepping onto one and sniffing it (Lamb will later leave the paw print in the finished painting). Things begin to happen during the drying period that will produce the surfaces for which Lamb is renowned. The famous Lamb "pucker" will issue from the interaction of his custom-mixed materials, the drying process itself, and the heat of his ubiquitous blowtorch. (Michal Ann Carley lauds the "almost mutant texture and chromatic excess" of the colorful puckers, while James Yood marvels over the "crusts of magma-like substance" that make it clear that "delicacy and restraint are not positions that interest Lamb."[2])

It's 6:30 at night now in Lamb's studio, and he's been going at it since early morning. Hoisting canvases, working the brooms, climbing up and down ladders, have tired his back, arm, and leg muscles and aggravated his arthritis. Tomorrow he'll have a massage, but for now, it's time for him and the assistants to have dinner. Fried chicken, finger-lickin' good, provided you take off the rubber gloves first. Meal over, Lamb sleeps, and so do his paintings, awaiting the day he will give life to the spirits lying dormant within them.

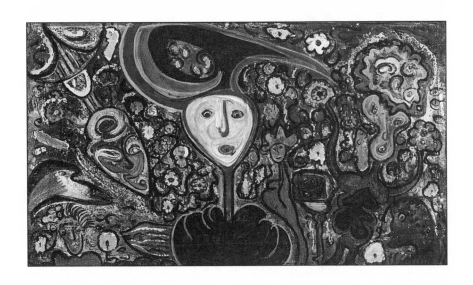

CHAPTER SEVENTEEN

FINDING FACES IN THE CLOUDS

It's been a year since the first dip. The canvases that were drying have dried. The liquids that were pooling have pooled. Whatever was puckering has puckered. The dip has given the canvases what Lamb calls his background.

"It's kind of like, if you build it—'it' being the background—they will come—they being the spirits."

Lamb has built it. It is time for them to come.

He's alone in his studio with 35 canvases hanging on the walls. He turns on the radio to his favorite hard-rock station, and Guns N' Roses blares "Paradise City." As if possessed, Lamb is suddenly dancing around, whistling, chugging his arms, bobbing his head up and down. It's *Headbanger's Ball* with oil paints. He's heard the song before and knows the words, which he sings along under his breath: "Oh, won't

you please take me ho-wo-om, yeah-yeah . . ." The Catholic knight covers Axl.

He grabs a brush, dips it in black paint, and prowls around the room, eyeing one painting, then another. Suddenly he's up close to one of them, up in its face, and where the bumpy, wrinkled surface on the left side of the canvas gives way to a smoother passage on the right, he draws a line. And another. He makes a semicircle and puts a dot in its center: an eye. Damned if there wasn't a face there all along, waiting for him to delineate it, except that to him, it's more than a face; it's a ghost from another dimension.

". . . where the grass is green and the girls are pretty . . ." wails the voice on the radio.

Lamb's already across the room, tracing along the heavily impasted ridge that spans the top half of another painting. He dips the brush into a tin of black paint, then skirts the crusted, gummy plane that vertically bisects the work. Another line later, and damned if it doesn't look like a horse! Lamb is doing nothing but tracing lines that are already there, as if he's finding faces in the clouds—it's just that he's the only one who can see them until he outlines their shapes for the rest of us. And so it goes for hours, until from the 30-odd canvases around the room the eeriest, most bizarre forms peer out.

He changes the radio station. U2's "With or Without You" is playing, and Lamb sings along with Bono, a fellow Irishman. He takes the horse painting off the wall and lifts it onto an easel, then dips a crusty, old brush into a muffin tin full of garish reds and fills in the horse's body. Dips the same brush into cobalt blue and paints curlicues of water at the animal's feet, then a bright yellow mane, silver eyes, and purple tail.

He bounds into the next room, where other paintings await. Goes up to one that reminds him of a woman's face, outlines the nose and lips and hair, then decides the shape is more like a fish, so he takes a differently colored brush and, in a matter of minutes, the woman isn't there anymore—or rather she is there, but now she's buried beneath a fish.

He hops over to the next painting. Grabs a butane torch and holds it next to a green expanse of paint. Slowly, irregularly, the green burns

off, and underneath lies yellow. It's a ghost, a *pentimento*, of a generation that came before.

Lamb doesn't know it in 1988, but in time, art critics will rave about his "generational" style. In 1994, the Central American newspaper *Diario Extra* will pronounce him "el padre de la Pintura Generacional" ("the father of generational painting"). "We are a conglomeration of our past," he will tell a reporter. "We won't be the same people 10 years from now that we are now. My art is painting over painting over painting, four layers, five, 10, 20 generations. Parts of it survive, other parts die, other parts are still there, but you can't see them anymore. People are the same way. One generation dies so the next can go forward. Death clears the slate."

Metallica's on the radio now, and Lamb's rushing over to a canvas in the corner. When he's in front of it, he stops bobbing his head up and down and just looks at it. Sizes it up. It's the stillest he's been since he walked through the door two hours ago. He looks at it more, studies it. Dips his brush in black paint and in the lower left-hand corner signs LAMB. A year after he plopped it down into the primordial soup of the dip, it's ready to go out into the world and raise some hell.

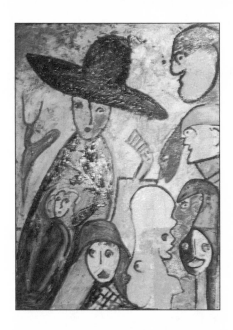

CHAPTER EIGHTEEN

THE SPIRITS WHO LIVE IN THE CANVAS

At first, Rose Lamb didn't really get the whole thing about the spirits from other dimensions.

"Matt had never talked about seeing spirits when we were working in the funeral home," she says, "so I actually thought it was kind of scary when he started painting and saying these things. The only thing I could think of was that he could see people 'on the other side' because he had worked so long in the funeral business."

Who can blame Rose for getting slightly spooked when her husband announced he could see dead people? In a fashion similar to that of the child psychic in M. Night Shyamalan's film, *The Sixth Sense*, Lamb maintained—and still maintains—that he senses the presence of spirits around him and sees them in his paintings. In certain spots around the world—Glacier Bay, Alaska; the Rio Grande Gorge outside

Taos, New Mexico; Drumossie Moor, site of the 1746 Battle of Cullo-
den near Inverness, Scotland—he says he feels the energy of ancient
spirits assaulting him, asserting their presences, imparting wisdom
without words. These, he believes, are the archetypes for the spirits he
finds within the irregular surfaces of a dipped canvas. Shadows of the
world before or after this one, they are the souls of people who have
died, have yet to be born, or who died before they were born. The spir-
its are not only people, though; they can be animals, plants, or bizarre
creatures of unknown genus. They assert their presence in his paint-
ings, he believes, because they have something to say. What, exactly?

"I don't always know. They say different things to different people,
and their messages can change over time."

Some of the spirits are benevolent, others malevolent. They are
opposing forces locked in combat for men's souls: "The angels and the
devils are battling, and we have to pick sides. My art is about taking
God and the devil and putting them in a form the rest of the world can
talk and argue about. We all have the capacity to be a saint or a devil or
both in the same lifetime."[1]

Running through this dualistic worldview is a pronounced strain of
Manicheanism, the philosophy advanced by the third-century Persian
sage, Mani, who posited two gods on equal footing, one good, one evil.
Mani held, as Lamb holds, that human beings are the gods' battle-
grounds, since humans meld *Ormuzd* (mind) and *Ahriman* (matter).[2]
Manicheanism also proposes that those who live by body and not the
mind will not enter heaven but be condemned to another go-round on
earth, a conception tantamount to reincarnation, a concept that fasci-
nates Lamb. It is also similar to Lamb's belief that earth itself is purga-
tory, with human souls caught between heaven and hell, good and evil.

For his part, Lamb says he does not know why he sees spirits: "I
know it's a gift, but I don't know why I have it. It isn't like some hand
came down from the heavens and touched me and said, 'You're the
Annointed One.' It was more as if I stumbled into the light and found
something I was missing. Like a drunk waking up after a night of
carousing and saying, 'Oh, this is neat. I've never had my head this far
open before.' "

It is a strange case, no doubt, this businessman who once lived by the mathematical absolutes of profit and loss, who had now donned the wizard's hat and claimed, like a human Ouija board, to channel the energy of spirits he saw in the Rorschach mess of a painting. Lamb's idea of spirits using him as a catalyst to jump through hyperspace into this dimension is part of his larger set of spiritual beliefs, which he freely admits many people find passé, kooky, or both. But it is impossible to know his art without knowing his heart, and his heart holds a hybrid of Roman Catholic, Protestant, Hindu, Zen, and humanist influences that pour from his brush onto the canvas and from his mouth into nearly every conversation he has. In their eclecticism, his beliefs are more catholic than Catholic, which surprises people who have him pegged as strictly doctrinaire. It surprised his friend and gallery rep, Judy Saslow.

"We have totally different religious beliefs," she says. "I grew up in a family of reformed Jews, and my stepfather was a rabbi. Later I became a Unitarian. Now I attend no church but still have spiritual beliefs."

Saslow had her doubts at first as to whether she and Lamb would find spiritual common ground, but she says she was ultimately drawn to "the aspect of brotherly love, the reaching out to those who are hurting and have suffered, that are a big part of Matt and Rose's life, and a big part of Matt's painting."

The artist's spirituality, it is clear, is but one part of who he is. He calls it part of his "baggage," along with his race, age, and place of birth, but make no mistake: Lamb is a traveler, and he keeps his baggage handy.

Periodically he speaks of "the spirit," by which he means "the power that some people call God, the prime mover of the universe, manifested in the processes of life, death, and resurrection. I do the grunt work of the spirit. It dictates the message, and I move my arms and legs." He also believes in angels, although his conception of them is far from the chubby cherubs winging about in rococo paintings: "Angels guard us, push us, pull us, but they can also beat the shit out of us if that's what their orders are. You don't want to screw around with

them too much." He believes he has a guardian angel, although the angel "isn't an order taker." For her part, Rose says she has "a very close relationship with my guardian angel. His name is Joe, and I talk to him and pray to him all the time."

When Lamb has something specific he wants divine intervention with, he "eliminates the middleman and goes straight to the spirit." This very spirit, Lamb believes, has intervened several times in his and Rose's lives. When he twice flunked his Army physical due to back problems, this was, he believes, a divine intervention.

"I might have been killed if I'd gone off to Korea, or maybe lived but come back so changed, I never would have become an artist."

When Rose suffered colon polyps in the mid-1970s, the Lambs asked people in their congregation to pray for her. Shortly thereafter, she says, the growths disappeared. When Lamb was pronounced free of infectious mononucleosis, chronic active hepatitis, and sarcoidosis of the liver in the early 1980s, it was because, he holds, the spirit wanted him to become a painter and spread the messages of communication and love. Finally, when Lamb stood entrenched in the biggest legal battle of his life, Rose prayed that "a phalanx of angels would surround and protect" her husband. An unexpected development in the proceedings proved to his advantage, and he emerged from the debacle unscathed.

In his take on the Holy Trinity, Lamb sees the Father in metaphysical terms, as the totality and mind of the cosmos; the Son in moral terms, as the embodiment of kindness, love, and peace; and the Holy Spirit in motivational terms, as a kind of universal foreman who directs individuals toward their life's missions.

He believes in a personal judgment and afterlife of some kind: "I think the moment of death is like the moment of birth. We were comfortable in the womb, then all of a sudden some doctor's smackin' us on the ass. We're comfortable here on earth, but when we die we're going to be wrenched away. I think whatever follows will be much calmer and more accepting than this world. You won't have to worry about some son-of-a-bitch coming up and trying to kill you. People will be loving each other, having a party, talking with and learning from one another, not arguing and fighting."

He is pro-life but laments that the issue has become more a political litmus test than an issue of personal morality. He is also willing to allow that "if I had a 14-year-old daughter who'd just been raped, I might feel differently than I do now. In my heart of hearts, I'd probably prefer her to have the child and put it up for adoption if she didn't want to keep it, but if she had an abortion, I would support her." He wanted his triptych, *Pro-life, Pro-choice, Pro-kill*, shown at ArtMiami 1995, to be a conversation starter about the abortion debate but was disappointed when the work provoked nothing beyond the standard political polarizations.

He is tolerant of homosexuality ("I don't think I should go around telling people what to do in their bedrooms—it's none of my business.") and does not think God has a problem with people who swear ("People think God is some bow-tied powder puff up on a cloud, but I think he's more like a burly truck driver: He can give you a hug if you need it, but he can also kick your ass."). He also thinks that the unconditional love and forgiveness prescribed by the Church is difficult, if not impossible, to achieve ("I cannot forgive. People who say they forgive the killer who raped and murdered their daughter—where do these people live, in a bowl of milk?").

Less interested in evangelizing Catholicism than finding common ground between the world's religions, in 1991 he helped organize a symposium in Chicago on strategies for bringing Christians, Jews, and Muslims together in peace. His Beatitude, Bishop Michel Sabbah, flew in from Jerusalem to attend the event. A decade later, Cardinal Carlo Furno, the head of the Equestrian Order, came to Chicago from Rome to attend a similar event organized by Lamb. For eight years, Lamb ran a prayer campaign endorsed by the Vatican, the goal of which was for Christians, Jews, and Muslims to pray together for world peace. The Muslim press took a particular shine to Lamb, reporting his efforts in *Sayasat* and *Rahnumai-Dakan*, the newspapers of record in Hyderabad, India, as well as in *Pakistan Link* and *The Minaret*, a magazine for Muslim Americans in Los Angeles.

Always a spiritual quester, Lamb has a wanderlust that has led him to experiment beyond the borders of Catholicism. He and his family members have attended charismatic Protestant and Southern Baptist

churches, and he has accepted spiritual guidance from "a prophet at a black evangelical church."

He believes the dead can communicate with the living, as evidenced by three examples from his personal life. The first involves an incident that happened years after his father, M.J., had died. Lamb's daughter, Sheila, had a dream one night while visiting Paris. When she awoke, she picked up the phone and asked the international operator to put her through immediately to her father. "Dad, I saw Grandpa in a dream, and he said to tell you he loves you, and he's proud of you." Lamb was moved greatly, because in life, M.J. had never verbalized his love.

The second incident happened in the summer of 1987, when Lamb was experiencing doubts about his art career. In prayer, he called upon his departed mother for guidance. Two weeks later he got a call from Renata Beuhler, who told him she had decided to add him to her stable of artists and give him a one-man show in November 1987, due to an unexpected hole in her schedule. The show opened November 6, Peg Lamb's birthday.

The third example involves one of his dearest friends, who lost his wife and could not get over her death. The friend confided in him: "I just wish she would send me some kind of sign that she's in a better place." A few weeks later, the friend told Lamb about a strange event. His wife had always made the bed a particular way. Since her death, the friend, forced into involuntary bachelorhood, had been lucky to make the bed at all. One evening after returning from a social function, he noticed to his amazement that the bed was made the way his wife had always made it. "Do you think it was a sign?" the man asked Lamb, "because I'm not sure. Making the bed isn't a very dramatic way to show she's still around." Lamb looked at him incredulously: "What did you want her to do, stuff a firecracker up your ass?"

Given to cosmic speculations, fueled by pop culture, Lamb is enchanted by the mythic tomes of Joseph Campbell, the cosmic theories of Stephen Hawking, and the sci-fi philosophizing of TV's *Star Trek: The Next Generation* ("The Borg blows my mind!"). He is fascinated by the Swedish scientist, inventor, and mystic, Emanuel Swedenborg (1688–1772), with whom he feels a certain kinship. Author of

the three-volume *Principia Rerum Naturalium,* Swedenborg had an epiphany in his fifties that compelled him to leave his first career in the world of science for the realm of the spirit. The naturalist-turned-mystic believed that the divine is present in all religions, not just Christianity, and claimed he saw visions of angels and spirits. Heaven, he claimed, is a realm of supersaturated colors, atmospheres sparkling like diamonds, and light continually split into the hues of the rainbow—a conception of color that influenced the Hudson River School of painting and the architect John Wellborn Root, who designed, lived in, and died in the home in which Lamb now lives.[3]

A walking, breathing blend of Catholic orthodoxy and an eclectic range of other beliefs spanning the spectrum from Manicheanism to the frontier of the occult, Lamb intrigues art scholars and curators with his enigmatic spirits. Greek art historian Athena Schina believes Lamb's works integrate Manichean dichotomies, leading "incompatible and uncompromising situations to coexist in an ecstasy which is utopian yet hopeful, as in untrammeled dreams or pre-Adamic states."[4]

Lamb's view is more plainspoken, if no less profound. He believes his spirits are teachers urging us to seize the day: "These paintings call out for fulfillment. They're telling us, This is not a dress rehearsal. We're born, we live, we die. How we orchestrate this pilgrimage is really up to us, and we don't have anything but the here and now."

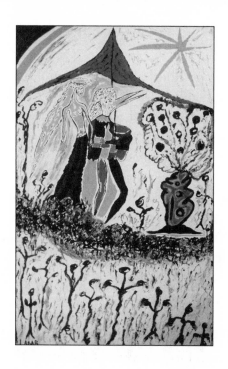

CHAPTER NINETEEN

THE CHARACTERS TAKE THE STAGE

With an urgent drive to give birth to the spirits he heard calling to him from the canvas, Lamb painted everything he could get his hands on in the late 1980s: stretched and unstretched canvases, untreated cloth, wood panels, cardboard, glass, furniture, clothing, handbags, and mannequins.

"Matt will paint anything," Rose says, only half jokingly. "Anything that stands still for 60 seconds is at risk."

In those early years, he began painting vaguely Byzantine cityscapes punctuated by slanted roofs, onion domes, and minarets. The pieces looked a bit like the fantastical world created by the late author/illustrator Theodor Seuss Geisel, better known as "Dr. Seuss," who, like Lamb, was self-taught. The twisty towers define a utopic skyline that might be lifted from Shangri La, El Dorado, John F.

Kennedy's Camelot, or Ronald Reagan's oratorical chestnut, the Shining City on a Hill. Lamb called the series *Once Upon a Time*.

"It's a place in our own psyche. You go to it when you're at a boring cocktail party drinking ice water when everybody around you is drinking martinis. In your mind, you crawl up into this womb-like place where there's a fire burning and you're fed and loved."

Lamb returned to *Once Upon a Time* repeatedly over the following years. Whenever he developed a new process and wanted to try it out, he came back to this idyllic place and used it as a test study.

The young clerk at the art supply shop had sold him acrylic paints to use, but Lamb came to dislike the limitations of acrylics' quick drying time and less lustrous finish. He started working in oils and never looked back.

Long lauded as a fearless colorist, Lamb was surprisingly conflicted about color during his first four years as a painter. While he always gravitated toward bold hues, he was afraid "to let one color have intercourse with another," so he used palette knives instead of brushes in order to keep the colors from mixing and migrating. It was as if, intent on portraying battles between good and evil, he was worried that mixing colors would muddy the polarity of these diametric forces. Then, one night, he awoke to a simple but seismic realization: "Color can't hurt me, and I can't hurt color. Why be afraid? Why not throw colors together, start the conversation between them, and let them accept each other?" From that point on, "anything I could do to present color in a different way, I did: mix it with water, concrete, gesso, turpentine; wipe it off, pool it, burn it, whatever. No boundaries, no rules. Color was my friend."

Some of his first compositions were experiments in color fields and geometric forms reminiscent of abstract artists Ellsworth Kelly and Sol LeWitt. But Lamb sensed that hard-edged abstraction was not his forte. He took Polaroids of these geometric works, then promptly painted over them in a rougher style.

In 1986, perhaps inspired by Chagall, he began painting the Eiffel Tower, surrounding it with sun, stars, or fireworks. Around the same time he painted abstract swirls of diagonal motion and rising plumes of orange and red, evoking licks of fire. He did other rudimentary studies and throwaway musings as slowly he metamorphosed from amateur to

professional. Some of these studies were trite, even to the kindest eye, and held no redeeming value except to show Lamb what *didn't* work: a clown, a wooden rocking horse, a drawing of a clock with the word "TIME" scrawled above it, and a drawing of a red-and-white barber pole entitled *Hair's Away*. Perhaps it was Simone Nathan's and Jack Levin's place to warn Lamb away from these rather silly dalliances and recommend he concentrate on more ambitious works such as his four-panel series, *The Four Seasons*. Portraying the seasonal cycle of a tree, Lamb shows branches and a stream flowing through the landscape as surrounding firs, flowers, and leaves hued green and gold morphed seamlessly in a natural loop. The painting shows a sophistication in composition and color mixing that belies the fact that its artist was only three years into his painting career.

Next he undertook 16 "meditation pieces," which, despite the series' serious-sounding name, were anything but serious and marked the emergence of his fanciful cast of characters. In one narrative painting, a character Lamb called the Fun King "turns his house into a river, and his wife doesn't know about it until she shows up at what used to be the house. His friends give him balloons, and then he lends his fish-friends bikes so they can race with some birds." Another piece showed buxom, pink-skinned women standing in a cornfield, their heads yellow suns, their hair sunrays. Another piece called *King-Bird* featured a long-haired woman, topless but skirted, holding hands with a long-beaked bird.

These were fanciful creatures, but they were not Lamb's "spirits." It was in 1987, in a floral piece called *Pandora's Box*, that the spirits made their first appearance, floating on either side of the bouquet, their shapes amorphous but with clearly delineated eyes, which Lamb rendered as simplistic semicircles and lowercase "p"s with dots inside. These shapes were not Fun Kings, King-Birds, humans, or any other recognizable entities; they were presences with identity but without matter. The spirits he sensed around him, shadows of dimensions prior to and beyond the grave, had finally come out to play.

"What is driving the brooding figures and visages that populate his canvases?" wrote Northwestern University's James Yood of Lamb's spirits. "You are made alert and expectant by their uncanny presence, by their almost spooky aura of iconic power. They have form and

substance, but the eternal silence that is part of their nature is frustrating. If they would only speak!"

In the next few years, Lamb mixed character-driven and spirit-driven works. A character-driven 1987 watercolor called *Let's Go!* shows two men, one chomping on a cigar, the other wearing a tuxedo, salaciously eyeing a prostitute reclining on a sofa. This painting, he remembers, was done in Paris after he'd thumbed through a Toulouse-Lautrec coffee-table book on the Left Bank. Eventually he tired of this style. Painting a vignette with discernable characters doing recognizable things was not his forte. He moved more into the spirit paintings, in which the spectral beings simply exist, sometimes gasping, sometimes screaming, sometimes merely peering out of the canvas, but never engaged in activities that suggest a conventional storyline. Lamb's signature style was to be declamatory, not narrative.

He experimented briefly with a figurative style reminiscent of Modigliani and the sculptor Constantin Brancusi, then moved on to a psychedelia-influenced style in which shapes and bouquets appear shadowed with LSD tracers. Another stylistic fling, apparent in his watercolor, *If Computers Could Have Flowers*, is borrowed from constructivism.

In 1988 Lamb commenced his *Archangel* series, which, rather than looking like traditionally portrayed angels, instead resemble flowers, bushes, trees, and, in the words of one critic, "gruesome crustaceans or monstrous, beheaded insects."[1] Lamb was making the point that archangels, which he sees as the executors of divine will, are around us everywhere, floating through the air and crouching in the vegetation. When collectors saw the archangels, they asked the artist which one was Lucifer.

"I don't know," he told them.

Also in 1988, Lamb painted an embryonic form in a piece called *Apparition* that would become an enigmatic mainstay of his repertoire. He also continued his abstract-timeline series with *The Civil War, Dachau, The Ascent of Man*, and two similar works, *Power* and *Crucifixion*. He addressed Darwinean evolution in his ode to the primordial soup, *Primal Life*.

"I don't know what I think of evolution," he says. "Everything's open for discussion. Who's to say what recipe God used?"

In 1989, one of Lamb's major motifs, the American Indian, appeared in his work for the first time, and in a fanciful piece called *Harlequin* he arrived at his mature figurative style, with its creatures and spirits making merry and mischief and morphing impossibly into one another from every corner of the canvas. Arts writers reviewing these paintings knew Lamb had arrived at an important synthesis and began to speculate on the natures of the inscrutable characters that inhabited them. Michal Ann Carley wrote, "Flat figures emerge predominantly in profile or are frontally iconic. Simplified and emblematic, they often appear Assyrian, as on the walls of Assurbanipal's palace."[2] In *ARTnews* Carol Damian observed that "purple people-eaters are among his creatures . . . Lamb's figures bear mask-like faces and a strange and incomplete corporeal presence . . . flat, colorful, and imprecise."[3] Michael D. Hall wrote that Lamb's spirits "do not play specific roles, nor are they a part of some continuous story that must be read from one picture to the next. . . . They're more like music-video images than those in novels or films . . . a kind of open-ended video that follows the lives of many characters."[4]

Lamb gives the following interpretations of his main characters:

The dog: He's like Groucho Marx to me. He's saying, "Lighten up, you're never going to get out of this world alive!" He wants us to join in the parade. Where's the parade going? Who knows, who cares, just get in line and dance!

The fishes: They're not a Christ symbol. They're the ballerinas of the world. They should be in the air like the birds, not underwater, so we could watch them swim through the sky.

The horse: The horse is a great symbol of vitality. I had this crazy realization one day. Have you ever known a horse to have a headache? Me neither. At our place in Ireland we're surrounded by horses, and they prance around and eat grass all day even if it's raining. I like to whinny like a horse three times a day. Three whinnies a day keeps the doctor away. I love to whinny and curse. It keeps me out of the madhouse and out of the bottle!

The Fun King: Oh, he just has a hell of a time. He or she, that is—the spirits don't really have genders. The Fun King makes fun of everything. Doesn't take anything seriously. "Let's go on a picnic! Hang loose! The hell with it!"

The hat-wearers: The power figures wear the hats and cloaks. The hat has to do with power and posturing. I used to wear a lot of hats. Still do.

The harlequin: He plays pranks and throws confetti in the air. He reminds me of a character named Ishtash from a tale I read in my childhood. He was a fun guy who'd jump on a mule and scream and holler. He has a funny hat and a suit and a staff with all different kinds of colors.

The lookers: They hang out on the sides of the canvas and observe. They're too afraid to get in the middle of the action. Sometimes they get too far into the painting and get the shit scared out of them.

The two-faced person or animal: Two faces on people or an animal represents the duality of the spiritual and material. Same thing with a single face where one half is one color and the other half is another.

The fish with two heads: I call this one "No Shit." An old lady came up to me during a show and asked me what the two-headed fish meant. I told her I had no idea. "Well," she said, "they look very disturbed to me." And she sort of giggled and said, "I don't think they can go to the bathroom." And it becomes clear to me: She's right! They have two heads but no asshole! They can eat, but they can't shit!

The Indian (Native American): Everybody gives lip service to the Indian: "Oh, the Indian lived in harmony with nature, the Indian used every part of the buffalo he killed." We idealize the way the Indian lived before the white man came over and fucked everything up. But we could plug into Indian culture if we wanted to: stop driving cars, give up air-conditioning, go out in loincloths and kill our food with bows and arrows. But who wants to do that? We'd rather

talk the talk than walk the walk. That's our Indian. Finding our Indian is finding the hypocrisies and prejudices inside ourselves. Maybe your Indian is, "Oh, I love everybody but the Jews," or "Everyone is wonderful except my mother-in-law." Or my own personal Indian: "I'm against abortion unless my own 15-year-old daughter is raped." I paint the Indian so I can confront my Indian.

These characters and others jostled about on Lamb's canvases in 1990, delighting and confounding not only collectors, but the artist himself: "One day I paint an animal that I think is a horse. The next day I look at it, and it looks like a dog. The truth is, I have no idea what it is!"

1991 was the last year Lamb titled his paintings. He says he stopped because the titles he assigned, upon later reflection, no longer made sense. Perhaps he just ran out. When you paint at least 500 works a year, you tend to run out of fresh titles. Certainly, Lamb had had fun with his titles: *Pissed, Spaced, Cocaine, Power of Youth, Little Corporal, Strange Swimmers, Beast and Friend, In Command, Rage, Porn,* and *Lamb Mad.* But by 1991 they were beginning to sound arbitrary: *Windy, Helped, Sweet,* and *Who's This?,* which is probably what Lamb was wondering when he tried to think up a title for the 300th painting he'd done that year. In the absence of titles, Lamb catalogued his works, indicating on the back of each piece the studio in which it was completed (C=Chicago, FL=Florida, EU=Europe), the year of completion, and whether the work was the first, second, 109th, etc., that he'd done in a given year. He encouraged the collectors who bought his work to title the paintings themselves.

In 1991 the conversation motif made its first appearance, in an oil and gouache on canvas called *So What?,* a Cubist profile facing an embryonic form in the soon-to-be-familiar Lamb conversational stance.

In 1992 and 1993 he continued developing his figurative style, departing occasionally from his multiple-figure works to render a single iconic creature, most often in the center of the composition.

In 1994 the work grew bolder. One large canvas showed an African-American woman with concentric circles for eyes and a late-60s "flip" do, while another portrayed a green-headed woman with fish flying out of her outrageous, punk-rock hair.

In 1995 he undertook his most controversial political paintings, *Pro-life*, *Pro-choice*, and *Pro-kill*. He also matured in his ability to handle large crowds of spirits in asymmetrical compositions, a notable growth from his previous dependence on symmetry. In the spring of 1995 he did his inaugural "dip," and the next year he tweaked the dip's recipe, pouring in more concrete and sand, which made for a marvelous topography of concrete nuggets but at times imparted a dry and lusterless finish.

In 1997 and 1998 Lamb's figures took on a heightened drama, throwing their arms up and widening their mouths in silent screams, as if trying to hail a cosmic cab out of a universe whose injustices horrified them.

1999 saw Lamb beginning to paint semi-abstractly, and in 2000 and 2001, as if to mark the last year of the twentieth century and the first of the twenty-first, he essayed vaguely outer-space imagery of nebulae, asteroid belts, and distant galaxies in which embryonic consciousnesses floated, à la the Star Child in Stanley Kubrick's *2001: A Space Odyssey*. Works from this period show a heightened sense of motion, his brushwork making wide striations of color across the canvases.

In 2002 he produced his first works of mature abstraction. At first he called these works minimalist but soon realized they were more an intensely personal update of Abstract Expressionism. This was a sea change for Lamb, one he wrestled with terribly before finally coming to peace with abstraction in 2003, when he began experimenting with wild "controlled migration" pieces that resembled a cross between 1960s tie-dye and a chemical experiment gone amuck.

In 2004 Lamb worked simultaneously in figurative, semi-abstract, and abstract styles, with an emphasis on abstraction.

That he, as a self-taught painter, evolved from a point of complete artistic ignorance to the arrival at a signature naïve figurative style, yielding after much soul searching to a highly sophisticated abstract style, is a testament to his growth, dynamism, and passion for the new, recalling abstract pioneer Piet Mondrian's mantra, "Always further!" and reminding us that sometimes growth consists not of adding onto what we are, but of cutting off what weighs us down.[5]

PART FIVE

THE CAREER BLOSSOMS

"Puke on the wall and call it art. Jack off on the wall and call it art. Cut a cow in half and call it art. Personally, I'm not far enough in my art education that I can go into MoMA, look at that kind of thing, and say, 'That's art.' If you think it's art, fine. Maybe it is, if it's really an expression of the artist's soul. But the moment you put a $50,000 price tag on something like that, it's not art anymore—it's bullshit."

—*Matt Lamb*

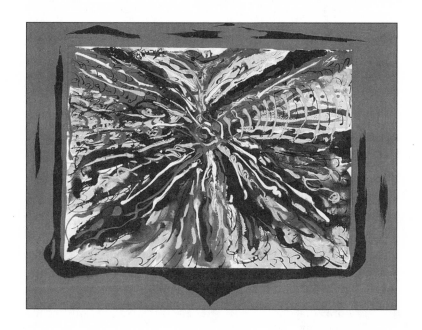

CHAPTER TWENTY

GETTING HAMMERED

Simone Nathan's opinion meant a lot to Matt Lamb in his early days as an artist, and so when she suggested that it was time to graduate from the Galleria Renata, in which he'd made his debut, to a more prestigious venue, Lamb listened.

Enter Carl Hammer, then and now one of the most respected dealers in Outsider art in the United States. Since 1982 Hammer has represented the cream of the Outsider crop, including the estate of Bill Traylor, the former slave who became an artist at the age of 85; the estate of William Edmondson, the first black self-taught artist to be given a solo exhibition at the Museum of Modern Art; the estate of Henry Darger, the Chicago shut-in whom many consider the archetypal Outsider; and a stable of living artists including Gregory Warmack, more commonly known as Mr. Imagination. Despite Lamb's

unease with gallerists and the gallery system, he couldn't help but be flattered when Hammer took an interest in representing him. Soon after their initial meeting, Hammer formally took Lamb on.

Early in 1988, Hammer first showed Lamb as part of a group show for emerging artists. Critics responded enthusiastically, drawing comparisons to Paul Klee, Marc Chagall, and Jean Dubuffet.[1] Late in 1988 Hammer gave Lamb a one-man show, *Archangels*, of which *New Art Examiner*'s Garrett Haig observed, "The vitality of Lamb's surfaces and his superb color sense determine the emotional intensity of his work."[2] In a preview of the insider/Outsider controversy that would dog Lamb for years, the *Chicago Sun-Times* noted that the painter "is prosperous, well educated, and not unaware of the contemporary art world," but conceded that "his themes are universal, his subject matter is quirky, and his techniques are vigorous and unconventional."[3]

Hammer championed Lamb in his media interviews, appearing with the artist on cable and public television programs and telling broadcaster Linda Marshall that there was nothing odd about calling Lamb "an emerging artist" even though he was in his fifties. On the same program, Hammer marveled at Lamb's generational technique, adding only half-jokingly that the paintings "are never really done, they're just sort of at rest!"

It seemed Hammer's enthusiasm for Lamb's work knew no limit. For his part, Lamb welcomed the support and responded by creating more and more work for his champion to show. Lamb may even have seen Hammer as another mentor figure in the mode of his business-world mentors, a protective guide and advisor to teach and nurture him as he cut his swath through a new jungle.

The honeymoon didn't last long. Why things began to fall apart between the two is a matter that's difficult to get either man to discuss, but it seems to revolve around several smaller issues that added up to bigger issues.

"This was one of those classic disputes that art history is strewn with," says Simone Nathan, "between the artist and the gallery director, both of whom want to control the work and both of whom have very strong egos. I suppose Matt felt like Carl was trying to sit on his head. Big mistake. No one sits on Matt Lamb's head."

Hammer refuses to comment on his and Lamb's troubles, but according to Nathan and other sources close to Lamb, the gallerist, the artist, and his advisors disagreed on the best way to market Lamb's work. Hammer reportedly wanted to market Lamb specifically as a naïve artist, but Nathan believed he should be presented under the broader "self-taught" rubric. Hammer also apparently thought the large signature with which Lamb signed his paintings—LAMB in proud, uppercase script—was gauche and should be nixed in favor of a smaller signature. Lamb took Hammer's suggestion under consideration but didn't change his signature an iota.

Hammer is also said to have objected to Lamb's habit of giving friends, including Mayor Richard M. Daley and his wife, Maggie, personal tours of his studio, including sneak peeks at his newest work. Lamb says Hammer believed his gallery was the only place members of the public, including Chicago's First Family, should be able to see the artist's work. Moreover, he felt Lamb should only exhibit the pieces which he, as Lamb's representative, had personally okayed.

How to price the paintings proved a source of strong disagreement between the men. Hammer, whose primary concern was to sell the work, naturally wanted to set the prices as high as the market would bear. Lamb, whose primary concern was to get his paintings seen—and their underlying spiritual message absorbed—by as many people as possible, naturally wanted to keep the paintings more affordable. Hammer also reportedly felt that the prolific Lamb was producing too much work and thereby lowering his price point.

Says Lamb, "He told me I was painting too much and should give it a rest."

By way of response, Lamb upped his production even more.

As a result of these factors and others that may be known only to the parties involved, the two had a major falling out, the result of which was that Lamb left Hammer's stable in 1990. The men, whose paths often crossed in Chicago art circles, continued to speak and be civil, but Hammer's actions in succeeding years, whether actual or perceived, have added to Lamb's feelings of betrayal.

While the painter is philosophical about the parting of ways, traces of bitterness linger.

"The whole premise of the gallery system," he says, "is that *they* want to make the artist. They want to control the access to the work, the way the work is presented, and the price charged for it. The galleries want a vice-grip on the production, the price, and the distribution. They're like OPEC. Meanwhile, the artist, the one who made the art in the first place, has very little say. When Carl Hammer asked me to limit my output, he may as well have asked a heart surgeon not to perform too many angioplasties so that the price of the operation wouldn't go down."

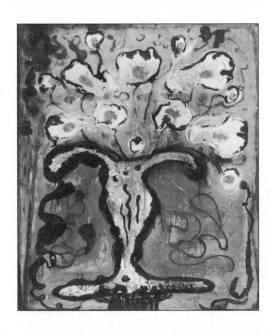

CHAPTER TWENTY-ONE

PAINTING FOR PIERRE CARDIN

Chic, young, and raven-haired, Véronique Sournies met the Lambs in the late 1980s. The charming Parisienne, well connected in French cultural circles, worked for the Maxim's School of Hotel and Restaurant Management, and it was through Maxim's business that she crossed the Atlantic for meetings at Saint Xavier University in Chicago. There, she saw some of Matt Lamb's pieces in the school's permanent collection and found herself thunderstruck by their rugged beauty. Immediately she sought Lamb out and asked him if he'd ever shown his work in her home country. He had not.

Upon her return to Paris, Véronique took a catalog of one of Lamb's first Chicago shows to one of her more illustrious acquaintances, the legendary couturier, Pierre Cardin, who owned an eponymous gallery at 1 Avenue Gabriel in Paris. That Cardin had never

heard of Lamb is unremarkable, given that the artist had been painting only a few years at that point; what is remarkable is that the designer was so enraptured by Lamb's work that he invited the artist to Paris for a one-man show at the Espace Pierre Cardin.

The invitation floored Lamb and infused the fledgling painter with new confidence. Carl Hammer picked several dozen paintings and shipped them off to the City of Light.

On October 2, 1990, Cardin threw a champagne reception for Lamb, attended by many of "the beautiful people" in Paris art and fashion circles. The artist found himself surrounded by shimmering fabrics and millions of francs' worth of jewels adorning the milky-white throats of heiresses and runway models. He himself wore all black that night, a counterpoint to his rakishly long white hair, and Rose wore a gown of dark sequins. Véronique acted as translator as party-goers approached Lamb, eager to hear the story behind his unconventional paintings. It was a heady scene for a former undertaker from the South Side of Chicago, and Lamb's emotions were on over-drive, especially when Cardin himself arrived.

"He was very graceful, very unassuming," Lamb says of the designer. "Gentle but powerful. He reminded me of Frank Sinatra in that Sinatra didn't need an announcer or a drumroll, he just walked onstage and started singing. Cardin was the same way. I looked up, and there he was."

The two exchanged pleasantries, and the party continued. After-wards, when the show itself opened in the gallery adjoining the recep-tion area, Lamb saw Cardin standing in front of a particular painting for a long time, utterly motionless. Lamb circulated a bit, working the crowd as he moved through the gallery, with its walls of gleaming white juxtaposed with ebony divider panels. After a few minutes, he glanced nervously back at Cardin, who was still alone in front of the same painting. He approached Cardin slowly. After a few long moments, Cardin turned to him, shaking his head as if in astonish-ment, and said in perfect English, "I have just counted 36 different col-ors in this painting."

Cardin purchased the painting at the end of the night.

The man whose hometown debut in Chicago had been publicly panned by critic Harry Bouras, now had a champion in Pierre Cardin, a *gentilhomme* possessed of one of the world's most celebrated and discerning aesthetic eyes. In the years following the Cardin show, Lamb would exhibit at the Salon des Indépendants and the Salon de l'Automne and enter the internationally juried Deauville Exhibition, competing against 127 other artists and taking home the Bronze Medal.[1] His enthusiastic reception in France presaged a larger phenomenon that was to follow him, perhaps haunt him, to the present day. Europe was to embrace his work without caveat, while America fixated on the myopic debate of whether he was a true Outsider. Was this to be his lot, beloved in Europe, besieged in his own country? Was Matt Lamb to be the Jerry Lewis of the art world?

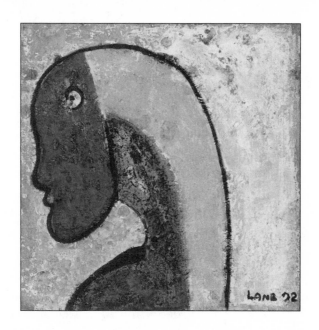

CHAPTER TWENTY-TWO

FINDING FASSBENDER

With Pierre Cardin's gold star gleaming on his résumé, Lamb soon found himself oddly without a champion in his own hometown. The implosion of his relationship with Carl Hammer left him knocking on the doors of venues like Vanderpool Gallery, Prairie Avenue Gallery, Tough Gallery, and World Tattoo Gallery. Lamb had shows with all of them, but it must have been a letdown after having been the darling of the blue-chip Hammer.

After a year of playing "musical galleries," he took up with dealer Glenn Joffe.

"Glenn Joffe was the best salesman I ever met," says Lamb, "and that's saying something. He could sell ice cubes to an Eskimo. It wasn't uncommon for him to sell $80,000 worth of art in a weekend. The man was amazing to behold, and I say that with a lot of respect. My father

used to say that a piece of jewelry is only worth what you can pawn it for. What Glenn Joffe did was like taking a secondhand Rolex from a pawnshop and selling it like it was brand-new from Tiffany's."

Joffe's finesse as a salesman fit neatly into Simone Nathan's conception of building the Lamb myth.

As Lamb explains, "In the art world it's difficult to sell work, especially if you're fresh on the scene and people have never heard of you. That's where 'building the myth' comes in. A gallery owner can say, 'Oh, you've never heard of this artist? How can that be? He shows in this gallery and that, and he's represented by So-and-So, and didn't you know he did an installation at Notre Dame Cathedral, and look at this book and this catalog of his, and did you know he's in the private collection of the Queen of Sweden?' And all of a sudden, you're dealing with a different animal. You have the label, the song and dance that justifies somebody paying $300,000 for a piece."

Joffe published a limited-edition book of Lamb prints called *The Diary Pages*, in which Lamb used pastels, watercolors, gouache, collage, Magic Markers, crayons, and enamel paint to give voice to his internal duel between what he called "my inner Pollyanna and my inner Patton." Lamb intended the series as an exercise in free association, "an archaeological dig into my mind and psyche to see if I can make sense out of the little creatures, humanoids, animals, flowers, and birds that people my world." On each page, Lamb drew a vignette, then added a caption. One caption read: "Who is that person so in control? I wish I could be more like him. Holy cow! It's me, as seen by the world!" Another read: "Is this the devil? Such a comical, frightful image. I wonder who it is. Oh my, it's a mirror!"

During the course of their association, Joffe also arranged Lamb's first exposure in Latin America, coordinating several shows in Mexico. He was not as successful as Carl Hammer had been, however, in attracting attention from critics, and this was an issue with Lamb, who wanted his work critically reviewed, not just commercially sold. Added to this was the fact that Lamb wasn't entirely sure what Joffe was ultimately more passionate about: the art or the money. After a short but lucrative association, the two parted.

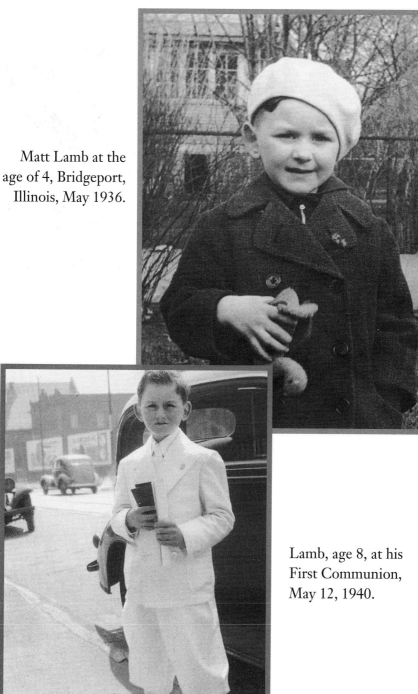

Matt Lamb at the age of 4, Bridgeport, Illinois, May 1936.

Lamb, age 8, at his First Communion, May 12, 1940.

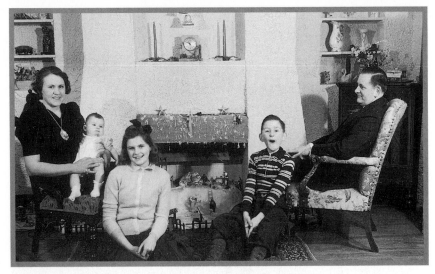

The Lambs, Christmas 1940. From left to right: Margaret Lawler ("Peg") Lamb, Richard Joseph ("Dick") Lamb, Margaret Regina ("Peggy") Lamb, Matt Lamb, M.J. Lamb).

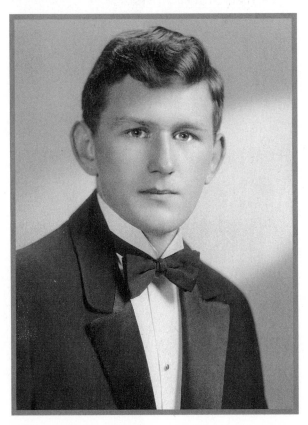

Matt Lamb, senior year at St. Leo High School, Chicago, 1950.

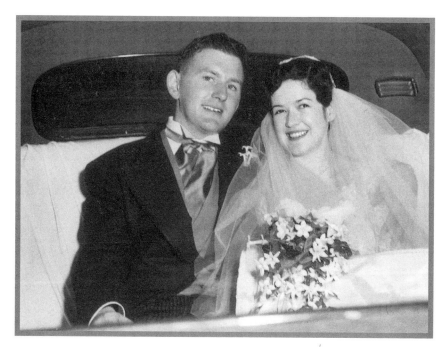

Matt and Rose Lamb on their wedding day, October 2, 1954.

In front of the Blake-Lamb Funeral Home, 4727 West 103rd St., Oak Lawn, Illinois, in the mid-1960s. From left to right: Matt, M.J., and Dick Lamb.

Source: Courtesy of Van Westrop Studio, 012860 S. Western Ave., Blue Island, Illinois (Tel. 388 0190).

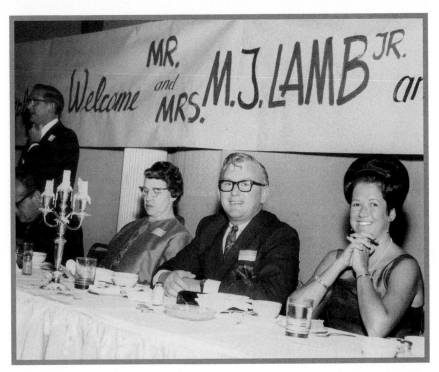

Matt and Rose Lamb at one of the hundreds of banquets they attended in the late 1960s as players in Chicago's social scene.

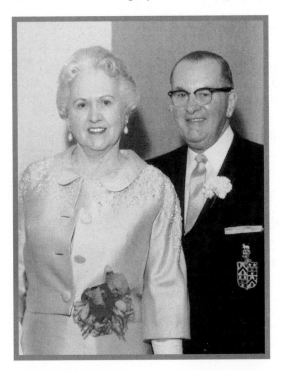

Matt Lamb's parents, Peg and M.J. Lamb, mid-1960s.

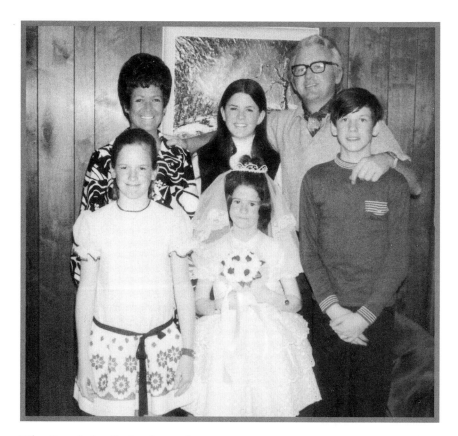

The Lamb family in the early 1970s. From left to right, back row: Rose, Rosemarie, and Matt; front row: Colleen, Sheila, and Matt Jr.

Artist and P.R. guru Simone Nathan helped shape Lamb's development as a painter and brand him as an artist.

January 1987. From left to right: Rose Lamb, New York Archbishop John O'Conner, and Matt Lamb after O'Conner bestowed Lamb's second Papal Knighthood.

Early 1990s. From left to right: The Honorable Neil Hartigan, Attorney General of Illinois, Bonnie Derwinski, Edward Derwinski, U.S. Secretary of Veterans Affairs, Matt Lamb, Rose Lamb, and Cardinal Joseph Bernardin, Archbishop of Chicago.

Source: Courtesy of Nathan D'Angelo, Public Relations Counsel, 20 North Wacker Drive, Chicago, Illinois, 60606.

Pierre Cardin and Lamb at the opening of the artist's one-person show at the Espace Cardin, Paris, October 2, 1990.

Lamb distressing canvases on the beach, Florida Keys, early 1990s.

Left: Lamb prepares "the dip."

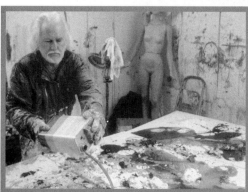

Below: Lamb standing beside stacks of paintings after "the dip." The paintings will dry under giant fans for a year or more.

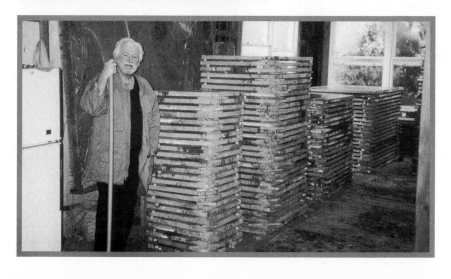

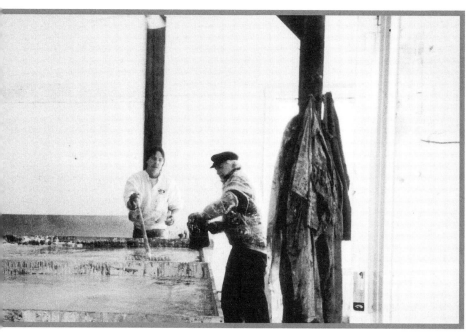

Lamb fills his "motherboards" with paints, concrete, turpentine, and a closely guarded recipe of other ingredients as he begins a "dip," rural Wisconsin, late 1990s.

A study in chaos: Lamb's studio in Southside Chicago.

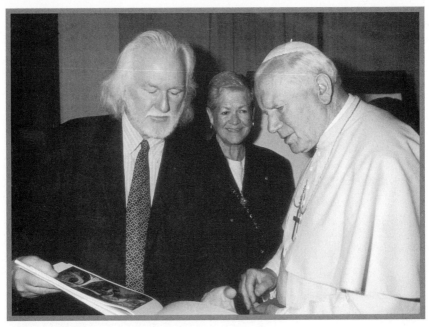

Lamb presents His Holiness, Pope John Paul II, with a catalog after one of the artist's paintings was unveiled at The Vatican Museums of Art, April 7, 1994.

Source: Courtesy of L'osservatore Romanco, Citta Del Vaticano, Servizio Fotografico (Tel. 698 84797).

June 6, 2000. Her Royal Highness, Princess Michael of Kent, with Lamb at the opening of Lamb's soaring installation at Westminster Cathedral, London.

Lamb and his international agent, Dominic Rohde, late 1990s.

Late January 2003. Art dealer Carolyn Walsh's infamous Winnebago parked outside the historic Puck Building, SoHo, New York City. Walsh stuffed the vehicle with Lamb's paintings and sold them "like Turkish carpets."

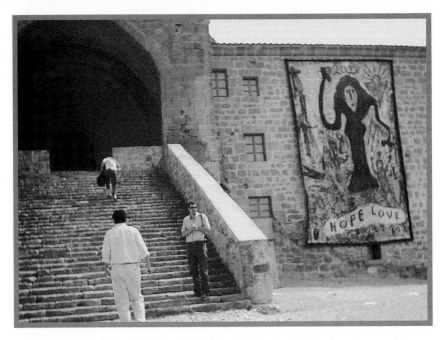

Lamb's massive unstretched canvas, *Hope and Love*, hangs on the ancient wall of the Convent of San Salvador, Horta, Spain, heralding the opening of the Centre Picasso's *Lamb Encounters Picasso*.

September 7, 2003, opening of the exhibit, *Lamb Encounters Picasso*, Horta, Spain.

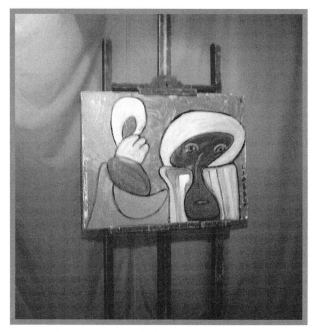

One of Lamb's untitled paintings on Pablo Picasso's antique easel welcomed visitors to *Lamb Encounters Picasso*, September 2003, Horta, Spain.

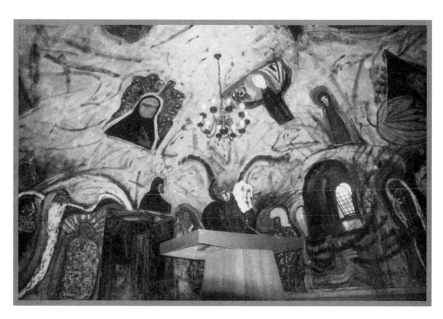

Maria, Regina Pacis ("Mary, Queen of Peace") Chapel by Matt Lamb, Tünsdorf, Germany.

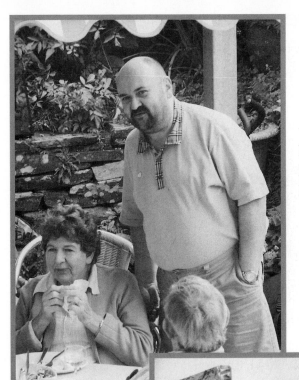

Fergus O'Mahony,
Lamb's agent in
Ireland.

Virginia Miller,
Lamb's agent in
Miami.

Source: Courtesy of
Richard Speer.

Lamb's Ireland manor home.

Lamb's Florida Keys condo.

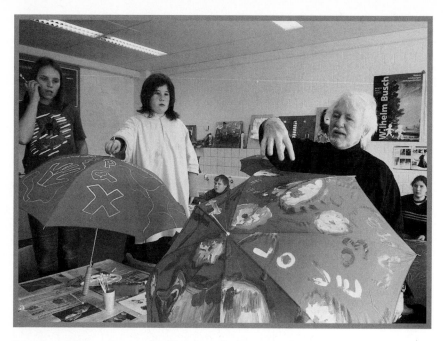

Lamb explains the umbrella's symbolism to German schoolchildren, as part of his "Lamb Umbrellas for Peace," 2003.

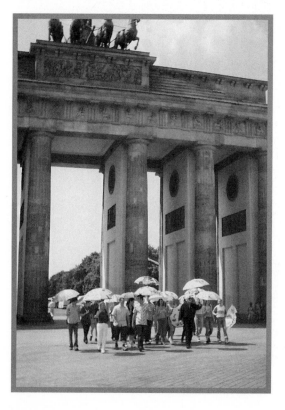

Lamb leads a group of German high school students through the Brandenburg Gate, Berlin, Germany, June 4, 2003, as part of "Lamb Umbrellas for Peace."

Shortly thereafter, in the mid-1990s, Galerie Kasten in Mannheim, Germany, gave Lamb a one-man show. As an adjunct to this exhibit, Lamb hung a major installation in the Cathedral of the Holy Spirit in Mannheim. One of the people attending both the show and the installation was Ingrid Fassbender, the German-born art dealer whose gallery in Lamb's native Chicago represented A-list contemporary artists like James Rosenquist, Al Held, Louise Bourgeois, and Jim Dine. It was, therefore, a considerable coup for Lamb when Fassbender approached him after the Mannheim shows and offered to represent him.

"I really didn't think she liked my work at first," he confesses. "It took a while before I was convinced I'd really won her over."

For eight years Fassbender represented Lamb not only in Chicago, but at some of the most prestigious art fairs in the country. Sometimes, when he accompanied her to these fairs, his impish humor and irreverence toward art collectors got the best of her. At the San Francisco International Art Exposition, several of his large paintings hung on the walls of her deluxe booth. Fassbender had momentarily excused herself to the ladies' room, leaving Lamb alone, reading a magazine. A collector and his wife ambled over and began scrutinizing one of the pieces, which was priced at $16,000. Slyly, Lamb rose and approached the couple, pretending to be Fassbender's assistant. (Such tactics were old hat to a man who, as CEO of Blake-Lamb, had impersonated chauffeurs in order to get families' feedback on the company's service.)

"May I help you?" he asked the couple.

"We love this painting," the man said.

"You have excellent taste, sir. I recommend it highly."

"We've been looking at it the past two days."

"Really?"

"Yes, and today we're going to make our decision. It's between this one by Matt Lamb and that one over there by—" and the man named a far better known painter whose work was hanging across the walkway in another agent's booth.

"Ah," said Lamb.

"My wife is a little worried that this one"—he gestured at the Lamb canvas—"might be a bit . . . *much* for our living room."

"I see, well, if that's a concern, then I'd definitely recommend you go with the other one."

"Really? Why's that?"

"Because if you're worried about what people will think when they come into your living room, the other one's probably a better bet. I mean, you put *this* one on your wall, your brother-in-law's going to think you've gone crazy."

"Well, I don't know, I don't mean to say that we're only concerned with what . . ."

Fassbender arrived back from the ladies' room and approached the two.

"No, no," Lamb was saying, "the other piece is safer. This one here is tough, no doubt about it."

"You know," the collector said, "it's just that it would probably take . . ."

Lamb interrupted him: "It'd take a great big pair of balls to buy this one, that's what it would take."

Fassbender blanched, then broke in. "May I help you, sir?"

Chuckling, Lamb retreated.

Half an hour later the couple bought Lamb's painting.

Two years later, again in San Francisco, Lamb was again playing incognito at one of his shows when he overheard a middle-aged collector and his twentysomething girlfriend conversing before a mid-sized Lamb painting.

"No, no," the man was saying, "to me it's not childlike at all, it's just childish." Casually, he turned to Lamb. "We're talking about the show. What do *you* think of it?"

Playing along, Lamb answered, "I haven't made my mind up yet. What about you?"

"In a word, redundant," the man pronounced.

"Redundant?"

"Yes, very."

"Hmm, I'd have to disagree," Lamb said. "I actually don't think it's the least bit redundant."

"Are you"—the collector asked suddenly, nervously, looking around—"are you the artist?"

"Um, no."

"Oh, well, are you friends with the artist?"

"In a manner of speaking," Lamb replied, feeling mischievous. "I'm his lover, actually."

Mortified, the collector and his young companion excused themselves.

When she could make Lamb behave, Fassbender was able to work wonders for his blossoming career. Through her international contacts, she arranged representation for him at the Galerie Leupi in Lucerne, Switzerland, and the Galeria Punto in Valencia, Spain. She introduced his work to the major collectors that made up her core clientele, including a Chicago doctor who grew so obsessed with Lamb's art, he filled his every wall with them, and when there was no more wall space left, had additional paintings hung from the open rafters in his penthouse. This collector, who prefers to remain anonymous, currently owns the largest private Lamb collection in the world.

Under Fassbender's representation, Lamb saw the selling price of his works jump dramatically. She also had clout with the critics. During this period, Lamb's work was reviewed often (and mostly favorably) by local, regional, and national arts publications. Margaret Hawkins of the *Chicago Sun-Times* penned a rapturous review of a one-man show toward the end of Lamb's association with Fassbender, remarking that "the paintings seize the viewer on an emotional level with freewheeling, joyous movement and exuberant, yet earthy colors . . . These rhythmic organic patterns send up a kind of hymn to universal forces and the ascendancy of natural order as a guide to spiritual harmony."[1]

The spike in critical, academic, and popular attention afforded Lamb during his years with Fassbender cannot be overestimated. Many in the art world came to know his work for the first time during this period. A nurturing presence, protective of her artists to a fault, she enjoyed an easy rapport with Lamb, based on mutual respect. In the end, it was a radical shift in Fassbender's aesthetic focus that led the two in opposite directions: She began focusing on "finish-fetish" geometric abstraction and minimalist art by the likes of painter Frank Badur and neon sculptor Christian Herdeg. Her eye for this work

proved impeccable, but it became increasingly clear that Lamb—who, even at his most restrained, is far from a minimalist—did not fit into this new world of hard edges and color blocking. Reading the handwriting on the wall, he began putting out feelers.

As it turned out, he didn't have to stretch his antennae very far. In fact, he had only to walk across Superior Street, where Judy A. Saslow had been offering her mix of intuitive, Outsider, self-taught, visionary, folk, and ethnographic art since 1995.

"Ingrid's windows and mine faced one another," Saslow says. "And I remember looking over there and seeing for the first time these big, bold works by this fellow, Matt Lamb. I guess I was the only person in Chicago who had never heard of Matt Lamb, either as a businessman or a painter. So looking at these paintings, there was something in them that reminded me of why I'd always loved van Gogh as a young person: the sweeping colors, the original shapes. And I found myself saying, 'Wow, who is this artist, and why can't I find artists like that?' "

Just as Lamb had reinvented himself over the years, so had Saslow, transitioning from stay-at-home mom to elementary school teacher to practicing attorney to Outsider art expert. As the latter, Saslow had organized several important symposia in her areas of specialization and forged working relationships with scholars such as Genevieve Roulin, who, until her recent death, was Associate Director of Le Collection de l'art Brut in Lausanne.

Early in the new millennium, Lamb visited the Judy A. Saslow Gallery, introduced himself to Saslow, and confided in her about Fassbender's shift toward minimalism and the corresponding incongruity between his work and her new passion. Fassbender and he had been discussing the possibility of parting amicably, he told Saslow, if he were to find a more suitable "home." At the time, interest in Lamb as an Outsider was nearing its peak, and so to join with Saslow Gallery, a respected source of Outsider art, was a prospect that made a lot of sense. Saslow didn't want to step on Fassbender's toes, but during the following days, both women, along with Lamb, came to the agreement that Saslow was a better match.

"I was absolutely thrilled to take him on," Saslow says. "He couldn't fit in better with the work I carry. His painting is so sincere,

direct, original, and expressive, so far from the copycat style that so disgusted Jean Dubuffet. Matt goes at it with such passion, such a powerful internal vision! He isn't driven by the need for recognition or dollars, he's driven just by need to create something that's exciting and beautiful and that sends a message."

With Saslow representing him in Chicago, Lamb was covered on his home turf. But a host of other gallery reps, some of them as quirky as the characters that populate his paintings, were courting him elsewhere, from the caffeinated hipster hubs of the Pacific Northwest to the sultry streets of Miami Beach.

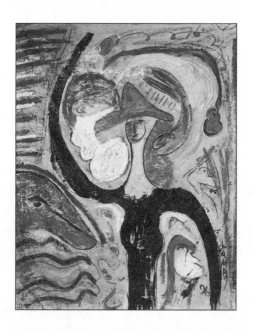

CHAPTER TWENTY-THREE

THE DOYENNE IN LEATHER PANTS

Virginia Miller looks hot in leather pants. She's a stunning redhead, six feet tall, whom both *Lear's* and *Town & Country* call "the doyenne of the Miami art scene" and whom *Miami* magazine dubbed "a one-woman cultural explosion."[1] She's wearing the leather pants as she escorts collectors through her Miami gallery, and there's something about her that's reminiscent of Frances McDormand's mature sex appeal as a rock 'n' roll producer in Lisa Cholodenko's *Laurel Canyon*. Miller's telling the collectors about the gallery's history, which starts back in 1925 . . .

It was Miami's golden age. The Biltmore Hotel had just opened, and starlets and playboys were driving down Miracle Mile in their Stutz Bearcats. The automobile company opened a showroom in Coral Gables in a building that used to stable trolley horses. The decades

passed, and the building changed hands, becoming a sculptor's studio after the Bearcat fell out of fashion, then a studio for the Russian ballet master, George Milenoff. A little girl, tall for her age, took ballet lessons there, and then grew up to be an art dealer. In 1979, Virginia Miller, who needed more space than her Coconut Grove gallery could provide, purchased her old ballet studio and hired an architect to gut and renovate it. Halfway through the renovation, the architect inherited millions of dollars and quit. Miller hired another. This architect turned out to be a severely disturbed manic-depressive who, after a few months of work, went off his meds and jumped off a five-story building nearby. The third architect, happily, was a charm. Two years after the project began, Art-Space/Virginia Miller Galleries opened with a gala attended by a thousand people. The evening had a Russian theme in homage to Milenoff, complete with caviar, vodka, and the Russian Balalaika Company strumming "Somewhere, My Love" beneath the 14-foot ceilings.

Miller's reputation is impeccable, her instincts nonpareil. She gave the portraitist Alice Neel a show in 1978 and Richard Pousette-Dart his first retrospective outside New York in the mid-1980s, anticipating the precise moments when both artists, widely perceived as past their prime, sprang back into fashion. She pushed the envelope with avant-garde installations by Sam Gillian and Eric Staller and brokered million-dollar commissions for sculptor John Raimondi, whose massive bronze sculpture in downtown Miami stands just feet from Biscayne Bay. A sought-after consultant for Fortune 500 companies, she outfitted E.F. Hutton's Manhattan headquarters with artworks by Pérez Celis, Kitty Klaidman, Richard Lytle, and Patricia Tobacco Forrester. In her hometown, she is, as *Lear's* calls her, "the heart and salsa" of Miami's Latin American art scene, with Latino and Latina artists comprising more than half her stable.

Miller had seen Matt Lamb's paintings in reproduction for several years, but the first time she laid eyes on them in person was in 1998 at Ingrid Fassbender's booth at the Art Miami fair. Her reaction was immediate and emotional: "They were so powerful, they made me smile and cry at the same time." She marveled at the "shimmering patina that other artists could only marvel at, but never reproduce." The works haunted her for a year.

In January 1999 she called Lamb and asked if he'd like to meet. He suggested she visit his studio in the Keys, and when she did, she offered him representation on the spot.

In December of that year, she presented a one-man show called *Matt Lamb: Another World*. In her introduction to the show's catalog, she warned her clients: "This is not tame art. This is wild, crazy, wonderful work that engages the emotions and challenges the intellect. If you're not careful, these fantastic creatures, colors, and forms will hold you in their spell forever."

In the spring of 2003 she presented his second one-man show at the gallery, *Evolution of a Vision*, which received a largely favorable review (written by yours truly) in *ARTnews* magazine. She has curated Lamb shows in Germany, the Southwest, and throughout Florida, and brokered the acquisition of an 8′ × 8′ Lamb painting by The Vero Beach Museum of Art, where it currently hangs as part of the permanent exhibition, *Tradition and Modernism*.

Of all Lamb's current gallery reps, Miller is the one with whom he has the most interesting relationship. Though she and her husband, the writer Bill DuPriest, are good friends with the Lambs, there is no denying that Miller is a gallerist and Lamb is an artist—which is to say, Miller can be a stickler, and Lamb can be a hard-ass.

"Virginia is a perfectionist," says Lamb, "which is her blessing and her curse. Nobody hangs a show like she does. She's obsessive sometimes. It'll be an hour before the show opens, and she'll have her assistants move a painting a quarter-inch down and an eighth of an inch to the right. She's impossible. She drives everybody nuts, but you know when she hangs your show, there's no one in the world who could have hung it better."

"Sometimes," Miller counters, "when Matt gets an idea in his head about how he's going to do something, there's nothing that can change his mind. He did some abstract pieces a couple years ago, six of which I hung in a grid for our Summer 2002 group show. They were really marvelous—they had the most delicate, ethereal passages in them— but then he went and slammed his big name on each of them, LAMB LAMB LAMB LAMB LAMB LAMB. I had advised him to sign them on the back, since they were hanging in a series—otherwise it looks

awkward with all those signatures. I had actually taken a triptych of his to a client's home, and they didn't buy it for that very reason."

"I remember that," says Lamb. "After she told me to do that, to sign them on the back, I thought about what she'd said. Then I went back into my studio and signed four more of them right on the front. I'm not interested in doing the customary thing. I'm too old and too rich to give a shit."

"There have been some gentle tensions between us," Miller acknowledges. "When I went down to pick pieces from his studio in the Keys, I spent considerable time getting the selections just right, and I had earmarked everything I chose to be shipped up to my gallery. So then the shipment arrives, and I notice that a number of the pieces are missing. So I call him up and ask what happened, and he tells me that my eye is so good, and that the pieces I picked are so excellent, that he's decided to send them to a show he has coming up in Ireland! He'd actually taken the paintings right out from under me! I mean, it was a compliment, but at the same time, it was confounding!"

Today, as Miller leads the collectors through her gallery, she pauses to show them stains on the oak floors. "You know what those are?" she asks them. "Paint stains from Matt Lamb paintings! They have so many of what he calls 'generations,' layers and layers of paint, that they take forever to dry. These stains came from when we got a shipment of his paintings that were three years old. We pulled them out and put them on the floor, assuming they had long dried. Bad assumption. He has paintings that have been drying for five years and are still wet!"

She pulls some of Lamb's works out and lets everyone take a look. Many of the works glint with gold and silver leaf, while others have big, puckered blobs that form a spirit's head or hat. Some of the collectors remark on the affinities between Lamb's work and the Latin American art Miller represents.

"Yes," she says, "there's a similarity in the uninhibited use of color." She points to one. "These tropical yellows and oranges are a bit reminiscent of modern Cuban painters like Pelaez, Portocarrero, and Carreño."

For all her good-natured exasperation at Lamb's idiosyncrasies, Miller appears to have found a way to do what certain other gallerists

have not been able to manage. She has found a way to "handle" Matt Lamb, if such a thing is possible. By bringing the omnipresent tensions between dealer and artist into the open, she defuses them with humor, rather than letting them fester in silence. This attitude is one difference between Virginia Miller and Carl Hammer, whose relationship with Lamb ended contentiously. There is another difference between Miller and Hammer: Miller looks better in leather pants.

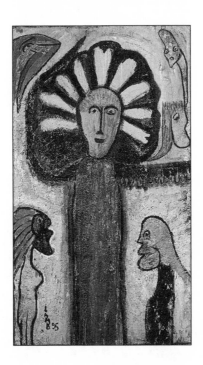

CHAPTER TWENTY-FOUR

THE DEALER WITH GLOW-STICK NUNCHUCKS

The booze is flowing, the deejay's spinning techno, and the dance floor's bouncing with androgynous twentysomethings in thrift-store retro chic, punked-out hair, and labret piercings. It's a warehouse party in hipster-meets-hippy Portland, Oregon, and the art scenesters are out in full force for the closing night of a performance festival sponsored by the Portland Institute of Contemporary Art. Outside there's a slight nip in the air, but inside it's sultry with body heat. Out on the dance floor a man is twirling glow-stick nunchucks, whipping them around in diagonal blurs amidst the flashing lights projected onto the walls. The man is in his fifties, and he's probably the oldest person on the dance floor. He's also one of the most connected.

Mark Woolley owns one of the more cutting-edge art galleries in the Pacific Northwest. He shows art other gallerists are afraid to show: a mix of lowbrow, highbrow, and avant-garde ranging from Walt Curtis' homoerotic reveries and Joe Thurston's psycho-portraits to Tom Cramer's intricately carved mandalas and Julia Fenton's multimedia feminist manifestos. Woolley knows everyone and has his nose in everything in Portland, organizing charity benefits for homeless youth, sitting on the board of the Cascade AIDS Project, and making it his business to circulate among the leaders of both the establishment and the up-and-comers in the DIY (Do It Yourself) movement. Ergo, you'll find him at whatever's the most happening party of the night, margarita in hand, chatting up blue-haired old ladies or blue-haired mohawk punks with equal commitment. Woolley, like Matt Lamb, skips merrily along the line between reactionary and radical, which may be the reason the two hit it off in December 2003, when Woolley, who shows Outsider artists like Anne Grgich at his gallery, flew to Chicago to pick paintings for a Lamb floral show.

"I was in awe of his studio," Woolley says. "It just goes on and on! And his floral pieces are unlike any I've ever seen."

Woolley talked art and noshed Italian food with Lamb by day, then danced his derrière off at Buzz and the Buddha Lounge by night.

Back in Portland, some worried whether the Northwest—birthplace of the grunge movement and home to a cadre of leftist Gen-X slackers—was ready for Lamb's chirpy, aggressively motivational message. They needn't have fretted. *The Oregonian* welcomed Lamb with a glowing show preview, and *The Portland Tribune*'s Joseph Gallivan penned a slyly observant profile, observing that, "with his crooked mustache and rumpled clothes, Lamb could pass for a barfly. He quit drinking decades ago and says painting has replaced alcohol in his life, but he still has the happy-go-lucky air of a boozer in his cups."

On April 1, 2004, after the opening of his show, Lamb held court before an audience of 75 young artists who'd crowded into architect Robert Oshatz's riverside home for a standing-room-only talk by the artist. Every gap that divided the speaker and his audience—generational, economic, religious, sociocultural—melted away as he whipped them up, these hempy vessels of patchouli-scented ennui, into a

remarkably receptive mood of optimism and free-flowing spirituality. After he'd concluded his 45-minute talk, the artists kept him for a full hour of questions and answers. As he spoke and the audience (including a somewhat relieved Mark Woolley) listened, his mind traveled back to an evening much like this one, eight years before in Chicago, when he'd set other young minds aflame with new ideas—ideas that had grown, as a direct result of his inspiration, into one of the nation's most innovative artistic successes.

It had begun, appropriately, in rage. Andres Serrano's *Piss Christ* had pissed Matt Lamb off. As radical as Lamb's own paintings were in the violence and unconventionality of their technique, he facetiously conceded that he had "still not evolved far enough in my art education that I can look at a crucifix in a bowl of piss and hail it as a masterpiece." Serrano's work had polarized the art world in 1989, but Lamb was still fuming in the mid-1990s. He was fuming not at the piece's blasphemy per se (although as a Roman Catholic, he must have been offended), but more pointedly at the trend toward negativity and nihilism in art, the preoccupation with dystopic themes that contrasted so markedly with his utopic vision of peace and brotherhood. So in 1996 he decided to hold a salon in his home in which local artists could discuss this aesthetic schism. He printed up flyers, distributed them in the visual and performing arts community, and waited. Fifteen people showed up, all between the ages of 18 and 30, and till the wee hours of the morning they batted ideas around like baseballs. These kids were not the disaffected youth they had been painted as in the media; they were passionate about the state of American cultural life and about their own stake in it.

One of the people at the meeting was Joe Cerqua, a composer, singer, and sound designer who'd written music for productions at the Steppenwolf, North Light, and Goodman Theaters. Cerqua's life partner and creative partner was Wilfredo Rivera, a Honduran-born artist quickly establishing a reputation as a dancer and choreographer on the regional and national scene. Inspired and energized, Cerqua left the salon and rushed back to Rivera, full of ideas and plans.

Several days later, Cerqua phoned Lamb and told him he and Rivera wanted to form an arts group dedicated to the ideals the group had discussed in the salon: openness, optimism, beauty, and creativity. Intrigued, Lamb met with the two almost daily for an entire month, coming up with grandiose schemes for projects that would combine visual arts and dance. Never one to dream small, Lamb suggested Cerqua compose music for an interpretive dance, which Rivera would perform while Lamb himself, off to the side of the stage, would paint images of peace onto the surface of a vintage World War II fighter plane.

At the end of the month, with many castles built in the air, the Lambs flew off to Florida for the winter, then Ireland for the spring, then Germany and Paris for the summer. When they returned to Chicago in the autumn after a full year away, there was a message on the answering machine from Joe Cerqua. Lamb called him back.

"It's done," Cerqua told him.

"What's done?"

"What we talked about last year."

"Refresh my memory."

"The arts group. We incorporated, I wrote the music, Wilfredo did the choreography, and we're in rehearsal. You've got to come over to meet with us, because we want to use your art as our backdrop— actually, as more than just the backdrop, as the whole inspiration for the dance pieces, the costumes, everything!"

And so was born the Cerqua Rivera Art Experience, which would grow into one of Chicago's and the nation's most innovative dance troupes. A cross between Cirque du Soleil, Hubbard Street Dance Chicago, and the lingering ghost of Bob Fosse, the troupe married ethereal, sometimes dissonant music with colorful dance routines that engaged the mind while pleasing the eye and ear. The Experience put on provocative programs, using the Mexican Day of the Dead as a metaphor for the AIDS epidemic, and staging a solemn but ultimately triumphant meditation on the Holocaust. They performed a eulogy to the victims of September 11th called *Jazz Pie*, and, in a lighter vein, delighted audiences with mambo and tango routines so *caliente*, they raised the auditorium's collective temperature by several degrees. Behind the dancers at nearly every performance, slides of Matt Lamb's

paintings were projected on enormous screens behind, beside, and above the stage. Sometimes, actual paintings are used, including two canvases 18 feet tall and 6 feet wide.

"Matt's art is the perfect complement to our dance and music," Cerqua says. "It's visceral and multilayered, which is exactly what Wilfredo's choreography and my music are all about."

Many Chicagoans, especially those young enough never to have heard of Lamb as a high-profile funeral director, came to know his work as an artist through Cerqua Rivera, which continues its innovative performances to the present day.

"You should see the young people who come to these concerts," the artist enthuses. "They've got all these piercings all over their faces, and crazy colored hair and mohawks! Most people Rose's and my age would be scared away by all that stuff, but we love it!"

The dance troupe was only one of the many organizations with which Lamb was to collaborate through the years. The American Heart Association of Metropolitan Chicago and The Ronald McDonald House at Wyler Children's Hospital in Chicago both enlisted him to create works of art to hang in their facilities or be auctioned off at charity fund-raisers. He also received significant commissions, including one from the William Ferris Chorale, which in 1993 enlisted him to create the visual component of a gala performance at the Chicago Cultural Center. On the Chorale's program was Sir William Walton's 1923 experimental performance piece, *Façade*, a landmark of early Surrealist theater that combines Walton's musical sketches with Dame Edith Sitwell's poetry. To commemorate the 70th anniversary of *Façade*'s premiere, Lamb created one of his largest pieces to date, a 32-foot-tall painting called *Great Façade*, comprised of 64 panels, each 2' × 2'. When the installers mistakenly juxtaposed several of the panels, the artist told them to leave them that way, since mistakes and chance happenings are part of the Dada/Surrealist tradition. The composer's widow, Lady Susana Walton, attended the performance bedecked in a scarlet feather boa and pronounced Lamb's painting "magnificent."[1] Perhaps even more significantly to the ever-youthful Lamb, the 20-year-old gallery assistant who helped transport the piece to the concert hall pronounced it "totally cool."

Another important commission came when Moraine Valley Community College in suburban Chicago asked Lamb to create a 15′ × 11′ piece for the entry to the college's Contemporary Technology Center. For the pyramid-shaped *Tomorrow's Child*, Lamb affixed 11 canvases to a stainless steel background, whose highly polished surface reflected the art-viewers' faces, making them realize that they themselves were the children of the future. The college rededicated the work in 2003 with a special ceremony honoring Lamb and in 2004 announced plans to erect a Matt Lamb Museum. College administrators also began using reproductions of Lamb's art on all their promotional materials and catalogues and made his monumental series, *Contemplating Diversity*, the centerpiece of a two-year campus-wide educational program.

Saint Xavier University in Chicago also enjoyed a close working relationship with Lamb, as did Saint Thomas University in Minneapolis, Minnesota. Over the past 20 years, Saint Thomas amassed an impressive public collection of Lamb's paintings, reproduced his artwork on the college chorus' compact discs, inaugurated its downtown Minneapolis campus with a 16-painting Lamb exhibit, repeatedly hosted him as a lecturer, and in 1996 awarded him an honorary doctorate.

Sasaki and Villeroy & Boch, two companies dealing in art-glass, crystal, and ceramics, enlisted Lamb as a designer in the late 1990s and early millennium. Headquartered in Germany, Villeroy & Boch has been crafting crystal and china since 1748 and commissioned Lamb to design a limited-edition "Peace Glass." Lamb asked his family for inspiration and ideas, and together they came up with the idea behind the glass: Each time it is raised, its owners drink a toast to world peace. The resulting six-inch goblet was prepared by Villeroy & Boch in association with PapaPaints, Inc., a company owned by Lamb's youngest daughter, Sheila Lamb Gabler. The glasses were sold internationally and carried in the United States by Nordstrom's and other upscale retailers.

In 2001, the crystal and china manufacturer, Sasaki, commissioned Lamb to design a line of glass sculptures to be sold at Bloomingdale's and Marshall Field's. Adamant that the pieces be hand-painted on the finest crystal, Lamb also demanded that the finished product retail at no higher than $100 apiece, making them affordable as birthday or

Christmas presents. With daughter Sheila responsible for quality control, he began designing the pieces: eight hand-cut sculptures, each depicting a different spirit from his pictorial menagerie, housed in a deluxe presentation case embossed with his signature. Amid much fanfare, the pieces were released during the 2002 Christmas season.

Also in 2002, a French publisher licensed reproduction rights to Lamb's painting, *The Crucifixion*, and used it as the cover of Pierre Bordage's novel, *L'evangile du Serpent*. The painter's artwork was also featured on the cover of two German-press poetry anthologies, *Blaue Glocken* and *Wurzeln der Kraft*, by Hans-Guido Klinkner.

That same year, the Argentinean wine maker Jesus Carlos Fantelli purchased the rights to use reproductions of Lamb's paintings on the vineyard's wine bottles. Fantelli e Hijos owns large vineyards at the foot of the Andes and produces, among other varietals, a line of Cabernet Sauvignons that has been voted the finest in the world.[2] The first year the Lamb-adorned bottles were produced, Fantelli sold 60,000 units worldwide, with a portion of proceeds from every bottle benefiting "The Lamb Umbrellas for Peace." There is a measure of irony in the fact that a man who gave up drinking 20 years ago now has his name and paintings affixed to bottles of Merlot, Malbec, Mistela, Cabernet, Chardonnay, and three varieties of Syrah. Lamb is fully aware of this irony—and loves it.

PART SIX

THE POPE, THE PRINCESS, AND THE GIANT CHILD

. . . The Piper turned from South to West,
And to Koppelberg Hill his steps addressed,
And after him the children pressed;
Great was the joy in every breast.
—*Robert Browning, The Pied Piper of Hamelin (1888)*

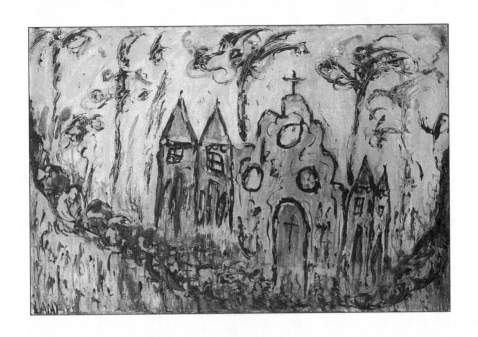

CHAPTER TWENTY-FIVE

PAINTING FOR THE POPE

It wasn't Lamb's prestigious commissions or quirky gallery reps who got his work into the Vatican Museums' permanent collection—it was Michelangelo. In the early 1990s, Dr. Walter Persegati, then director of the Vatican Monuments, Museums, and Art Galleries, was in the United States raising money for the restoration of Michelangelo's Sistine Chapel frescoes. During his stop in Chicago, Persegati, whose curatorial eyes never closed, took in several gallery and museum shows. In the course of these rounds, he saw a one-man show featuring Lamb's figurative work and was particularly struck by one of his explicitly religious works, *The Crucifixion*. The painting, with its simplified but evocative shapes, portrays Christ as a childlike innocent whose benevolence emanated even during his most horrific sufferings. Persegati was deeply moved, contacted Lamb, and spoke with him

about acquiring the piece for the Vatican Museums. As both an artist and a Catholic, Lamb was thrilled.

Persegati took slides and photographs of the painting back to Rome to share with his curatorial advisors, and on November 2, 1993, after a long review process, he sent Lamb a letter that read, in part:

> The Vatican Museums' Modern Art Commission will dedicate your painting, *The Crucifixion,* as part of the celebration of the unveiling of Michelangelo's *The Last Judgment* at the conclusion of our 13-year conservation project in the Sistine Chapel. Be this acceptance an encouragement to pursue your vocation with purity of heart, your hand guided by spiritual inspiration.

Five months later, the Lambs numbered among the VIPs at a formal Vatican dinner celebrating the completion of the Sistine Chapel restoration. Splendidly costumed guards escorted the artist to the front of the banquet hall, hung with gilded chandeliers, where *The Crucifixion* was unveiled as the newest addition to the Vatican Museums' permanent collection.

That evening after dinner, just as the Lambs returned to their hotel room, their telephone rang, and the hotel switchboard operator told them to hold for a call. It was the personal appointment secretary to Pope John Paul II, inviting them to Mass the following morning at six.

And so it came to pass that on April 7, 1994, Lamb's 62nd birthday, the artist, his wife, and 14 other people were escorted into Pope John Paul II's apartments for an audience and Mass with the leader of the Roman Catholic Church. Lamb brought a catalog in which *The Crucifixion* was reproduced and presented it to the Pope upon his introduction, explaining that, as head of the Church and sovereign of Vatican City and its museums, he was now the painting's official owner. John Paul accepted the catalog and the painting with deep thanks and spoke with Lamb about the nature of artistic inspiration and its importance in a world racked with turmoil.

"He was a true mystic," Lamb says. "He had this profoundly otherworldly quality about him. He's a paradox in many ways. He has the

ability to bring people together but also to grind people down if they're doing something he feels isn't right."

The Vatican's relationship with Lamb was to continue. Five years after the unveiling of *The Crucifixion*, a series of 15 paintings was hung in the Pontifical North American College, a seminary and residence for priests doing graduate work in Roman universities. The series was assimilated into a chapel dedicated to Lamb's late friend, Cardinal Joseph Bernardin, Archbishop of Chicago. The painter enlisted folk artist Larry Ballard to create additional art for the chapel and for the Immaculate Heart of Mary Chapel that adjoined it. Ballard, a fellow South Sider, carved a large, wooden sculpture depicting Christ bearing the cross, while Freeman & Associates, the designers who had decorated many of the Lambs' homes, collaborated on the installation.

To have his work acquired by the Vatican Museums was a source of spiritual reflection and personal pride for Lamb. In 1999, upon his return to Chicago from the Pontifical College unveiling, he encountered a gallery-goer hostile to his work.

"Sorry you don't like my stuff," Lamb told the man, "but, you know, the Pope thinks it's pretty good!"

CHAPTER TWENTY-SIX

THE SPIRITUALIST TAKES ON
THE MALL OF AMERICA

It's a long way from Bernini's colonnade in Vatican City to the Gap and Hot Topic at the Mall of America. But the journey from Rome to Bloomington, Minnesota (near Minneapolis/St. Paul) was a journey Matt Lamb was determined to make—and almost did.

As the 1990s neared their end and the millennium loomed, Lamb dreamed up a trilogy of related paintings to mark the temporal odometer's rollover from nines to zeros. The first of these pieces was his series for the Pontifical North American College, a 15-painting meditation on the theme of acceptance even in the face of injustice. The second installment was to address the indomitable hope for world peace and was to be exhibited at Saint Thomas University, then moved to the Mall of America, (in)famous mecca to consumer culture. The

series' third and final component was to be a monumental installation at Westminster Cathedral in London, addressing Lamb's perennial pet themes: life, death, and resurrection.

As fate would have it, the Vatican and Westminster projects not only came to pass, they went swimmingly, on schedule and on message. Not so with the Mall of America project, which Lamb had looked forward to as an exercise in juxtaposition: counterposing his spiritual themes with the *haute* consumerist setting the Mall afforded. On paper, the project looked like one for the ages. But a funny thing happened on the way to the mall. The devils and angels Lamb had long painted wound up doing battle over the project, and this time, the devils won.

It all began promisingly enough. St. Thomas University in Saint Paul, Minnesota, coordinated an initial outreach to the Mall of America in 1996, a full four years before the installation was to be unveiled. As part of celebrations marking the millennium, the mall was to display a 64′ × 12′ painting featuring two giant figures in transit between the material and spiritual worlds, surrounded by flowers, a supporting cast of Egyptian- and Etruscan-looking spectators, and a savior figure whom Lamb likens to basketball player Michael Jordan, but who might, *just might*, have been Jesus Christ, depending on whether your reference point was Nazarene or the N.B.A. Mall managers and arts-and-entertainment coordinators met with Lamb in Chicago for two days in 1997 and followed up the following year, flying down to the artist's studio in the Florida Keys to discuss technical aspects of the piece's installation. St. Thomas sent two composers and a choreographer to meet with Lamb to collaborate on a song-and-dance extravaganza for the piece's dedication. Licensing and other legalities were settled, and in 1999, all systems were go.

Then, about a month before the scheduled opening, Lamb received a letter from the Mall's top managers informing him that the installation had been canceled. No explanation was given beyond the vaguest references to unforeseen scheduling difficulties, no apology proffered beyond the most peremptory. He appealed for more explanations but found none forthcoming and made behind-the-scenes inquiries but uncovered only hearsay.

Did the Mall's board of directors come down with a case of eleventh-hour cold feet? Was the painting's spiritual imagery perceived as too overt in the era of P.C. and A.C.L.U.? To this day, the matter remains a Churchillian "riddle wrapped in a mystery inside an enigma."

"Whenever you do a project about peace and love," Lamb says, "there's a whole counterbalance of forces about destruction, killing, and envy that work against it."

Recently contacted for comment on the incident, Monica Davis, public relations manager for the Mall of America, reported that "unfortunately, the people that were here at that time and may have worked on the event are no longer at Mall of America."[1]

For whatever reasons, a vital leg of Lamb's millennial tripod had been amputated, and now, the trio would have to suffice as a duo. The score was now even: angels one, devils one. The tiebreaker would be fought in a cathedral, and a princess would referee.

CHAPTER TWENTY-SEVEN

THE KNIGHT AND THE PRINCESS

Disappointed by the Mall of America setback, Lamb forged on toward the millennium and one of his most spectacular challenges as an artist: an enormous, gravity-defying installation inside Westminster Cathedral, officially patronized by one of the most glamorous members of the British Royal Family. Lamb's showstopping entrée to the London art scene was remarkable not only for its venue and scope, but also for the sometimes shocking behind-the-scenes maneuvering that led up to it.

Seat of the Catholic Church on the British Isles, Westminster Cathedral was designed by the Victorian architect, John Francis Bentley, and erected between 1895 and 1903. Unlike the Gothic Westminster Abbey, which was begun in the thirteenth century and completed

in the sixteenth, the Cathedral was built in the Early Christian Byzantine style and has an airier feel.

In 1998, Monsignor George Stack, then the Cathedral's rector, traveled to Chicago during the Westminster Cathedral Boy's Choir's tour of the United States. While in town, he encountered the art of Matt Lamb and was struck by its mixture of complexity and simplicity. Through Church channels, the Monsignor arranged to meet the artist, and during the meeting, the irrepressible Lamb launched into an impromptu dissertation on his idea for a millennial trilogy: one part in the Pontifical College, another in the Mall of America, and another in a location yet to be determined. At this point, Stack made Lamb an astonishing offer: to bring his *Love* series (12 monumental panels depicting the life of Christ) to Westminster Cathedral for the first-ever exhibition by a living artist inside the Cathedral's walls. Lamb could think of no better climax to his trilogy and agreed in principle to go forward, at which point both men began courting corporate sponsors to underwrite the project's significant costs.

As the undertaking evolved, several high-profile patrons in the British art world associated themselves with the historic exhibition: Dr. Alan Borg, director of the Victoria and Albert Museum; Professor Christopher Frayling, Vice Provost of the Royal College of Art; Cherie Blair, wife of Prime Minister Tony Blair; His Excellency, Edward Barrington, Irish Ambassador to the United Kingdom; Anne Mary Teresa Constable-Maxwell, the Duchess of Norfolk; Lord St. John of Fawsley; and most prominently, Her Royal Highness, Princess Michael of Kent.

While the interest generated by these socially elite patrons was high, a corporate sponsor with sufficiently deep pockets never materialized. Lamb and the Cathedral's top brass agreed to work together to minimize the exhibition's incidental expenses, in which Lamb consented personally to share.

The logistics associated with the show, however, turned out to be far greater in scope than Lamb ever dreamed. The details were worked out between Lamb and a British liaison whose crass pettiness in dealing with the artist contrasted sharply with the project's high-minded aspirations. Lamb's daughter, Sheila Lamb–Gabler, served as her

father's right-hand woman in negotiations with this liaison, who at the outset of the negotiations made it known that Lamb could not simply fly over his own assistants from Chicago to hang canvases in the Cathedral. That would not do, even though those assistants were more familiar than anyone with the technical requirements of Lamb's art. No, for one thing, there were lighting and electrical issues to be dealt with. Elaborate checks would have to be performed to ensure that the lighting grid could withstand the show's demands and not throw the circuit breakers. In addition, an elaborate scaffold, from which the paintings would hang, would need to be designed, engineered, constructed, and installed. In order to hoist the paintings up onto this scaffold, an elaborate rope-and-pulley system would have to be custom-built. Furthermore, health and safety requirements would need to be researched, addressed, and complied with, with the necessary legal counsel employed and permits applied and paid for. The paintings, moreover, could not be hung just any old time, but would have to be installed—and later taken down—only during a brief window in the afternoon or the wee hours of the morning. Workers could enter and exit the Cathedral only through controlled security access points. Temporary hardwood floors would need to be installed so that none of the heavy equipment used for erecting the scaffold would scuff the Cathedral's marble-mosaicked walkways.

Most important, the overall scheme for hanging the works would have to be reviewed at length and approved by the Cathedral's supervising architect. This meant that detailed plans would need to be drafted by a professional team in advance of submission to the architect. This complicated process was necessary in order to insure that the installation would come across in the most professional manner possible; Lamb couldn't just have a couple goons from Chicago slap the canvases up on a clothesline, after all—this was Westminster Cathedral!

Already, Lamb's generous offer to help out monetarily—he'd initially believed his contribution would run only a thousand or two pounds sterling—was mutating into a bureaucratic and financial nightmare in the tens of thousands of pounds, all subject to the United Kingdom's 17.5 percent value-added tax, with no end to the complications in sight.

When the drafting team sent an estimate of its charges to the liaison, he faxed it directly on to Lamb, adding: "I must impress upon you that Westminster Cathedral cannot be seen to be putting on something that looks cheap and nasty . . . It will reflect very badly on the Royal Presence [Princess Michael] and the Archbishop." Time was running out, furthermore, for Lamb to cough up the cash. In a week's time, the artist would need to either foot the massive bill or forfeit the entire exhibition. "And that," the fax concluded, "is no bullshit."

After receiving the fax, Lamb made a round of calls to other drafting and installation teams in London, shopping around for more reasonable bids.

The hard sell continued. "As you know, money talks," read another fax. "I am sorry to speak like this, but I think it is better to be frank than beat around the bush."

In the meantime, Lamb's daughter, Sheila, was volleying e-mails back and forth with the liaison regarding the attendance of Princess Michael at the installation's gala opening.

The Princess, formerly Baroness Marie-Christine von Reibnitz of Bohemia, married Prince Michael in 1978, when he was eighth in line to the throne. She is a cousin of both Queen Elizabeth and the Queen's husband, Prince Philip, an avid equestrian, author of two historical books, and a lecturer who speaks on history and the humanities. The Princess often represents the Queen at state funerals and coronations and lives with the Prince at Nether Lypiatt Manor in Gloucestershire and Kensington Palace in London, the Jacobean mansion where royals from William III to Queen Victoria have lived and which more recently housed Princess Diana after her divorce from Prince Charles in 1996. A timeless blond beauty, Princess Michael possesses great charm but is prone to occasional bouts of feistiness and controversy, not unlike Matt Lamb himself. (Her inopportune remark in a Manhattan restaurant early in 2004 set off a field day in the New York and London press.)

After a definite date for the show was arrived at, the Lambs drafted a list of friends and family members who wished to fly to London to attend the opening and Royal Reception. When Sheila e-mailed this

list to the liaison, he balked, advising her to radically cut down on the invited guests: "Buckingham Palace has just informed me that a maximum of 150–170 people are acceptable, so as not to have a crush around HRH [Her Royal Highness]." Besides, he sniffed, the guest spots were better reserved for English guests, as Lamb's family and friends "have no influence upon the English press."

Sheila, growing impatient with these condescending airs, was at last thrown a bone and put on the list, along with her young daughter, for the royal receiving line. But, she was warned, she must do a drop curtsey when the Princess approached. Clothing guidelines must also be strictly adhered to. Pantsuits, for the love of God, must not be worn: "It is regarded, as one might say, as having no taste and very, very common. And if such a person were to wear such an outfit, they would not be allowed anywhere near the Presence of Royalty, and might not even be allowed to enter the building." Nor should Sheila get any ideas about wearing a dress that too closely resembled a ball gown, nor anything strapless, off-the-shoulder, or brightly colored. No, only an evening dress would do, one that stopped an inch or two below the knee. Sheila's daughter was highly advised to wear a black dress, sleeves just over the arm, with white lace trim. As for jewelry, "ladies can wear diamonds, gemstones, the lot, as long as it is real—showing off jewels is always a lady's privilege in the evening."

It is no great stretch to imagine what Matt Lamb, whose hatted figures satirize pretension and power plays, must have thought of these supercilious communiqués. Nevertheless, he and Sheila were successful in finding ways to cut costs without sacrificing the installation's quality, and while Lamb did wind up spending more than he'd originally planned, he did so with the end goal in mind: sharing with thousands of people a series of deeply meaningful paintings whose theme was no less than universal love.

"To me," he says, "getting the message out was the most important thing. For the Church to put this crazy, Irish-American artist inside Westminster with this avant-garde look at the life of Christ was a statement on their part saying, 'For the millennium and for the people of the next generation, we're open to everyone who'll come in the door.'

Catholics believe that Christ, by his life and death, changed the world. My message at the Cathedral was: The individual can also change the world. And the installation was a real megaphone for me to scream that message out to the world."

On June 6, 2000, the guests—not a one of them wearing a pantsuit—did their drop curtsies and bows at the royal reception. Among those guests was Lamb family friend Erica Meyer, who recalls how at ease Lamb was when greeting the Princess. "He was so laid-back," Meyer says, "and it struck everyone how remarkable the whole show was, the contrast between this stuffy, old cathedral and Matt's paintings, which are these emotional, trying-to-get-in-touch-with-yourself contemporary works."

When the Princess met Lamb, he presented her a piece of jewelry he had designed especially for her: a necklace crafted from a small piece of coral that had washed up in front of his beach house in the Keys, which he'd painted, hammered gold leaf into, and set in an 18-karat gold pendant. Next, he led her through the installation, which was hung aloft in the first three triforiums on either side of the Cathedral's nave. Squiring her around like the princess she was, Lamb, a Papal Knight himself, pointed out the *Love* paintings' significant features and spoke passionately about their meaning. She asked him a bit about his first life as a funeral director and his current life as an artist and marveled at the courage it must have taken to leave behind an established reputation in business to pursue the nebulous dreams of the painter.

"You are an inspiration to us all," she told him as the British press gathered round. "Thank you for what you have given us and all the British people today."

One of the members of the press in attendance was London art critic Maria Walsh, who went on to rave:

> . . . The paintings are not didactic . . . Instead, they communicate
> the sensibility of these values in a joyous and ebullient cacophony of
> color and form. Lamb's figures and objects are almost calligraphic,
> his brand of pictorial writing functioning as a shorthand for
> profound spiritual feelings.[1]

The Times of London had announced the exhibit in its Court Circular, which records the comings and goings of the Royals, and sent correspondent Ruth Gledhill to the opening to pen a feature on Lamb. Gledhill reported that, because of Lamb's highly idiosyncratic Art Brut style, the "exhibition was expected to cause controversy in conservative Roman Catholic circles. But what has astonished clergy at the Cathedral, which is built in the Early Christian Byzantine style, is how well the paintings fit with the marble, mosaics, and religious art already there. Nervous Cathedral staff . . . expected a flurry of complaints, but the paintings received nothing but praise. 'They truly seem to belong here,' said one priest. 'We would love to have them permanently, but we could never afford them.' "[2]

Thousands of churchgoers, tourists, art collectors, and curators saw the installation during its month-long run, and for many among them it was their first exposure to Lamb's work. This auspicious London debut would open many doors, leading to gallery shows and Lamb's participation in a major art project involving students at five London schools—a project that would culminate in a celebration at Trafalgar Square and an official reception at Clarence House, residence of Prince Charles.

Shortly after his return to the United States after the Westminster show, Lamb received a letter from Kensington Palace, dictated by Princess Michael to her Lady in Waiting. "Thank you," said the Princess, "for the marvelous exhibition of your moving and beautiful work. The panels are truly amazing."

The kid from Bridgeport, who'd roamed the streets with the Dirty Dozen getting the shit kicked out of him, had now hobnobbed with royalty and become the toast of London. For most people, this would have been a peak experience that defined and capped a lifetime. Not so for the ever-restless Lamb, who was already on to the next big dream. No time to look at scrapbook photos and press clippings—the big 7-0 was just around the corner, and the millennium, which the Pontifical College and Westminster exhibits had so optimistically presaged, had commenced with a dewy blush of hope, happiness, and the promise of world peace.

Then came September 11, 2001.

CHAPTER TWENTY-EIGHT

GIANT CHILD

The terrorist attacks of September 11 made widows and widowers out of thousands of wives and husbands, and orphans out of countless children, some of whom had yet to be born. In the attacks' aftermath, a Washington-based nonprofit group called TAPS (Tragedy Assistance Program for Survivors) received a mandate from U.S. Representative Henry Hyde (R-Illinois) and the United States Congress to help the orphans of 9/11 deal with their profound losses. Drawing on the long-established practice of art therapy, TAPS counselors began developing strategies through which the children might deal with their traumas through the healing power of art. Several members of the TAPS board of directors were familiar with Matt Lamb's painting and his history with humanitarian causes. After the somber, six-month anniversary of the attacks had passed, the board approached Lamb and asked him to

lead a program called "Good Grief Camp for Young Survivors." He agreed and chose the umbrella as the central image of the program.

Lamb and umbrellas go way back. In the late 1960s, he'd flown to New Orleans for a Preferred Funeral Directors convention. On the convention's last night, the group, no doubt rowdy from a few Hurricanes too many, took down the decorative parasols adorning the conference room, hoisted them aloft, and began a mock funeral procession in classic Big Easy style. They'd marched around the room singing, "When the Saints Go Marching In," then paraded through the hallway and down the escalators, taking the party out onto Canal Street and east into the Vieux Carré.

Since then, he has reprised the jazz funeral at every opportunity, with the umbrella his leitmotif and talisman.

"I call him the Giant Child," says Simone Nathan, "because he's like a grown-up kid, always pulling you into these wild conga lines with his hats and umbrellas."

Since his dalliance with death in the early 1980s, his impromptu parasol parades have held a special poignance, as if the mock processions were the funeral march that might have been his own, had he not been given a second chance. He has also reprised his umbrella parade in his art, in which fanciful parasols appear out of nowhere, floating in the corners of his compositions or brandished like scepters by his Fun King, his jester, his mad hatters.

"I love the symbolism of the umbrella," he says. "If it's pouring down rain and you're wearing your best suit, and somebody offers you a place underneath a big, oversized umbrella, you're not going to refuse just because the person is an Irishman or a Jew or a Latino."

For his workshops with the children of 9/11, the umbrella's symbolism would prove even more significant. Over the course of three days in the spring of 2002, Lamb flew to Washington, D.C., and met with 38 children who had lost at least one parent in the terrorist attacks. Wearing a dark shirt, a blue denim vest, and blue jeans, he strode into the conference room where the children awaited, many of them withdrawn or nervous. One by one he greeted them, handing them umbrellas and an assortment of glitters, glues, pom-poms, paints,

and other art supplies. He hoisted his own umbrella and opened it, throwing superstition to the winds, and broke into a wide smile.

"Today we're going to paint or collage something about ourselves on the outside of these umbrellas," he told the kids.

A boy with a spiked, asymmetrical haircut raised his hand. "You mean we're going to paint our pictures?"

"Whatever you want. Your face, your hobby, your dreams. Any way you see it, you do it."

He paced back and forth between them, encouraging them as they began to work, whinnying at them with his "Have you ever seen a horse with a headache?" routine and provoking squeals of laughter. A fourth-grade girl in baggy pants and a clunky silver necklace who, according to her mother, hadn't cracked a smile in weeks, was now laughing out loud at Lamb's loony antics.

The children painted in orange and kelly green and lilac and blood red. One boy wrote the phrase, "I am, so I exist," across the panels of his umbrella. Several painted American flags. Some hung streamers from the umbrellas' spokes, while others stabbed holes through the nylon. One girl wrote a poem. A boy glued tulle onto his, and another girl painted Chinese characters. A teen drew the faces of Thalia and Melpomene, the classic comedy/drama icon.

"Now, I want you to put down the umbrellas for a minute, take some of the paper I gave you, and draw something on it about the person you lost on September 11th."

The children became quieter. They drew stick figures of an adult holding a child's hand. The initials of a mother. "I love you, Dad." Stars, angels, messages: "Lost forever, Love forever."

"Now," Lamb instructed, "tear it up."

"Huh?"

"Tear up the drawing you just did."

Some tore the sheets into four neat sections. Others ripped them to shreds.

"Now we're going to take the torn pieces and glue them on the inside of the umbrella. The pieces on the inside represent the people who died. They're not in the same form they were in before, but

they're still here. The outside of the umbrella is you: your hopes, your dreams, your personality. The two sides are touching. They're close together even though there's a membrane between them. The people on one side can permeate that membrane and help the people on the other side. What we're doing here represents an interplay between those of us who are alive and those who aren't."

The next day, the kids took the umbrellas that lay drying overnight and filed into parade formation. In the front of the room, Lamb rallied them with a speech that would have put a statesman to shame: "With these umbrellas, we're showing the world what we're about. We've been kicked, we've been killed, our buildings have been destroyed, but our spirits haven't. Our loved ones are still with us. What you've done these last couple days is about rising from the ruins and being victors, not victims. So let's go outside and express that. Laugh, cry, raise your fist, sing, wave, anything you want. And know that the umbrellas you made are going to travel all over the world as we work with more children who've had their own tragedies to deal with. So come on, let's go have a parade!"

And they did. Some of these kids had never heard, much less sung, "When the Saints Go Marching In," but they learned the verses as Lamb belted them out. Dancing his jig, one hand jabbing a cane into the air in staccato rhythms, his other hand clutching the umbrella he himself had painted, he led them through the room, out into the lobby, and around the hotel in circles, these children and teenagers of all colors and backgrounds, following him, screaming and clapping, to the spot where a group of Congressmen and TAPS representatives received them and whisked the umbrellas away to the Sam Rayburn House Office Building on Capitol Hill, where they were put on display. Camera crews surrounded this motley crew, the children and the Giant Child, zooming in on faces that had been sullen three days ago but now glowed with a joy that would hopefully be more than temporary. A blond reporter in a salmon-colored top thrust a microphone in Lamb's face and asked him what he thought of the children's umbrellas.

"They're just magnificent," he beamed. "This is one of the best days of my life. When I look at these kids, I think to myself, 'This is what hope and love look like.'"

Word of the Good Grief Camp's success traveled quickly back to Lamb's hometown, Chicago. Several months later, Gallery 37, cofounded by Chicago's Cultural Affairs Commissioner Lois Weisberg and Maggie Daley, the city's First Lady, invited the artist to participate in a similar project, not with 9/11 survivors, but with at-risk youth from the city's most depressed neighborhoods. TAPS teamed up with Gallery 37, as did Paul Newman's charitable foundation, Newman's Own, which selected the project to receive one of its annual grants.

Because the Chicago children had not lost loved ones, but were facing challenges like poverty, gangs, drug and alcohol abuse, and teen pregnancy, the symbolism of the umbrella's two sides underwent necessary adjustments. The drawings inside—which were left intact, not torn up—became the kids' hopes, dreams, and ambitions for the future, while the outside represented their lives in the present. The interplay between the two sides, then, signified the dynamic between today's dreams and tomorrow's reality. After the umbrella-painting workshops were over, Lamb led the children down Randolph Street and across LaSalle as the wind blew many of the umbrellas inside out. They marched onward into City Hall and then through the County Building, their voices bouncing off the marble walls as they sang "God Bless America." Finally they reached the Richard J. Daley Center, with its walls of windows and views of skyscrapers outside rising up past the plaza's 50-foot-tall, 162-ton untitled sculpture by Pablo Picasso. Several TV news crews greeted them there, thanks to the efforts of veteran Chicago public relations consultant Sheila King, who had lent her considerable talents to the endeavor.

Since the Chicago event, schools around the country and the world have asked Lamb to visit them and paint with their students. In March 2003 he took "The Lamb Umbrellas for Peace" to Strasbourg, France, where the umbrellas assumed the symbolism of togetherness fostered by the European Union. This time, the entourage marched into the Louise Weiss Building of the E.U. headquarters and raised the rafters with song, Lamb teaching the kids American tunes, they teaching him French ones.

Two months later, he traveled by train with 29 German children from the state of Saarland northeast to Berlin, where together they

marched through the Brandenburg Gate. With them they carried not only the umbrellas they'd painted the day before, but also, as Lamb had promised, the umbrellas decorated by the kids from Washington, D.C., and Chicago.

As 2003 came to an end, Lamb took his "Umbrellas for Peace" to London, working with physically and mentally challenged children from the Paddock Special Needs School and other schools throughout London, Middlesex, and Kent. The artist and children gathered on November 6, 2003, for an exultant parade around Trafalgar Square and were later received at Buckingham Palace and Saint James Palace by the offices of the Queen and the Prince of Wales, respectively.

Clearly, Lamb's message of unity and love is resounding in Europe. Under the sponsorship of E.U. Education and Culture Secretary Viviane Reding, the 626 members of the European Parliament have invited more than 8 million primary and secondary students to stage their own version of the "Umbrellas for Peace." The response thus far has been phenomenal.

Plans are in the works for a group of Chinese students to parade with Lamb through Tiananmen Square in Beijing, stopping to arrange the umbrellas in a circle on the very spot where a defiant Chinese student blocked a column of government tanks during the infamous 1989 crackdown. (Whether Chinese authorities will allow this symbolic tribute to occur remains to be seen.) The next day, Lamb and the children will take the umbrellas to the Great Wall. And thanks to the sponsorship of David Sabin, founder of the Salton corporation, and his wife, Susan, Lamb will take the "Umbrellas for Peace" to South Africa in 2006 as a fund-raiser benefiting children with AIDS.

Working pro bono, Lamb hasn't made a penny off the "Umbrellas"; in fact, because he pays for his own flights, he's lost money. Why, then, does he do it?

Lamb relates something that happened to him nearly a year after he'd done his project with at-risk youth in Chicago. One day he was walking home from a function, the streets relatively deserted, the clicking of his heels echoing through the alleyways and up the sides of concrete buildings. Suddenly he heard other footsteps behind him, and the chatter of male voices, the footsteps getting faster and closer, and

when he looked up he found himself surrounded by a dozen tough-looking teenagers. The man who preached tolerance and understanding now looked into the faces all around him. The faces began to smile.

"You're that painter guy!" one of the teens said.

"You were the one who painted those umbrellas with us! What's your name?"

"Matt Lamb," he answered with a smile that mirrored theirs.

"Did you take our umbrellas around the world yet?"

"I sure did—I took 'em through the Brandenburg Gate in Germany!"

There were whoops and a rustle of excitement. "Germany?" one of the teens exclaimed. "Wow!"

As he finished walking home that day, he realized he was onto something.

CHAPTER TWENTY-NINE

POLLYANNA MEETS PATTON

Coming out of the Washington and Chicago "Good Grief Camps" on a wave of goodwill, Lamb had little way of knowing he was sailing into the biggest maelstrom his art career had ever known. Still, temperamentally, he could not have been better prepared.

"I'm part Pollyanna, part Patton," he says. "I love Gandhi, but I'm more of a warrior than a pacifist. I'd rather cut off their fuckin' heads than love them. I'll love 'em after I've killed 'em. My art is about peace and love, but it comes from rage."

It is a rage that begins in the seething chaos of the dip, continues as he terrorizes the canvas with blowtorches and ice picks, and terminates in his tirades against the world's injustices and the art establishment's hypocrisies. To use his terminology, Lamb's "Indian" is that he

gives lip service to a world of apple trees and honeybees and snow-white turtledoves but behaves more like a hawk. During "Operation Iraqi Freedom" (March–May 2003), in which the United States led an effort to oust dictator Saddam Hussein, Lamb was not standing along-side peacenik protestors. Rather, he said at the time, "You have to pro-tect yourself, because no one else will. If there's any chance Iraq has weapons of mass destruction, we should kick their ass. Because if they do have them, we're fucked."

This is the same man who prefers the New Testament, with its "Turn the other cheek" pacifism, to the Old, with its angry God and "eye for an eye." No one ever accused Lamb of not owning his contra-dictions.

When he turned 70 in 2002, he created a mantra to codify the "Pollyanna" side of his dualistic worldview: "Peace, Tolerance, Under-standing, Hope, Love."

"Peace," he has said, "has to start on a micro level before it hap-pens on a macro level. We can't control the world, but we can control what goes on between our ears. World peace will happen when we're at a stoplight behind a 90-year-old woman who doesn't know her own name, and we wave at her instead of running her over. World peace will happen when we go up to the fat, cross-eyed kid on the play-ground and give him a hug instead of beating the shit out of him."

He continues: "Understanding that there's another point of view means that if I like Murphy's beer and you like Budweiser, I'm not going to get five guys to hold you down on the floor and funnel Mur-phy's down your throat and make you swear, under penalty of death, that Murphy's is the best beer in the world. Understanding means I shouldn't spend my life trying to make a Catholic into a Jew and a Jew into a Buddhist and a Buddhist into a Muslim.

"Tolerance means risking that you're going to accept something. Can you open up the steel box on the shelf that says 'All Irish are drunks' and look inside it? Maybe they aren't all drunks. If you open that box, you might find you were wrong about the Irish. And if you were wrong about the Irish, maybe you're also wrong about the Puerto Ricans and the blacks. Tolerance makes you realize you're fallible.

Yesterday you were gonna shoot somebody. Today you'll just leave them alone.

"Hope is the balm of life. You never think about hope when you're drunk or screwing, you think about it when you're broke and hungry. When you have nothing, there's one thing you do have: hope for the future.

"Love is the synthesis of peace, understanding, tolerance, and hope. It's all-accepting, forgiving, kind, tender. It's the salve that heals wounds and binds people together."

Lamb's peace-and-love mantra sounds like 1960s redux. Indeed, the question of whether 1960s counterculture values influenced his art was raised in a magazine profile in 2000:

> Is there really a place in contemporary art for pictures addressed to themes of peace, hope, and brotherhood? Conventional wisdom in the historic art preserve holds that such themes are more appropriate to UNICEF Christmas cards than to "real" contemporary art. Lamb . . . can offer up reimaginings of clichés that become fresh and new. His dream of peace is not simply a residue of the ethos of 60s counterculture.[1]

For all his hippy-dippy talk, Lamb is an old Irish chieftain, and when, freshly septuagenarian, he ran into the brick wall of the New York art establishment, he put Pollyanna to bed and broke out George S. Patton's pearl-handled pistols, ready to fire, then aim, at SoHo's most sacred cows.

PART SEVEN

THE CONTROVERSY

"Lamb arrives at his art in a seemingly artless way, a way so unmarked by current high-art concerns as to appear naïve. This fact has confused the question of Lamb's place in contemporary art. It has caused him to be occluded from the mainstream and designated an Outsider."

—*Michael D. Hall (Matt Lamb: Obsessive Spirit*
Wrestling with the Angels)

CHAPTER THIRTY

FUCK THE PUCK

This is not your grandfather's Winnebago, unless your grandfather's Winnebago is stuffed with a quarter-million dollars' worth of fine art. This Winnebago, parked in downtown Manhattan on the corner of Lafayette and Houston, only 12 feet from the historic Puck Building, is not here for transportation, but for protest. And the Armani-clad blonde in the driver's seat isn't here to drive, but to raise a ruckus and sell art. Carolyn Walsh is Matt Lamb's Nantucket gallery rep, and she's rented this 30-foot monstrosity and festooned it with banners proclaiming, "MATT LAMB—OUTSIDE THE OUTSIDER ART FAIR," because Lamb has been excluded from the 2003 Outsider Art Fair, held annually in the Puck Building.

"This truck is disgusting," she sniffs. "It reeks so badly of beer, we had to buy potpourri to make it tolerable."

She has crammed the vehicle front to back with some of Lamb's most outlandish paintings: flying fish jumping over two-headed dogs, a man's head sprouting from a woman's fingers, and *Star Trek*–like creatures with huge, exposed brains.

"We strung wires across the front of all the cabinets and hung the smaller and medium-sized pieces on them. The big ones we propped up on top of the double bed. Some of them we put in the little hallway by the latrine. It's sort of like selling Turkish carpets."

After having exhibited her gallery's wares, including Lamb's paintings, at the Outsider Art Fair for 10 consecutive years, Walsh had been told she was no longer welcome, unless she agreed never to bring a Lamb painting inside the Puck Building again. The fair's organizers, who number among the more powerful players in the New York art scene, had huddled and determined that Lamb was too rich and savvy to qualify as a bona fide Outsider. And so they had decided to do what exclusive clubs do in order to remain exclusive: exclude. But rather than capitulate by deep-sixing Lamb's works, Walsh had opted to withdraw from the fair altogether, mounting this protest-on-wheels as a clarion-clear "F.U." to those who would shun her and declare Lamb persona non grata.

Today is January 23, 2003, the fair's first full day and thousands of men and women are filing into the show, hundreds of them stopping first to look through the paintings in Walsh's Winnebago.

"You show 'em, Carolyn!" a man admonishes her. "Lamb should be in the fair!"

Another man, whom Walsh recognizes instantly as one of New York's most prominent collectors, climbs into the trailer. The two talk, and when they're finished, he takes his ticket to the show and ceremoniously rips it up in front of her. "If you and Lamb aren't good enough to be inside," he says, "then neither am I."

People bring by copies of the day's *Wall Street Journal* and ask her, only half-jokingly, to autograph the prominent article about her and Lamb, whom the article dubs "the Outsider Outlaw."

As the day wears on, the *Journal* article spawns more media attention. *Reason* magazine follows up. Newspapers up the Eastern Seaboard call Walsh for comments. Talk radio hosts weigh in, chat rooms buzz,

and Outsider web sites post entries about the controversy. The questions at stake are important ones: Should an artist, whether Vanderbilt wealthy or vagabond poor, be judged by the quality of his output or the quantity of his income? And just how did Lamb, after a two-decade-long art career, become, seemingly overnight, the lightning rod in the center of such a firestorm?

Where is "the Outsider Outlaw" right now, as New York wags its tongue over him, and Walsh tends to her bazaar of the bizarre? He's 1,400 miles to the south, far removed from the winter chill of Lower Manhattan, painting in his studio in the Florida Keys. His phone rings every half-hour or so with an update on the goings-on outside the Puck Building.

"Yes," he says. "Right . . . Okay . . . Bye."

And then he returns to his oil paints, their caustic scent mingling with oleander beneath the sabal palmettos.

"Fuck the Puck," he curses when a reporter gets through to him. "The Puck Building is the bowels of Hell as far as I'm concerned. I wouldn't allow my cremated remains in there."

"What if the organizers changed their minds," the reporter wants to know, "and invited you back?"

"I'd go," Lamb replies without hesitation, "just so I could moon them."

CHAPTER THIRTY-ONE

THE STRAIGHTJACKET AS
PAINTING SMOCK

The seeds of Lamb's discontent had actually been sown two years
prior to his expulsion from the Puck Show, and those seeds, in turn,
had fallen from trees planted by a French artist named Jean Dubuffet.
Born the year Scott Joplin's ragtime two-step, "The Easy Winners,"
was lilting through the air, Dubuffet died the year Madonna's "Like a
Virgin" topped the charts. A lot can change in 84 years, and Dubuffet
most decidedly changed our conceptions about art between 1901 and
1985, and beyond.

Dubuffet's personal art collection, which effectively jump-started
what today we call Outsider art, began with his interest in the works of
Adolf Wölfli, a Swiss farm worker whose schizophrenia landed him in
the Waldau insane asylum near Bern in 1895. Four years into his

committal, he began to draw, using his drawings as *Brotkunst* (bread art), a kind of currency for trading modest luxuries among inmates. One of the Waldau psychiatrists, Walter Morgenthaler, took an interest in Wölfli's works and began documenting his output, eventually publishing an illustrated catalog. Another psychiatric researcher, Hans Prinzhorn, read the catalog, began collecting art by Wölfli and others like him, and published a book of his own in 1922 called *Artistry of the Mentally Ill.*

Enter Dubuffet, who read Prinzhorn's book some years later and was so fascinated by it that he and André Breton founded the Compagnie de l'Art Brut in 1948. The Company of the Art Brut means pretty much what it sounds like: a group of aficionados of brutal art. Art Brut is proudly unrefined and crude, the sort of stuff that punches you in the gut when other art merely tickles your ribs. It's a style antithetical to the sissified landscapes and finely brushed still lifes churned out by many academic painters of Dubuffet's time. Dubuffet began collecting works by people who had never taken an art class, nor knew very much about the art world, nor gave a damn, nor possessed the mental means to care about the way people were *supposed* to paint. This collection took on a life of its own, surviving Dubuffet's death as the Collection de l'Art Brut, housed to this day in a museum in Lausanne, Switzerland.

Officially, the works in Dubuffet's original collection are the only artworks in the world that may legitimately be termed "Art Brut," with the exception of works formally anointed as such by the museum's curators. Work by self-taught artists who were not mental patients were not allowed into the collection, except under the auspices of an annex called "Neuve Invention." Thus, the seeds of exclusions, exceptions, and future schisms were planted.

Searching for a suitable translation for the term "Art Brut," British art critic Roger Cardinal suggested "Outsider art" in a 1972 book of that title. The umbrella phrase, while catchy, could not unify the loose community of Outsider artists, who, like metastasizing cells, were rapidly subdividing into competing factions: marginal art, visionary art, Art Singulier, intuitive art, low-brow art, folk art, and a befuddling array of other subgenres.[1]

Despite the daunting terminology and hairsplitting semantics, the public at large gets occasional glimpses of Outsider elitism via pop culture references that spring up in the most unexpected places. On November 4, 1999, an episode of the animated American TV show, *The Simpsons*, featured an episode entitled "Mom and Pop Art," in which, according to the show's web site:

> Homer becomes a conceptual artist, creating striking Outsider art
> that catches the eye of Astrid Weller, a beautiful Springfield art
> dealer. Astrid arranges for Homer to have his own show, but when
> the Springfield elite gather for the opening, many are disappointed
> by his work.

Pop culture surfers also stumbled across Outsider art in 2003, when film star Jack Nicholson was briefly mentioned as a candidate to play perhaps the best known Outsider, the late Henry Darger. (The Nicholson project fell through, but in 2004, Darger was the subject of Jessica Yu's documentary, *In the Realms of the Unreal*.) A Chicago recluse, Darger had created tableaux teeming with naked, hermaphroditic children engaged in fantastical scenarios of evisceration and sexual torture. Of Darger, Dubuffet had written: "[Darger's] neighbors in his North Chicago apartment building remembered him as an odd, unkempt man who scavenged through garbage cans and talked to himself in numerous voices."[2] In the Outsider canon, Darger is as good as it gets, eclipsing other historic Outsiders like Wölfli, the impoverished Mexican immigrant Martin Ramirez, the emancipated Alabama slave Bill Traylor, the African-American stonecutter William Edmondson, the Idaho deaf-mute-autistic James Castle, and the Alabama mixed-media artist Jimmy Lee Sudduth, who used mud, coffee grounds, and turnip greens in his compositions.

Today, a new asylum has become the Outsider's dominion: the asylum we carry within. Psychological baggage, developmental setbacks, personal tragedies, and financial woes are the heirs to Wölfli's madhouse. The idea that hardship is good for character, an idea rooted in both Eastern asceticism and Judeo-Christian altruism, has infiltrated

the art business to the extent that the disadvantaged are viewed as infinitely richer in experience than the privileged. An artist who lacks the professional savvy to sell his work is, in many circles, regarded as morally superior to an artist who can sell his work. The art of a deaf-mute shut-in ward of the state is perceived as broader in symbolism and more profound than that of an artist who has traveled widely, read extensively, and enjoyed a full social life. There is a perceived inverse proportion between personal efficacy and artistic merit.

For many, Jean-Michel Basquiat embodied both the apex and the nadir of that inverse proportion. His fashionable poverty, raw technique, and eleventh-hour fame followed directly by tragic death defined the quintessential artist, Outsider or otherwise. An unassuming graffiti artist of Haitian and Puerto Rican descent, Basquiat (originally known by the handle "SAMO") poured his emotion and invention into quick, improvisational pieces that could be dazzling. He was famously taken under the wing of Andy Warhol in the fall of 1982, lending him fame by association, but met his end at the age of 27, the victim of a heroin overdose, conferring onto him that special brand of glamour Americans value so much in their Marilyns, their Janises, their holy trinity of Jimmies: Dean, Hendrix, Morrison.

Among living Outsiders, self-taught Seattle painter Anne Grgich comes close to the archetypal, with a life story that reads like a contemporary Cunnegonde's. In her late teens, Grgich had her teeth knocked out in a freak accident involving a beer mug and a friend tripping on LSD. Two weeks later, a drunk driver plowed into the car she was riding in, killing her boyfriend, who was at the wheel, and sending her into a two-week-long coma. After she emerged from the coma and was released from the hospital, a gas stove blew up in her face, burning every follicle of hair off her head. Soon afterwards, during an epileptic seizure, she fell off a 20-foot cliff. She survived but was left with chronic pain and a string of surgeries. Looking for solace in the aftermath of these mishaps, she joined what turned out to be a cult and was subjected to mind control. After summoning the fortitude to leave the cult, she became a drug addict and married a fellow drug addict who beat her senseless. All the while—and here's the magic—she was making art.[3] For an artist with a life like this, who needs asylums? Grgich,

with her combination of misfortune and brazen pictorial style, is the contemporary Outsider art world's gold standard. She is the anti–Matt Lamb.

Outsider sob stories play remarkably well in the art market, increasing the category's credibility and financial caché. In January 27, 2003, Christie's held its first stand-alone auction of an Outsider art collection, raising some well-waxed eyebrows when sales totaled $1.1 million, an impressive sum, though not as staggering as the collection's seller, new-media mogul Robert M. Greenberg, had hoped for.[4] Clearly, Outsider art represents big bucks to dealers who winter in St. Moritz and fund their children's Ivy League educations off their 50 percent cut.

Into this seething psychological and financial ferment plops Matt Lamb like a lead balloon. As art critic Michael D. Hall asked in a *Raw Vision* profile: "How does a successful, cosmopolitan businessman qualify as an Outsider? Where has he been locked up? From what psychosis does he suffer?"[5]

Not only is Lamb's lifestyle far removed from the typical Outsider's, he can also be openly contemptuous of the Outsider label, embracing it when it suits his aims but disassociating himself from it when it does not. Playing it both ways in this manner has not endeared him to those who desire consistency within the category, but Lamb and his gallery reps saw no reason to hold themselves prisoners to semantics or limit the artist's career over a line in the sand. Busy "building the myth," Lamb and his entourage had no qualms with using or abusing the Outsider term as they saw fit—until the spring of 2002, when the you-know-what hit the fan.

CHAPTER THIRTY-TWO

THERE ONCE WAS A GALLERIST FROM NANTUCKET

When Carolyn Walsh was a little girl in New Bedford, Massachusetts, she decided that when she grew up, she wanted to sell one of three things: ice cream, T-shirts, or art.

"As I got older," she says today, "I decided ice cream was too sticky and T-shirts were too tacky, so art won out by default."

Since the early 1980s she has owned Sailor's Valentine Gallery on Nantucket Island, named after the intricate, nineteenth-century compass cases that seafarers crafted for their sweethearts. Sailor's Valentine isn't your typical Nantucket gallery—don't go there if you're looking for seascapes, lighthouses, wharves, schooners, and grizzled mariners. Walsh mixes contemporary and Outsider art and considers the gallery the island's edgiest. When she encountered Matt Lamb's work in the

mid-1990s, she was taken with "how unabashed and honest it was, and how pointed its message. It's an old message—tolerance, hope, love—that a lot of people consider cliché, but somehow, through his imagery, he's able to rekindle a fascination with those ideas."[1]

Walsh took Lamb into her stable and in 1996 began showing his work at the Outsider Art Fair. Organized by the suave Sanford L. Smith and his son, Colin Smith, with the help of freelance coordinator Caroline Kerrigan, the fair employs hotshot publicists and limits exhibitors to around 40 in order to perpetuate an air of exclusivity. As many as 10,000 people file into the Puck Building each year to check out a mix of "classic" artists and fresh talent. For a time, Walsh sat on the fair's advisory committee, charged with upholding its rigorous standards. In 2001, she and the other committee members decided the fair was losing its integrity, "getting fuzzy around the edges" by letting in too much folk art. "We needed to weed out the butter churns," she says bluntly.

The committee disinvited certain gallery owners who represented folk artists and delivered ultimatums to gallery owners who represented both folk and Outsider artists: Lose the folk, or you're history.

Little did Walsh know that in only a year, when organizers began planning the 2002 show, she herself would stand in the crosshairs she'd trained on other gallerists, not because of any association with folk art, but because one of her most illustrious artists was being made an example of. The ultimatum she received boiled down to this: Lose Lamb, or you're history.

The ultimatum came by e-mail on May 7, 2001. Caroline Kerrigan, working under Sanford Smith, informed Walsh that the fair's advisory committee had met to discuss Lamb, and that, "although everyone agreed he is a talented artist, it was the general consensus that his work is not appropriate for this Fair."

Walsh, spunky New Englander that she is, demanded to know why, and to know exactly who had sat on the committee that deemed Lamb unfit to hang in the Puck. Kerrigan confirmed that Carl Hammer, who had once been Lamb's gallery rep and strongest champion, had been a committee member.

"It is not at all that we feel the work is not up to par," Kerrigan insisted, it was simply that Lamb's status as an Outsider was suspect. "As you know, we have been trying very hard to tighten up many areas of the fair in the last couple of years . . . Much as we all dislike these labels, for the fair to have an identity, these lines need to be drawn and redrawn each year. I am sure you can see how an artist who is a savvy and successful businessman with a keen awareness of the art world and marketing techniques, is necessarily a much harder fit than certain other artists."

There it was, the smoking gun, in black and white: Lamb's savvy as a businessman—even though he had sold his businesses nearly two decades ago—and his "keen awareness of the art world"—even though he'd never taken an art lesson in his life—got him kicked out. It had nothing to do with his painting portfolio and everything to do with his financial portfolio.

Walsh shot back in an e-mail to Kerrigan: "Yes, Matt Lamb has means. He does not have to rely on luck or someone else's skills and patronage to bring his work to the marketplace. Since when does an artist's affluence determine his acceptability in a field? Matt has applied both his wealth and his business acumen *after* the fact of creating the artwork. The works remains unaffected by either." She asked Kerrigan to reconsider her ultimatum.

She also forwarded the entire correspondence to Lamb, who was shell-shocked to see the rationale behind his blacklisting outlined with such brutal clarity. He forwarded the e-mails to *Raw Vision* publisher John Maizels, art critic Michael D. Hall, and other people influential in the visual arts. He then bought two pages of ad space in *Raw Vision* and told Walsh to give Sanford Smith a message: Lamb was going to reprint the complete e-mail exchange between Kerrigan and Walsh on the ad pages, exposing what he considered a blatant case of economic discrimination against him. The smoking gun Sanford L. Smith & Associates had provided Walsh and Lamb via e-mail, was now turned back around and pointed at them.

Soon thereafter, as if by magic, Sanford Smith's son, Colin, made a personal phone call to Walsh and re-invited Lamb to the fair.

Lamb subsequently dropped his plans to publish the damning correspondence but stipulated that any future discussion of his or other artists' place in the fair be held in a public forum rather than a smoke-filled room. Fair managers promised to strongly consider sponsoring an open symposium on the controversies surrounding the Outsider label. No such symposium was held.

On October 24, 2001, Colin Smith e-mailed Walsh to reiterate that Lamb had been re-invited, but added ominously: "The inclusion of Matt Lamb's work . . . in the 2002 Fair shall not be taken as approval to exhibit in any subsequent Fairs."

The e-mail may have been in the In-box, but the handwriting was on the wall. When the 2002 fair was over, Sanford L. Smith & Associates regrouped and retaliated. On June 12, 2002, Colin Smith and Caroline Kerrigan sent Walsh a letter that read in full:

Dear Carolyn,

We would like to thank you for your participation in the Outsider Art Fair in the past years. We regret to inform you that we will not be able to offer you a contract for the 2003 Fair. Please refer to last year's contract, paragraph #14, if you have any questions.

Sincerely,
Caroline Kerrigan and Colin Smith

The paragraph in question states "that showing one year does not guarantee the right to exhibit in any future shows."

Walsh fired back, demanding a more explicit explanation, but Smith didn't bite. He'd learned his lesson and wasn't about to hand over another smoking gun. The response he wrote Walsh was so bland, vague, and political, it didn't even mention Lamb by name.

Lamb himself was eating up the controversy. "I love getting kicked out of shows," he said at the time, "because I love starting conversations, even if they're controversial. I only regret that Carolyn Walsh will lose income because they're not letting her in the fair."

But Lamb and Walsh decided to fight back. They hatched a plot to crash the Puck party by splitting the cost of a rented Winnebago and

parking it right outside the building. This way, Walsh would not only be able to sell art, she'd also be able to raise awareness of the power plays rapidly redefining the often incendiary relationship between money and art.

Word of the audacious plan got around. In December 2002, just weeks before the Lamb-less art fair was to commence, the phone rang in the painter's studio in the Florida Keys. It was Tessa DeCarlo, a reporter from the *Wall Street Journal*, calling to interview him for an article to run on the eve of the Puck Show. The article, Lamb thought, would fire the opening salvo in his and Walsh's battle plan to storm the Bastille-like Puck Building.

That is, unless the plan backfired.

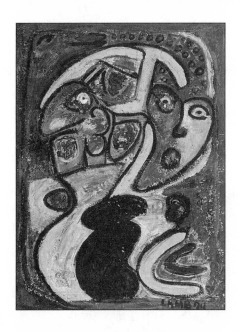

CHAPTER THIRTY-THREE

THE MEDIA SHARKS TEAR IN

Tessa DeCarlo does her homework. The Napa, California-based freelance writer, who covers art for the *Wall Street Journal* and the *New York Times*, had heard murmurs in late 2002 of Lamb's ouster from the forthcoming Puck Show. So she called the artist up and grilled him for an hour. She called Carolyn Walsh in Nantucket, Sanford Smith in New York, Carl Hammer in Chicago, and Lamb's biographer—that would be moi—in Portland, Oregon, to gather information for her *Journal* article, "When Is an Outsider Really an Insider?" which hit newsstands on Wednesday, January 22, 2003.

In her story, DeCarlo pointed out the inscrutability of the committee's criteria for excluding Lamb, noting that "neither the Fair nor the Outsider art field has ever been able to specify exactly what those criteria are." She also opined that Walsh's Winnebago was a modern-day

throwback to the Salon des Refusés nearly a century and a half ago, in which Monet, Manet, Pissarro, Degas, Renoir, Morisot, Whistler, and Jongkind thumbed their noses at the elitist Parisian art establishment.

Caroline Kerrigan, quoted in the article, obliquely referred to Lamb by saying, "With certain artists, questions came up every year: Does he really belong in the fair?"

Carl Hammer, the loved-him-and-left-him former champion of Lamb, offered his two cents' worth: "What happens when people collect these artists and spend several thousand dollars and then find out they aren't really Outsiders after all?" Real Outsiders, Hammer suggested, "have no idea what the mainstream definitions of art are all about. Artists that actually *want* to be Outsiders know exactly where they fit in—they just haven't been accepted there."

Coming out swinging in her portion of the interview, Carolyn Walsh said of Lamb: "He's not toothless and not marginally brain-dead, and he doesn't live in Appalachia, so he can't be snowed by some dealer who can make a lot of money off of him."

Them's fightin' words, and they didn't go unnoticed by the fair's powers-that-be.

Here's the scene, according to Walsh: It's the fair's opening day, the *Journal* is in everybody's hands as they encounter the Winnebago on the way into the Puck Building. As if out of nowhere, Sanford Smith himself, smartly suited and oozing charm, strides up to the art-mobile. He leans on the trailer, catching Walsh's eye. He smiles. "Hi, Lynn."

"Hello, Sandy," she says.

He shakes his head in mock sadness. "What are you doing out here?"

"You gave me no choice, Sandy."

"You know that's not true. You should be inside in the show, not . . ."—he casts a dismissive glance at the Winnebago—"not out *here*. This is bad business, Lynn. You should have called me, dealt with me directly, not through Caroline or Colin. I wouldn't have let you off the phone until I'd convinced you."

"Caroline and Colin made it very clear what your position was."

"Now, now, it's not *my* position or Colin's or Caroline's—it's the

committee's. And yes, they made their decision, and no, they're not going to budge. But you can't take it personally."

Walsh stands there for a long moment, looking at him, and it's as if the din of horns and passersby fades down to nothing, and the two are facing each other in a soundproof room.

"Here," Smith says, breaking the staring match. "Here are some passes to the show. Come on in! Take a look around! Have some food! Use the facilities if you need to."

She takes the tickets and hands him something back, a flier with the name MATT LAMB printed in the middle with a circle around it and a diagonal line slashing through the name in the universal symbol for exclusion. The bold-print text below the graphic screams:

Who'd have thought a quiet little gallery from a WASP'y summer resort would be so controversial? Sailor's Valentine Gallery of Nantucket has been told, "Don't come back to the Outsider Art Fair," because Carolyn Walsh, director of the Gallery, defended Matt Lamb.

According to Fair officials, it is Lamb's business skills and wealth, not his paintings, that disqualify him.

Walsh, defender of the exiled Lamb, says: "The stories of the makers of Outsider Art have been allowed to become freak-show curiosities for a public enamored of the bizarre. Enough of these pathological, illiterate, incarcerated, behaviorally deviant life stories! These juicy tidbits' only value is to add color for the edification of collectors with an otherwise humdrum, middle-class, suburban, two-cars-in-the-driveway, two-kids-at-school, gotta-stop-at-the-supermarket-on-the-way-home lifestyle! What we need to focus on is the art itself."

Sanford Smith takes the flier from Walsh, gives it a glance, then turns around and saunters back into the Puck Building.

Later that morning, John Maizels, publisher of *Raw Vision*, who'd run an advancer on the controversy in the magazine's Winter 2002

issue, plows through the people waiting to get in the Winnebago, pokes his head inside, and says to Walsh, in his English accent, "Looks like there's quite a bit of excitement going on out here!"

Walsh tells him there'll be even more going on tonight. She's coordinated a one-person show for Lamb at Grant Gallery, three blocks west and five blocks south of the Puck Building on Mercer Street, to supplement the art in the crowded trailer. She hands Maizels a flier with directions.

As the day wears on, the brouhaha makes more waves.

At the Lower Manhattan studios of WNYC-FM, nationally syndicated radio host Kurt Andersen is taping his show, *Studio 360*, heard on more than 160 affiliates across the United States. Andersen, who'd stopped by the Outsider Art Fair earlier in the day, is all worked up. In the transcript on his on-line blog, he points out the irony that "the connoisseurs of Outsider art" are "sophisticated aesthetes, every one of them," an irony that is "inherently funny . . . because these insiders are engaged in an argument over the definition of Outsiders."[1] He continues:

> One painter got kicked out because he's rich. He's a successful
> mortuary tycoon in Chicago named Matt Lamb, but he also
> paints—in the five different studios he maintains around the world.
> His dealer says that Lamb is both untrained as an artist and
> compulsive, and is therefore a bona fide Outsider.

Reason magazine's Tim Cavanaugh, scouring the day's headlines from his office in San Francisco, runs across the *Journal* article and immediately pegs the story as one that'll appeal to *Atlas Shrugged* libertarians. He updates the "Hit & Run" section of the *Reason* web site with a feature called "Outside In," bemoaning the plight of a "blackballed Outsider and funeral-home tycoon named Matt Lamb . . . nixed not for his artistic style but for his 'keen awareness of the art world and marketing techniques.' " The article concludes: "The keepers of the Outsider label are insisting that anybody who makes money or knows what he or she is doing must be shunned."[2]

Up on Nantucket Island, *The Inquirer and Mirror* runs a piece slugged "On the Outs: Island Gallery Tossed from NYC Outsider Art Fair." Reporter Hadley St. John interviews fair organizer Caroline Kerrigan, who answers his questions in a doublespeak that would have done Orwell proud. "We haven't banned anyone from showing Matt Lamb," she tells the reporter. "The advisory committee decided that he was technically a self-taught artist, but he was self-educated about art history."[3]

In the on-line world, news of the controversy is traveling at fiber-optic speed. Message boards for *Reason* and *Raw Vision*, blogs such as *Eyeteeth: A Journal of Incisive Ideas*, and newsgroups such as Yahoo's "Art Visionary" and "Self-Taught" are filling up with passionate discussion threads, which will continue for months after the fair is over.

One Yahoo poster rants that Walsh's and Lamb's handling of the controversy is "disgusting," while another disparages Lamb's wealth and art: "His money only powers his arrogance. The work is cold, and he plays one note over and over."

Others disagree: "I'm interested in Lamb's work and can appreciate it for what it is, which is whimsical and dreamy."

Offers another: "I don't think it's money or lack thereof that makes someone an artist or not."

One poster writes that any artist's "richness of spirit is priceless and not dependent on what you earn," while another sums up the larger issue quite succinctly: "I guess the real issue here is not about money, it's about, What is an artist?"

Among those attending the fair in person, reaction is similarly mixed.

"I thought that without Lamb, the quality of the whole show was up," one says.

Counters another: "The fair bigwigs have their heads up their rear ends, not allowing Lamb in but allowing a bunch of other crap and junk. It was the weakest selection of art I've seen in all the years I've been coming."

Following up her *Wall Street Journal* piece with another Outsider-related article in the *New York Times*, Tessa DeCarlo, without naming

Lamb, refers to the plight of the artist too wealthy to be taken seriously: "One corner of the art world still embraces the ideal of art uncorrupted by commerce. In the field of Outsider art, creators who show too much interest in marketing are likely to find their work devalued, if not shunned altogether."[4]

Also at the *Times*, it's clear where critic Ken Johnson stands when he reviews the fair, sniffing that it "looks better than ever this year, with the percentage of phony and kitschy material way down from a few years ago."[5]

As the tempest-in-a-teapot continues to steam and whistle, Lamb's supporters around the country are quick to issue press releases in his defense. From her gallery in Coral Gables, Virginia Miller argues that "whether we label him 'Outsider artist' or not has no relevance to his unique place in art history. What is truly significant is that Matt Lamb's paintings are powerful and totally original."

Illinois folk artist Larry Ballard issues a statement that concludes, "Let the market decide what can be included in the Puck Show, not a small handful of gatekeepers."

A few weeks after the show closes, Carolyn Walsh calls me with her postmortem. "I thought the *Wall Street Journal* article was thin," she says. "The committee members quoted in the article, Carl Hammer for one, spoke half-truths, giving these calculated opinions on how things *should* be, but evading the fact that it's their own actions that determine how things *are*."

The next day, I dial up the Carl Hammer Gallery in Chicago to ask Hammer why, after championing Lamb's work for years, he now seems to have let his membership in the Matt Lamb Fan Club lapse. Hammer's receptionist picks up. She asks who's calling, and when I tell her, she asks what it's regarding.

"Matt Lamb," I say.

"One moment, please." A long pause, and then she picks back up. "I'm sorry, sir, Mr. Hammer is not available."

I call him again a few days later, and again he's not available. So I e-mail him, telling him I'm Lamb's biographer and asking him about his relationship with the artist. A terse reply arrives in my In-box within minutes:

I believe the *Wall Street Journal* article and the *New York Times* review just about said it all. I don't see the point of dragging this on. You may contact me sometime by phone in my gallery. However, at this time, I am tired of dragging this issue out, making it into something more than it is. The issue of creating the same standards of excellence for both Outsider and mainstream art is of much more importance to me.

Carl F. Hammer[6]

Lamb, meantime, is still in Florida painting. "They're all trying to portray that it's about my money," he says by phone, "when in actuality it's about the fact that I don't kiss their ass. The art world is built on the concept of the artist feeling it's beneath him to participate in an economic event. The artist hands the nasty business of money over to the dealer. The collector and the dealer go into the back room and have tea, and it's all very discreet, and finally the collector pulls out the credit card or writes a check, but they're talking about the weather while he's writing it. Everybody tries to pretend that an economic transaction isn't happening. Everyone's hung up on the struggling artist. At what point did Picasso or Warhol go from struggling to not struggling?"

Lamb is adamant that in the aftermath of his exclusion from the fair, he is done with the Outsider label. He also points out with some amusement that the *Wall Street Journal's* Tessa DeCarlo had derided his paintings as "clumsily Chagallesque."

"Did you see Miss DeCarlo's byline?" he asked. " *'DeCarlo's last piece for the Journal was an article on fingernail art.'* Now I can die a happy and fulfilled man. I've been panned by the fingernail art critic!"

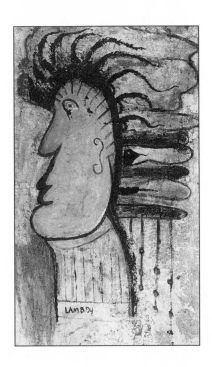

CHAPTER THIRTY-FOUR

OUTSIDER, OUTSCHMEIDER

The media's focus on Lamb during and after the 2003 Outsider Art Fair posed more questions than it answered. Did Lamb's financial viability disqualify him from artistic credibility? Had he ever really been a true Outsider, or had his "sharing sessions" with Arthur Rubin, Simone Nathan, and Jack Levin amounted to *de facto* formal training? And granted that Lamb had never studied art in the academy, had he nevertheless brought the academy to himself via Rubin's, Nathan's, and Levin's critiques?

"My best training for being an artist came long before I ever met Art Rubin or Simone or Jack," he maintains. "It was my years as a funeral director: looking at the wake as a collage, becoming maniacal for detail, and absorbing the message that my art is about the regrets people have when a loved one dies and what that teaches those of us

who live on. I considered Simone and the others mentors, similar to the mentors I gravitated toward in the business world. They gave me feedback, good and bad. They reacted, they shared their perspectives, they answered my questions. Does that have any impact on whether I'm an Outsider artist? Some critics say yes, some say no. As for me, I really don't give a shit. I just keep on painting."

Lamb is hardly the only wealthy or well-known self-taught artist to have first earned a fortune or attained social prominence in a field outside the visual arts. Beatle John Lennon's drawings and doodles became well known through licensed reproductions. In the 1970s, operatic tenor Luciano Pavarotti began painting vistas of the Italian Riviera in acrylics. Grateful Dead guitarist and cofounder Jerry Garcia's watercolors, gouaches, and drawings were transformed into neckties and silkscreens. Crooner Tony Bennett's cityscapes, portraits, and still lifes were featured in the 1996 coffee-table book, *What My Heart Has Seen*. At the age of 83, former South African dissident and President Nelson Mandela began working in charcoals and pastels.[1] *Penthouse* magazine publisher Bob Guccione, who studied art formally for a grand total of two weeks, is a prolific oil painter in a style that owes much to Picasso and Modigliani.[2] These artists—every one of them better known to the public than Matt Lamb and most of them richer—never found themselves thrust into any debate as to their legitimacy as Outsiders, while Lamb has been dogged by such controversies for two decades now.

There are two reasons for this: (1) John Lennon, Jerry Garcia, et al., never needed to be marketed as Outsiders, because their celebrity itself was their calling card; and (2) There is a glamour to being a rock star, crooner, anti-apartheid crusader, or even a pornographer that adds caché to the work of these other self-taught artists, an allure missing from Lamb's "first life" as an undertaker/businessman.

While many writers have portrayed Lamb, essentially, as an Outsider poseur, others have come to his defense, pointing out the ways in which he and others like him fit the category's mold.

Michal Ann Carley writes: "Outside? Yes. But only outside of the academy and liberated from what Harold Bloom called the 'anxiety of influence.' "[3]

Writing about Grandma Moses in *The New Yorker*, Peter Schjeldahl

delivers a one-two punch to the gatekeepers who would ghettoize self-taught artists: "Moses fell victim to the sterile categories of 'naive' and 'Outsider' and 'self-taught'—labels that the educated classes use to protect a culture of credentials. The truth is that every genuine artist—and preeminently, every great one, like Pollock—retains childlike and alienated qualities and remains self-taught where it counts."[4]

After viewing the American Folk Art Museum's Adolf Wölfli show, Roberta Smith wrote in the *New York Times* that "the distinction between insider and Outsider art should finally be declared null and void."[5]

In late 2003, the *Village Voice* threw up its editorial arms at the ludicrous distinction between so-called insiders and Outsiders, taking the *New York Times* to task for perpetuating the dichotomy and raising a collective eyebrow at Christie's auction house for asserting that "heavily hyped Outsiders might turn into sellouts."[6]

And yet even Lamb's own gallery reps can't seem to agree on his Outsider status. Virginia Miller presents Lamb as a contemporary artist rather than an Outsider. "He's not on the bandwagon of any current trend," she says. "People have distressed canvases before, but not in the way he does. People have used bold colors before, but not in the way he does. He's unique in the contemporary art world, but that's the world I see him in."

Judy A. Saslow begs to differ. "As savvy and comfortable as he may be in the world of art, he is still an untrained artist in the manner of Art Brut. Not considering his biography—and frankly I don't think that should be considered—he is most definitely an Outsider."

In cyberspace, insider/Outsider distinctions matter increasingly little. In his *Manifesto of (Dis)content*, writer David Logan argues that our increasingly Internet-based culture, by replacing traditional vertical hierarchies with the horizontally expanding World Wide Web, has rendered the Outsider label—and its socioeconomic implications for artists—moot:

> Success is no longer synonymous with selling out, and obscurity in and of itself is not the proof of integrity it used to be . . . Being on the outside of one category simply means being inside the one next

to it . . . Artists are taking control of the means of distribution themselves, allowing them to define their own marketplaces, economies, and currencies.[7]

"All of this is moot in Europe," Lamb says of the brouhaha. "The Europeans couldn't care less about labels; they care about the art itself and the ideas behind it."

Why is it, then, that Americans in particular laud ambition in the businessman but pooh-pooh ambition in the artist? In all likelihood, it is because Americans hold artists, particularly Outsiders, to a double standard, expecting them to produce universally relevant art while living off food stamps within a two-block radius in Detroit. We expect artists to ennoble us osmotically by selling their assemblages and collages to a dealer, who in turn marks them up 100 percent and presents the work at chi-chi gallery previews to the strumming of soft guitars and the clink of wine glasses. We expect bohemians to conform to our fantasy of their fast-living, hard-drinking lives so that we may feel vaguely superior as we drive our Lexuses from the suburbs to the corporate park, yet still feel altruistic and socially responsible in the knowledge that we are, in fact, patrons of the arts. It's not so much about the artists as it is about us, the upwardly mobile classes who just can't shake the edict that money is the root of all evil, even as we strive for raises and promotions. We expect the Outsider artist to atone for our conflicted success by virtue of his glamorous asceticism. And because we lack the time or specialized knowledge to know which artists are passing current litmus tests for cool, we leave it to well-heeled, well-connected dealers to point us toward artists who are sufficiently destitute and alienated to be deemed Outsiders.

What, finally, is an Outsider? After so much debate by so many "experts" in so many media outlets, gatekeepers like Sanford Smith and Carl Hammer have yet to come up with an answer any more satisfying than that proffered at the conclusion of a 1964 court case. The issue was different, but the cop-out was the same. Faced with the impossibility of objectively defining obscenity in *Jacobellis versus Ohio*, Supreme Court Justice Potter Stewart could offer no opinion beyond "I know it when I see it."

PART EIGHT

THE PRESENT TENSE AND FUTURE PERFECT

"He consciously tried to create art that was great and deep. He held to a romantic view of the individual able to transform reality through his own spiritual and philosophical strength."

—*Roger Ebert on Andrei Tarkovsky*[1]

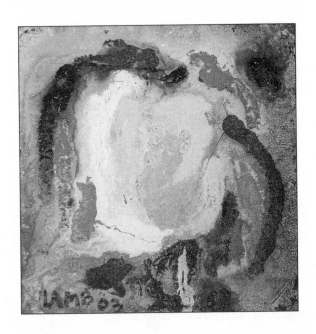

CHAPTER THIRTY-FIVE

HERR LAMB

If there is any one person, besides Matt Lamb himself, responsible for elevating the artist from a cult hero among German cognoscenti in the mid-1990s into the pop-star-like phenomenon he has recently become in Germany, Spain, and Argentina, it is Dominic Rohde. Lamb's right-hand man in Europe and on the international art market, Dominic is leading the near-evangelical charge to spread the artist's message of hope and love, as well as sell his paintings, throughout the Continent, the British Isles, South America, and beyond.

Six-foot-five, dark-haired, and bespectacled, Dominic looks great in a double-breasted suit, which is a good thing, since he rarely appears in public in anything but. In addition to his native German, he speaks fluent Spanish, French, and English, as well as servicable Italian, Luxembourgese, and Afrikaans, and he hails from a prominent Germany

family. His father, Hubert Rohde, was a professor at Saarland University and a member of Saarland's House of Representatives before becoming CEO of the Saarländische Rundfunk television and radio stations. Dominic's mother, Karin Elisabeth, was a civic and church leader who managed a continuing education center. On a fast track to becoming cultivated citizens of the world, the Rohde children attended boarding schools in Germany and France. Dominic graduated from Zweibrücken American High School in 1986, then headed to universities in Barcelona and Luxembourg and embarked on a business management program that would take him to Madrid, Paris, and Oxford for a year apiece. Fresh out of college, he worked for an international ceramics firm in Buenos Aires, where he met Lía Villar, the dark-eyed beauty who became his wife and the mother of his seven children.

In 1991 he founded St. Matthias Kolleg (SMKT) in the idyllic hamlet of Tünsdorf, naming the college after the region's patron saint. Two years later, on a trip to the United States to network with other Catholic schools, Dominic encountered Lamb's work and fell in love with "the thickness of paint, the wildness of line, the fun and comedy of the figures." He met with the artist and invited him to do a one-man show at St. Matthias the following September.

The show sold several major paintings the first night, with 200 collectors and a full complement of regional reporters and photographers in attendance. It was, says Dominic, "the beginning of a beautiful friendship" between the two men, and between Lamb and Europe. During the next three years, Dominic coordinated dozens of other Lamb shows throughout the Continent, translating the reviews and faxing them to Lamb, who read them hungrily. Between academic semesters at St. Matthias, Dominic stacked paintings in the back of an oversized van and drove them around to galleries in Germany, Luxembourg, Belgium, France, Italy, Spain, and England, introducing a new curatorial audience to the world of Lamb.

"It was crazy but great fun," he says of the time. "Lía and I were living like art nomads."

When the couple's six-year-old son started elementary school, the nomadic lifestyle came to an end, and Dominic concentrated on

expanding SMKT, opening up satellite campuses in France, the United States, Mexico, Argentina, Singapore, and China. He decorated each new campus with Lamb's paintings and on certain campuses established Matt Lamb Centers, dedicated studios and lecture halls in which Lamb teaches, mostly in the summers.

Says Lamb: "A lot of the art students I teach are ready to throw their hands up and quit. They're discouraged by the constraints of the system, the fact that they have the 'day job' that feeds them and the creative job that feeds their souls. I try to empower them to take control of at least the second half of that equation. I talk with them about the big questions: What is art? If you draw two dots on the wall, is that art? If you put pubic hair and puke on a canvas, or a urinal on the wall like Duchamp, or you throw raw meat on a wall and watch the blood drip down, is that art? And I tell them, yes, it is, but only if that's the way they want to explore their innermost souls. That being said, I personally am not going to pay $50,000 for puke and pubic hair!"

Lamb also tries to embolden his students to talk about their art. The yes-or-no answers with which Andy Warhol used to confound reporters are his personal pet peeve. He loathes the deliberate enigma, the refusal to interpret, the attitude of choreographer Mark Morris, who recently told an interviewer, "I refuse to explain my work. I'm not going to tell you what to look for or what it means."[1] This couldn't be further from Lamb's penchant for gabby Irish exposition.

"Your art is your soul," he tells his students. "Share your art, share your soul!"

The flagship Matt Lamb Center in Tünsdorf opened on August 31, 2001, and is a converted half-timbered home, centuries old, painted on the outside with Lamb's mantra, "Peace, Tolerance, Understanding, Hope, Love," in English, German, French, Spanish, Italian, Arabic, and Hebrew.

In 2003, Dominic coordinated a meeting between Lamb and the Brussels-based International Diabetes Federation, regarding a major commission. In the aftermath of the meeting, the Federation named Lamb artistic director of its Global Diabetes Stamp Project and invited him to design a postage stamp and calendar dedicated to diabetes awareness. If the project develops as planned, the stamp will go

into circulation sometime before 2007 and will hold great personal significance for the artist, since Rose Lamb has lived with diabetes for more than 20 years now. When asked to brainstorm phrases to run beneath his paintings in the calendar, Lamb faxed the Federation a list remarkable for its levity in the face of diabetes' grave repercussions: "Always running to the toilet? Get a diabetes test," "Do you love your toes? Get a diabetes test," "Your feet are your friends. Get a diabetes test," and "You have such beautiful eyes. Get a diabetes test." Only Lamb could tackle toilet trips, amputated limbs, and blindness with such winning insouciance.

Working with producer/director Theo Fickinger and Spon-Films in Germany, Dominic produced a series of television programs following the painter as he migrated between his studios and homes in four countries. With their breezy, *Lifestyles of the Rich and Famous* feel, the programs have been translated into five languages, including Chinese, and aired in various forums with subtitles. They're also shown to art students at St. Matthias Kolleg campuses and Matt Lamb Centers worldwide.

Dominic also has his hands full coordinating the "Lamb Umbrellas for Peace" as the project makes its way around the world. When the artist took his umbrellas to the European Parliament in Strasbourg, France, CNN featured the event on its program, *CNN World Report*. In Germany, the umbrella project is called "Regenschirme für den Frieden" and has endeared Lamb even further to his core base of European fans, the people of the German state of Saarland. It would be hard to imagine a more ardent group of Lamb aficionados than the Saarländer. The state's minister of culture and education, Jürgen Schreier, has named him an honorary citizen; the *Saarbrücker Zeitung* newspaper covers his every move when he jets into Germany; a Saar songwriter named Jürgen Diedrich has composed and recorded a pop song for children's choir called "Lied vom Schirm" ("Umbrella Song"); and Saarländer chow down on Argentinian steaks at El Gaucho Matt, a seventeenth-century wine-cellar-cum-banquet-hall hung with dozens of Lamb's paintings. The bürger of Tünsdorf—a town with no small resemblance to the slanted-roof village in the artist's *Once Upon a Time* series—line up for autographs after his lectures and

seek him out for philosophical and theological discussions as if he were an ambassador or philosopher-king (or at the very least, a Fun King). Through their German accents, they call him "Mett Lemm." Others have taken to simply calling him "Der Künstler" (The Artist), which, interestingly enough, is what American pop star Prince was known as for several years. Europeans, it would seem, treat their favorite artists like rock stars.

German children have a special affection for the grandfatherly Künstler. To watch him lead a parade of children through the cobblestone streets of Tünsdorf is to behold a mutual love-fest. Clapping, twirling his pom-pommed parasol, whinnying and having them whinny back, he dips into his sack of goodies like Santa Claus and tosses each girl and boy a silkscreened Lamb T-shirt. They stop at the end of Lindenstraße, and he signs autographs with a purple Magic Marker. Through Dominic's translation, he tells them, "Thank you for being *my* teachers today. Thank you for helping me find my child." When Dominic grabs his camcorder, Lamb turns to the camera, raises his hands to his ears, and razzes him. Hard to know who's younger, Lamb or the kids.

In the summer of 2003, the St. Martinskirche (Saint Martin's Church) of Tünsdorf commissioned their honorary Tünsdorfer to paint the entire interior of the church's baptismal chapel, floor to ceiling. For 10 days straight, Lamb transformed the somber chapel into an explosion of color, painting 120 square meters of wall with a blend of secular and religious imagery, the former including an entire wall full of flowers, the latter including the Virgin Mary and the holy trinity: Christ, the Holy Spirit, and God the Father. The structure was rechristened the Regina Pacis (Queen of Peace) Chapel and became an instant destination for art lovers and religious pilgrims alike.

"During the three months since it was completed," parish priest Ralf Hiebert told *Saarbrücker Zeitung*, "we've had more visitors to the chapel than we had in the previous 10 years."[2]

In light of the Tünsdorf chapel's popularity, the Cathedral Notre Dame de la Treille in Lille, France, mounted a large Lamb installation the following year. At the peak of the installation's run, it reportedly drew 8,000 visitors a day.

Juggling painting, lecturing, umbrella projects, and the like would exhaust many men half Lamb's age, but he wouldn't have it any other way. During one 13-day visit in the spring of 2003, Dominic shuttled him between 12 official receptions and meetings, from the country's Lederhosen-and-Alpenhorn south to its wind-whipped north. There were meetings with Pat Cox (president of the European Parliament) and Wolfgang Thierse (president of the German House of Representatives), and strategy sessions with the managers of the SOS Kinderdorf orphanage in Merzig to discuss an umbrella workshop. Lamb also met with Rudolf Dadder, head of the Trägerwerke Soziale Dienste, a social services organization in Weimar, about establishing a Matt Lamb Award for Tolerance and Understanding, followed by a powwow with the head of a prominent international luxury hotel chain about the chain's planned purchase of more than 100 Lamb paintings to decorate hotels and resorts worldwide. And that was just the first five days. The pace was so frenetic, Lamb had trouble keeping track of where he was.

"Where are we going now?" he asked Rose as they climbed into Dominic's van.

"The E.U. in Strasbourg," she answered.

"Okay."

She chided him good-naturedly: "You should brush your hair. It looks like you combed it with an eggbeater!"

"That's the look I was going for. They like that in the E.U."

Lamb doesn't milk all the European attention by posturing as an eccentric American jetting into town for a celebrity appearance: "I don't want my sensibility to be seen as typically American. I hope it's universal. I think we are all one. Our manners, customs, and languages may be different, but underneath there's the same core, and that's what art speaks to."

To this end, Lamb's web site, www.MattLamb.com, has been translated into English, Spanish, German, and Greek, with additional translations in the works.

China is a tremendous untapped market for Lamb's paintings and message, and Dominic has spent much of the last two years forging connections in Chinese political and artistic circles. Lamb's China

debut came in 2002, with the opening of a Matt Lamb Center in Kunming, Yunnan, and a gallery show in Shanghai. Dominic believes the Chinese public is eager for more of the artist's work, even though it's born of a radically different cultural, aesthetic, and philosophic/religious paradigm. Still, the fantastical creatures and vivid colors in Lamb's palette are reminiscent of the festive, garishly hued grotesques of Chinese folklore and opera, an underlying affinity that may explain the cross-cultural appeal.

Lamb's appeal to Europeans is easier to understand. He's a much easier sell on the Continent and British Isles than in the United States. Like American opera singers who find themselves more accepted on the stages of Covent Garden, La Scala, or the Wiener Staatsoper than the Met, Lamb is more appreciated across the Atlantic than on his native sod. The European ethos has long been more suffused in matters cultural than the populist American sensibility. Compared to the United States, where programs like the National Endowment for the Arts and the Public Broadcasting Service face continual Congressional threats and ever-shrinking budgets, Europe's funding of the arts is relatively robust and its arts institutions correspondingly more proliferate. Artists are regarded in a more vital light; young people and "average citizens" in Britain, for example, are far likelier to have heard of Damien Hirst than their American counterparts of Matthew Barney. Brits and Continentals have also been exposed over the past three decades to near-toxic levels of the reigning Eurotrash avant-garde nihilism and are positively hungering for a cleansing naïveté. For them, Lamb is the perfect enema.

To capitalize on Europeans' receptivity to his work, Lamb has a loose network of associates who promote his art there and in South America. The politically and artistically astute Fergus O'Mahony, Lamb's top-producing gallery rep worldwide, shows the artist's paintings in his County Cork, Ireland, gallery and evangelizes his work throughout the Emerald Isle. Also a restaurateur, pub owner, and philanthropist, O'Mahony masterminded two phenomenally successful shows in 2004, one in Dublin, the other in London's billion-dollar business complex, Canary Wharf. He also facilitated another Lamb show in conjunction with Cork's designation as the E.U.'s "City of

Culture" in 2005 and is organizing a 2005 one-person show for Lamb in Dubai, United Arab Emirates.

"Out of all the gallery owners who represent me around the world," Lamb enthuses, "Fergus might be the most important. He can pick up the phone and call the President of Ireland or Lord David Puttnam or Jeremy Irons and hit them up to be auctioneers at a charity event, then turn around the next day, round up a group of millionaires, bring them to my studio, and sell them a major painting apiece. He's gregarious, passionate, and very outspoken politically. There's this amazing international cast of characters who come into Castletownsend by helicopter and yacht to have a pint in his pub and look through his gallery. His eye for art is incredibly eclectic, and he's aggressive when it comes to selling it—I call him the Donald Trump of County Cork."

While Fergus works the Emerald Isle, marketing guru Juan Guinot develops and brands Lamb products in international venues, Hans Peter Mürz promotes the art in Russia, and Dr. Claude Treyer coordinates Lamb's outreach in Paris. Patricia Pellegrini promotes Lamb in Germany and Spain, Siegfried Hohmann in Luxembourg, and Jadwiga Gorska and Joana Bryl in Poland. Sebastian Benedetti, Eddy Guedikian, Ana Rosa Giovanetti, Vivi Anderson, and Guillermo Olivera represent and curate Lamb's work in Argentina. Fine arts professor Swana Mozgovoy is a docent at the Lamb Museums in Europe, while her husband, Georg, translates articles and catalog essays about the painter. Joern Gaedcke, meanwhile, sells Lamb's paintings and promotes his projects in Singapore, while Cristina Sicardi and Diego Gougenheim establish and maintain relationships between Lamb and museums worldwide. Willy Olivera and Bibianan Beberaggi facilitate educational tie-ins, Chris Gillham hosts the Lamb web sites, and Javier Bellingeri catalogs the painter's works for the European market. All of these operatives coordinate their efforts through Dominic and Lía and their plucky office manager, Claudia Braga.

Increasingly, Lamb seems to be turning his back on the United States and concentrating on Europe, South America, and Asia, where he believes his guiding star, his "spirit," is leading him. After returning from a recent stay in Europe, he phoned me and left a voice mail. With

his customary blend of reverence and irreverence, he betrayed his excitement at being home and his laser-like focus on developments far away.

"Richard," he said with only the faintest hint of jet lag in his voice, "it's Matt. Rose and I are back on American soil. The spirit is kickin' ass in Europe and all over the world!"

What he did not say in the message, was that the spirit was also kicking *his* ass, torturing him with a dilemma that could either rocket him into the ranks of Picasso and Miró, or prove his ultimate artistic undoing.

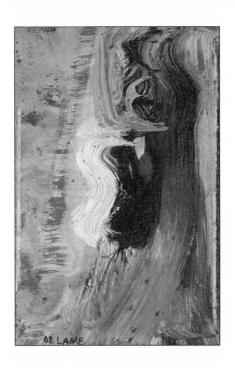

CHAPTER THIRTY-SIX

THE MAXIMALIST WRESTLES WITH MINIMALISM

Matt Lamb never does anything small.

"I could send a couple paintings over your way for you to study for the book," he suggested to me by phone one spring day. "I'll put them on loan to you while you're looking at them."

"Okay," I replied, and forgot about it.

A few weeks later, the 18-wheeler pulled up in front of my house, carrying 69 paintings, many of them oversized. After the driver unloaded them in my driveway and left, it took me three hours to unpack them from their crates. When the task was done, I was drenched in sweat and covered with paint (some of them, as I discovered, had not quite dried yet). Where would I put them? How long would I keep them? How would I return them? Alas.

The reason that Matt Lamb never does anything small is that he spent the first half of his life maximizing things: his businesses' productivity, his sphere of contacts, his funeral home's name recognition, his profit margins. During the second half of his life, he maximized other things: his paintings' surface texture, color saturation, and visual impact. Imagine his surprise—and the art world's—when, in 2002, he made public his dalliance with minimalism. Suddenly, a man who wanted more of everything—money, fame, love, tolerance, peace—had discovered Ludwig Mies van der Rohe's injunction that less is more. The maximalist had turned minimalist—or had he?

"I've always carried an image in my head from the 1968 Olympics in Mexico City," he says, then recalls being glued to the television screen those years ago, watching the victory ceremony for the 200-meter run. African-Americans Tommie Smith and John Carlos had won gold and bronze medals in the run, and standing on the victory platform as a brass band played "The Star-Spangled Banner," they had bowed their heads and raised their black-gloved fists in the Black Power salute. "That gesture, to me, was the embodiment of the power of minimalism, and starting in 2001 and 2002, I began asking myself whether my painting could have an impact anywhere near that powerful, working with simple, limited gestures like those men had."

So the artist went into his studio, took a dipped, dried canvas, looked at the myriad spirits within its puckers and potholes, and did something he'd never done before. He ignored them. Ignored their screams of "Give birth to me, you bastard!" Ignored the urge to paint in their faces and bodies. Ignored everything his 20 years in the studio had conditioned him to do, signed the work as it was—no spirits, no Harlequins, no two-headed dogs—and let his nuggetty surfaces and jaw-dropping color combinations speak for themselves as pure abstraction. It was one of the hardest things he'd ever done.

"For me not to outline the spirits," he said at the time, "is like telling a man who's been bitten by 50 mosquitoes not to scratch the itch. It's just so hard for me to 'let it lie' without painting the faces because my basic nature is to control things. I still see the spirits in the paintings, I just don't choose to paint them every time, and I have no

idea why I even want to work this way. Am I trying to cater to the elitists? Am I making what I used to call 'bullshit art'? Am I 'out to lunch,' as Jack Levin used to say? It seems like such a step back for me not to delineate the spirits, but I wonder if it's a step forward in accepting more mysterious messages, parts of my psyche that I only experience in dreams."

Lamb sought out the opinions of friends and colleagues, and found that many of them considered his pure abstraction pure folly. A German collector told him that, frankly, he didn't like the new works: "They don't seem finished. They don't seem like Matt Lambs."

Deeply troubled, the artist sank back into his studio, where he took a batch of 20 minimalist works, freshly dried, and began painting spirits onto them, only to scratch the paint off minutes later.

"Am I taking the easy way out?" he remembers wondering at the time. "If these paintings were to hang in the Guggenheim someday, would I be proud of them?"

Gallery rep Virginia Miller, who had initially encouraged his new stylistic explorations, admitted to him that the so-called minimalist work was a harder sell than his signature figurative paintings. She worried that his collectors, suddenly faced with a style unrecognizable as the Lamb they knew and loved, would be dubious: Was this style a flash in the pan? Would these works hold up as well on the resale market than more traditional Lambs?

In Chicago, Judy Saslow also had reservations. "I would never presume to tell an artist what to do and not do, but do the abstract works appeal as much to me personally? No. Certainly I can appreciate the swirling or contrast of colors, but I find art most effective if there's a communication of *something*, something that has definition. If it's too vague, I don't really catch it."

Lamb continued to agonize. He had dreams about the paintings. Thought about them while he ate dinner, talked on the phone, took a shower. Fought with his spirits in the studio. Most of all, he fought with himself.

"Sometimes I feel the way I did back when I first started painting and was afraid of color. Now I'm afraid of working abstractly. My

impulse is so strong to draw in the figures—like if I just leave it abstract, I'm pulling the wool over people's eyes, I'm passing off a sow's ear as a silk purse. Other times I wonder why I'm feeling so guilty for not choosing to outline 15 or 20 spirits in every single painting. Why should I feel like I'm required to paint like folk artists do in Bali, where you have 5,213 figures and you try like hell to cram in a 5,214th? It's ludicrous. It's like reusing toilet paper because there might be a half-inch that doesn't have shit on it yet."

And so the internal debate raged on between his long-standing maximalist tendencies and his nascent flirtation with minimalism. Except that in reality, Lamb's "minimalist" work wasn't minimalist at all. While it may have seemed minimalist to him because he was leaving out his beloved spirits, his luxuriant surfaces and colors couldn't have been further from the cool, hard-edged sensibility of classic 1960s minimalism. Lamb's new style, as he gradually came to realize, was not in the tradition of Ellsworth Kelly, Sol LeWitt, and Frank Stella, but sprang from the earlier lineage of Abstract Expressionism, a movement first identified by *The New Yorker*'s Robert Coates in 1945.[1]

It made a certain kind of sense that an artist long corralled into the Outsider herd would break out into the open prairie of neo-Expressionism. In technique and sensibility, many Outsiders are expressionists; the raw, impulsive quality of self-taught art is only a stone's throw away from Abstract Expressionism's emphasis on the direct portrayal of raw emotion. Indeed, one of the premiere Abstract Expressionists of the San Francisco school, Clyfford Still, was largely self-taught and, like Lamb, often bumped up against the label's stigma. Of Still's 1943 show at the San Francisco Museum of Art, Susan Landauer writes:

> The major complaint leveled at Still's San Francisco exhibition—
> that his work looked technically naïve—was to plague him for the
> rest of his career, perhaps in part because there was a measure of
> truth to the charge: He had virtually no formal art training. If his
> own account can be believed, aside from forty-five minutes of
> instruction at the Art Students League in 1925, after which he
> allegedly walked out in disgust, Still was entirely self-taught.[2]

Also in the vein of the Abstract Expressionists, Lamb borrowed eclectically from historical styles and, like Edward Corbett, believed that the American art scene was crying out for the "romantic" and the "inspirational" through the cathartic power of painting.[3] Part of that romance in Lamb's case—his violent distressing of the canvas—recalls Jay DeFeo's *Jewel* and *Incision*, both from the late 1950s and early 1960s, just as Lamb's unrestrained, generational buildup of layers on canvas evokes DeFeo's *The Rose*, an 8-inch-thick, 2,300-pound behemoth that took the late painter more than six years to complete. With their broad, bold swaths of color, Lamb's abstracts also recalled Melville Price's works from the early 1960s and Franz Kline's jaunty, quasi-calligraphic compositions dating from his rediscovery of color in 1955 to his untimely death seven years later at age 51.

As 2002 yielded to 2003, the ratio of Lamb's abstract work to figurative work grew greater, as did his comfort within this new paradigm. He began consciously working in three modes: naïve figurative, semi-abstract, and abstract. On a painting-by-painting basis, and often after considerable internal struggle, he decided just how visible or invisible his spirits would be, how boldly they would assert themselves or how completely they would fade into the controlled chaos of the background. Sometimes, when the undelineated spirits in a particular abstract painting "screamed" at him with especial vehemence to be outlined, Lamb would place the canvas up on the highest shelf in his working station, up out of his reach. Like a cookie jar placed beyond a child's reach, the canvas would be protected from his meddling and would have a better chance of remaining abstract.

By late 2003, he had declared himself at peace with abstraction and was busy producing works of extraordinary beauty and complexity. His crisis of confidence had benefited both his figurative and abstract work, stirring up a pond that had begun to stagnate. Everything he had taught himself about color and surface during his years as a figurative painter came to inform his abstractions, while everything the abstract work had taught him about subtlety and restraint had boiled down his figurative efforts into an increasingly richer reduction.

As his own comfort with abstraction grew, so did that of his collectors and associates. In Ireland, Fergus O'Mahony couldn't keep the

abstract works on the wall. In Miami, Virginia Miller, who had avoided hanging Lamb's abstract work in her Spring 2003 show, *Matt Lamb: Evolution of a Vision*, began exhibiting the work in group shows and on her web site, where she praised their "extraordinary depth of color and dynamic sense of movement." In Chicago, Judy Saslow, who had initially shown little enthusiasm for the abstractions, picked several of the paintings for an upcoming exhibition. And in *ARTnews* magazine, I lauded Lamb's "dynamic gestural paintings" and pronounced him "highly sophisticated as a neo-Expressionist." Clearly, Lamb was making a name for himself as an upstart abstract painter and winning new fans, many of whom preferred the new work to the old. He had made it through his most daunting hour and not only overcome his self-doubt, but used it to open the door to a whole new world, ripe for exploration. For a 71-year-old artist, nothing could compare to that kind of thrill.

Except, perhaps, being hailed as the heir to Picasso.

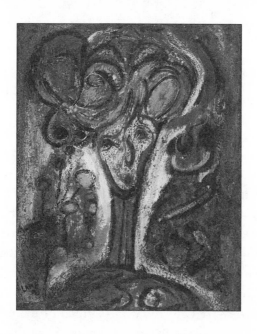

CHAPTER THIRTY-SEVEN

LAMB MEETS PICASSO

The only thing more striking than the differences between Pablo Picasso and Matt Lamb are the similarities. That the curators of the Centre Picasso in Horta de San Joan, Spain, recognized and celebrated the affinities between the hot-blooded, formally trained Spaniard and the affable, self-taught Irish-American, is a testament to the depth and nuance of their vision as they prepared the historic exhibition, *Encuentro de Lamb con Picasso* (*Lamb Encounters Picasso*).

In the late summer of 2003, the president and board of directors of the Centre Picasso, one of the world's leading resources for Picasso studies, flew to the SMKT-Matt Lamb Center in Germany to hand-pick the pieces for the exhibition. A grueling week later, they had chosen the paintings, many of them monumental in scale, and shipped them off to Catalonia, where, from September 7 to December 1, 2003,

the Centre mounted what was only the second exhibit of a living American artist in its history (the first was Pop artist Mel Ramos). *Lamb Encounters Picasso* was a showcase of 41 major paintings by Lamb, counterposed against the Centre's rich Picasso archives.

To flesh out the show's central conceit—that Lamb and Picasso are formally and thematically linked—the Centre held two symposia on the topic, one at its headquarters in Horta and another at the Hervás Amezcua Foundation for the Arts in nearby Barcelona. The Centre also documented the show with a 79-page color catalog featuring essays by five writers: Elias Gastón, director of the Centre Picasso; Professor Leonard Folgarait, chair of the Fine Arts Department at Vanderbilt University and a specialist in Cubism; Professor Enrique Mallen of Texas A&M University and author of numerous books on Picasso; Dr. Guido König, professor emeritus at the University of Saarland and a noted arts writer and linguist; and finally, Lamb's biographer, myself.

"Everything I know, I have learned in Horta," Picasso said often, referring to the Southern Catalan village that was his home for nine extraordinarily formative months in 1898, when he was an apprentice painter, and again in the summer of 1909, when he had already established himself as an ascendant star in Paris. "The purest sensations I experienced," he said of his time in Horta, "were in the great, forested area there, where I retreated to paint . . ."[1] Because of the formal revelations that shook Picasso to his very fundament during his stays in Horta, the city is known in many circles as the birthplace of Cubism.

Into this picturesque historical town, rising from a plain dotted with vineyards and olive trees, came Matt Lamb in the summer of 2003, followed by Spanish and German camera crews, diplomats, students, academics, and a contingent of German, Argentine, and American collectors who'd flown there especially for the opening. Drawn by the magnetism of Lamb's personality and the rawly emotive quality of his work, the Spanish people—who have a long-standing reverence for the artist as hero figure—flocked to Horta for a chance to meet the Irish-American celebrity painter in their midst. When the town's mayor presented Lamb a medal in the city square to commemorate his visit, a crowd of nearly a thousand cheered as if for a military leader,

sports hero, or Hollywood star. When Lamb and Catalan children paraded through the cobblestone streets, hoisting painted umbrellas aloft, 400 people filled the square to greet them at their parade's conclusion. "Los Niños de Horta Pintan por la Paz con Matt Lamb" ("The Children of Horta Paint for Peace with Matt Lamb") trumpeted the newspaper, *La Vanguardia*.

The exhibition itself was held in the Centre's headquarters, a stunning example of Renaissance architecture dating to 1580. By night, Lamb's massive unstretched canvas, *Hope and Love*, hung on the exterior of the nearby convent of San Salvador, bathed in golden floodlights, beckoning visitors to the museum's opening gala. When Lamb himself arrived at the Centre Picasso, he was stunned and humbled to see, just inside the museum's foyer, one of his own paintings resting on Picasso's large, antique easel. The Centre's director, Elias Gastón, had placed the painting there as an unprecedented gesture of admiration for Lamb's body of work. Lamb's heart skipped a beat when he saw it. Later that night, post-gala, in his hotel room, he wept, overcome by the gesture and by memories of the long journey that had led up to it.

Certainly, for any artist to be paired with Picasso by one of the world's great nexuses for Picasso studies is an honor nonpareil. For Lamb personally, it was particularly so, as he has for many years acknowledged a debt to the "uncompromising strength" of Picasso as a stylist and has harbored a fascination and identification with Picasso's controversial nature and loose-cannon outspokenness. The late Spaniard had, after all, told Christian Zervos in 1935: "Museums are just a lot of lies, and the people who make art their business are mostly imposters."[2]

The quote presaged Lamb's own in 2002: "Museums are about exclusion. Galleries are about business. Some gallery owners are great people, but a lot of them are shitheads."

Mutual distrust of the art establishment aside, what of the show's central tenet: that common threads indelibly link Lamb and Picasso? No doubt some would balk at such a thesis—and many did, especially on art-oriented Internet discussion groups—and yet the experts lined up to present their cases. Echoing Angela Tamvaki, who has long drawn parallels between Lamb's and Picasso's "polished and quite

sophisticated Primitivism," Elias Gastón finds within Lamb's "very personal retransmission of the history of twentieth century art" not only "the breath of Chagall and Dubuffet," but also "the mask-like face and tragic expression of the last Picassian self-portraits."[3]

"It seems to me," offers Leonard Folgarait in his catalog essay, "that both artists belong on the same continuum of imagery and philosophy of art." The Vanderbilt professor finds "a high degree of dialogue and correspondence" between Lamb's and Picasso's "intense saturation of color, tendency to emphasize the flat surface of the canvas, playful attitude toward his subjects, childlike treatment of drawing and perspective, [pictorial] world populated by fantastically invented people and animals, and heightened sense of emotion."[4]

Enrique Mallen points to the artists' common opposition of male and female figures, transgressive eroticism, and thematic interplay between death and renewal, sacrificer and victim. The Texas A&M professor also compares Lamb's "translucency of forms," delineated by black outlines, with a similar effect in Picassian works such as *Jeune fille devant un miroir* and several others painted in the summer of 1932. He also draws direct parallels between an untitled Lamb work of 2000 and Picasso's *Nature morte aux tulipes*.[5] So strong is Mallen's contention that an evolutionary line exists, beginning with Paul Cézanne and continuing through Pablo Picasso and Matt Lamb, that he has undertaken a catalog raisonné of Lamb's corpus to complement his ambitious catalog raisonné of Picasso, the Online Picasso Project. He has also lectured on Lamb and Picasso at Texas A&M and at the European Academy (Europahaus) at Otzenhausen, Germany.

It is not only the formal echoes that bridge Lamb and Picasso, but also their working methods and attitudes about art, which sometimes converge in surprising ways. Since 2002, Lamb has been alternating between three very different styles: figurative, semi-abstract, and Abstract Expressionist modes. Picasso, of course, had a spectacularly diverse range as he matured into and beyond Cubism, becoming the master of disparate styles. Later in life, Picasso would decide on a painting-by-painting basis which style he would employ, which is exactly what Lamb is doing now as he explores abstraction while continuing to evolve his semi-abstract and figurative styles.

Picasso's view of painting and repainting as a method for convey-
ing higher truths is similar to Lamb's "generational" method of paint-
ing over and excavating older layers. Said Picasso:

> When you begin a picture, you often make some pretty discoveries.
> You must be on guard against these. Destroy the thing, do it over
> several times. In each destroying of a beautiful discovery, the artist
> does not really suppress it, but rather transforms it, condenses it,
> makes it more substantial.[6]

Lamb, whose output is now climbing toward the 15,000 mark, and
who began painting at an age decades older than did Picasso, often
seems in a race against time to cram a lifetime's worth of ideas and
work into however many years he has left. On his 90th birthday,
Picasso, whose lifelong output many art historians estimate at around
50,000 works, told a reporter: "I am overburdened with work. I don't
have a single second to spare and can't think of anything else."[7] More
than 30 years before, already conscious of his mortality, he had told
Louis Aragon, "I have less and less time, and yet I have more and more
to say, and what I have to say is, increasingly, something about what
goes on in the movement of my thought."[8]

This is extremely relevant to Lamb. When Picasso confesses that
what he is interested in as an artist is primarily "the movement of my
thought," he admits a reflexive narcissism similar to Lamb's own
unapologetic monomania.

Says Lamb: "I'm always asking myself, How does this affect *me?*
How can I make sense of the things happening in *my* world?"

There are further parallels. Lamb is leery of artists who adopt a
vow of silence and refuse to discuss the intent behind their work.
Picasso felt similarly: "Everyone wants to understand art," he said.
"And why not? Why *not* try to understand the songs of a bird? Why
does one love the night, flowers, everything around one, without try-
ing to understand them?"[9]

Lamb and Picasso both show a belief in art as a realm transcending
ordinary experience—no prissy academic experiment, but a mad
explosion from unknown regions of the soul, channeling powers both

benevolent and evil. Said Picasso in 1946: "Painting isn't an aesthetic operation; it's a form of magic designed as a mediator between this strange, hostile world and us, a way of seizing the power by giving form to our terrors as well as our desires."[10]

Lamb has made it clear he believes he is a vessel, "the arms and the legs" that move for a larger consciousness, which for him is "the spirit." For Picasso it was the purpose of painting itself. Both portray themselves as subservient to higher powers. Said Picasso: "Painting is stronger than I am. It makes me do what it wants."[11]

Finally, there are similarities between Picasso and Lamb as materialists. Picasso was born of modest means but died a wealthy and well-known man. Lamb inherited a cash-poor, mom-and-pop business and parlayed it into a multimillion-dollar franchise long before he ever picked up a paintbrush. Both men had to contend (and Lamb still does) with critics who felt they had lost their edge to money. As Arianna Huffington points out, "Picasso's days as a starving artist were over in September 1909, when he moved to 11 Boulevard de Clichy," after which point he lived in great comfort in magnificent homes such as the Chateau de Vauvenargues and his World War II residence, a splendid hotel on the Rue des Grands-Augustins in Saint-Germain.[12]

"What I want," he said, "is to be able to live like a poor man with plenty of money."[13]

Lamb lives by a similar credo, with one foot on the street and the other in the penthouse suite.

With these formal and philosophic convergences as a backdrop for comparison and contrast, the Centre Picasso's *Lamb Encounters Picasso* drew thousands of art lovers, critics, and scholars from around the world to the mountains of northern Spain. Lamb found himself uncommonly moved by the experience. At the Barcelona symposium, he admits "it was the first time I'd had butterflies since I'd conquered my fear of public speaking years ago in Toastmasters. They'd wired me up with a lapel mike, and the sound guy kept getting this loud pounding noise. They couldn't figure out what it was. Turned out it was my heart. I was awed, humbled, and extremely emotional."

He came away from the show with the feeling that something had changed both inside and outside of himself: "When I left America to

go to Spain for the *Lamb/Picasso* exhibition, the whole Puck Show controversy was in the foreground. By the time I came back to Chicago from Horta, I was so far beyond it, it was like I'd come back from the mountaintop. I felt like a different person, like the whole insider/Outsider thing was a moot point and all the battles were over."

If only.

It's late summer, and Lamb has just gotten back to the States. My phone rings, and it's him.

"Richard," he says, "the angels and the devils are going at it again . . ."

And he proceeds to tell me about a new set of ups and downs in his career: So-and-so, one of his detractors in the U.S. art world, has apparently gotten ahold of Herr What's-His-Face in Europe and persuaded him to cancel a Lamb show . . . A certain venture in South America is not turning out as well as he had hoped . . . He's had a bout of gout and hasn't been able to paint in two days . . . But on the other side of the Manichean equation, a promising new gallerist is representing him in Scottsdale . . . His show in Ireland sold out and broke new price records for him . . . And plans are underway for a Matt Lamb Museum in Poland . . .

He changes the subject: "How goes the book?"

I tell him I've amassed hundreds of pages of notes and am nearly done with my year-long stint as his shadow.

"Oh no you're not," he counters. "Not yet."

"Huh?"

"If you really want to get to the bottom of me, there are three more things you need to do. Go to Taos, New Mexico—all my spirits are there. Go to my studios around the world—there's a different part of me in each one of them, and some people say I paint differently according to where I am. And one last mission . . ."

"Yes?"

"I'm sending you my personal archives, which contain every single thing ever written about me over my 20-odd years as an artist. Read it all, then let me know who's full of shit, the critics or me."

CHAPTER THIRTY-EIGHT

THE CANYON FULL OF GHOSTS

I'm staring into a 650-foot hole 12 miles northwest of Taos, New Mexico. It's one of Matt Lamb's founts of inspiration, this great rift in the earth, the Rio Grande Gorge: "There's a primeval energy emanating from it," he swears. "It's terrifying, but it speaks to me. My spirits are all there."

Which sounds like a line of New-Age hokum. Lamb himself would likely be the first to admit as much. But I'm willing to stare down the void and walk the bridge that overspans it with an open mind. That is my mission, and this is my pilgrimage: to come here to Taos Mesa on U.S. Highway 64, amidst fields of sagebrush, juniper, and piñon pine, and see what it is about this place that resonates with and terrifies Lamb the spiritualist and painter.

I pull into the parking lot on the Gorge's east side and make my way

past stands manned by Native Americans and hippies hawking turquoise necklaces, tie-dyed shirts, and *sopaipillas*, paper-thin fried bread drizzled with honey. Motorcyclists whiz by in leather chaps and fringed jackets, would-be Peter Fondas and Dennis Hoppers on their way to the raucous Red River Ralley being held this weekend 50 miles north of here.

My dog is with me on a short leash. Panting, he looks up, wondering what we're doing here, then nervously eyes the open fields that precede the precipice, as if he wants to bolt. I pull the leash tighter.

The sidewalks are narrow on either side of the bridge, which a plaque announces is the second-highest in the United States, completed in 1965. Warning signs adorn fences that guard the canyon's rim, lest people venture too close to the ledge and fall to their deaths: *"Hazardous Area—No Tresspassing/Area Peligrosa—Se Prohibida la Entrada."* A woman makes the sign of the cross, kneeling before a roadside memorial just yards away.

When I reach the bridge, my dog stops cold. I tug his leash, but he won't budge. Maybe the little guy knows there's something unnatural about stepping out onto a 500-foot ribbon of concrete with 650 feet of absolutely nothing underfoot. Or maybe, like Matt Lamb, he has a sixth sense and can pick up vibes from those pesky spirits floating up from the bowels of the earth. Could it be my dog has more in common with Matt Lamb than I do? (Now, if only I could get my dog to paint!) I tug harder on his leash, and reluctantly he follows.

The bridge is shaking. If this is an earthquake and the whole thing collapses, I'm history. But no, it's just the vibrations of cars and Hogs hurtling by. Zia sun symbols are built into the guardrail's metalwork in peeling orange paint, circles with four sets of four-pronged sunrays, cornerstones of the Zia Pueblo's faith: four seasons, four directions, four times of day, four ages of man. Grafitti covers the guardrail:

> *Kev—Aus—Tex—'85*
> *Angela + Esteban 4-8-96*
> *Danny + Maryanna 10/28/90*
> *Jane Loves Ben 8/8/76*

Does Kevin still live in Austin? Does Jane still love Ben, 27 years later? 650 feet below, the muddy Rio Grande snakes its way through the

canyon, breaking intermittently into rapids. The Sangre de Cristo ("Blood of Christ") mountains loom to the east. A moment ago they were green, but a cloud is covering the sun and turning them deep, moody purple. Not too far from here, Wheeler Peak, snow covered even in summertime, towers 13,161 feet, the highest mountain in New Mexico. Amazing that something so high could be so close to something so deep.

How did Lamb convince me to come here? He's in Berlin today, painting umbrellas with *Kinder* and parading with them through the Brandenburg Gate. German and French television crews are racking focus and zooming in, asking him questions about peace, tolerance, and all the rest as he heads off to a five-course reception dinner at The Four Seasons. And here I am among the roadrunners and rattlesnakes, staring down into a big gash in the ground.

The Gorge is not pretty in any conventional sense. Unlike the Grand Canyon, it boasts no myriad hues of orange, red, and copper, no strata silently singing of eons past. The Rio Grande Gorge is all brown, all the way down. It's what you get when you rip the skin off the earth and find not vivid, shimmering viscera, but dirt—when you peel open your life looking for your bliss or your quest or the hidden beauties lurking in your imagination's nether regions, only to find nothing but a pile of brown crud. Is this why Lamb calls this place "terrifying," because of its sheer, soul-sapping banality? I think of Marlon Brando in an infamous scene from Bertolucci's *Last Tango in Paris*, screaming at his young mistress about man's aloneness in the universe: "You won't be able to be free of that feeling of being alone," he rants, "until you look death right in the face . . . until you go right up into the ass of death, till you find the womb of fear." This gaping scar in the earth is Lamb's womb of fear—and ours.

I take a deep breath—the altitude must be getting to my head. Nearly 7,000 feet up, and everything's getting all existential. I look back down at the river and realize I got it wrong, the whole womb of fear thing. That's not it. It's the river. Lamb's drawn to this place because of the river, which has worn down tens of thousands of years' worth of rock. It's the ultimate generational art—the earth as canvas, the elements as artist. What Mother Nature buildeth up, Mother Nature teareth down.

When I reach the opposite side, I descend the slope to the safety

fence and look at the parabola of steel undergirding the bridge. My dog pees on the dry, cracked ground, and in my mind's ear I hear Lamb relating his homily on power—the big dog teaching the little dog a lesson: "If you can't eat it and you can't fuck it, piss on it." In that moment I know I've been working too hard. My dog can't even take a leak without my relating it to the world of Lamb. I resolve to take the rest of the night off and down some serious agave over at Adobe Bar. Thus decided, I head back up the slope to cross back over the bridge to my car.

But the spirits aren't going to let me off that easily. From the chasm a gust blows up like a soul rising from purgatory, whispering up my calves and thighs, cooling my chest and underarms beneath my tank top, feathering through my hair like a lover's touch. Like a soul rising up. Maybe it *was* a soul: Lamb says he divines spirits here, takes inspiration from this spot and slathers it onto his canvases. Taos, 12 miles to the southeast, is where he promised Rose, that autumn night in 1983, that he would become a painter—if only he could claw his way out of the medical mess he was in. Could the spirits of the Anasazi have gotten to him that night, wafted down the kiva fireplace and had a secret visitation with his soul as he and Rose slumbered? Made a pact with him? *We'll cure you if you paint our shaman-spirits.* Could the ancient, petroglyphic kachinas—the medicine men and kokopellis, bears, badgers, and buffalo dancers, crow mothers, and corn maidens—have gotten to Lamb and bade him paint the forgotten icons lurking at the bottom of those twin abysses: the Gorge and his own primordial memory? Perhaps Lamb, oblivious to the ghostly visit, had risen the following day with the words of D.H. Lawrence inscribed upon his soul: "In the magnificent fierce morning of New Mexico one sprang awake, a new part of the soul woke up suddenly, and the old world gave way to a new."

My chest heaves as I stumble back to my car, my brain desperate for oxygen. Somewhere between vertigo and nausea, it becomes chillingly clear: The Anasazi made a deal with Lamb's soul—*Give life to us in your painting, and we'll give you your life back.* And they had.

For a long moment it seems I've discovered the secret of Lamb's inspiration out here in the high desert. The moment passes. Maybe it's just a line of New-Age hokum after all.

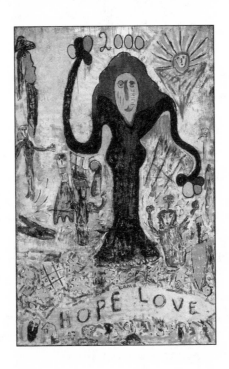

CHAPTER THIRTY-NINE

AROUND THE WORLD IN 80 STUDIOS

My eyes are watering, I'm having chest pains, and I'm getting seriously high. That's how strong the fumes are in Matt Lamb's studio in the Florida Keys. If you lit a cigarette in here, the whole place would blow up. Gigantic fans are all around, blowing a hundred paintings dry at once, evaporating the borderline toxic mix of pooled paint, turpentine, polyurethane, linseed oil, and any other godforsaken grab bag of secret ingredients Lamb splashes onto his canvases. These giant fans stay on all year, except for the three months when the artist himself is on the island. If you're reading this paragraph in any month other than January, February, or March, the fans are blowing right now.

Lamb's not in the studio today, he's back in Chicago. I missed him by two days—the man gets around—but he's arranged for me to be let

in. Tiptoeing over the fans' extension cords, I look down at the enormous planks on which the paintings are drying and notice that—

The cell phone rings. "Hello?"

"Richard, it's Matt!"

I tell him where I am. "Do you ever get high off the fumes?" I ask.

"No, never. I love the fumes. They're mother's milk to me."

The studio's just off a secluded courtyard in a strip mall across from a SCUBA shop. Strip malls are everywhere in the Keys, long and thin like the islands themselves.

Lamb leads me on a tour of the place by cell phone, directing me toward one of his motherboards, the deep-lipped wooden platters where he plops canvases down in the first step of their evolution. This motherboard, he says, is one he's been using for 12 years and has so many "generations" accumulated on it, he's planning to remove the lip and hang the board as a giant wooden panel.

"The stuff on the floor," he says, "that looks like kitty litter is actually a product for absorbing oil that I order from an auto garage. With all the paint I sling around, I have to have something to soak it up, otherwise I'd be slipping and sliding everywhere."

He says to go in the back room.

"You see those big abstract pieces? A week ago there were huge bubbles of fermenting paint on them. I took a knife and sliced into them, and all the paint came dripping out. It was like lancing a boil and watching the pus explode."

Lamb loves to talk about his paintings as if they were human bodies with skin, wrinkles, moles, and zits. If he weren't a painter, he'd make a heck of a dermatologist.

The studio, frankly, is a mess. Screwdrivers, rags, crowbars, and staple guns litter the floors. On the worktables, loose nails and scrub brushes lie haphazardly, along with electric paint stirrers and an assortment of whisk brooms. Red paint is splattered across the walls like blood. It's unsettling but fitting that a man obsessed with life and death would give birth to his art in a room that looks like a murder scene.

Lamb gets another call and hangs up.

There's a big boom box on the floor. I turn it on, and the deejay announces, "101.3 FM, WKYZ . . . Key Z." And then "30 Days in the

Hole" by Humble Pie starts up, and I see Lamb in my mind's eye, tossing his wild white hair to and fro as he paints.

These fumes are tough on the allergies, so I turn the radio off, lock the place up, and head in my car up U.S. Highway 1 to the artist's condo, part of an immaculately landscaped complex smack dab on the beach. I park, unlock the door, and catch my breath—the place is a knockout, two stories brimming with antiques from around the world and Lamb's paintings hung everywhere.

Freeman & Associates, a Dallas design firm, completely redid the home a few years ago. Betsy Freeman runs the firm, and her parents, Tom and Gay, consult. The Freemans met the Lambs while doing contract work for Blake-Lamb and have since decorated not only the beach house, but also the couple's Chicago town house and Paris apartment, carrying over the color schemes to impart a subtle chromatic continuity. When the Freemans originally asked Lamb what he wanted the Florida house to feel like, he answered, "The womb." Rose, thankfully, was more specific: "Cozy, warm, no white walls, a safari look without the toothy animals on the wall." Betsy had imported an antique bookcase from India that was so enormous, it had to be cut in two, lifted over the second-story balcony by crane, then reassembled inside. She installed a lazy fan of reeded bamboo in the living room and flung hand-embroidered Pakistani throws, glittering with tiny mirrors, over the railings upstairs.

The cordless phone rings in the kitchen, and after a moment's hesitation, I answer it, "Lamb residence."

"Richard, Matt!" And once again he walks me through the place, telling me the story around every corner. "There's a really early *Once Upon a Time* covering the entire living room wall. And at the top of the spiral staircase there's a new painting that's still drying—in fact, little rivulets of paint have dripped down from the bottom of the canvas like stalactites."

Over the computer facing the upstairs bedroom is another new painting, a striking abstract piece with a craggy, oval-shaped form in the middle and jagged forms hurtling outwards on all sides.

"It's like the Big Bang," he says. "It comes right out like it's gonna eat ya! There's a figure to the side of it, see? It's sticking its tongue out, razzing the world. That's my 'Fuck you!' face. Okay, now go over to the watercolor studio."

Lamb insists his watercolors are a form in their own right, not a vehicle for working out ideas for painting, but a quick glance through a random folio throws this assertion into doubt. There are studies of hair, double faces, and embryos, in quick, free-form gestures that seem to be nimbling up his fingers and mind for his work in oils.

"The way I do watercolors," he says, "would be considered bizarre by the traditional watercolorist," and indeed, his unorthodox mix of water-soluble paints, pencils, crayons, craypods, and Magic Markers, with which he lays down a smudgy background, seems to be a smaller version of his mutant, media-mixing dip. "I never wash my brushes, either. If I'm in black and I want white, I have to go through a lot of gray first."

On a hutch stands a watercolor he gave to Rose as a homemade anniversary card, portraying a female figure on the left, a male on the right, and in the middle, a heart. "45 Great Years with My Beloved Rose," it reads.

A couple years ago he painted the walls of the upstairs bathroom with fish, dolphins, sea horses, whales, and a big umbrella. He also painted the dining room tablecloth, a wooden trunk, desk, folding chair, and the curtains leading to the downstairs balcony. He also created sculptures out of slabs of sea rock from the beach. Welded onto a steel pedestal, one of these sculptures bears a colorful face, inlaid with gold and silver leaf. Chicago entertainment reporter Jack Zimmerman wrote that these sculptures evoke El Greco,[1] but Lamb is slightly more down to earth: "I guess this is one way to achieve immortality through art: work with rock, steel, and concrete. You'd have to dynamite them to get rid of them!"

He recommends I try lunch at a local dive called The Stuffed Pig, and if I'm staying for dinner (which I'm not—I have to get to Miami) I should sup at The Barracuda Grill or Mike's Hideaway, where the duck "is out of this world . . . Potter Palmer came to see us and pronounced it the best duck in the world, and he oughtta know." Lamb proceeds to describe the dish in exhaustive, mouth-watering detail. Five minutes later, he's still going on about it. Apparently, this duck has changed people's lives.

There's a pool outside in which he swims his daily laps. He also exercises in a peculiar fashion, a hybrid of power-walking, cross-country skiing, and weightlifting.

"Look in the downstairs hallway closet," he says, and directs me to a

backpack filled with 40 pounds of sand and rocks from the beach, which he carries around as he propels himself forward with a cane in each hand, wearing all the while two specially designed shoes weighing five pounds apiece, weighted magnets on his arms, and a weighted magnet around his neck. For an hour a day, listening to books on tape on his Walkman, he sets off through the streets of the Keys, looking, with his white beard and white hair, like Ernest Hemingway back from the grave and on a fitness kick.

I tell him I need to hang up—I have to be at the Virginia Miller Gallery in Miami by 3 o'clock. For a brief moment I relax in an over-stuffed chair in the living room and prop my feet up on the ottoman. The fan turns languidly overhead as, through the window, palms sway in the breeze. The eggplant- and sienna-colored walls glow warmly, and I cuddle up with a chenile throw. This place rather *is* like the womb: warm, comfy, and surrounded by water on all sides. No wonder Lamb loves to come here—and hates to leave.

It's October, and Lamb is leading me through his studio in one of Chicago's grittiest industrial areas. Outside in the distance, the city's skyline cuts the horizon, but inside there's nary a window to be found.

"I don't like to paint in natural light the way most artists do," he explains. "I prefer artificial lighting, because it gives me an idea of what the paintings will look like in galleries or under track lighting."

By any standard, the studio is immense, a converted warehouse reminiscent of the *Citizen Kane* finale. Storage bins line the walls, brimming with canvases of all sizes. Beside the bins are a cement mixer, palette jacks, several motherboards, drying tables, easels, rows upon rows of paints, and a sculpture fashioned out of metal and rags entitled *Our Lady of the Sand*, which Lamb describes as "the Blessed Holy Mother as a cactus."

Suddenly, a short, beefy man whizzes by on RollerBlades.

"That's Wojtek," Lamb says.

Wojtek (pronounced VOY-tek) is Lamb's assistant, and he RollerBlades from one end of the studio to the other because it takes too long to walk.

"He's a very sensitive soul," Lamb says in a protective tone. "His emotions are always close to the surface."

Wojtek moved to the United States in 1985 from Poland, where he'd been a draftsman, and found work doing maintenance for Blake-Lamb Funeral Homes. Gradually, he began working on the side for Lamb personally, helping the artist during his transition from CEO to painter. One day in the late 1980s, Lamb sent Wojtek to the art supply store near his studio to buy a large canvas. Holding the canvas as he walked the short distance back to the studio, Wojtek was mortified when one of Chicago's famous gusts whipped the canvas out of his hands, sent it sailing through the air, and plopped it with a splash in Lake Michigan. He was fearful his boss would be furious upon learning the news but was relieved when Lamb, hearing the story, laughed until tears streamed from his eyes. A year later, while delivering a monumentally sized painting to a collector who lived in a high-rise penthouse, Wojtek found that the painting simply would not fit into the smallish freight elevator. It would, however, fit into the stairwell if angled and turned just so as he ascended. So he carried it sixty stories up, his arms and legs aching by the time he was finished. Wojtek may be a gentle soul, but he's made of muscle.

Now he's skating by with a fresh roll of duct tape and a permanent marker, boxing up several dozen paintings for delivery to Rima Fine Art in Scottsdale. He addresses the boxes in a round, fastidious hand.

"Out of all my studios, this one is where I'm able to focus the most," Lamb says. "The physical environment has no outside stimuli: no light, no outside view to distract me, it's just me and the work." He claps his hands. "Let's go have lunch."

Out on the street, two hip-hop kids stop him and compliment his eyeglasses, oversized red plastic frames he bought in Paris in the 1980s, which have been out of style long enough to now be back *in* style. He opens the doors to his BMW, which he drives when he's not in the mood to be chauffeured, and the radio's playing Def Leppard on 97.9, WLUP-FM, "The Loop."

"Hard rock is my 'happy music,' " he says.

After lunch (a turkey-and-dressing special at a local deli), he drives to his town house, designed in 1890 by John Wellborn Root, who designed Chicago's Rookery and was immortalized in the best-selling book, *Devil in the White City*. It's a narrow, four-story structure—"You

have to be a mountain goat to climb these stairs!" Lamb says—that was showing its age when the Lambs moved in a few years ago but returned to its former splendor after decorators raised the ceilings, installed an antique Irish mantel over the fireplace, and hired New York decorative artist Joe Brady to paint the foyer.

Lamb gives me an impromptu nickel-and-dime tour of this million-dollar residence, starting downstairs with the basement he's turned into a watercolor studio. "I come down here in the mornings, when Rose is asleep," he says, "and I paint while I listen to Don Imus on the radio."

Some of the watercolors are painted on old notepaper. "Wed. dinner 5:30," one of them reads beneath the paint, while another is underlaid with stock quotes printed off the Internet.

Up one flight from the foyer is the library, lined with cherrywood bookcases. Lamb's office is up here, a miraculous mess with notes scattered everywhere.

"The really important stuff I stick up here," he says, pointing at the chandelier, and sure enough, there are notes stabbed through the brass arms and yellow Stick-em notes affixed to the dangling crystals. "This is a real growth for me, not caring whether I lose track of an important note or not. I had to be so on top of things in my former life. Now I don't give a damn."

Up another flight is the pale yellow-painted sunroom, far lighter in color and ambiance than the dark-paneled library. Brass Buddha and Shiva statues from the Lambs' travels to India stand guard, as does a ceramic foo dog from China. Paintings cover the walls, Lamb's own works along with many by other artists.

The top floor is the master bedroom, in which John Wellborn Root, at the age of 41, is thought to have died of pneumonia. On the bedside armoire rests a black-and-white photo of Rose's mother gazing out from the 1920s, crimped hair rippling from under her bonnet. Lamb had nearly a dozen layers of paint and wallpaper removed from this room, exposing the original cracked plaster and graffiti scribbled by workers who built the place 110 years ago. He chose not to have the walls redone, and the result is that the room is the home's rawest, with a primitive, elegiac—if not haunted—feel.

"Excuse me for a moment," he says. "Wander around some on your own. Feel the spirits."

One floor down, two *Once Upon a Time*s adorn the walls. A rock sculpture from the Keys sits on a pedestal, a face painted on the rock, bent metal rods poking out of the head like windblown hair. The dining room tablecloth has been painted by Lamb, as has a chest of drawers. Are there spirits here? The spirit I feel the most, the one permeating every cranny and corner, is Lamb's own: his taste, his creativity, his life and travels with Rose.

Emerging from his office, he bids me rest on the sofa as he takes his favorite chair beside the window and picks up a book called *Politically Incorrect Fairy Tales* by Chicago author James Finn Garner. Would I like to hear one of the tales? And so, for the next half-hour, his voice rising and falling and laughing in an infectious falsetto, he reads these tongue-in-cheek stories like a parent reading to a child at bedtime. I sink further down into the couch, and it's all very snug and cozy and warm, surrounded by the cherrywood and lulled by his voice and the sight of him, so paternal, with his reading glasses, fuzzy sweater, and white, white hair. He could be my father if I were orphaned, my priest if I were Catholic, my older lover if I were gay. He could be my confidant were I not his critic, my mentor were I not his memoirist. He could be my friend. I sit up and shake my head ever so slightly, trying to snap out of it. Lamb just keeps on reading. Even as he hypnotizes me, I hug the remaining vestiges of my objectivity like a blanket, lest they fly out the lead-paned windows into the crisp air, swirling away with the autumn leaves.

It's the perfect fall day, sunny but just cool enough to dress in layers. Lamb and I and some of his friends—the folk artist Larry Ballard and his wife, Annette, and Dominic Rohde and his wife, Lía—have gathered for an afternoon picnic at his Wisconsin farm. Bob, the caretaker, has just returned from Piggly Wiggly with fried chicken and potato salad, fish and chips. He sets the table and brings around a selection of beers. Dominic and I take an ale apiece, while Lamb opts for iced tea. For the next two hours everyone chows down and argues about religion, politics, and art in the shade of oak, hickory, and black walnut

trees. It's a classic Lamb discussion, impassioned but civil. This is what he means when he talks about—and paints—a conversation.

The farm dates to 1841 and sits on 50 acres once inhabited by Ho-Chunk and Pottawamie Indians. It's a pastorale that one art historian, noting its wildflowers and water plants, once likened to Monet's garden at Giverny.[2] Bob Banci, the caretaker, is a retired filmmaker who used to be production manager for spaghetti-western icons Bud Spencer and Terence Hill. Dante, Bob's German Shepherd, has the run of the place. A quiet, quirky man, Bob tends to the grounds and occupies himself reading metaphysics, keeping honeybees, and designing meditation labyrinths in the fields. He points to one of his mazes: "*Solvitura bolondum*," he intones. "You will solve it by walking."

We head into the 100-year-old barn where Lamb does his dips. Beneath the open beamwork, canvases lie drying and motherboards await their next batch of babies. A monumental wood-panel series, 165 feet long and 12 feet high, stretches out along two walls. It's not finished yet, but already it teems with dozens and dozens of figures: women with gasping mouths and orange hair, men with red-and-yellow ladders for bodies, horses galloping through fields, and wispy specters off to the sides, surveying the proceedings with a look of dread. They are, it would seem, demi-gods and -goddesses, fairies, trolls, and witches. They are the old gods of rain, wind, tree, and soil. Beneath all the Catholic posturing, Lamb, I'm convinced, is pagan.

"Do you ever think," I ask, turning to him, "that there are many gods instead of just one?"

"No," he says flatly.

And that's that.

Lamb spends only a few weeks a year in the City of Light, but his intimate apartment in the Bastille neighborhood of Paris gives him a stimulating environment in which to paint his watercolors. The living room window open, children giggle on the avenue below, and merchants yell at one another as they set up the produce and flower market. The Opera Bastille is nearby, down streets lined with crêpe stands and tapas restaurants.

The Lambs had their Dallas decorators, Freeman & Associates, do the apartment up in a luxe, Continental style. Appointed with antiques, the walls hung with tapestries, the residence glows with amber-colored crushed Italian velvet. In the den and living room, silk draperies puddle decadently on the floor, while the dining nook overlooking the street and market is a simpler affair, with a plain but functional table purchased from a bistro down the street.

When he isn't doing watercolors or haunting bookstores, Lamb hangs out with artist friends from the Montmartre Republic, an order founded in 1921 to preserve the artistic integrity of the legendary neighborhood *d'artistes*. In recognition of his hearty appetite for life, much appreciated by the Gauls, and presence on the local art scene, Lamb was recently named "L'Ambassadeur aux Etats-Unis de la République de Montmartre," making him an official cultural ambassador from Montmartre to the United States.

"That and about five Euros," Lamb says, "will get you a café au lait on the Champs Elysées."

As the green-blooded great-grandson of the Irish immigrant whose name he bears, Matt Lamb was perhaps destined to return to "the old sod." His studios and homes in the west of County Cork, Ireland, are among his favorite abodes. On a cliff overlooking the Atlantic, near a fishing village with a population of 250, stands the artist's half-timbered manor and its gazebo, where his paintings dry. Nearby is a 300-year-old guest cottage and four buildings that function as his studios. Unlike the windowless Chicago studio, all the buildings in the Ireland compound offer sweeping vistas of the verdant, stone-fenced farmland across the strait and the great ocean beyond.

There are no hard-rock stations in the fishing village, so Lamb listens to classical music while he paints. Sometimes he drags his easel outside and works to the music of crashing waves. Life is slow here. Cows graze, horses trot, foxes run through the fields. It's a place to breathe deeply, think deeply, and create. The Lambs cook a lot when they summer here: fish, soup, roast chicken, lamb chops. Every day at lunch, the artist leaves a bit of food on his plate, takes it outside, and

calls the seagulls: "Come here, ye beasts!" And they fly up and pick the food off, 15, 20 of them at a time.

There are human diversions now and then. Today, *The Sunday Independent* has sent a reporter down from Dublin to interview Lamb. The Warren Gallery in Castletownshend is wrapping up a show, which sold an astounding 44 paintings, and Lamb's due at the closing next week to press flesh, sign autographs, and gab.

Declan McCarthy, a manager at a local bank, drops by to visit the Lambs and dish about local politics. From 1998 to 2002, McCarthy and the Lambs were active in an initiative to designate part of the village a development-free zone. They also joined in the push to get local politicians to construct a highway bypass and build playgrounds for schoolkids.

"Matt and Rose are not Ugly Americans," McCarthy says. "They're good neighbors. We didn't need money for our political cause, we just needed people to contribute their time and brains. And that's exactly what Matt and Rose gave us."

Two other friends drop by, Mick and Catherine Molloy. Mick's a former rugby champion, and now he and Catherine are both doctors and art collectors. Catherine sits down with Lamb to bend his ear about an idea she has to exhibit his work in two Cork churches—one Protestant, the other Catholic. The prospect of uniting religion and politics through art is right up Lamb's alley.

"You won't have to twist my arm on that one," he tells Catherine. "I'm in!"

When Lamb visits Germany, it is primarily as a teacher at St. Matthias Kolleg in Tünsdorf, a village in the bucolic hills of southwestern Germany, less than a mile from the French border. Dignitaries from nearby Strasbourg often pop over to visit him, and there's no shortage of art groupies eager to get his autograph or bend his ear. When he can grab free time, he does oil paintings and watercolors in the Matt Lamb Center's workspace, often as students watch him, taking notes.

The food around here is incredible, a mélange of Alsatian and Teutonic traditions marrying delicate sauces with hearty *Rahmschnitzel*

and *Späzle*. Lamb struggles to stick to his Atkins-inspired diet when he's in town, and he walks daily through the countryside, often to and beyond the French frontier.

Typically Lamb and Rose stay in a private home owned by Dominic and Lía's friends during their German visits. This is atypical for the couple, who value their privacy. While the Lambs are generous with their homes throughout the world, lending them to friends and family when they're not in residence, visitors stay in hotels when the Lambs are home. No overnighting in the guest bedroom. Lamb doesn't want the distraction of hosting guests, and Rose spent "so many years hosting dinners above the funeral home, trying to be all things to all people," that playing bed-and-breakfast mistress is the last way she wants to spend her golden years.

"I have seven studios," Lamb says, "but I'm always on the lookout for new places to paint. Rose and I have toyed with buying a place in New Mexico, but so far we haven't. I also went to the South of France to paint—you always hear about how marvelous the light is there—but for whatever reason, my work there was junk."

Many people who know Lamb's art believe he works differently in different studios. Virginia Miller feels he uses more "coral tones and tropical yellows" when he paints in the Keys. Simone Nathan also believes his work takes a softer turn "when he's down there in paradise." To this day she cautions him not to spend too much time in Florida, lest his work lose the edge of rage that inspires it.

"Personally," he opines, "I don't think the work I do in Ireland is any different than my work in Florida, Paris, Chicago, or wherever. I think people are reading too much into it."

With the exceptions of Africa, Australia, and Antarctica, Lamb and his work have traveled to every continent. Those exceptions will likely narrow, with early plans in the works for a show in Johannesburg. And knowing the big-dreaming Lamb, could a show atop Ayers Rock or afloat on some South-Pole glacier be out of the question? *Lamb Agitates the Aborigines? Lamb Paints for Penguins?* Don't rule it out—he hasn't. In the wide world of Lamb, the more impossible something seems, the more likely it is to happen.

CHAPTER FORTY

PANS AND PRAISE: THE CRITICS
LOOK AT LAMB

The archives that Lamb promised to send have arrived, the six crates stuffed with old magazine and newspaper clippings that contain "every single thing ever written about me." The clippings aren't limited to his career as an artist; they stretch back to the 1940s, when he was a kid working for his dad at Blake-Lamb. In scrapbook after scrapbook, Lamb is pictured in ads and P.R. materials for the funeral homes with his father, then his brother, then his own children. The later scrapbooks chronicle his transition from an undertaker into an artist and overflow with catalog essays, feature articles, and reviews of his work in publications as quaint as *The Florida Keys Keynoter* and as august as *The Times of London*.

Among the arts writers who have held forth on him and his painting throughout the last two decades, there is no critical consensus. The reviews are good, bad, and mixed, and often reflect the reviewers' difficulty in dealing with the misconceptions and internal contradictions that surround Lamb's unusual life story and equally unusual art. This is understandable. After all, it would be easy to peg Lamb as a rich playboy with a new hobby, except that he's been painting for nearly a quarter-century now—as a doddering old coot, except that he's quick-witted, feisty, and maintains an unforgiving schedule that would break many a younger man—as a leftover hippy painting LSD flashbacks in the name of peace and love, except that he was never a hippy to begin with and has never dropped acid—as a religious freak out to evangelize the world to Roman Catholicism, except that he's active in the Jewish, Greek Orthodox, and Muslim communities—as a savvy marketer hell-bent on promoting his art as a product for mass consumption, except that he's compelled not by market forces but by an inner need to create hundreds, even thousands, of paintings a year with no regard for whether or not they'll ever sell—and as a vainglorious poseur passing himself off as a "real" artist, except that he's exhibited in upwards of 150 one-man shows, won prestigious juried competitions, been collected by museums on four continents, received significant commissions, and garnered serious attention from academics, art historians, and the press. Clearly, it is tempting but impossible to pigeonhole Matt Lamb, and while his detractors—and there are many—love to diss and dismiss him, he is simply too important, too prolific, and too present at the center of contemporary art's most topical debates, to ignore.

As she helped prepare for Lamb's Greek debut, Angela Tamvaki, curator at the National Gallery in Athens, realized how tricky it was to evaluate his output without being sucked into the cult of personality that envelops the flamboyant painter:

> I have often thought that an artist's creative endeavor should be
> viewed and assessed independently of the story of his life. Even
> more often, I have resented the aura of romance and myth that may

distort the evaluation of the work. Such a danger would seem imminent in the case of Matt Lamb.[1]

But Tamvaki goes on to argue that both Lamb's art and his very "lifestyle" defy easy classification. To her, his work's most striking feature is its multiplicity of figures and spirits, which she believes may be stand-ins for Nietzschean supermen. She is also taken with his thematic preoccupation with "agony and hope," which invites the art lover to protest "against social and political injustice and cruelty."

John Orders, a Los Angeles art consultant who encountered Lamb's work while Associate Director of the Museum of Contemporary Art in Chicago, believes that the "energy and focus" of the painter's technique is his forte:

It's hard not to be taken by the sheer energy of it that communicates itself almost immediately. It's really satisfying and arresting. As I saw more and more of his work, the thing that struck me was the sense of color and texture he achieves. It grabs you. There's something very in-depth and tactile about it. He uses mythological motifs, Indians, and bird-like creatures that are representational, but in an abstract sort of way. He's able to convey with incredible emotional impact a kind of mystical or ecstatic vision, a dream moment, an epiphany. Certainly, his art isn't for everybody; it drives some people crazy. But for me, quite simply, it works.[2]

The German author, linguist, and art historian, Guido König, maintains that Lamb's work "does not come out of any established tradition," but "seems to come from a place outside art history . . . Lamb is a contradiction, both reactionary and rebel, Romantic and modernist, and his art serves as a spiritual instruction manual on the universal themes of knowledge, power, loss, and salvation."[3]

While König is unable to find historic antecedents for Lamb, others have not come up so empty-handed. Michal Ann Carley, art professor at Cardinal Stritch University, finds his method of divining figures from the dip's chaos evocative of "the Surrealists' automatic

mark-making and discovery of correlative symbols." She also places Lamb's métier squarely within "Jean Dubuffet's conception of Art Brut: that which is created in a 'feverish impulse,' " and finds "distinct parallels in Lamb's work with the idiosyncratic Symbolists James Ensor and Odilon Redon, whose expressionistically worked surfaces and compositions evoke both rhapsodic and tortured narratives." Finally, she points to the "curious relationship" between Jackson Pollock's early psychoanalytic drawings and Lamb's "autonomic drawing and free association."[4]

Athena Schina, art historian at the University of Athens, sums up Lamb's paintings as "a narrative mesh consisting of realist, surrealist, and expressionist elements,"[5] while Donald Kuspit, art professor at State University of New York and author of more than 20 books, invokes Baudelaire's and David Riesman's conception of the lonely crowd in considering Lamb's "almost amorphous wraiths, differentiated and identifiable only through their faces." Kuspit goes on to pointedly suggest an element of male chauvinism in Lamb's figures:

> Men loom large, with women as lesser beings, essentially attributes
> of the men—a hierarchical and condescending, not to say
> narcissistic, means of composition for a male artist. We know who is
> top dog: The male figure dominates. The man—implicitly Lamb—
> is frequently crowned, regal and victorious, while the woman is a
> silly, simplistic figure below and inferior to him . . . The smallness
> clearly articulates Lamb's fear of woman, for all his attraction to
> her . . .[6]

Kuspit made these rather arguable assertions, no less, in a catalog essay for one of Lamb's shows, a move that took a certain chutzpah.

Sophie Delassein, writing for *Muséart,* opined less controversially that Lamb's "expanses of warm colors framed by black outlines" recall Jean-Michel Atlan, while his symbolism puts her in mind of Maurice Denis and the Nabis.[7] Venetian author and art critic Paolo Rizzi, on the other hand, reaches considerably further back in time and finds antecedents to Lamb's wild-eyed spirits in Native American art's

"seductive primitivity, like an Indian totem, a darkened mask . . . and those altered, dazed eyes, that hallucinated look, that feeling of retuning to a lost barbarian virginity."[8]

Elisa Turner, art critic at the *Miami Herald*, finds Lamb's work reminiscent of "the slap-dash, faux-naïve style of European postwar artists like Karel Appel and Asger Jorn." She prefers his smaller paintings to his bigger. "Despite their richly worked surfaces," she writes, "Lamb's paintings can look thin and repetitive, especially when he tackles big canvases. His smaller works seem less busy with making big philosophical statements about the Beauty of Life and more in touch with spontaneous expression."[9]

Peter Hartig of the *Luxembourger Wort* echoes: "The artist gets lost when he paints too big, gets confused with too many lines in chaos. The smallest of the works are the best."[10]

In *Raw Vision*, prolific arts writer Michael D. Hall points out that Lamb's "use of cement, sand, glue, and tar evokes Julian Schnabel's use of Bondo and broken shards of pottery. Similarly, the eccentric figuration (and the not-so-veiled religiosity) in Lamb's painting is akin to that in the work of Francesco Clemente." He goes on to liken the painter's didacticism to Georges Rouault: "Like Rouault, Lamb sees painting as an embrace of life to be held up to a public perceived as decidedly in need of admonishment." He concludes that Lamb's work is "most appropriately understood as an offbeat hybrid of traditional symbolist and expressionist art . . . a new genre of eccentric figuration stylistically beholden to naïve art, Art Brut, and neo-expressionism, but distinctive for its narrative form and its message-based content."[11]

Collectors are art critics, too. They praise or pan by spending or withholding dollars. Miami gallerist Virginia Miller recalls a collector who saw a Lamb painting during one of her group shows.

"Now, you see that?" the collector asked her, pointing. "That's exactly the kind of painting we *don't* want today."

"That's just fine," Miller assured him. "We have plenty of others."

After an hour at the show, the man left without buying anything.

Two weeks later he telephoned her. "You know that painting I said I hated?"

"The Matt Lamb?"

"Mmm-hmm. Well, it's funny to say this, but I haven't been able to get it out of my head. Is it still available?"

It was, and Miller agreed to hang the work in the man's home "on approval," meaning on a trial loan. All wainscotings and brass chandeliers, the home was the height of Colonial style, not exactly a natural environment for a Lamb. In less than a week, the collector called Miller.

"I like the piece a lot," he said, "but it just doesn't work in my house."

Miller came and took the painting back to the gallery.

A week later, her phone rang again: "Do you think," the man asked, "you could frame it in a way that would make it work better in my home?"

After some consideration, she put the piece in an Old Masters frame, replete with gilded shells and laurel leaves. The collector loved it, bought the piece, and bought more of Lamb's work in subsequent years.

Another client of Miller's was considerably less enthusiastic. The man, who'd recently purchased a Lamb painting from the gallery, approached Miller after the artist's Sasaki art-glass pieces became available at Bloomingdale's and Marshall Field's. He was worried that the availability of mass-produced Lamb products would taint the artist's reputation as a fine artist and thereby decrease the value of his paintings. Miller reminded the collector that Grandma Moses had licensed her paintings to Hallmark to be reproduced in millions of Christmas cards, and that Keith Haring had licensed his paintings to Swatch to be reproduced on wristwatches and T-shirts, and that neither Moses nor Haring, nor Warhol nor Lichtenstein, for that matter, had suffered in reputation or price point as a result of mass-produced endeavors. Unconvinced, the collector sulked away, never to collect Lamb again.

One British collector who enjoys Lamb's "vibrant use of color" nevertheless despises the fact that the painter wears his elaborate spirituality on his shirtsleeve. "Please help me unravel your gibberish," he wrote in a comment posted on Lamb's web site in September 2003.

"Your artist's statement uses phrases empty of any meaning, such as 'pilgrim in an alien world,' and 'The paradoxes of life baffle me,' and 'To truly interact with my work, I must become like a little child every day.' Your attempts to brainwash gullible folk with this nonsense strike me, frankly, as rather sick."

A different collector who had purchased a Lamb painting at an American gallery had at first decided to hang her new acquisition in her bedroom opposite her bed. But over the course of the next few nights, she found that the strange figures leering out from the painting were unnerving her as she tried to get to sleep. One night she awoke with a start and was spooked as she saw the faces staring at her across the dimly lit room. The next morning, she moved the piece into the living room, where she has kept it ever since.

A psychiatrist in a major U.S. city purchased a Lamb in the early 1990s and hung it in the waiting room of his practice. A few months later, he happened to run into the gallery owner who'd sold it to him. "I had to take it out of the waiting room and put it in my office," the psychiatrist confessed, and added, under his breath, "It was making my patients even crazier."

And then there was the woman in Atlanta, Georgia, who tried out a Lamb in her home in 1993 on a courtesy loan. She wound up returning the piece to the gallery, explaining in a letter: "Thank you, but I am returning the painting, one of the options you offered. This painting gives me no peace. It seems to be wiggling around. It exhausts me."

Some critics and curators have felt the same way, although they have framed their objections in more elevated discourse. "Unevenness in the work of the self-taught painter is greater than in the work of the studied artist," wrote Sidney Janis, and while he was not writing of Lamb, he could have been.[12] There can be an unevenness in Lamb's sense of composition, as one gallery rep pointed out in mid-2003.

"I wish he had continued this form over here a little more," the gallerist said, pointing to a painting. "And he probably should have used this color over on this side to balance it out better. If only we could crop it!"

True enough, from a technical perspective. Not every one of Lamb's compositions hits it out of the ballpark. When he composes

asymmetrically, the figures or color values are not always ideally weighted. His symmetrical compositions have also not escaped critical reproach. German writer Friedrich Kasten notes that "Lamb takes his bearing from the central axis of a painting, thereby manifesting not only his desire for balance and symmetry, but also an apparent need for temperance."[13] This overarching symmetry, Kasten implies, can grow tiresome, as can the flatness of perspective, the absence of "all classical concepts of foreground, middle-, or background composition."

It bears remembering, however, that Lamb never studied composition or perspective and is not interested in their laws. His modus operandi is not to face a blank canvas and create a pleasing composition out of thin air; it is to look at the possibilities suggested by a dipped canvas and bring forward forms he believes are already there. Lamb does not compose; he responds. Sometimes his responses conform to Western compositional ideals, sometimes they don't. Of course, it goes without saying that modern art abounds with painters who flaunt or selectively ignore perspective, Gauguin and Rousseau foremost among them.

Another technical issue that arises with Lamb is that while his generational technique can produce jaw-dropping effects, it can sometimes prove problematic. If the dip is too concrete- or sand-intensive, the resulting works can take on a dry, lusterless finish. This problem is visible in several paintings hovering around the 1996 vintage but largely disappeared as Lamb recognized the problem and tweaked the dip's formula accordingly. Also, not every collector is willing to accept the anomalies that can befall a Lamb painting during the course of its generational journey. Dog prints, leaves imbedded in the paint, or indentations from the spacers that separate the works as they dry can test some gallery-goers' patience.

"My feeling," Lamb responds, "is that whatever happens on the canvas was meant to happen. If a piece falls off, then whatever's behind it is better than what was up front. Sometimes I'll work on a painting so hard, it eats a hole in the canvas. I could repair it if I wanted to, but I don't want to. If the hole's there, it's supposed to be there."

There's a convenient Panglossian fatalism to this line of thinking that is not always entirely convincing. But this is Lamb in rebellion

mode, acting out against the anal-retentive perfectionism of his funeral-home days. This is the antithesis of "Is this candle an eighth of an inch lower than the other one?" This is Lamb's new creed: "Que será, será. And if people don't like it, they can go to hell."

It is as important for the critic to understand what Lamb is *not*, as it is to understand what he is. He is neither a realist nor a surrealist, but a highly intuitive, glamorously messy painter in the direct lineage of Abstract Expressionism. He puts the brute in Art Brut. He grabs the somnambulant yuppie by the shoulder pads, the hipster by his ennui, and shakes both out of their respective aesthetic comas. The kindly grandpa, the committed Roman Catholic, he takes you by surprise with his radicalism, hits you over the head with it. When you least expect it, he outright coldcocks you with life, death, and sex. His paintings are sensuality incarnate: landscapes shimmering with tiny crystals, waves of paint rising and cresting, molten materials frozen mid-ooze, and colors that have no business coexisting, yet *do*. Donald Kuspit is right when he asserts that "surface and color dynamics are ultimately what make Lamb's pictures work and keep them from becoming a kind of sentimental primitivism."[14] Bright, garish, funky, chunky, and generally gonzo, his surfaces seduce not only your eyes, but your eyes' fingers as well. His "mutant textures" recall the *RE* series of Yves Klein, who soaked pebbles and sponges in his trademark cobalt hue, then attached them to a paint-saturated canvas, creating nuggetty surfaces similar to those that emerge from Lamb's concrete-intensive dip.

With his host of historic influences, Lamb has intuited the collective unconscious of Western art history, particularly from van Gogh forward, and shot it through the prism of his own life experience. The result of this assimilation is a sensibility that is on the same page as only a handful of his contemporaries. In her 2003 show in New York's Walter Wickiser Gallery, Florence Putterman finessed surface in Lamb-like ways, laying down bold colors over a rich topography of sand and pulverized seashells. Interestingly, Putterman's subject matter— "strange birds, fish, proto-mammals, ghostly human faces, Paleolithic vegetation, and arcane symbols that recall the Native American petroglyphs the artist saw during a sojourn in the Southwest"—also parallels Lamb's figurative iconography.[15] The Aboriginal artist Samantha

Hobson creates abstractions (see *Burning Fire* and *Big Fire*, 2002) in which organic shapes and miasmas of vivid color seep with lichen-like tendrils into one another, recalling Lamb's canvases fresh from the dip. Santa Fe painter Carol Kucera creates swirling, striated nebulae of shape and color (see *Geologic Universe*, 2002, and *Dividing Universe*, 2003) that recall Lamb's abstracted space-scapes, while New York neo-expressionist David Geiser sets random, quasi-geologic materials into motion on the canvas, seeking the same sort of oozy, volcanic effects as does Lamb.

These effects are particularly striking in the abstract work Lamb has produced since 2002. If he keeps working in this vein and the work is seen by enough of the right people, he may go down as one of his generation's preeminent abstract painters. The techniques he pioneered during the last two decades—the dip, the Lamb pucker, the topographic surfaces, and the controlled color migration—have led him to a sophistication of materials and gestures that belie his lack of formal training. It's as if there is an inversely proportional ratio between his naïveté as a figurative painter and his sophistication as an abstractionist. As a consequence, cognoscenti predisposed to turn up their noses at his figurative work as cloying or trite, may wind up hailing his abstraction as historic.

In the meantime, Lamb continues working in figurative and semi-abstract modes as he continues exploring pure abstraction. His output is higher than ever. In years past, he did an average of four dips; in 2004, he did 13. The man who once painted prolifically to make up for lost time, is now painting prolifically to maximize the time he has left. When, in a frenzy, he "terrorizes the canvas," it's as if he is scribing his name into the sand to leave his mark before the tides wash him away. With his palette knife, ice pick, and blowtorch, he is slashing with rays of Apollonian light into the devouring midnight of death: punching, hitting, stabbing, and incinerating his way to immortality. Ultimately, there is no real way to divine why Lamb keeps up the grueling international schedule of painting, exhibiting, teaching, and working with children on the "Lamb Umbrellas for Peace." His erstwhile mentor, Jack Levin, says Lamb would "need a shrink to figure it out." Who knows? Perhaps Lamb is still trying to prove himself to the father who

never told him he loved him. Maybe he's searching for the approval that the New York art establishment has thus far withheld. Perhaps he's Citizen Lamb, trying to reclaim the Rosebud of his childhood through his childlike paintings, putting his financial might behind his art career just as Charles Foster Kane put his behind would-be diva Susan Alexander. Or maybe, just maybe, Lamb actually is a channeler of spirits, as he claims. Maybe his hand, as *The New Art Examiner* suggested, is truly "the hand of God."[16]

The crates and crates of criticism and catalogs Lamb has sent hold no pat answers to such speculations. He wanted me to go through these archives, then tell him "who's full of shit—the critics or me." The jury is out. The only thing that seems certain is that this is a complex, preternaturally motivated man, single-mindedly devoted to spreading his message around the world, who has undergone a tremendous artistic evolution over a relatively short career. He has converted the passion and energy that made him a powerhouse in the business world and translated it directly into a successful, if controversial, art career. He has searched for and found his strengths as a painter and capitalized on them, deploying his every spiritual and material resource to widen the audience of his art and philosophy. He has, in other words, devoted everything he possesses to his life's highest mission. Can a man do any more?

Pablo Picasso died at 91, Marc Chagall at 97, Georgia O'Keeffe at 98, Grandma Moses at 101. All were actively painting during their final years. In 2005, Matt Lamb was 73, nearly 20 years younger than the youngest of the artists above. If he enjoys similar longevity, he will no doubt continue his startling evolution over the coming decades. What will he be painting in 2013, 2023, 2033? Will he still be getting kicked out of shows, still be terrorizing the canvas? Will he still be painting out his rage at man's inhumanity to man, or will the world, by then, have heeded his message of peace and rendered his rage obsolete?

The future recedes with every sunset; tomorrow's utopias shimmer, then vanish, like mirages over a canyon full of ghosts. Which is to say, stay tuned.

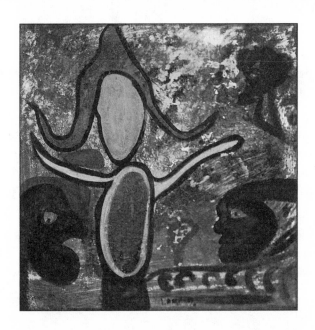

CHAPTER FORTY-ONE

ALWAYS FURTHER: LAMB TODAY
AND TOMORROW

Early in the summer of 2003, Matt Lamb managed to badly bang up his right hand. He has no idea how it happened. Could have been anything: a random impact by a large wooden spacer or a lever on a cement mixer—any of a dozen things that happen in a working artist's studio every day, except that this time, the torque and angle and right hand didn't agree. However he did it, though, he did a heck of a job. Separated the tendon from the bone. Lamb is right-handed and paints with his right hand. Fitting him with a cumbersome splint, his doctor told him to immobilize the hand for at least a month. This is not something an energetic painter wants to hear.

The next day, Matt Lamb began painting with his left hand. Over the following month, he painted dozens of works with his left hand.

Then he painted the Mary, Queen of Peace chapel in Germany from floor to ceiling, all with his left hand. This tells you a little something about Lamb. Ain't nothin' gonna stop him from painting. His whole fitness routine centers around keeping his body doing what it needs to do in order to keep him painting. His greatest fear is losing the ability to pour the dips, suffuse the canvases, paint the spirits, and ascend the 20-foot ladders that enable him to paint his monumental concrete works. So he takes a daily regimen of dietary supplements. Swears by lecithin. Wears magnetic vests, bracelets, and shoes; sleeps on a magnetic mattress under a magnetic blanket, his head resting on a magnetic pillow; and drinks magnetically filtered water, all of which he believes counteract the back pain that's plagued him since his early twenties.

"I used to think magnets were a lot of bullshit," he says, "like voodoo. But they've taken away my pain. Rose's too."

He's tweaked his diet away from carbohydrates and boasts that he's lost 33 pounds since he began this "lifestyle change." He takes his medication assiduously for gouty arthritis, from which his paternal grandfather and grandmother suffered.

"Grandpa Lamb fought it tooth and nail, every day of his life, but Grandma just stayed in bed and curled up into a pretzel. I'm going to fight it like my grandfather."

Every morning for an hour, he walks with his sand-filled backpack and two canes, cross-country-ski style. When he gets back and starts his day, he surrounds himself with people young enough to be his kids and grandkids, preferring their company to the retired millionaires his age whose lives revolve around the country club.

"Those guys are old ladies, as far as I'm concerned," he says. "I refuse to live in an old people's world. I don't want to talk about having operations and taking blood-pressure pills. I want to die with a paintbrush in my hand, not in some nursing home turning food into shit. I'm in my seventies now. So what? What's the alternative, to have died at 69? The thing I get up for in the morning is my painting. When I get to the studio, I'm like a mad dog in a meathouse: I don't know what to eat first. Growth and challenges are what it's about for me now. If I

ever decide I'm a great painter and can't improve any more, I'll quit and take up tap dancing."

Over the years he has grown less materialistic: "I'm a different person from the arrogant bastard I was in my first life. In fact, I'm a different person than I was 10 years ago or even one year ago." He's sown his oats as a conspicuous consumer and moved on. You won't find gaudy diamond rings on his fingers anymore, nor Rolls-Royces in his garage. He moved out of the historic mansion that hosted two presidents ("It was more like a museum than a house.") and has no idea whether he still owns the crystal goblets Napoleon drank out of.

"I've finally started practicing what I preached. I live more spiritually now. So I made $150,000 on the stock market today, or I sold a $20,000 painting. So what? I'll still wear the same clothes. I'll still go on my walk every morning. I'll still have to stick to my diet."

The pendulum has swung so far away from Lamb the flamboyant spendthrift, he's actually made it a goal to live the life of an ascetic. It is, of course, a goal he'll never achieve. He'd dreamed of becoming a hermit at 70, pulling the plug on his phone and fax, cutting his remaining business ties, and holing himself up in Florida or Ireland for the duration. He wondered "whether it would be freeing artistically to go broke," but concluded that "money is something that comes in handy as a tool to help get my message out."

Even if Lamb wanted to go broke, his art career has grown too complicated for such fantasies to come true. A penniless hermit can't juggle commissions, teaching gigs, art openings, autograph signings, museum dedications, and art-glass events at Bloomingdale's. And those are only a handful of the developments on Lamb's plate. There are more.

In 2004, Zurab Tseretely, president of the Russian Academy of Arts (which in 2002 purchased eight Lamb paintings for its permanent collection) announced plans for a major upcoming Lamb retrospective at the Moscow Museum of Modern Art. Also in 2004, the Centre Picasso in Horta de San Joan, Spain, converted a medieval jail into an adjunct museum devoted to Lamb's art and the study of the cross-currents that link him to Picasso. In Salvador Dalí's hometown,

Figueres, city fathers sponsored a small Lamb show in the Consejo Comarcal del Alt Emporda, paving the way for a larger Dalí/Lamb exhibition the following year. The directors of the Centre Joan Miró in Mont-roig, Spain, subsequently curated an exhibit entitled *Lamb Encounters Miró* and opened a Matt Lamb Museum, linking its educational outreach with that of St. Matthias Kolleg in Germany. In the autumn of 2004, nine of Lamb's painted metal sculptures were put on permanent display at the Els Arcs Foundation Park in Barcelona.

Also in the fall of the same year, the Sorbonne University, Paris, acquired several of Lamb's paintings for its permanent collection. Elsewhere in the City of Light, Dr. Dalil Boubakeur, rector of the Muslim Institute, acquired three abstract Lamb paintings for the Institute and hung them in the entryway of the Grand Mosque of Paris. In the Alsatian city of Bitche, an alliance of cultural and governmental leaders announced plans to inaugurate a museum dedicated exclusively to Lamb's art.

Elsewhere in Europe in late 2004, the Museo Diocesano d'Arte Sacra in Venice held a one-person show featuring Lamb's figurative and abstract painting, and in the U.K., Cambridge University signed on as a full partner with SMKT Colleges and began planning a symposium on Lamb's peace-through-art worldview.

Back in the United States, the Chicago First Church of the Nazarene announced plans to convert a 104-year-old church in the city's rough-and-tumble Austin neighborhood into an outreach center for at-risk youth, using Lamb's art and spiritual message as a catalyst for change. Lamb will paint the near-West Side building at 500 North Laramie Street with umbrellas and other symbols of inclusion. At night, the facility will be floodlit, and spotlights mounted on its roof will shine into the sky, a literal and figurative beacon of light in an area rife with shady alleyways and crack houses.

"Matt has a way of opening doors," says church pastor Kevin Ulmet, "and using his art to bring peaceful resolutions to people in conflict. In the Austin community, many people are praying for and seeking hope for their future. Through our partnership, Matt's art will adorn the walls of a new place of hope that will serve the physical and spiritual needs of this community."

"We're planning to bring in students from around the world," adds Lamb, "and have them interact with the Austin kids. Then we'll send the Austin kids around the world and complete the circuit. It's an opportunity for cultural exchange and healing, and I think of it as the exact opposite of the Los Alamos labs in New Mexico: That whole compound was made to build bombs; the Austin building will be an edifice of peace."

Moving into 2005, there are plans for a one-person Lamb show in Japan and a joint Chagall/Lamb exhibition at the Musée du Pays de Sarrebourg, a stone's throw from Chagall's stained-glass *Peace Chapel* (Chapelle des Cordeliers). The renowned Spanish photographer Martí Català Pedersen, known for his photo essays on Miró and other Surrealists, photographed Lamb in 2005 for a traveling international exhibition tentatively entitled *Miró, Dalí, Rom, Lamb.*

Lamb is also increasing his involvement with several prominent universities worldwide, offering them temporary custodianship of dozens of his paintings apiece if they agree to institute a 10-year program teaching the virtues of peace, tolerance, understanding, hope, and love.

"As a species," Lamb explains, "we've done okay teaching our kids reading, writing, and arithmetic, but we've done a terrible job of teaching peace and tolerance. We can add, subtract, multiply, and divide, but we can't wait to go out into the world with that knowledge and kill everybody. So my foundation is working with Cambridge and the Sorbonne and a number of other universities in Europe, Asia, South America, and in the United States, to try to teach young people the ideas that will lead to world peace. If, at the end of the 10-year program, we feel they've lived up to their commitment, then the art collection we've lent the universities will become theirs, lock, stock, and barrel."

In the United States, business analysts are showing a renewed interest in Lamb's midlife career change, drawing parallels between the funeral-director-turned painter and veteran NBC broadcaster Jane Pauley, who left a successful television news career at the age of 52 to pursue her dream of starting a talk show. Lamb's midlife metamorphosis figured prominently among the topics discussed during a special

report on the artist on WXAV-FM, a Chicago radio station. The report drew so much praise from listeners and broadcasters alike, it won the Silver Dome Award from the Illinois Broadcasters Association, which pronounced the program one of the top public affairs programs of the year.

That the award was given in his home city and state heartened Lamb, who is known in Chicago more as a businessman than a painter. The art world at large may know him as Lamb the controversial Outsider artist, but most of Chicago knows him as the "Lamb" in Blake-Lamb Funeral Homes, and a few well-placed detractors in Chicago (including a nun from the Diocese) know him by less exalted names: "That mortician who thinks he's an artist." "A self-promoting undertaker who bought his way into the art world." "That rich son-of-a-bitch who thinks he can paint." Even Lamb's participation in the city's famous "Cows on Parade" in 1999 didn't raise his profile enough to shake his funereal past. (Lamb's cow, entitled *Balloons + Flowers = Fun Cow*, which grazed at the corner of Superior and Franklin, is now on display at a suburban Chicago school.) But there are signs the chill is thawing. He's happy with his gallery rep in town, Judy Saslow, and with his Gallery 37 association, sponsor of his "Lamb Umbrellas for Peace." And in late 2003, the Chicago Artists' Coalition made him the cover story of the *CAC Artists' News*, proclaiming him an "artistic genius."[1] It was a rare but forceful vote of confidence from his local peers, and one that moved him greatly.

"Maybe," he said after the article came out, "after more than 20 years, Chicago is finally accepting me as an artist."

For her part, Rose Lamb continues to be every bit as stalwart a supporter of her husband's work as she was the night before his Renata Gallery debut in 1987, when she promised him in a handwritten note: "Now we will all follow your new dream and rejoice with you in excitement and happiness." She is his fan and critic, guard dog and consoler, and his advisor on matters creative, financial, and familial. With time, she has grown into her role as "the artist's wife," yet she is also her own person, an expert on homeopathic medicine who for several years consulted for Dr. Julian Whitaker's eponymous clinic and wellness institute. Today she also consults for another California-based alternative

health company, Nikken Products. She continues to live with diabetes, checking her blood sugar and giving herself insulin shots four times a day. Being Mrs. Matt Lamb for 50 years, she admits, hasn't always been easy, but the woman who says "Supportive" is her middle name has stuck with her mad genius "because I'm tough, it was a challenge, and it was worth it."

Once the deferential, "Yes sir, no ma'am" funeral director, Lamb himself is now free to be the free-wheeling provocateur he always itched to be. He relishes his role as a cantankerous nose-thumber, railing at the art world, even as increasingly he's assumed into its pantheon.

"There's a Pink Floyd song I love called 'Mother,' " he says improbably, "and it's all about being so afraid of the world that you have to ask somebody's permission to live—your mother, your boss, whoever. In my life now, I say to hell with it. Just be comfortable with who and what you are, whether you're a complete and utter jackoff or a saint. Do what you can do, and what you can't, say, 'Fuck it.' You wanna eat a banana split, go off your diet? Who gives a fuck? What's going to happen, the world's going to end?"

The string of hypothetical questions are vintage Lamb, as are the dozens and dozens of articles and photographs spread out on my desk tonight as I near the conclusion of my year as the artist's shadow. I'm thumbing through 73 years of a man's life, his many faces, fashions, and personae: the cherubic toddler in 1930s Bridgeport; the dreamy teen with his arms around Rose in the 1940s; the beaming groom and blossoming businessman of the 1950s, with his skinny tie and notched lapels, posing alongside his father and little brother in ads for Blake-Lamb; the increasingly worldly entrepreneur of the 1960s, looking out at the world through heavy, black-framed glasses, his hair turning from dark brown to salt-and-pepper; the flashy man-about-town in the 1970s with muttonchop sideburns and polyester suits; the Blake Carrington/Gordon Gekko hybrid of the 1980s, all white beard and red ties and contrasting-collar shirts; the neo-Beat *artiste* of the 1990s in his black silk Nehru jackets; and finally the millennial Lamb, who's "too old and too rich to give a shit" about fashion, whether sartorial or aesthetic, who alternates between paint-for-peace love-ins and gallerists-are-shitheads tirades, and who's doing exactly what he wants to

do, on his terms, guided by an intransigent inner vision and a spiritual force he believes is responsible for his every success.

I'm looking at his photos when the phone rings, and it's him, calling to relate the latest developments in his impossibly busy world. As he speaks, my mind wanders back to his opening at the Judy Saslow Gallery, when that imperious, nasal-voiced collector had cornered him and demanded he reconcile himself with her vision of the garret-dwelling bohemian. She'd noted his expansive studios and homes throughout the world, his penchant for private jets, and the limousine idling outside for him that evening, and she'd asked him, exasperated, "What kind of starving artist's life is *that?*"

After Lamb hangs up, as I put the photographs back into their albums, it occurs to me that in all the important ways, he *is* a starving artist. He is starving for the same things all artists starve for: creative fulfillment and growth, critical and financial validation, a sense that the work will endure, and perhaps at least some small measure of fame—even if it be limited to those glittering, endorphic 15 minutes that, once commenced, begin inexorably to tick away.

PART NINE

THE EPILOGUE

"The 21st Century archetypal artist . . . is going to be global. He's going to break down all the national and geographic borders."

—*Timothy Leary*[1]

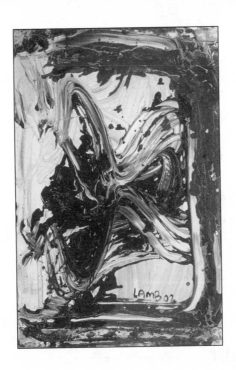

CHAPTER FORTY-TWO

WHEN THE SAINTS GO MARCHIN' IN

I'm in the limo with Matt and Rose Lamb, heading to their daughter Sheila's home. The couple are under the impression that we're going to a simple get-together so that I can meet and interview Sheila and the other children. But I know something they don't know. Two months ago, Sheila contacted me secretly and told me she and her siblings were planning a surprise anniversary party for their parents, for which hundreds of the couple's friends would fly in from around the globe. I've been good about keeping the secret, but I'm chomping at the bit to meet all the players in the Lambs' lives, many of whom I've already spoken with by phone.

"Somebody must be having a party," Rose says, noticing the dozens of cars parked along the neighborhood streets.

Rick, the Lamb's chauffeur, rounds the corner, and the Lambs'

jaws drop. Sheila has hung her driveway with balloons and streamers, and out back under a covered tent, a band is playing jazz. Lamb and Rose look at the scene, then look at me.

"Did you know about this?" Rose asks.

Sheepishly, I admit that I did.

"What is it for?" Lamb wants to know.

Rick pulls up in front of the house and hurries around to open the car door. The couple's four children emerge from the house and yell in unison, "Happy Anniversary!" The couple's anniversary was actually a week ago, so they've been caught completely off guard. Lamb and Rose walk inside and are mobbed by well-wishers. Discreetly, I follow behind.

Lamb's brother, Dick, is here, and his sister, Peggy, and Rose's sister, Vivian. Virginia Miller is here, wearing her leather pants, along with her husband, Bill DuPriest. Dominic and Lía Rohde have jetted in from Germany, and decorator Betsy Freeman is up from Dallas, impeccably made up and wearing a strapless gown. She smells good.

"Matt has taught me to live for the moment," she says. "Get on a motorcycle, skydive, do crazy stuff!"

The Lambs' friends from Ireland, Declan and Maura McCarthy and their two boys, have saved their Euros for a year to make the trip, and Heinz and Karin Schwengber are freshly in from Germany. Leticia Cadwallader, Lamb's executive office manager, and Chuck Friedman, one of his attorneys, circulate. Another attorney, Leo Athas, raves about how active the Lambs are in Chicago's Greek community.

"As for his art," Athas adds, "I don't understand it, but then, I have no eye for art."

Potter Palmer is here, sophisticated and patriarchal, emanating the élan of old money. His ladyfriend, Erica Meyer, is telling some other guests about Lamb's installation at Westminster Cathedral, which she and Palmer attended in 2000.

Ray Greune, spitting distance from 80 years old, is in rare form tonight, 35 years after he saved Lamb's hide with a no-interest $50,000 loan. He's entertaining a circle of revelers with stories of himself and "that asshole" (Lamb) raising hell in their younger days. Greune is either totally wasted or is a born raconteur, hard to tell. He has sketched

a crude picture of Lamb sitting on a toilet, an easel before him, painting as he poops. (Last year, as a gift, he'd drawn a cartoonish Lamb throwing up into a commode and inscribed it, "In remembrance of our many drinking adventures years ago.") Now, with much fanfare, he presents Lamb the new drawing. Lamb passes it around, and folk artist Larry Ballard, tongue in cheek, pronounces it "great folk art."

Lamb grabs me and ushers me around, introducing me to everybody. Simone Nathan, elegant and smooth-spoken, shares memories of what it was like to be with Lamb at the very genesis of his life as a painter.

Rose's wedding gown and Lamb's charcoal gray morning suit are on mannequins by the fireplace. As the band plays Dixieland jazz, a svelte photographer with an Eastern European accent snaps shots here and there. Waiters and bussers stroll among the guests, offering hors d'oeuvres, while uniformed bartenders preside at a full courtesy bar in the middle of the great room.

The couple's children gather round them. Their only son, Matt (who is either Matthew Lamb II or V, according to how you count the middle names), once worked at Blake-Lamb but realized that undertaking was not for him. He went on tour as drummer with the rock group Bachman Turner Overdrive, then, with his father's encouragement, followed his bliss into the martial arts. Now he teaches self-defense to Cook County Sheriff's deputies and Navy Seals. The Lambs' three daughters all work in the funeral industry but have full lives outside work. Rosemarie Lamb has been active in the Irish Children's Fund and on the board of the Cerqua-Rivera Dance Experience. Colleen Lamb-Ferrara works with senior citizens, leading grief counseling programs and volunteering for the Disabled American Veterans. Sheila Lamb-Gabler is a former "Mrs. Illinois" from the Mrs. America/Globe Pageant and volunteers for programs that aid victims of spousal abuse.

"My children are some of my best friends," Lamb told me once. "We huddle together when there's a problem, and we celebrate together when there's an occasion of joy. My only regret in life is that I didn't get to know my kids more when they were growing up. Rose is the one who really raised them—I was too busy building business relationships to build relationships with them."

The band ends its first set, and each of the children takes a turn on the P.A. system, speaking off the cuff about their parents. They read telegrams of congratulations from Cardinal Carlo Furno in Rome and Cardinal Francis George, Archbishop of Chicago. Each of them speaks naturally and articulately in front of this 200-plus crowd, the by-product of years of board meetings, public hearings, and discussion groups. At the conclusion of their remarks, the children raise a glass to toast their parents.

Lamb's namesake grandson is here with his new bride. He's an amiable lad with long hair hanging down over his eyes, and Lamb introduces him by his pet name, "The Fiend Without A Face." In response, the young man calls his grandpa "Papa Beast." Lamb introduces another grandson, a slender 20-year-old named Justin, as "Fatty Arbuckle." Lamb tells the boys to whinny three times a day for good health. Although they've heard this anecdote before, they listen patiently and laugh when their grandfather bellows out a whinny so loud, it drowns out the din of the crowd. The boys' sister, Elizabeth, is running around the room, having a ball with the other Lamb grandkids, Matt, Joey, and Rose.

Up front by the P.A. system, Sheila hands the microphone to her mom, Rose, who turns and faces her husband.

"How do you talk about a Renaissance Man?" Rose asks the crowd. "When I was 14 years old, I met my knight in shining armor. I wore his signet ring. In college I wore his frat pin." She chokes up, composes herself, and continues. "Life with Matt Lamb has been a great adventure. Thank you all for being a part of it."

Rose hands the mike to Lamb.

"I'm Irish," he kids, "so you know I can't just stand here and say nothing!" He thanks everyone for coming, then turns to his wife. "And as for Rose . . ." He breaks into a chorus of "Ain't She Sweet?" The band picks up the tune, the audience joins in, and Rose, beaming, dances a jig.

The whole scene is reminiscent of the end of Woody Allen's *Deconstructing Harry.* Allen, playing novelist Harry Block, walks into a surprise party in his honor, attended by all the fictional characters he's created during his writing career. Moved, he tells the guests, "I love all

of you—you've given me some of the happiest moments of my life. You've taught me things, and you've even saved my life at times."

Tonight, Lamb is surrounded by characters from the narrative of his life, a story in many ways more improbable than fiction. Many of them have taught him lessons, and some of them, in their own ways, may have helped save his life—or at the very least, his rear end.

As Lamb finishes the song, Sheila hands him a parasol. Hoisting it into the air, he launches into a chorus of "When the Saints Go Marchin' In." The band knows the tune well, the trumpeter dueling with the clarinet player as the trombonist slides up and down the scale. Lamb begins making his way through the crowd, and Rose follows, putting her hands on his hips. Rosemarie follows suit, then the other kids, and all of a sudden, it's a full-blown conga line.

A woman with jet-black hair tries to entice me into the line, but I resist, determined to remain an observer.

"Come on!" she admonishes, her hand reaching out for mine.

But my hands are full, reporter's notepad in one, ball-tipped pen and micro-recorder in the other. Still, the energy is catchy, and so is the tune, and I realize in this moment frozen in time that my efforts to stay impartial toward Lamb were doomed from the beginning. Somewhere in the course of the hundreds of hours I've spent interviewing him, something intangible has bridged the gap between septuagenarian painter and Gen-X writer, and suddenly I wonder how on earth I'd ever thought I could remain objective toward one of the most spectacularly subjectivist, intuitive painters in the art world today. Matt Lamb is the guru of a cult of personality—that's as much a fact about him as his birthdate or the viscosity of paint he prefers—and if I'm ever going to truly infiltrate the cult, I'm going to have to drop the pretense and drink the Kool-Aid.

The woman's hand is hovering midair, reaching for mine. I toss my notepad and recorder onto a chair, join her, and am swept into the conga line, just as I've been swept into the adventure of chasing Lamb around the earth's four corners.

"Oh, when the saints . . ." he sings at the head of the line, and everyone echoes the lyric in call-and-response fashion: "Oh, when the saints . . ." "Go marchin' in . . ." "Go marchin' in . . ." "Oh, when the saints go marchin' in . . ."

He's twirling his parasol, fully in his element, his family, friends, and associates revolving around him like planets around the sun. Tonight he's the Sun King and the Fun King, all wrapped up in one. How a man can have this much fun completely sober, I'll never know.

"I'm about 18 years old in my head," he told me once.

Tonight he looks it.

As we snake our way around Sheila's house, we're surrounded by Lamb's paintings on the walls, and it seems as if the spirits on the canvases are following us around with their eyes, as if they want to join the parade. They peer down from under their festive, wide-brimmed hats and outlandish crowns, these horses and dogs and dinosaurs, harlequins tossing confetti, fish jumping into the air, and green-gowned women with saucer eyes and beehive hairdos. So many of the players, spirit and human alike, in the drama of Lamb's life are here in the middle of this moment, bopping along behind the Grand Marshall, the Giant Child. It's like the "Amen" at the end of a hymn, the curtain call at the end of a play, except for one thing: The show ain't over yet.

PART TEN

THE EXIT INTERVIEW

"All the things I have going on now—the museums, the teaching, the 'Umbrellas for Peace,' the initiatives with the universities—I have no idea how any of them will turn out. They're like a wave in the middle of the ocean, getting bigger and bigger, and you never know what it's going to churn up from the bottom of the sea. Sometimes it washes up diamonds, sometimes it washes up shit, but it just keeps rollin' along."

—*Matt Lamb*

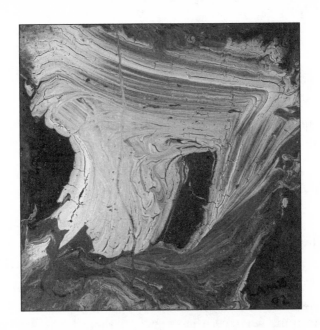

CHAPTER FORTY-THREE

THE PONY AT THE END
OF THE RAINBOW

Towards the end of my year with Lamb, we sat down for one of our last marathon interview sessions. The conversation was, as it always is with him, a wide-ranging hybrid of sermon, bull session, and comedy routine, peppered with equal parts profundity and profanity. From the fine art of business to the business of fine art, from the thing he regrets about his visit with Mother Teresa to his thoughts about his own eventual death, he held forth with candor and humor, tossing out those outrageous bon mots in the way only Matt Lamb can.

On the art world . . .

Your work is often compared to Chagall's . . .

I love Chagall: the whimsy, the flowers, and weddings and people, the great things he sometimes does with the color white.

Was he a major influence on you?

Maybe by osmosis. I saw his paintings in museums and art books and loved him.

Your paintings of the Eiffel Tower in the mid- to late-80s, with fireworks exploding and spirits flying over the Tower, are so similar to paintings Chagall did that some people have suggested you ripped Chagall off.

People can think whatever they want. Anything I may have absorbed from Chagall or Picasso or any other artist was really by osmosis. I didn't set out to paint like anybody else. I was too busy discovering techniques on my own.

You've made no bones about the contempt that you hold certain aspects of the art establishment in. What's your biggest beef with the art world?

The way some gallery owners like to keep their artists scared that they're going to be dropped. It's what I call the Mushroom Concept: Feed 'em shit and keep 'em in the dark. Most of the time, artists are too timid to fight back. They're so obsessed with getting shown, they'll do anything. Gallery owners perpetuate it, because they love to be fawned over.

How do you feel about collectors?

I have some very nice, very well-off collectors who buy my work year after year. But there are also some real assholes out there, like the collector who didn't buy my abstract painting because I signed my name on the front instead of the back! Fuck that. Fuck the collector! Am I making art for some collector? I'm done with giving people whatever they want. I did that in my business life. I don't do that anymore.

Do you like going to your show openings?

Sometimes, but there's always some know-it-all who comes to your show—about 21 years old and surrounded by his entourage, just

smoked a joint and drank a fifth of whiskey and screwed everyone he came in contact with since he was 12. There was a guy like that who came to one of my shows in Miami. I overheard him say to somebody, "Hey, look at that shit!" So I went up to him and told him, "Guess what? It *is* shit. It's actual shit—I crapped my pants and threw it at the canvas! Don't get too close; it stinks. Can you believe they're charging $10,000 for my shit? And to think, you're giving yours away for free!"

When was it that you started being marketed as an Outsider artist?
Carl Hammer has a big reputation in Outsider art, and I was with him. Ingrid Fassbender also really had a strategy to market me that way.

Do you think the strategy backfired?
I don't know. I don't give a shit about it. It was just another way to keep the gate. Personally, I hate labels. So I'm a white, Irish, Roman Catholic artist from the South Side of Chicago. What is that? Who cares? When it comes right down to it, I really don't know that much about Outsider art. I know a lot more, just by osmosis, about Chagall and Picasso.

Would you go to a Bill Traylor show today if it were just down the street?
Probably not.

What about folk art? Would you go see Grandma Moses?
Probably not. I'd go to van Gogh, though.

Obviously, you're aware a lot of people think you're not an Outsider because you're wealthy.
I don't think money has anything to do with art. Money isn't the standard for what makes art. People think artists have to be poor. If having money makes your art bad and being poor makes your art good, then Bill Gates should be the worst artist in the world, and some falling-down drunk on the street should be the best.

On painting . . .

Let's talk about your own art. Why do you like to lay paint down so thickly?

Because I can get light and shadows and lots of refractions. And because the world is not a tidy place, it's messy. The world is chaos, so a painting should reflect that. You wake up in the morning, you wonder whether you're going to get killed by some drug addict. Or whether your grandkids are going to get kidnapped by some asshole with a big dick who wants to screw them and kill them. I used to spend a lot of time driving hearses thinking about these things. There was a school bus accident back in the '50s, and a mother and father had all four of their children die at the same time. I had one of the kids in the back of the hearse. Is that fair? No, it's chaos, and it's frightening. So in this kind of world, why would a painter want to be a debutante, standing in front of an easel and dabbing on paint with a two-hair brush? If you live in a gated community in the suburbs, thinking the world is great and everything's fine, I guess that's how you'd paint. Whatever. To live in the world is to live in chaos.

You've been called "the father of generational art." Are you still working generationally?
Sometimes. There are some of my abstract paintings I sign now as soon as they dry after the dip, so those aren't really generational, although I think I'm going to start painting generationally in my abstract work. I think that's my next big thing. But there are other paintings I do that are very much still in the generational vein. There's one painting I've worked on for 15 years that I still haven't signed. Some of my best paintings are the ones that fight me, that won't let me finish them. I always say a painting is only done when an agent has sold it. I don't think I'd be well received if I went into somebody's home or office and started scraping paint off a work they owned, so I could bring on the next generation!

You've talked about the dip and how it represents chaos to you, and yet there's one kind of chaos you don't allow yourself in your painting: a drip. When you get a drip, you either wipe it off or paint over it. You celebrate all the messy organic processes of paint and materials, but you make an exception when it comes to drips.
To me, a drip in a painting is like a fart in church. It's out of context. It dominates everything else. But there are times when I'm beginning to

allow a drip to stay. And you've seen that one abstract of mine where I allowed the drip to come down right through my signature. That was a huge growth for me to allow that to happen. I can't let myself get stagnant, I've always got to be a little agitated. It's like the story of the A.A. meeting in a little Irish village, where they were finally successful in curing the last drunk. But then there was nothing left to do. There was nothing to strive for anymore. So they all went out to the pub and got drunk.

[Laughs.] Now, besides your surfaces, the critics always talk about your bold colors. Granted, you sometimes paint in earth tones, but there's no denying that you favor the big, bold reds and yellows and blues.
I love the primaries. Some people are fascinated by, say, the almost imperceptibly subtle shift from a deep purple to a midnight blue to a black. I'm not. Although, again, some of my recent abstract work is actually very subtle.

Through the years, the critics have been all over the place about what your paintings represent. How do you see the meaning of your art?
My paintings are the ravings of a madman caught in the material world and destined for the spiritual world, where things will become clearer. Right now I'm encased in this body, but one day I won't be. So my art is a snapshot of where I am right now in the pilgrimage from the material to the spiritual: What's on my mind at any given moment, what's pissing me off? Every morning I get up and puke on the canvas. I puke up the stuff that's bugging me and try to make sense out of it.

An artist friend of mine in Santa Fe, Selena Engelhart, has a really hard time parting with her paintings when they sell. Does that ever happen to you?
Rarely. There are only a few of my paintings I can't part with. I really want my work out in the world getting seen and argued about. My paintings are my ambassadors. I want them to talk to the people who own them, tickle them, agitate them.

One of your big themes in your work is power, and you love to say there's no such thing as real power. But I'm wondering whether painting gives *you* a sense of power.

Power is transitory. I always quote David in the 62nd Psalm: "Lowborn men are but a breath,/The highborn are but a lie./If weighted in balance, they are nothing./Together, they are only a breath." People talk about empowering the disenfranchised, like the issue of racial equality. But the only time we'll have true racial equality is when a black kid from the inner city can buy a $250 ticket to a cocktail party for a politician. As to whether I have any power as a painter, I'm an underdog in the art world, and power traditionally doesn't belong to the underdog. But I would say painting gives me an inner power, an inner peace. When I don't paint, like when my hand was giving me fits, I get nervous, I get depressed.

I know you want the world to "get" the message behind your art, but if somebody's looking at one of your paintings a hundred years from now, and they know nothing about your whole mantra of peace, love, and all the rest, what are they going to take away from the art?

Hopefully that there's something more to life than Wal-Mart and The Gap. We don't realize there's something more. Maybe that's why so many people are addicted to drugs. People are looking for something, but there's nothing in the culture to fulfill their needs, so they become twisted. The times we live in are like the last days of the Roman Empire. We may not be sitting in the Coliseum watching Christians get eaten by lions, but we're sitting in front of an electronic box watching some guy on "reality TV" try to screw 12 women.

Do you think artists can change the culture?

Nelson Rockefeller destroyed Diego Rivera's mural in Rockefeller Center because it showed Lenin, so he must have thought art could affect culture. I think an artist can point out the strengths and weaknesses in a culture and present another point of view. Cultural change starts at the bottom, not the top. If you go ahead 25 years after any revolution, the one-time rebels are now the dictators. Art can help point out the absurdity of this, so that people can have a conversation and debate it, and you begin to crawl toward a solution.

Do you get competitive when you look at other artists' work?
No, just a sense of wonder when I see something great.

And what is great to you, when you look at other painters?
A sense of mystery, a broad sensibility, a technique I really like.

If you yourself hadn't been a painter and hadn't been a funeral director, what do you think you would have been?
Something in show business. A musician, a composer. Music is the pulsing of the soul. I know there's a God when I hear *La Bohème*.

On life, death, and rebirth . . .

When you were 55, you told the *Chicago North Loop News* that your goal was "to love and be loved," and that your most cherished desire was "to die an old man with a young mind." Do you stand by that today, in your seventies?
Yes. The only thing I would add is that when I turned 70, I had the realization that the answer to all the eternal questions of the universe is love. Period.

Looking back, does it seem to you that your life has been long?
No. A blink of an eye.

Do you feel old?
No. I surround myself with young people. I don't buy into the generation gap. There's no difference between the generations, because there's always been rebellion of one kind or another, on a superficial level or a big, societal level. So my generation wore Zoot Suits, and now young people wear these crazy pants that look like they're falling off. So what?

You've said you regret not getting to know your children more when they were growing up. Any other regrets?
Yes. Something happened when I met Mother Teresa that I regret to this day. I used to have this 18-karat gold wristwatch that was covered in diamonds, and I was wearing it when I was in the receiving line to meet her. When she came up and clasped my hands and greeted me, there was a higher power that told me to take off the watch and give it

to her on the spot, so her missionary in Calcutta could sell it and use the money. But I didn't do it, and I've always kicked myself that I didn't.

So much of your art is about life, death, and rebirth. Do you ever think about your own death?
Generically. I know it's going to happen. It is what it is.

Have you planned your own funeral?
Yes. If they do everything I want them to, it'll last four days! Here's the thing about death. At this point, Rose and I and our friends our age are standing in line to get our ticket punched. Our next adventure is the grave. It reminds me of people standing in line for a bus, looking at the road, fidgeting. It's like they're trying to make the bus come faster. The bus will come when it comes. People waste their time wondering about when the end of the world will come. Will it be a nuclear bomb, will it be a meteor crashing into the earth, will it be Armageddon? It's no mystery. Go to an insurance actuary. They'll ask you a battery of questions and tell you within six months of when you're going to die. That's when *your* world will end. Who cares about the rest of it?

What do you think happens when we die?
It's Judgment Day, which in my mind I see as God showing you the totality of your life and saying, "Here it is, here's what you were." And maybe he'll show you that you were a son-of-a-bitch. And you can protest all you want: "Oh, no, God, that's not me!" And God will say, "Well, here's what you did, here's who you were, and now you'll live with it for all eternity. If you were a son-of-a-bitch, you'll live forever as a son-of-a-bitch." The funny thing is, even if you were a son-of-a-bitch, somebody still has to get up at your wake and say good things about you. What can you say about a son-of-a-bitch? "Well, he played good marbles as a kid."

So you believe that's what the afterlife is going to be . . .
I don't know. It could be. It reminds me of the joke about the man who was in line at the Judgment behind Mother Teresa, and he gets really worried when Saint Peter says to Mother Teresa, "Could you have done more?"

You've said you think earth itself might be a kind of purgatory, and if we don't evolve to the next step, we're condemned to come back to life on earth—which is reincarnation, basically.

Right. Who knows? When it comes down to it, we really have no idea what the afterlife's going to be like. I do think there is an eternity, though. You know how long eternity is? You ask God how long forever is, and he says, "Well, you're from earth. Diamonds are the hardest substance on Earth. Think of a diamond that's as big as from the earth to the sun. Now line up a million of them in a row. A dove flies by and scrapes each of them with its wing once every million years. After all of them are worn down by friction, then eternity is just beginning."

Is there some sort of lesson in that?

Yeah. Don't fuck around. We buried a man at Blake-Lamb whose goal in life was to become the chairman of the board of the company he worked for. He spent his whole life moving all over the world, running this plant and that one. Never had any kids, never had any real friends, never owned a real home. So he's 60 years old, and he finally gets named chairman of the board. He arrives at the first meeting, calls it to order, and collapses onto the desk of a heart attack. We buried him beside his brother-in-law and sister-in-law. So the idea is, don't fuck around with the things that aren't really important. In an instant, you could be gone.

You yourself were a pretty ambitious, goal-oriented guy in your "first life." In many ways, you still are.

Right, but I've realized now that everything material is transitory. The only thing you really have is your own integrity and peace of mind, and you can't attain those with *things*. Happiness does not reside in a gold-plated automobile. People think, "If I only had a Rolls-Royce, I'd be happy. If I only had a jet, I would be happy. There's no end to it. What's next, "If I only had a small country or a continent, I'd be happy?" You know what materialism does to a man? You give a guy $40 million and all the women in the world, and he says to you, "Is that all?"

You're saying this as a man who once owned two Rolls-Royces.

I'm not putting money down. It's fun. But people say, "If I only had the money Matt Lamb does, I could be a painter, too! I could buy all the

paint and studio space in the world, and that would make me a great painter!" Which is like saying, "Oh, if I only had Michael Jordan's money, I could buy a million basketballs and be as good a basketball player as he is!" It's crazy. When it's all over with, nobody talks about the car you drove or how many square feet your house had. So I had two Rolls-Royces. You want to know something about driving a Rolls-Royce? When you drive one, people give you the finger. They won't let you into the lane. You become the enemy. I realized at a certain point that I didn't like being the enemy, so I sold them. At this stage of the game, I'd rather be Mr. Little than Mr. Big. But I suppose you've got to go through the Mr. Big lifestyle to know there's nothing there.

It's interesting to hear you talk this way, because a lot of people I've interviewed for this book, including some of your good friends, say you've always enjoyed being Mr. Big, that you still have a big ego.

You have to have a big ego to be an artist. To me, having a healthy ego means baring your whole soul and saying, "Here I am, take it or leave it." I'm not talking about somebody who's "Me, me, me," the kind of person who gets upset if he has to miss his golf appointment to go to his best friend's funeral. I'm talking about the kind of ego you need to survive. To me, the opposite of ego is, "What will *they* think?" Who the hell are *they*, and who cares what they think? You have to be selfish with your happiness, and if that's ego, then so be it. We all have two buttons: a happy button and a sad button. I guard my happy button very jealously, because the world is always pushing my sad button.

Are you a person who cries?

Absolutely. I find it a great release. There's nothing worse than a macho asshole who never cried. He was born with a hard-on, and the only thing he ever did with his life was fuck somebody. He was a one-bristle brush. When they bury him, they'll get up in front of the casket and say, "Well, that was old George. He fucked, he farted, and he shit."

[Laughs.] Okay, I want to talk to you for a minute about Rose.

My rock and my rudder. She's the steady one. Without her, I'd be long in my grave.

Your chauffeur, Rick, told me that in all his years of driving you and Rose, he couldn't recall overhearing a cross word between you.

What would we argue about? We do what we do. I would hate to think that when I walked into my house that I was walking into a battleground or a prison. Rose and I let each other do what we think is right. Granted, there has to be discussion and some give and take, but it's not giving anything up. I think that's the way civilized people should act toward one another. And it makes for a wonderful, caring relationship. This is *it*, after all. We're not here on a weekend pass.

Another thing I wanted to touch base with you on is religion and spirituality. You've been actively trying to bring Christians, Jews, and Muslims together, but at the moment, tensions between those groups seem to be as bad as, if not worse than, ever. Does that disappoint you?

I don't like it, but it is what it is. You can take anybody who's disenfranchised and mold them to do anything or kill anybody. What will they do when they kill the last infidel? They'll start killing each other. It's not just the Muslims; the Christian Crusades are a parallel example. Once we killed all the Muslims, we started killing the Christians. In the United States for the longest time, if you were a good white person, you lynched black people. So the people in power at any given time always corrupt the intent of God under the guise of religion in order to get more wealth and power. You can construct any kind of Crusade: Maybe the sub-Saharan people are mad that it's so damn hot, so they say, "Let's go kill the Eskimos, since they obviously stole all the cold!" It's crazy! My great dream is that one day, when I'm long, long in my grave, some asshole will buy up all the tanks and guns and bombs and planes, and go out and try to use them to start a war. And he'll go out to enlist his army to use all these weapons, but nobody'll join up. They'll all be in the park dancing and drinking and having a good time, and they'll look at the guy and say, "Go fuck your war!"

Do you think it's possible for people to be moral without a belief in God?

Yes, because ultimately it's personal pride that you have to have in order to function in society, a belief in the human spirit. Otherwise you'll pay no attention to a red light.

So then how do you view atheism?
Well, if you don't believe in God, let's take a look at what you do. You eat the world's biggest porterhouse steak, fuck the prettiest girl, and then you fall out the window and are killed instantly. That's the best death there is for an atheist. What's the last thing you did? Puked because you ate too much. That may sound cruel, but I try to tell people what I really think, not just what they want to hear. When you tell people what they want to hear, that's what I call whorespeak. When I was growing up, it seemed like there were three things people would always talk about: the flag, motherhood, and apple pie. Nowadays, you can't talk about any of those. If you talk about the flag, you talk about, "Should you burn it? Should you piss on it? Does it mean anything any more?" If you talk about motherhood, you get dragged into the abortion debate, and "Should the state or federal government pay for abortions?" and "Why bring kids into this awful world, anyway?" You can't even talk about apple pie without obsessing over how fattening it is, and "Are we destroying the forests by harvesting apples?" All of a sudden, instead of talking about anything you want and saying whatever you believe, you have to tow the party line and say the politically correct thing. It's like a whore: "Just give me the money, and I'll give you anything you want."

Whorespeak.
Right. Not to be confused with pub-talk and donkey-talk.

Oh, my. Do I dare ask what those are?
In Ireland, pub-talk is when you say crazy things that sound like they're possible when you're with the boys drinking: "Ah, it's cold out, but I'm going to put my shoes on the sun so I can warm them." And the next day is donkey-talk: "Oh, my shoes are all the way under the fuckin' bed, and I can't get them out, and my feet are freezing!" Pub-talk is when everything is possible; donkey-talk is when nothing is possible.

Are you more pub-talk or donkey-talk?
I'm still looking at the glass half full. I'm the kid who looks at the pile of horseshit and says, "There's gotta be a pony in there somewhere!" I'm always looking for that pony. And occasionally I find it.

ACKNOWLEDGMENTS

For their help, cooperation, time, and belief in this project, I would like to thank Dominicus H. Rohde, Claudia Braga, Simone Nathan, Leticia Cadwallader, Chuck Mack, Chuck Friedman, Virginia Miller, Bill DuPriest, Judy Saslow, Carolyn Walsh, Mark Woolley, Dr. Enrique Mallen, Jack Basso, Rick Yarnell, Wojtek Barszcz, Jack Levin, Sheila King, Sheila Lamb-Gabler, Rose Lamb, and Matt Lamb.

For her meticulous written records and reminiscences, so helpful in reconstructing "the old days" of the Lamb family and Blake-Lamb Funeral Homes, I would like to acknowledge the late Margaret Lawler Lamb, a woman I never met but to whom I am endebted.

For their multifarious influences, I thank Gail Visgilio, Daniel Nukala, Michael Jones, Clint Killin, Bill and Maryann Carter, Erik and Cheri deHaas, Michael Leno, Larry and Mary LeFebvre, the Veterans of Foreign Wars' "Voice of Democracy" program, Professor Daniel R. White, Burnham Edson, and Steffen Silvis.

I would like to acknowledge Gordon Leslie, James Whitney Clarke, Sally Andrews-Pfister, James Lambeth, and E. Fay Jones, all of whom have departed but whose lessons linger, and the late Jessie Ruth Hunsinger Goodell, who read me fairy tales and dinosaur books long past both of our bedtimes, and the late Louise Wilson.

Thank you, Bridget Wise Schultz, Cheryl Cuzco, and Lena Horton.

My thanks to Joan O'Neil, Pamela van Giessen, Jennifer MacDonald, Kim Craven, Alexia Meyers, and Danielle Lake, and to my publicist, Barbara Henricks at Goldberg McDuffie.

Thank you to my colleagues at *Willamette Week* and my outstanding, outrageous friends in Portland, Oregon.

Thank you, Janie Louise Goodell Myers, for a lifetime of love and support.

And a wide, shining smile for Patricia Daphne Lynn, who knew, as we drove westward through Montana that night, that I—and we—could do it.

TIMELINE

April 7, 1932: Matthew James Lamb born in Chicago, Illinois

1947: Joins the Teamsters Union and begins driving hearses for the family business, Blake-Lamb Funeral Homes

May 1950: Graduates from St. Leo High School

September 1950: Enrolls in Worsham College of Mortuary Science. Graduates a year later and passes State Board exams with high marks.

Spring 1953: Volunteers for the Armed Forces Civilian Draft but fails his physical due to back problems and is rejected for service

October 2, 1954: Marries Rosemarie Graham

1958: Buys into his father's funeral home building corporation in Oak Lawn, Illinois, which would go on to build Blake-Lamb's flagship funeral home

1965: Lamb and his brother, Dick, form Matt-Rich Investments and begin buying and managing properties

1968: Cofounds Chulucanas Fellows, a group dedicated to improving living conditions in a remote Peruvian village

1970: Diversifies holdings, begins investing in oil and natural gas

1975: Visits Peru with Chulucanas Fellows, helps improve infrastructure in the village and region

1980: Physician diagnoses Lamb with a potentially fatal trio of chronic active hepatitis, acute infectious mononucleosis, and sarcoidosis of the liver. For the next two-and-a-half years, struggles to run Blake-Lamb despite the conditions, divulging details of his diagnosis to no one outside immediate family.

November 1983: Doctor advises him to put his affairs in order after a

severe onslaught of symptoms. Begins planning his own funeral but vows to become a painter if he lives.

December 1983: Undergoes five days of testing at Mayo Clinic, Rochester, Minnesota. Panel of doctors tells him they can find no trace of hepatitis, mononucleosis, or sarcoidosis in his body. Decides to make good on his vow to become a painter. Symptoms begin to fade away.

Spring 1984: Begins painting

1984–1987: Gradually divests himself of many of his businesses, resigns from various boards of directors, and lives a double life as head of Blake-Lamb and fledgling artist

October 1984: Visits Dachau concentration camp, Germany, and is profoundly moved

January 1985: Invested by order of Pope John Paul II into Equestrian Order of the Holy Sepulchre of Jerusalem

1985–1986: Paintings are evaluated by art dealer Art Rubin, artist/architect Jack Levin, and artist/public relations consultant Simone Nathan. Nathan holds regular "sharing sessions" with Lamb and represents his art to the press until 1995.

Summer 1985: Visits India and is moved by the life of Mahatma Gandhi. A year later, paints *Gandhi*, the first painting in which he consciously uses abstraction to express a metaphysical journey.

1986: Establishes studio in Chicago

1987: "Spirits" make first appearance in the painting, *Pandora's Box*. Lamb believes the spirits hail from another dimension and are using him as their mouthpiece to preach the virtues of peace, tolerance, understanding, hope, and love.

January 1987: Invested by New York Archbishop John O'Conner into Association of the Master Knights of the Sovereign Military Order of Malta

November 6, 1987: Paintings appear in public for the first time at a one-person show at Renata Galleria, Chicago. Gallery sells 19 of the 25 paintings on view, but the show is savaged by influential critic Harry Bouras. Defiant, Lamb continues to paint despite the merciless review.

November 25, 1987: Blake-Lamb Funeral Homes sold to Service Corporation International (S.C.I.)

1988: Establishes studio in Florida Keys

1988–1990: Is represented in Chicago by Carl Hammer, one of the most respected Outsider (self-taught) art dealers in the United States, and builds reputation as an Outsider artist. Leaves Hammer's stable due to practical and philosophic differences.

1990: Establishes studio in rural Wisconsin

October 2, 1990: One-person show opens at Espace Pierre Cardin, Paris, with the legendary fashion designer in attendance

1991: Stops titling his paintings, gives them catalog numbers but lets gallerists or owners title the works

May 1992: Enters the National Federation of French Culture's Deauville Exhibition and is awarded Bronze Medal

1994: Establishes studios in Tünsdorf, Germany, and County Cork, Ireland

April 7, 1994: Pope John Paul II accepts Lamb's painting, *The Crucifixion*, into permanent collection of the Vatican Museums

Spring 1995: Inaugural "dip," a quantum leap for Lamb's technique

1996: Awarded honorary doctorate of humane letters by University of Saint Thomas, Minneapolis, Minnesota

April 4, 1999: Pontifical North American College in Rome, Italy, acquires 15 Lamb paintings

2000: Establishes studio in Paris, France

June 6, 2000: Installation opens at Westminster Cathedral, London, with royal patron, Princess Michael of Kent, in attendance

Spring 2001: Crystal manufacturer Sasaki commissions Lamb to design a line of glass sculptures for Bloomingdale's and Marshall Field's

May 7, 2001: Art fair giant Sanford L. Smith & Associates informs Carolyn Walsh, Lamb's Nantucket gallery rep, that she will not be allowed to exhibit at the prestigious 2002 Outsider Art Fair in New York City if she shows Lamb's art. The reason: Lamb "is a savvy and successful businessman . . ."

August 30, 2001: Inauguration of the Matt Lamb Center/Museum für Moderne Kunst, Tünsdorf, Saarland, Germany

October 24, 2001: Sanford L. Smith & Associates retracts threat to Walsh and allows her to exhibit Lamb

2002: Begins painting in the vein of Abstract Expressionism, sometimes leaving his "spirits" out of the works. Decides to work henceforth in three styles: figurative, semi-abstract, and abstract.

May 26–28, 2002: Under a mandate from the U.S. Congress, leads art therapy workshops for 38 children orphaned by September 11, 2001 terrorist attacks

June 12, 2002: Sanford L. Smith & Associates disinvites Carolyn Walsh from 2003 Outsider Art Fair

January 22, 2003: On eve of 2003 Outsider Art Fair, the *Wall Street Journal* reports on Lamb's exclusion. Other newspapers, magazines, radio talk shows, and Internet sites follow up on the story. Lamb's rep, Carolyn Walsh, sells his paintings inside a Winnebago parked outside the fair's venue, the historic Puck Building in SoHo.

January 23, 2003: New York City gallery debut at Grant Gallery in SoHo

September 7–December 1, 2003: *Lamb Encounters Picasso* exhibition mounted by the Centre Picasso, Horta de San Joan, Spain

June 4, 2003: Leads 29 German high school students through the Brandenburg Gate at the climax of a series of art therapy workshops

March 2004: Establishes studio in Gualeguay, Argentina

May 22–June 30, 2004: *Lamb Encounters Miró* mounted by the Centre Joan Miró, Montroig, Spain

May 22, 2004: Centre Picasso opens a Matt Lamb Museum in a converted medieval jail in Horta, Spain, as an adjunct to its Picasso studies program

October 2–31, 2004: One-person exhibition at Museo Diocesano d'Arte Sacra, Convento Sant'Apollonia, Venice, Italy

July 22–August 19, 2005: *Lamb Encounters Chagall*, Musée du Pays de Sarrebourg, Sarrebourg, France

SELECTED COLLECTIONS
AND EXHIBITION HISTORY

Selected Collections
Museums:
The Vatican Museums, Vatican City
Centre Picasso, Horta de San Joan, Spain
Centre Joan Miró, Mont-roig, Spain
Moscow Museum of Modern Art, Moscow, Russia
Russian Academy of Arts, Moscow, Russia
Museum of Modern and Contemporary Art, Ferrara, Italy
National Museum of Modern Art, Poznan, Poland
Zamek Cultural Center, Poznan, Poland
Museo de Bellas Artes, Buenos Aires, Argentina
Museo Ambrosetti, Gualeguay, Argentina
Spertus Museum of Judaica, Chicago, IL
Rockford Art Museum, Rockford, IL
Vero Beach Museum of Art, Vero Beach, FL
Beverly Art Center, Chicago, IL

Religious Institutions:
Notre Dame Cathedral, Paris, France
Grand Mosque, Paris, France
Westminster Cathedral, London, U.K.

Government Institutions:
The House of Lords, London, U.K.
The German Bundestag, Berlin, Germany
People's Congress of China, Kunming, China
The State Department of the United States of America, Washington, D.C.
The Pentagon, Department of Defense, United States of America,
 Washington, D.C.
The National Treasury of the United States of America, Washington, D.C.
The State of Illinois
The City of Chicago, IL

Educational Institutions:
Oxford University, Oxford, U.K.
University of Bristol, Bristol, U.K.

Royal Hibernian Academy of Arts, Dublin, Republic of Ireland
Université Sorbonne, Paris, France
Collège St. Augustin, Bitche, France
Europahaus, Otzenhausen, Germany
St. Xavier University, Chicago, IL
Moraine Valley Community College, Palos Hills, IL
Roosevelt University, Chicago, IL
St. Thomas University, Minneapolis, MN

Hospitals and Miscellaneous:
Veterans Administration Medical Center, Washington, D.C.
Little Company of Mary Hospital, Evergreen, IL
Gardner, Carton & Douglas Attorneys, Chicago, IL
Cork Opera House, Cork, Republic of Ireland

Private Collections:
Her Royal Highness, Princess Michael of Kent
His All Holiness, Patriarch Dimitrios
His Beatitude, Michael Sabah
His Eminence, Cardinal Carlo Furno
His Eminence, Cardinal Guiseppe Caprio
His Eminence, Cardinal Jean-Marie Lustiger
His Excellency, Cardinal Joseph Bernardin (estate)
His Excellency, General Count d'Arcourt
Sir Charles Colthurst
President Wolfgang Thierse
The Most Honorable Theresa May
The Right Honorable George Ryan
The Honorable Edward J. Derwinski
The Honorable Richard M. Daley
The Honorable James R. Thompson
Professor Hubert Rohde
Professor Pierre Seck
Dr. Robert Derden
Dr. Ross Heller
Dr. Brigitte Castell
Dr. Guido Klinkner
Dr. Wolfgang Kölling
Pierre Cardin
Irv Kupcinet (estate)
Dich Locher
John Maizels
Potter Palmer
Veronika Heinz
Olivier Strebelle
Alain Hermelin

Joseph Giachino
Carlos Fantelli
Heinz and Karin Schwengber
Dr. and Mrs. Alexander von Boch
Luitwin Gisbert and Brigitte von Boch
Eugen and Margarete von Boch

Selected One-Person Shows
1987:
Galleria Renata, Chicago, IL

1988:
Galleria Renata, Chicago, IL

1989:
Carl Hammer Gallery, Chicago, IL
Beverly Art Center, Chicago, IL
Moraine Valley Community College, Palos Hills, IL
St. Xavier College, Chicago, IL

1990:
Espace Pierre Cardin, Paris, France
Carl Hammer Gallery, Chicago, IL
University of St. Thomas, Minneapolis, MN

1991:
Compassions Gallery, New Buffalo, MI

1992:
Gallerie Berlin, Berlin, Germany
University of St. Thomas Gallery, Minneapolis, MN
Sangamon Gallery, Chicago, IL

1993:
Galeria Praxis Arte Internacional, Mexico City, Mexico
Gallerie Berlin, Berlin, Germany
Chicago Cultural Center, Chicago, IL
University of St. Thomas Gallery, Minneapolis, MN
Minnesota Historical Society, St. Paul, MN

1994:
Galerie Pleiades, Athens, Greece
Hellenic American Union, Athens, Greece
Galerie Lisette Alibert, Paris, France
St. Matthias Kolleg, Tünsdorf, Germany
Robert F. diCaprio Gallery, Moraine Valley College, Polos Hills, IL
Carole Jones Gallery, Chicago, IL
Fassbender Gallery, Chicago, IL
Rosary College, River Forest, IL

1995:
University of Luxembourg, Luxembourg
Galerie Kasten, Mannheim, Germany
Galerie Lisette Alibert, Paris, France
St. Augustin College, Bitche, France
St. Matthias Kolleg, Tünsdorf, Germany

1996:
University of Bristol, U.K.
Oxford University Hospital, Oxford, U.K.
John Cabbot University, Rome, Italy
La Casa de la Cultura, Gerona, Spain
Cocomir Art Galleries, Valladamat, Spain
State of Illinois Gallery, Lockport, IL
Fassbender Gallery, Chicago, IL

1997:
Galeria Punto, Valencia, Spain
Galerie Lisette Alibert, Paris, France
Cathedral of the Holy Spirit, Mannheim, Germany
Galerie Praxis, Mandelbachtal, Germany
Gert Petgen Vineyard, Perl, Germany
Rockford Art Museum, Rockford, IL

1998:
Fassbender Gallery, Chicago, IL
Dallas Children's Theater, Dallas, TX
City of Saarbrücken Gallery, Saarbrücken, Germany
Tünsdorf Art Institute, Tünsdorf, Germany
St. Matthias Kolleg, Tünsdorf, Germany

1999:
Salon Nacional de Arte, Palais de Glace Recoleta, Buenos Aires, Argentina
Bank of Boston Foundation, Buenos Aires, Argentina
ArtSpace/Virginia Miller Galleries, Miami, FL
Great American Stuff, Hamtramck, MI
Zenner Gallery, Saarbrücken, Germany
Galerie Kasten, Mannheim, Germany
State Academy of Art Education, Ottweiler, Germany

2000:
Westminster Cathedral, London, U.K.
Melo Gallery, Buenos Aires, Argentina
Fassbender Gallery, Chicago, IL

2001:
Europahaus, Otzenhausen, Germany
ArtSpace/Virginia Miller Galleries, Miami, FL

Boys and Girls Club, San Francisco, CA
SMKT-Matt Lamb Center, Tünsdorf, Germany

2002:
Visitors Center of the People's Republic of China, Yunnan, Kunming, China
Judy A. Saslow Gallery, Chicago, IL
Cardinal Stritch University Museum, Milwaukee, WI
Museo Ambrosetti, Gualeguay, Argentina

2003:
Grant Gallery, New York, NY
Centre Picasso, Horta de San Joan, Spain
Kochhaus Museum, Schengen, Luxembourg
ArtSpace/Virginia Miller Galleries, Miami, FL
Warren Gallery, Castletownshend, West Cork, Ireland

2004:
Museo Diocesano d'Arte Sacra, Convento Sant'Apollonia, Venice, Italy
Centre Picasso, Horta de San Joan, Spain
Centre Joan Miró, Mont-roig, Spain
Warren Gallery, Castletownshend, West Cork, Ireland
Cabot Hall, Canary Wharf, London, U.K.
Mark Woolley Gallery, Portland, OR
Al·so Gallery, Dallas, TX
Arteipunto Gallery, Buenos Aires, Argentina

2005:
Moscow Museum of Modern Art, Moscow, Russia
Université Sorbonne, Paris, France
Musée du Pays de Sarrebourg, Sarrebourg, France
Villeroy & Boch Keramikmuseum, Mettlach, Germany
Zamek Cultural Center, Poznan, Poland
Judy A. Saslow Gallery, Chicago, IL
Warren Gallery, Castletownshend, West Cork, Ireland
Rima Fine Art, Scottsdale, AZ

Selected Group Exhibitions
1987:
Galeria Renata, Chicago, IL

1988:
Carl Hammer Gallery, Chicago, IL

1989:
Chicago International Art Exposition, Chicago, IL
Prairie Avenue Gallery, Chicago, IL
Vanderpool Gallery, Chicago, IL

1990:
Chicago International Art Exposition, Chicago, IL
World Tattoo Gallery, Chicago, IL

1991:
Salon de L'Automne, Paris, France
Salon des Independants, Grand Palais, Paris, France
Tough Gallery, Chicago, IL

1992:
Salon des Independants, Grand Palais, Paris, France
Salon de la Côte Fleurie, Deauville, France
Grand Concourse Internationale, Trouville, France
Galerie Berlin, Berlin, Germany
University of St. Thomas, Minneapolis, MN

1993:
Parc des Expositions de Chateaublanc, Avignon, France
New England Fine Art Institute, Boston, MA
Claibourne Gallery, St. Louis, MO

1994:
Vatican Museums, Vatican City
Galeria Praxis Arte Internacional, Mexico City, Mexico
Espace Branly, Paris, France
Grand Palais Des Expositions, Avignon, France
Fassbender Gallery, Chicago, IL
Carole Jones Gallery, Chicago, IL

1995:
Fassbender Gallery, Chicago, IL
Chicago Center for Self-Taught Art, Chicago, IL

1996:
Art Cologne, Cologne, Germany
Galerie Kasten, Mannheim, Germany
Art Chicago, Chicago, IL
Galery Lisette Alibert, Paris, France

1997:
Art Chicago, Chicago, IL
Art Cologne, Cologne, Germany
Outsider Art Fair, New York, NY
Museum of Contemporary Art, Ferrara, Italy
Expo Arte, Guadalajara, Mexico
Crossman Gallery, University of Wisconsin, Whitewater, WI
Fassbender Gallery, Chicago, IL
Sailor's Valentine Gallery, Nantucket, MA

1998:
Royal Hibernian Academy of the Arts, Dublin, Ireland
Outsider Art Fair, New York, NY
San Francisco International Art Exposition, San Francisco, CA
Art Chicago, Chicago, IL
Galerie Ferfanes, Zurich, Switzerland
Hyde Park Art Center, Chicago, IL
Baltimore Folk and Visionary Art Show, Baltimore, MD
Fassbender Gallery, Chicago, IL
Sailor's Valentine Gallery, Nantucket, MA

1999:
Outsider Art Fair, New York, NY
Art Chicago, Chicago, IL
Cows on Parade, City of Chicago, Chicago, IL
Fassbender Gallery, Chicago, IL
Contemporary Art Center of Peoria, Peoria, IL
Sailor's Valentine Gallery, Nantucket, MA

2000:
ArtSpace/Virginia Miller Galleries, Miami, FL
Sailor's Valentine Gallery, Nantucket, MA
2 Sisters Gallery, Dallas, TX
Dallas Children's Theater, Dallas, TX

2001:
Outsider Art Fair, New York, NY
Fassbender Gallery, Chicago, IL
ArtSpace/Virginia Miller Galleries, Miami, FL
Sailor's Valentine Gallery, Nantucket, MA
Jesuit Museum, Dallas, TX
2 Sisters Gallery, Dallas, TX

2002:
Outsider Art Fair, New York, NY
Judy A. Saslow Gallery, Chicago, IL
ArtSpace/Virginia Miller Galleries, Miami, FL
2 Sisters Gallery, Dallas, TX
Sailor's Valentine Gallery, Nantucket, MA

2003:
Grant Gallery, New York, NY
Mark Woolley Gallery, Portland, OR
Judy A. Saslow Gallery, Chicago, IL
ArtSpace/Virginia Miller Galleries, Miami, FL
Al·so Gallery, Dallas, TX
Sailor's Valentine Gallery, Nantucket, MA
Warren Gallery, Castletownshend, West Cork, Ireland

2004:
Warren Gallery, Castletownshend, West Cork, Ireland
Grant Gallery, New York, NY
Judy A. Saslow Gallery, Chicago, IL
ArtSpace/Virginia Miller Galleries, Miami, FL
Mark Woolley Gallery, Portland, OR
Sailor's Valentine Gallery, Nantucket, MA

Selected Commissions and Special Projects
1993:
The Great Façade, Chicago Cultural Center, Chicago, IL

1996:
Dance Chicago, Cerqua-Rivera Dance Experience, Chicago, IL

1997:
Forward Motion, Museum of Contemporary Art, Chicago, IL
Dance Chicago, Cerqua-Rivera Dance Experience, Chicago, IL
Next Generation Dance Project, Northeastern Illinois University, Chicago, IL

1998:
"Peace Glass," Villeroy & Boch, Mettlach, Germany

1999:
Immaculate Heart of Mary Chapel, Pontifical North American College, Rome,
 Italy
Cerqua-Rivera Dance Experience, Chicago, IL

2000:
An Gorta Mor, Chicago, IL
Victims to Victors, West Cork, Ireland

2001:
San Francisco Boys and Girls Club, San Francisco, CA

2002:
"Good Grief Camp," Tragedy Assistance Program for Survivors, Washington,
 D.C.
"Lamb Umbrellas for Peace," Gallery 37, Chicago, IL
Sasaki Glass Co., Ltd., Art Glass Sculptures, Bloomingdale's, Marshall Field's,
 USA

2003:
"Lamb Umbrellas for Peace," Berlin, Germany
"Lamb Umbrellas for Peace," London, U.K.
"Lamb Umbrellas for Peace," Horta de San Joan, Spain

2004:
"Lamb Umbrellas for Peace," Mont-roig, Spain
"Lamb Umbrellas for Peace," Gualeguay, Argentina

CONTACT INFORMATION AND GALLERIES

For more information about Matt Lamb, visit:
www.MattLamb.com
or
www.MattLamb.org

For more information about "The Lamb Umbrellas for Peace," visit:
www.The-Lamb-Umbrellas-For-Peace.org

For Dr. Enrique Mallen's on-line catalog raisonné of Matt Lamb's work, visit:
www.tamu.edu/mocl/lamb/

To inquire about Richard Speer's lectures on Matt Lamb's life, art, spirituality, and the controversies surrounding his place in the art world, visit:
www.RichardSpeer.com
or e-mail *richard@RichardSpeer.com*

For information about the San Matthias Kolleg Tünsdorf/Matt Lamb Centers, visit:
www.SMKT.org

To inquire about purchasing Lamb-decorated bottles of Fantelli wines, visit:
www.VillarDeRohde.com

To inquire about Matt Lamb's art, please contact the gallery nearest you:

UNITED STATES OF AMERICA:
Grant Gallery
7 Mercer Street
New York, NY 10013
(212) 343-2919
E-mail: *graanit@aol.com*
www.GrantGallery.com

Judy Saslow Gallery
300 West Superior Street
Chicago, IL 60610
(312) 943-0530
Fax: (312) 943-3970
E-mail: *jsaslow@core.com*
www.JudySaslowGallery.com

ArtSpace/Virginia Miller Galleries
169 Madeira Avenue
Coral Gables, FL 33134
(305) 444-4493
E-mail: *info@VirginiaMiller.com*
www.VirginiaMiller.com

Al·so Gallery
1425 Dragon Street
Dallas, TX 75207
(214) 744-0173
Fax: (214) 744-0176
E-mail: *freemanassocinc@aol.com*
www.FreemanInteriorDesign.com

Mark Woolley Gallery
120 NW 9th St., Suite 210
Portland, OR 97209
(503) 224-5475
Fax: (503) 224-9972
E-mail: *mark@markwoolley.com*
www.MarkWoolley.com

Sailor's Valentine Gallery
12 Straight Wharf
P.O. Box 127
Nantucket, MA 02554
(508) 228-2011
www.SailorsValentineGallery.com

Rima Fine Art
7077 East Main St.
Scottsdale, AZ 85251
(480) 994-8899
www.RimaFineArt.com

REPUBLIC OF IRELAND:
Warren Gallery @ Mary Ann's
Castletownshend
West Cork, Ireland
Telephone: 028-36146
E-mail: *maryanns@eircom.net*

GERMANY:
Galerie Ludwig
Leitzweilerstraße 5
66636 Theley-Germany
Telephone: +49-(0)6853-922949
Fax: +49-(0)6853-922954
E-mail: *info@artengo.com*
www.Artengo.com

UNIKAT Gallery
Cecilienstraße 6
66111 Saarbrücken-Germany
Telephone: +49-(0)681-373313

Galerie Ellendorff
Juttastraße 3
49377 Vechta-Germany
Tel: +49-(0)4441-7744
Fax: +49-(0)4441-83882

ARGENTINA:
Galería Arteipunto
Gorriti 5253
Buenos Aires, Argentina
Telephone: +54 11 - 4833.4721
arteipunto@hotmail.com

ABOUT THE AUTHOR

Richard Speer is an Associated Press Award–winning writer whose articles, essays, and reviews have appeared in *Newsweek*, the *Los Angeles Times*, the *Sacramento News & Review*, *ARTnews*, *Opera News*, and other publications. He is Visual Arts Critic at Portland, Oregon's ground-breaking alternative newspaper, *Willamette Week*, where his take-no-prisoners reviews and features have won him vocal admirers ("Speer has a dramatic, baroque bent to his prose . . ."—critic/curator Jeff Jahn) and detractors (". . . suffers from an Oedipus complex and should go back to the whorehouse where his inspiration is born . . ."—*Willamette Week* Letter to the Editor).

Formerly a television news anchor/reporter, Speer worked at CBS, ABC, NBC, and FOX affiliates throughout the United States, earning accolades for his spot-news and feature reporting. He is acclaimed for his interviews and profiles of such national and international figures as opera superstar Luciano Pavarotti, composer Philip Glass, authors Chuck Palahniuk and Barbara Branden, painter David Geiser, and architects E. Fay Jones and James Lambeth.

An accomplished public speaker, Speer lectures on aesthetics, criticism, and popular culture in forums around the world and has discussed these topics as a guest on nationally syndicated talk radio. Also a pianist, singer, and photographer, he lives in Portland, Oregon, with his wife, Patricia.

NOTES

CHAPTER 3

1. Maeve Binchy, "For the Irish, Long-Windedness Serves as a Literary Virtue," *New York Times*, 4 Nov. 2002.

CHAPTER 5

1. Nov. 2003 <http://www.HBO.com>.

CHAPTER 6

1. *Chicago Sun-Times*, 20 Feb. 1986.
2. *Oak Lawn Independent*, 19 Jan. 1995.
3. *Regional News*, 29 Dec. 1994.
4. Mary Daniels, "Treasure House: The Showcase That World Travel Built," *Chicago Tribune*, 10 Aug. 1986.
5. Irv Kupcinet, "Kup on Sunday," *Chicago Sun-Times*, 13 Dec. 1987.
6. Christina January-Adachi, *Today's Chicago Woman*, June 1989.

CHAPTER 7

1. Irv Kupcinet, "Kup's Column," *Chicago Sun-Times*, 1 Nov. 1981.
2. "The Death Merchants," *Chicago Sun-Times*, May 1981.
3. Norma Libman, "Family Ties," *Chicago Tribune Magazine*, 17 June 1990.
4. Irv Kupcinet, "Kup's Column," *Chicago Sun-Times*, 1 Feb. 1987.

CHAPTER 9

1. Mary Towley Swanson, *Matt Lamb: His Art and Philosophy* (catalog essay for the unveiling of Lamb's monumental painting, *Great Façade*, at the gala performance of Sir William Walton's *Façade* by the William Ferris Chorale, University of St. Thomas, St. Paul, MN), Jan. 1993.
2. Swanson.

CHAPTER 10

1. Barbara B. Buchholz and Margaret Crane, *Corporate Bloodlines: The Future of the Family Firm* (New York: Carol Publishing Group, 1989), 212–228.
2. Buchholz and Crane.
3. *The University of St. Thomas Bulletin*, 19 Oct. 1992.
4. James Yood, *The Matt Lamb Message* (catalog essay for show, *Matt Lamb*, Pleiades Gallery, Athens, Greece), Nov. 1994.

CHAPTER 12

1. Robert M. Pine and Michael Greany, *Harry Bouras, First Retrospective Exhibition: Assemblage, Painting, Sculpture,* Elmhurst Art Museum, Spring 1999; original source Dennis Stone, *Chicago Scene,* May 1968.
2. Andrew Patner, E-mail to the author, 12 May 2003.

CHAPTER 13

1. Michael D. Hall, *Matt Lamb: Obsessive Spirit Wrestling with the Angels* (catalog essay for the show of the same title, Rockford Art Museum, Rockford, IL), Summer/Fall 1997.
2. Carley.
3. Carol Damian, *Matt Lamb: The Chaos of Modern Life* (catalog essay for the show, *Matt Lamb: Another World,* ArtSpace Virginia Miller, Coral Gables, FL), Oct./Nov. 1999.

CHAPTER 15

1. *Reporter,* 2 June 1994.
2. Micheal Ann Carley, *An Unfolding: Traditions of the Narrative: The Works of Matt Lamb.*
3. Lorraine Swanson, *Sky,* 21 July 1994.
4. *Windy City Times,* 15 Dec. 1988.

CHAPTER 16

1. Albright-Knox Gallery, Buffalo, NY, May 2003: <*http://www.albrightknox.org/acq_2001/Richter.html*>.
2. Yood.

CHAPTER 18

1. *God Matters with Sister Sue Sanders* (radio show produced by St. Xavier University's Center for Religion and Public Discourse and the Sisters of Mercy Regional Community of Chicago), "Wrestling with Angels," Fall/Winter 2002.
2. W.H.C. Frend, *The Rise of Christianity* (Philadelphia: Fortress Press, 1984), 661–62.
3. *Splendors of the Spirit: Swedenborg's Quest for Insight,* prod. and dir. Penny Price, Swedenborg Foundation, 2001.
4. Athena Schina, *Coexistences* (catalog essay for exhibition of the same title at the Hellenic/American Union, Athens, Greece), 1997.

CHAPTER 19

1. Garrett Holg, "Reviews," *New Art Examiner,* February 1989.
2. Carley.
3. Carol Damian, "National Reviews," *ARTnews,* Jan. 2000.
4. Michael D. Hall, "Just 'a Looking for a Home," *Raw Vision* 31, Summer 2000.
5. Hans L.C. Jaffe, *Mondrian* (New York: Harry N. Abrams, 1969), 9, quote attributed to Mondrian's autobiographical notes.

CHAPTER 20

1. Swanson.
2. Holg.
3. Ginny Holbert, "Galleries," *Chicago Sun-Times*, 21 Sept. 1990.

CHAPTER 21

1. *Southtown Economist*, 28 June 1992.

CHAPTER 22

1. Margaret Hawkins, *Chicago Sun-Times*, 8 Sept. 2000.

CHAPTER 23

1. "Places," *Lear's*, Sept. 1993; and "Connoisseur's World," *Town & Country*, February 1996; "82 for '82," *Miami Magazine*, Jan. 1982.

CHAPTER 24

1. Henry Hanson, *Chicago Magazine*, March 1993.
2. Oct. 2003 <*http://www.wawwj.com.ar*>.

CHAPTER 26

1. Monica David, Public Relations Manager, Mall of America, E-mail to the author, 7 July 2003.

CHAPTER 27

1. Maria Walsh, *Open the Door to the Redeemer* (catalog essay for the exhibition, *Matt Lamb: Millennium Art Exhibition*, Westminster Cathedral, London), June/July 2000.
2. Ruth Gledhill, "Colourful Theology for a New Millennium," *The Times of London*, 9 June 2000.

CHAPTER 29

1. Hall, *Raw Vision*.

CHAPTER 31

1. Jan. 2003 <*http://www.RawVision.com*>.
2. Ratcliff.
3. Rose Gonnella, "The Books of Anne Grgich," *Raw Vision* 22, 1998.
4. Steven Vincent, "The Problem with Outsider Art," *Art & Auction*, June 2003.
5. Hall, *Raw Vision*.

CHAPTER 32

1. Lynn Walsh, Interviewed by author, 2 Feb. 2003.

CHAPTER 33

1. Kurt Andersen, "When Insiders Define Outsiders," Online blog for *Studio 360*, prod. Public Radio International and WNYC, 1 Feb. 2003.

2. Tim Cavanaugh, "Hit & Run," 23 Jan. 2003 <*http://www.Reason.com*>.
3. Hadley St. John, "On the Outs: Island Gallery Tossed from NYC Outsider Art Fair," *Inquirer and Mirror,* 23 Jan. 2003.
4. Tessa DeCarlo, "Must Outsiders Be Above Selling?" *New York Times,* 23 Feb. 2003.
5. Ken Johnson, "Art in Review," *New York Times,* 24 Jan. 2003.
6. Carl Hammer, E-mail to the author, 25 Feb. 2003.

CHAPTER 34

1. Rachel L. Swarns, "Mandela Paints His Jailhouse Years," *New York Times* reprinted from *Robben Island Journal,* 12 Feb. 2003.
2. Jerry Tallmer, "Guccione: The Publisher as Painter," *Penthouse,* Sept. 1994.
3. Carley.
4. Peter Schjeldahn, "The Original: Grandma Moses Looks Better than Ever," *The New Yorker,* 28 May 2001.
5. Vincent.
6. Cynthia Cotts, "Tropes of the Times: When did Inside and Outside Get so Chummy?" *Village Voice,* 24–30 Dec. 2003.
7. David Logan, *Manifesto of (Dis)content,* 1999, Leaflet accompanying the video-taped lecture, *La Vie Boheme,* Larry Harvey, 24 Feb. 2000.

PART 8

1. Roger Ebert, "Tarkovsky's *Solaris,*" *Chicago Sun-Times,* 19 Jan. 2003.

CHAPTER 35

1. Catherine Thomas, "Giant Steps," *The Oregonian,* 9 May 2003.
2. Josef Ollinger, *Saarbrücker Zeitung,* 19 Sept. 2003.

CHAPTER 36

1. Robert Coates, "The Art Galleries," *The New Yorker,* 30 March 1946, 75.
2. Susan Landauer, *The San Francisco School of Abstract Expressionism* (Berkeley: University of California Press, 1996), 54.
3. Landauer.

CHAPTER 37

1. Elias Gastón, "Horta de Sant Joan: The Perfect Place for an Encounter with Picasso," (catalog essay), Sept. 2003.
2. Alfred Barr, *Picasso: Fifty Years of His Art* (New York: Museum of Modern Art, 1966), citing the original source, "Conversation avec Picasso," *Cahiers d'Art,* 1935.
3. Tamvaki; Gastón.
4. Leonard Folgarait, "Lamb, Picasso, and Horta" (catalog essay), Sept. 2003.
5. Mallen.
6. Barr.
7. Ariana Huffington, *Picasso: Creator and Destroyer* (New York: Simon & Schuster, 1988).
8. Sabartés.

9. Barr.
10. François Gilot and Carlton Lake, *Life with Picasso* (New York: McGraw Hill, 1964).
11. Hélène Parmelin, *Picasso: Women* (New York: Harry N. Abrams, 1967).
12. Huffington.
13. Daniel-Henry Kahnweiler and Francis Crémieux, *My Galleries and Painters*, trans. Helen Weaver (New York: Viking Press, 1971).

CHAPTER 39

1. Jack Zimmerman, "In Like a Lamb," *The Press*, 25 March 1992.
2. Swanson.

CHAPTER 40

1. Angela Tamvaki, *Agony and Hope: Matt Lamb's Optimistic Vision of the Universe* (catalog essay), November 1994.
2. John Order, Interview by the author, 3 June 2003.
3. Guido König, "Matt Lamb, ein Neuerer aus Tradition: Kunstphilosophische Betrachtungen angesichts eines außergewöhnlichen Werks" ("Matt Lamb: An Original Emerges from Tradition: An Aesthetic and Philosophic Essay on an Extraordinary Body of Work"), trans. Richard Speer, *Hominum Genus*, Dec. 2002.
4. Carley.
5. Schina.
6. Donald Kuspit, "Madness and Matt Lamb" (catalog essay for show, *Matt Lamb*, Fassbender Gallery, Chicago), 1996.
7. Sophie Delassein, "Si puissant, Si fragile," *Muséart L'Oeil*, Oct. 1990.
8. Paolo Rizzi, "Regaining Order" (catalog for show, *Matt Lamb e le Maschere del Carnevale di Venezia*, Museo Diocesano, Convento Sant'Apollonia, Venice), 2004.
9. Elisa Turner, *Miami Herald*, 14 Nov. 1999.
10. Peter Hartig, *Luxembourger Wort*, 10 Aug. 1995.
11. Hall, *Matt Lamb: Obsessive Spirit Wrestling with the Angels.*
12. Sidney Janis, *They Taught Themselves: American Primitive Painters of the 20th Century* (Port Washington, NY: Kennikat Press, 1942).
13. Friedrich W. Kasten, Ph.D., "An Island in the Sea, or: In the Garden of Dreams" (catalog essay for show, *Matt Lamb*, at Galerie Kasten, Mannheim, Germany), trans. Adelheid Mers, 1999.
14. Kuspit.
15. Arlene McKanic, "New York Reviews," *ARTnews*, Nov. 2002.
16. Holg.

CHAPTER 41

1. Kitty Rogers, "Chicago's Finest: Matt Lamb," *CAC Artists' News*, Dec. 2003.

PART 9

1. John Gruen, *Keith Haring: The Authorized Biography* (New York: Prentice Hall Press, 1991).

INDEX